ECHOES OF SURREALISM

Challenging Socialist Realism in East German Literature, 1945–1990

Gerrit-Jan Berendse

berghahn
NEW YORK • OXFORD
www.berghahnbooks.com

First published in 2021 by
Berghahn Books
www.berghahnbooks.com

© 2021, 2025 Gerrit-Jan Berendse
First paperback edition published in 2025

All rights reserved. Except for the quotation of short passages
for the purposes of criticism and review, no part of this book
may be reproduced in any form or by any means, electronic or
mechanical, including photocopying, recording, or any information
storage and retrieval system now known or to be invented,
without written permission of the publisher.

Library of Congress Cataloging-in-Publication Data
Names: Berendse, Gerrit-Jan, 1959- author.
Title: Echoes of surrealism : challenging socialist realism in East German
 literature, 1945-1990 / Gerrit-Jan Berendse.
Description: New York : Berghahn, 2021. | Includes bibliographical
 references and index.
Identifiers: LCCN 2020051934 (print) | LCCN 2020051935 (ebook) | ISBN
 9781800730687 (hardback) | ISBN 9781800730694 (ebook)
Subjects: LCSH: German literature--Germany (East)--History and criticism. |
 Surrealism (Literature)--Germany (East) | Surrealism in mass media. |
 Literature and society--Germany (East)
Classification: LCC PT3710.S87 B47 2021 (print) | LCC PT3710.S87 (ebook) |
 DDC 830.9/116309431--dc23
LC record available at https://lccn.loc.gov/2020051934
LC ebook record available at https://lccn.loc.gov/2020051935

British Library Cataloguing in Publication Data
A catalogue record for this book is available from the British Library

ISBN 978-1-80073-068-7 hardback
ISBN 978-1-80539-720-5 paperback
ISBN 978-1-80539-910-0 epub
ISBN 978-1-80073-069-4 web pdf

https://doi.org/10.3167/9781800730687

Echoes of Surrealism

In fond memory of the German Surrealist,
Adolf Endler (1930–2009)

Contents

Acknowledgements viii

Abbreviations, Definitions and Translations ix

Introduction. The Surreal without Surrealism 1

Chapter 1. The Fate of the Avant-Garde in Post-war Germany 17

Chapter 2. Return of the Avant-Garde? Brecht & Co. in the GDR 39

Chapter 3. '1968' in the GDR: Franz Kafka and the Prague Spring 53

Chapter 4. Flirting with the Enemy: The Absurd and Grotesque in 1960s Poetry 69

Chapter 5. The GDR's Surrealist Nerve Centre: Adolf Endler's Strange *Nebbich* World 90

Chapter 6. Wolfgang Hilbig's Landscapes 'Where the Minotaurs Graze' 116

Chapter 7. 'Flip-out-Elke': Elke Erb's Surrealistic Poetry 131

Chapter 8. Gabriele Stötzer under Surveillance: Feminism and the Avant-Garde 148

Chapter 9. East German Advocates of Surrealism 168

Conclusion. 'Max Ernst Was Here!' 181

Bibliography 193

Index 209

Acknowledgements

At the completion of this long-term project it is a pleasure for me to acknowledge the help and support of the people who made the writing of this book possible. Special thanks go to Ingo Cornils, Ewout van der Knaap, Kerstin Hensel, Sabine Berendse, Claudia Albert, Ingrid Sonntag, Klaus Michael, Rolf X. Schröder, Erdmut Wizisla, Helmut Lethen and Brigitte Schreier-Endler. Paul Clements is to be thanked for his translation skills and sharp eye for detail, especially when it came to correcting my sometimes-broken English.

In 2015 I was awarded a University Research Leave Fellowship by Cardiff University. This, and my research fellowships with the Alexander von Humboldt Foundation, enabled me to focus fully on preparing and finalizing this book. In particular, I wish to express my gratitude to staff working in the Deutsches Literaturarchiv (DLA) at Marbach for making my research visits a truly satisfactory experience. I also thank the people in the Akademie der Künste and the Stasi-Archiv (BStU) in Berlin for their help.

In most cases, literary passages are not quoted in their entirety. Missing text is designated with ellipses.

Versions of Chapters 3 and 5 have been published as articles in the *Times Literary Supplement*, in 2013 ('Laughed Back to Life') and 2018 ('All Power to the Imagination') respectively. A revised version of Chapter 7 has been published under the title 'Flirting with Surrealism' in Volume 18 of the German Studies Yearbook, *Gegenwartsliteratur*, in 2019. These outlets have kindly permitted me to reuse this previously published material.

<div style="text-align: right;">
Gerrit-Jan Berendse

Berlin, Spring 2021
</div>

Abbreviations, Definitions and Translations

BRD: Bundesrepublik Deutschland (Federal Republic of Germany, FRG)
DDR: Deutsche Demokratische Republik (German Democratic Republic, GDR)
DEFA: Deutsche Film-Aktiengesellschaft (GDR Film Company)
KPD: Kommunistische Partei Deutschlands (Communist Party of Germany)
NSDAP: Nationalsozialistische Deutsche Arbeiterpartei (National Socialist German Workers' Party)
SBZ: Sowjetische Besatzungszone (Soviet Occupied Zone, SOZ)
SED: Socialist Unity Party of Germany (Sozialistische Einheitspartei Deutschlands)
SMAD: Sowjetische Militäradministration in Deutschland (Soviet Military Administration in Germany)

11. Plenum des ZK der SED (11th Congress of the Highest Office of the ruling Communist party, the SED): Also known as the Kahlschlag Plenum, or Clear-Cutting Plenum, where the work of many writers, filmmakers and other artists was disapproved.
Der Bundesbeauftragte für die Unterlagen des Staatssicherheitsdienstes der ehemaligen Deutschen Demokratischen Republik (BStU) (Stasi-Archiv): The Federal Commissioner for the Records of the State Security Service of the Former German Democratic Republic.
Entartete Kunst (degenerate art): The label the National Socialists under Adolf Hitler applied to art they did not approve of, in an attempt to bring art under their control.
Formalismus-Kampagnen (Formalism Campaigns): Around 1950, the SED party considered foreign designs and products to be symbols of Western decadence. The campaigns were modelled after the Soviet anti-Formalism campaigns in the 1930s.

Inoffizieller Mitarbeiter (IM): Undercover informer, unofficial collaborator; employed by the Stasi.

Literaturgesellschaft (Literature Society): term coined by the Minister of Culture, Johannes R. Becher, in 1950; changed by Erich Honecker in the early 1980s to Leseland (Land of Readers).

Prenzlauer Berg Connection: scene of poets, visual artists, filmmakers and musicians in the district of Prenzlauer Berg in East Berlin in the 1980s, most of them born in the 1960s.

Real existierender Sozialismus (Real Existing Socialism): Ideological term popularized during the Brezhnev era in the Eastern Bloc countries and the Soviet Union; it refers to the Soviet-type economic planning enforced by the ruling communist parties.

Sächsische Dichterschule (Saxon School of Poets): Group of poets characterized by poetic dialogue, most of them born in the 1930s.

Sozialistischer Realismus (Socialist Realism): State-sponsored art form that portrays the idealized life of workers and peasants in a socialist state.

Ministerium für Staatssicherheit (Stasi): Ministry for State Security Service.

Verfremdungseffekt, or V-Effekt (V-Effect): Alienation practice in plays by Bertolt Brecht.

Wende: the historical period around German reunification (1989–90); sometimes called the *friedliche* Revolution (peaceful revolution).

Introduction

The Surreal without Surrealism

> The time will come, if it is not already come, when the surrealist enterprise will be studied and evaluated, in the history of literature, as an adventure of hope.
> —Wallace Fowlie, *Age of Surrealism*

Indubitably, Surrealism and the GDR are closely connected, and are more closely related to each other than one might think. When, for example, one listens to the recollections and reads the memoirs of those who lived in this country, apparently no other conclusion can be drawn. Life in the East German Communist state had a surrealistic disposition, was associated with the grotesque, absurd and irrational. Admittedly, Surrealism did not exist in the GDR. Not only are the insights of Hans Magnus Enzensberger and Peter Bürger on the death of the historical avant-garde convincing and applicable to the GDR;[1] it is also significant that no German artist or writer who considered him- or herself a Surrealist prior to 1945 returned from exile to settle in the SBZ or the GDR. Most of the celebrities of German Surrealism during the Weimar Republic were forced to go into exile or did not return to Germany at all. Max Ernst, for example, remained living in the USA, and then in 1953 moved to his wife's old quarters in Paris; Hans Arp decided to live in Switzerland, and in 1949 chose the USA as his home country. Others who had lived through and survived Hitler's Germany had to face the harsh demands of National Socialist cultural politics that downgraded the avant-garde to the status of *Entartete Kunst*, or degenerate art, and sidelined and even terrorized its representatives. Yvan Goll (a.k.a. Iwan Lassang), the German- and French-speaking poet who was associated with Surrealism, returned from New York to Paris where he died in 1950.

In occupied France, André Breton, Paul Éluard, Louis Aragon and other Surrealists had already started the process of loosening the grip of the group in the late 1920s.[2] They either lived in inner emigration or went into exile and found refuge in the USA, in Spain or in Mexico, where new post-war surrealist movements, linked to the original French movement, emerged. Generally speaking, if traces of surrealist writing and art can be detected in the GDR, this was not based on historical avant-garde movements as, for example, was the case with the Czech and Slovakian Surrealism that later developed into the post-war Surrealism or Nadrealism movement, and continued to impact on cultural politics in Czechoslovakia.[3] In East German art and literature, Surrealism was a home-grown product, as it contained traces of the surrealistic antidote to the predominant grip of Socialist Realism.

Before continuing, Surrealism in fictional literature needs to be defined. Generally speaking, Surrealism is meant to be strange and shocking, and to push the envelope in such a way that it forces us out of our comfort zones – so much so that it has even been known to cause riots. While the idea of Surrealism is complex, surrealist literature does share common characteristics. While it has contrasting – indeed jarring – images or ideas, this technique is used to help readers make new connections and expand their understanding of reality. Surrealists borrow Freudian ideas of free association as a way to steer readers away from societal influence and open up the individual's mind. Furthermore, Surrealism uses images and metaphors to compel the reader to think more deeply and to reveal subconscious meaning. Instead of relying on plot, surrealist writers focus on the characters, discovery and imagery to force readers to dig into their unconscious and analyse what they find. Literary Surrealism also uses poetic styles to create dreamlike and fantastic 'stories' that often defy logic. One of these 'stories' relates to what has often been called the 'definition' of Surrealism given by the Uruguay-born French poet Le Comte de Lautréamont (nom de plume of Isidore Lucien Ducasse), in *Chants de Maldoror* (*The Songs of Maldoror*), published in 1868: 'As beautiful as the chance encounter of a sewing machine and an umbrella on an operating table.'[4] Rather than incorporate normal prosaic, poetic and dramatic structures such as linear plots and structured settings, Surrealism – decades after Lautréamont's introduction of his strange imagery – uses poetic techniques, like leaps in thinking (free association), abstract ideas and nonlinear timelines.[5]

Admittedly, Surrealism was primarily a French product that flourished in the first decades of the twentieth century. It involved membership, a pledge to its manifestos (based on, for example, Sigmund Freud's insight into the unconscious mind) and, most importantly, conformity with the charismatic – others say dictatorial – leadership of Breton.[6] There is neither a need here to repeat the foundations of and procedures within the French

surrealist movements, nor to give an investigation into Breton's mindset, because in both cases there is a broad and fundamental stock of research, as, for example, the acclaimed *International Encyclopedia of Surrealism* (2019) has proven.[7] When discussing Surrealism and the GDR, it is significant that the movement's credo, reiterated in a book on Surrealism by the GDR art historian Lothar Lang (which, of course, appeared only after German unification), became the greatest fear of the SED cultural functionaries. Lang asserts that surrealist art focuses on disrupting or even overturning logical systems of reference.[8] This disturbing factor had already become evident for Marxists at the time when Breton, like many Surrealists in the 1930s, became a strident anti-Stalinist and instead flirted with Trotskyism. Surrealism's ideal was to forge together art and life – but given the hostility of Communism towards Surrealism, which led, in 1935, to the withdrawal of Breton's invitation to speak at the Writers' Congress in Paris, the latter was forced to locate the practice of his politics in creative endeavour: politics became embedded in the texture of the work. The foundation of the political in Surrealism was anarchism. In the 1935 publication *Du temps que les surréalistes avaient raison* (In the Time That the Surrealists Were Right), the complete break with the Communist Party was announced. The Surrealists accused the Stalinists of threatening to undermine the freedom of expression. The French Communist Party, for their part, openly despised the Surrealists.[9] In 1938 Breton met Leon Trotsky in Mexico, in the house of Diego Rivera and Frida Kahlo. Together they wrote the *Manifesto for an Independent Revolutionary Art*, which asserts that while the social revolution will be able to change society, true art is revolutionary *im Geistigen* (in spirit). In light of the oppressive practices of both National Socialism and the Soviet Communist regime, they pleaded for the freedom, independence and liberation of art – the birth of the rich Socialist avant-garde to be found in Latin America culture.[10] The organization that followed the *Manifesto*, however, was short lived and had no political effect at all, and the Stalinists did not respond to it.[11] Breton's expression of aversion to Stalinism in 1936–37 marked the conclusive end of the previous liaison between Surrealism and Communism.[12] Meanwhile, deliberations on the place of the avant-garde in Marxist aesthetics in the SBZ (as will be discussed in Chapter 1) intensified, and the difficult and tense relationship between Communism and Surrealism continued in the GDR. For this reason, this book's subtitle indicates the continuation of the conflict as an East German, not exclusively GDR-based, cultural issue.

Needless to say, in contrast to the cultural scenes in the SBZ and the GDR, in West Germany a smoother continuation of Surrealism was to be expected. In the early 2000s the journal *Herzattacke* set up the literary archive *Speichen*. There, extensive materials on post-1945 Surrealism in Germany are being

examined and evaluated. They document a dynamic process of transnational exchange and translation.[13] Indeed, the most important joint production was the yearbook of poetry, also called *Speichen*, that appeared between 1968 and 1971. There, various writers promoted the so-called *Nachkriegssurrealismus* (post-war Surrealism); among them were the writers Richard Anders, Johannes Hübner, Joachim Uhlmann and Lothar Klünner, all of whom began their artistic careers immediately after the Second World War. In their work they juxtaposed traditional and contemporary trends within European Modernism. Before *Speichen*, the first magazines and journals were *Die Fähre* (The Ferry) and *Athena*, licensed by the Western Occupied Powers. It is significant that the resulting new poetry and translations also filtered through into the East and, in spite of the division of Germany after the 1948 *Währungsreform* (currency reform), began to influence fellow writers in the SBZ and the GDR. The optimism of artists and writers following the end of Nazi barbarism gave way to an understanding that the cultural landscape was becoming narrowed by the limitation and ignorance of the artistic avant-garde – in the West, by traditionalism and the increasing aesthetic restriction to the Realism of the American School. Hence, in both parts of post-war Germany, Realism seemed to be a red rag for artists.

The authors of the *Nachkriegssurrealismus* in the West oriented themselves primarily to French literature, and began, in the first post-war years, to translate the work of significant yet still completely unknown poets. Friendships and contacts existed within West Berlin and beyond the sector borders. For example, the bohemians, who had gathered around the poet Günter Bruno Fuchs in the district of Kreuzberg, had productive contacts with GDR writers such as Johannes Bobrowski, Erich Arendt and Manfred Bieler. Important for this mediation was Klaus Völker, who later became a world-renowned scholar of theatre studies and Brecht expert. The international framework also included poets and translators such as Paul Celan, Hans Henny Jahnn and Michael Hamburger. The transnational agenda remains impressive to this day.[14] It is interesting to note that in the 1980s, a similar development occurred: at the same time as the dissident art and literature took root in the Prenzlauer Berg scene in the early 1980s in East Berlin, a Mecca of anarchist culture established itself in West Berlin, albeit with a different cultural and political background. Partly, those East Berlin artists and writers with indefinite entry permits who were able to cross the border freely nourished the countercultural outlook in West Berlin and were the main figures of the exchange: they cross-fertilized the East and West. This was a unique phenomenon. The literary critic Fritz J. Raddatz had already used the occupied term 'Exilliteratur' with reference to what he observed in the 1960s and what would become a major driver in German cultural history, both in the first and final decades of the GDR's existence.[15]

In spite of doubts about the revolutionary power of the post-war avant-garde, as formulated by Enzensberger in his essay 'Aporien der Avantgarde' (The Aporias of the Avant-Garde, 1962), the influence of the Surrealists and their impact on post-1945 West German culture has been often emphasized. As Mererid Davies has argued and demonstrated, the playful subversions of the Situationist International movement under Guy Debord, in the tradition of Dada and Surrealism, inspired the actions of Kommune I (the counter-political and cultural group in West Berlin that was linked to the German student movement) in the late 1960s, and were also partly associated with student rebellion in the FRG and West Berlin.[16] At that same time, in the GDR, other, though less obvious, traces of the surreal could be detected in writing. For this reason it is incorrect to assume that in contrast to its neighbours on the east and west side of its borders, the GDR was isolated and bleak in cultural matters, and should be perceived only in shades of grey. On neither side of the Berlin Wall could the death of the avant-garde be proclaimed. On the contrary, in the East, for example, traces of the surreal became tools for those who were in the process of breaking the protective wall which had been erected symbolically long before the construction of the actual Berlin Wall itself. This cultural wall was intended to prevent Western-style Modernism entering the GDR during the 1950s Formalism Campaigns. Consequently, the literary and artistic world of the GDR should be viewed as a more colourful spectrum than has previously been the case.

Aims and Objectives

This book intends to demonstrate a growing awareness among East German writers and artists that Surrealism had the power to contradict and even to resist the predominance of the dogma of *Sozialistischer Realismus* (Socialist Realism) in GDR cultural politics. This counter-discourse to the *Leitdiskurs* (master discourse) of monosemia aimed at rewriting the master code.[17] Thus, while there is no evidence of an 'official' surrealist movement in the GDR, Surrealism as an aesthetic entity was a concept embraced by writers and artists, with which they broadened our assessment of GDR culture. Further, scholars and connoisseurs of art promoted the significance of the absurd and grotesque, beginning with artists and writers who planted traces of artistic resistance in the minds of East German readers. Prominent among these were: Hans Mayer and Stephan Hermlin, in their *Ansichten über einige Bücher und Schriftsteller* (Views on Some Books and Writers, 1947); Erhard Frommhold's introduction to his *Kunst im Widerstand* (Art in Resistance, 1968); the publication of the 1975 monograph *Hieronymus Bosch* by Wilhelm Fraenger;[18] and Karlheinz Barck's anthology *Surrealismus in Paris* (1985). Most of these

significant cultural interventions occurred before the many urban alternative literary and artistic scenes began openly to display a vibrant collection of different applications of post-war Surrealism in the second half of the 1980s, as a kind of cultural apotheosis of GDR existence. In these countercultures it becomes most obvious that – in the tradition of Surrealism – the borders between conventional genres are being dissolved and consequently rendered irrelevant.[19] In other words, throughout the existence of the SBZ and the GDR there was a growing awareness of the significance of another culture, not so much of that on the other side of the Wall, but rather found as patches of the bizarre and irrational in its own literature and art.

The intention of this book is twofold. First and foremost, I focus on analysing the application of surrealist writing in the GDR[20], always with reference to the thoughts of other East German intellectuals and artists.[21] Socialist Realism was the officially sanctioned theory and method of literary composition prevalent in the Soviet Union from 1932 to the mid-1980s. For that period of history this relatively vague term was the sole criterion for measuring literary works. Since Socialist Realism had become the state-endorsed artistic genre around 1950, writers, artists and scholars associated with (historical or neo-) avant-garde aesthetics were subsequently marginalized. Surrealism, on the other hand, is the twentieth-century avant-garde movement in art and literature which sought to release the creative potential of the unconscious mind by the irrational juxtaposition of images. These two cultural phenomena could not be further apart. Since there was no space to allow Surrealism to blossom in the GDR, it became the all-embracing term for cultural resistance and deviance; that is, an alternative to the government's rigid and inflexible cultural policies, which frequently, and in whatever disguise it appeared, resulted in censorship. This defiance not only indicated the creation of an artistic identity for the marginalized groups of the East German literary scene; the antidote was also a political statement. It confronted the status quo of GDR cultural politics and indicated – especially to the outside world – that the GDR offered more in cultural terms. In the 1970s and 1980s in particular there was an explosion of a literature that fed on the historical avant-garde, and my hypothesis is that Surrealism was both one of the utopian carriers in the GDR and also, as will be shown in the following chapters, in the decades prior to it. This book will focus on the recycling processes in a political and cultural context in which all traces of Surrealism should have been erased. It is the combination of old elements and new aspirations that allows us to talk about Surrealism in the GDR.

This study also has an additional driving force in proposing the hypothesis that, paradoxically, some of the surreal fictional accounts of strange events in the GDR should be defined as realistic representations. The constant oscillation between the real and the surreal was to become a characteristic of GDR

fiction. Indeed, in many texts the contours of what is fact and what is fiction are often deliberately blurred. This becomes apparent when, for example, two different, sometimes even contradictory, text types clash and a dialogue between them emerges – a carnivalesque presentation of reality is staged. Some writers fought the discourse of monosemia by dissolving into a state of nebulousness. Instead of supplying the required clear-cut definitions of social and political life, more challenging, multifaceted views were presented. For the functionaries of GDR cultural politics, these artefacts were unequivocal evidence of bourgeois indoctrination. The result is a surreal effect. On another, but similar, level is the application of official slogans in fictional literature, such as those used by GDR officials in trying to surpass the Federal Republic of Germany in ideology. During the Cold War, the GDR gradually isolated itself from the West, and its officials were ridiculed, not least because of the nonsense of some of their statements. Hence, paradoxically, the perception of everyday real life could turn into a surreal record. In some tongue-in-cheek slogans it is hard to decide whether the text is on the side of reality or the surreal. When platitudes such as 'überholen, ohne einzuholen' (overtaking without running out) or 'Die Lehre von Marx ist allmächtig, weil sie wahr ist' (Marx's doctrine is almighty because it is true) become part of the narrative, the literary world tends towards satire and outright travesty. Finally, in hindsight, in the events of the countercultural scene in the East Berlin district of Prenzlauer Berg, the surreal was at its peak when in the hotchpot of bohemian ambition, genuine supporters and mentors were joined by spies and traitors. This created a truly hybrid and grotesque world. The surreal prospered in the GDR.[22]

Indeed, no post-war avant-garde movement established itself in East Germany; no manifestos were written, nor was the avant-garde considered an authorized cultural-political term featuring in official GDR cultural history. And, in that spirit of dogmatism, movements such as Surrealism and Dadaism were neglected or characterized negatively in the official *Kulturpolitisches Wörterbuch* (Cultural Political Dictionary), published by the SED in 1970.[23] But surrealist aesthetics and poetics were genuine homemade cultural products in the GDR, born out of frustration with existing cultural-political directives and practices, and intended to radically change the direction of the GDR through resisting the dogma of Socialist Realism, particularly during the Formalism Campaigns of the 1950s. After 1945, there was not only the urge to question any kind of dogmatism, there was also a challenge to the version of reality as presented by the SED. This implied a subtle and ironic alienation of the concepts of time and space. The doctrine of Socialist Realism was eventually denounced officially during the last Congress of Visual Artists in November 1988 under the slogan 'Kunst im Sozialismus' (Art in Socialism), but it had long before been ignored by

the majority of artists and writers who adopted Modernist techniques and topics in Marxist East Germany.[24] In the 1960s and 1970s, discussions began in (mainly West) Germany on the best way of assessing the historical avant-garde. These were initiated by Enzensberger's essay 'Aporien der Avantgarde', and subsequently reinforced by Bürger's *Theorie der Avantgarde* (*Theory of the Avant-Garde*) (1974, English 1984).[25] For many fellow scholars in the West, these discussions were considered irrelevant and redundant at a time when progressive students were trying to revolutionize culture. Departure from the past was also an incentive for East German academia. In the GDR, the recycling of Modernism and the avant-garde became relevant in the 1980s, initiated, among others, by Karlheinz Barck and Dieter Schlenstedt.[26] The avant-garde was a phenomenon that linked several ideological camps, since the mutual enemy was National Socialism with its vilification of avant-garde movements in Modernism. The GDR was facing a dilemma: that of condemning Hitler's cultural policies while at the same time embracing the rejection of the historical avant-garde by the fanatics of Socialist Realism in the 1950s and 1960s.

Surreal Post-1945 Germany

But before hostile cultural politics forged the echoes of Surrealism into a weapon, the surreal had already been present in the country. At the end of the Second World War, huge swathes of Europe had been reduced to ruins after the Allied bombing missions and the progress of the forces of the Soviet Union across Eastern Europe. The images of what was left of major German cities such as Dresden, Berlin, Cologne and Chemnitz, the ghostlike street views and shattered architecture, resemble the iconographic images of apocalyptic devastation we have become familiar with in the work of Max Ernst, Salvador Dalí and Joan Miró, among others. Photographs by the Irish war photographer Cecil F.S. Newman and the Russian Yevgeny Khaldei from ruined Berlin had a similar impact on the German public and the world's imagination after they were published.[27] In December 1948, Roberto Rossellini's film *Germania anno zero* (*Germany, Year Zero*) was released. He filmed on location in Berlin and intended to convey the reality in Germany three years after its near-total destruction at the end of the Second World War. The film contains dramatic images of a bombed-out Berlin.[28] The first paintings of the destroyed and surreal-like city of Dresden by Karl Hofer, Werner Heldt, Wilhelm Lachnit and Wilhelm Rudolph were exhibited during the *Allgemeine Deutsche Kunstausstellung* (General German Exhibition) in Dresden in 1946, and combined realistic and surreal imagery.[29] The art historian Lang chooses his words carefully in his seminal

Malerei und Graphik in der DDR (Painting and Graphic Arts in the GDR) when he writes that Rudolph's representation of Dresden's destruction is 'nearly a landscape of Surrealism'.[30] When Lang wrote and published this statement in the early 1980s, the use of the word 'Surrealism' was controversial, and it may be for this reason that Lang modified it with the adverb 'nearly'. In 1965, the painter Ralf Winkler (better known as A.R. Penck) presented his representation of the devastation of his hometown, entitled *Umsturz* (Coup d'Etat), by applying celebrated primitive-style imagery, recalling cave art, and reflecting the harsh realities of the Second World War and, later, the Cold War. Here, the beautiful landscape is replaced by an aggressive battle between two ideologies against a red background, represented by two images of unrecognizable leaders. Winkler seems to support the official interpretation of what the Second World War was really about: not an attempt to liberate Germans but rather to substitute ideologies, as indicated by the confrontation of both totems in the painting.[31]

Another more subdued but similarly bizarre imagery made its way into GDR cultural history in the poetry of the early 1960s. The Dresden writer Heinz Czechowski had survived the bombings as a 10-year-old child, and wrote in the first line of his poem 'An der Elbe', in which the picturesque landscape of what was known as 'Elbflorenz' (Florence on the Elbe) had suddenly changed into a macabre and inhuman setting, that 'Sanft gehen wie Tiere die Berge neben dem Fluß' (softly like animals the mountains move next to the river).[32] It has been reported that during the bombing of Dresden people left their destroyed houses and moved along the river – some burning, others jumping into the water.

And in the predominantly realistic narrative of his diary, the Romanist Victor Klemperer (1881–1960) noticed a surreal part of the city of Dresden after its destruction. On 22 February 1945 he remembers:

> Wir gingen langsam, denn ich trug nun beide Taschen, und die Glieder schmerzten, das Ufer entlang bis über die Vogelwiese hinaus. … Hier unten am Fluß, wo sich viele Menschen bewegten oder hingelagert hatten, staken im durchwühlten Boden massenhaft die leeren, eckigen Hülsen der Stabbrandbomben. Aus vielen Häusern der Straße oben schlugen immer noch Flammen. Bisweilen lagen, klein und im wesentlichen ein Kleiderbündel, Tote auf den Weg gestreut. Einem war der Schädel weggerissen, der Kopf war oben eine dunkelrote Schale. Einmal lag ein Arm da mit einer bleichen, nicht unschönen Hand, wie man ein Stück in Friseurschaufenstern aus Wachs geformt sieht.[33]

> We walked slowly, for I was now carrying both bags, and my limbs hurt, along the river-bank. … Down here by the river, where many people were moving along or resting on the ground, masses of the empty, rectangular cases of the

stick incendiary bombs stuck out of the churned-up earth. Fires were still burning in many of the buildings on the road above. At times, small and no more than a bundle of clothes, the dead were scattered across our path. The skull of one had been torn away, the top of the head was a red bowl. Once an arm lay there with a pale, quite fine hand, like a model made of wax such as one sees in barber's shop windows.

The blend of the abominable destruction of this city and images of a surreal nature has been immortalized by Kurt Vonnegut's *Slaughterhouse-Five or The Children's Crusade: A Duty-Dance with Death* (1969). The book combines science fiction with historical facts, notably Vonnegut's own experience as a prisoner of war during the Allied firebombing. The juxtaposition of the 135,000 killed, the unrealistic element and the grotesque highlights the absurdity of the novel, which was translated into German in 1970, and published for the first time in the GDR by Volk und Welt in 1972. This excerpt should illustrate the proximity to the surreal:

… Billy and five other American prisoners were riding in a coffin-shaped green wagon, which they had found abandoned complete with two horses, in a suburb of Dresden ….

Billy opened his eyes. A middle-aged man and wife were crooning to the horses. They were noticing what the Americans had not noticed – that the horses' mouths were bleeding, gashed by the bits, that the horses' hooves were broken, so that every step meant agony, that the horses were insane with thirst. The Americans had treated their form of transportation as though it were no more sensitive than a six-cylinder Chevrolet.

… When Billy saw the condition of his means of transportation, he burst into tears. He hadn't cried about anything else in the war.[34]

On 13 February 1947 in the Western Zone, Wolfgang Borchert's radio play *Draussen vor der Tür* (*The Man Outside*) documented another war experience. It was broadcast for the first time on North West German Radio. The premiere of the play in the Hamburger Kammerspiele was on 21 November of that same year. A prose version was published later. The terrible mental state of the protagonist, Private Beckmann, when returning from the front as a Wehrmacht soldier to his hometown Hamburg, was characterized as a *gesamtdeutsches* (pan-German) phenomenon, not merely related to the West Germany of which the writer was a citizen. The play, later turned into a novel, is a recording of dream sequences, and in the reparative and expressionist narrative, surreal imagery becomes obvious when in the dream the grotesque clashes with reality, as when, for example, Beckmann reveals his nightmare to his former commanding officer:

Da steht ein Mann und spielt Xylophon. Er spielt einen rasenden Rhythmus. Und dabei schwitzt er, der Mann, denn er ist außergewöhnlich fett. Und er spielt auf einem Riesenxylophon. Und weil es so groß ist, muß er bei jedem Schlag vor dem Xylophon hin und her sausen. Und dabei schwitzt er, denn er ist tatsächlich sehr fett. Und er schwitzt gar keinen Schweiß, das ist das Sonderbare. Er schwitzt Blut, dampfendes, dunkles Blut. … Es muß ein alter Schlachtenerprobter General sein, denn er hat beide Arme verloren. Ja, er spielt mit langen dünnen Prothesen, die wie Handgranatenstiele aussehen, hölzern und mit einem Metallring. Es muß ein ganz fremdartiger Musiker sein, der General, denn die Hölzer seines riesigen Xylophons sind gar nicht aus Holz. Nein, glauben Sie mir, Herr Oberst, glauben Sie mir, sie sind aus Knochen. Glauben Sie mir das, Herr Oberst, aus Knochen![35]

There's a man playing the xylophone. He plays incredibly fast. And he sweats, this man, because he's extraordinarily fat. And his xylophone's gigantic. And because it's so big he has to dash up and down with every stroke. And he sweats, because he's really very fat. But it's not sweat what he sweats, that's the odd thing. He sweats blood, steaming dark blood. … He must be a real old campaigner, this general, for he lost both arms. Yes, he plays with long thin artificial arms that look like grenade throwers, wooden with metal rings. He must be a very strange sort of musician, this general, because the woods of his xylophone are not made of wood. No! Believe me, sir, believe me, they're made of bones. Believe me, sir, bones!

In the GDR, Borchert's stage play was turned into a TV play, directed by Fritz Bornemann, and broadcast on 20 November 1960. The novel was published in the same year by Insel Verlag in Leipzig. Its huge popularity was diminished in 1972 when the SED decided that Borchert's drama could only be classified as West German, and no longer as an expression of a pan-German phenomenon. In the eyes of the Communist ideologues the play was too pessimistic, too pacifist and not sufficiently anti-fascist.[36] Borchert's interpretation of Hitler did not fit well into their parameters.

East Germany's cultural market had opened to Surrealism and the historical avant-garde, in different ways, shortly after the Third Reich ceased to exist. After 1945 the entire German cultural scene experienced a *Nachholbedarf* – the need to catch up after twelve years of dictatorship and disconnection from Modernism and the avant-garde, a textual and visual art that had been labelled *entartet* by the National Socialist regime. In contrast to popular belief, particularly in the West during the high tides of the Cold War, those responsible for cultural matters in the first four years after 1945 were open-minded, thus allowing non-realistic and non-socialist art and literature in the SBZ. This meant that experimental innovations were acceptable and even promoted by the Western and Eastern Zones. In his study of cultural politics

in East Germany, Manfred Jäger refers to the first years in the SBZ as 'Storm and Stress' years, a cultural idyll, in which innovation and pluralism flourished; an application of Lenin's thought, following the successful Bolshevik Revolution, that former bourgeois artists and writers needed time to adjust to the new aesthetic framework.[37] This attracted many artists sympathetic to Marxism. In this comparative cultural paradise for Marxists between 1945 and 1949, not only were new projects initiated, but books and journals on and by Surrealists also appeared in the Western zones. Before the *Währungsreform*, or currency reform in 1948, they were at everyone's disposal and therefore also available in the East.[38]

The German-speaking journals, which featured French Surrealism and other historical avant-garde movements and were available in the French Occupied Zone after 1945, were *Athena, Meta, profile, Das Lot* and *Lancelot, der Bote aus Frankreich*.[39] In the second issue of its second year of appearance, *Athena* featured André Breton's article 'Surrealismus und Marxismus',[40] an essential read for experimental artists and writers living in the SBZ, and at the same time an affront to dogmatists. In the opening of his article Breton refers to himself in the third person, 'Während er auf politischen und sozialen Gebiet den Marxismus anerkennt, lehnt er den 'sozialistischen Realismus' in der Kunst, der damals wie heute von vielen Marxisten vertreten wurde, uneingeschränkt ab' (Although he accepts Marxism politically and socially, he unconditionally rejects Socialist Realism in the arts, which many Marxists represent in the past and present).[41] Breton defines Surrealism as 'gesprengter Rationalismus' (busted rationalism) and 'gesprengter Realismus' (busted realism), a dangerous anarchist mixture of magic, the unconscious and anarchy.[42]

Socialist Realism had become a fearsome doctrine in the cultural politics of the GDR in the 1950s and 1960s – a protective wall that was threatened by the destabilizing power of, for example, Surrealism. One of the perceived threats to the cultural doctrine was suspected in the translations into German of texts by French Surrealists and the invitations of those associated with this avant-garde movement. The greatest threat, however, came from within the cultural scene of the GDR, that is, the publications of prose, poetry and theatre, and beyond this the scholarly effort to promote and popularize Surrealism. All these endeavours will be discussed in this book. After a short reminder of the 1950s Formalism Campaigns and the significance of the concepts of Georg Lukács in the early GDR (Chapter 1), the book will turn to Brecht's attempts to introduce the lost avant-garde to East Germany (Chapter 2). In the 1960s, the productive reception of Franz Kafka is discussed in the context of the International Kafka Conference in Liblice in 1963, and will be interpreted as a significant move towards infiltrating the East German culture scenes (Chapter 3). The application of surreal

motives and registers is particularly evident in the poetry of, for example, Uwe Greßmann, Karl Mickel, Wolf Biermann, Richard Leising and Adolf Endler (Chapter 4). Endler will be characterized as the representative of the nerve centre of Surrealism in the GDR, since he has been most outspoken about the reception of Surrealism and at the same time about his quest to portray the GDR as a surreal country (Chapter 5). The fantastic, absurd and grotesque are also investigated in the prose of Wolfgang Hilbig, after an examination of the non-realism of Irmtraud Morgner, Fritz Rudolf Fries, and Heiner Müller (Chapter 6). In the 1980s, multiple underground scenes are observed and become key engines in the alternative to realist, that is, conventional, art. In both the following chapters, the focus will be on examining in detail two of the female representatives of these underground scenes who promoted surrealist art and writing in the 1980s in different urban centres in the GDR. What has become obvious is the so-called 'double discrimination' of these neo-avant-gardists. We will focus on the work of Elke Erb (Chapter 7) and Gabriele Stötzer (Chapter 8), also investigating their dealings with the Stasi.[43] In the final chapter, advocates of Surrealism in the GDR will be introduced – intellectuals whose marketing efforts for this avant-garde culture were to be prevented. These supporters were Hans Mayer, Ernst Bloch, Stephan Hermlin, Lothar Lang, Diether Schmidt, Erhard Frommhold and Karlheinz Barck (Chapter 9). In the Conclusion, the energetic drive of Barck and Endler will be emphasized. These two individuals cemented Surrealism in the cultural makeup of the GDR and made sure this historical avant-garde movement prevailed.

There is much more to discover in the almost forty-five years of East Germany's existence between the end of the Third Reich and the fall of Communism in Europe and Russia. In particular, the GDR's difficulties in dealing with Europe's most important cultural achievement in the twentieth century, Modernism, is a significant way of defining the German Democratic Republic. In the eyes of the English historian Timothy Garton Ash, this was merely a footnote in world history, albeit one that offers 'a case study in the way literature, film and culture responded to the challenges of an authoritarian regime, so often staking out the territories beyond what was permitted and, to borrow a phrase from Christa Wolf, "stretching the boundaries of the sayable"'.[44] In this book the focus is on those artists, writers and academics who searched for and found alternatives to the doctrine of Socialist Realism, and expanded the zones of the 'sayable'. Their dissident status within the GDR is accompanied by their urge to be directly linked to the European cultural heritage of Modernism. This book should therefore not be misunderstood as a contribution to the currently immense popular research on Surrealism per se, but rather as an analysis of GDR cultural politics.

Nothing is what it seems, and most contours are blurred; sometimes the ways we see the GDR, and in particular our prejudices, must be changed. This book draws a picture of the rumblings in Cold War cultural politics in the Eastern part of Germany, and will eventually shed new light on how GDR literature is to be assessed. Both the SED and the West aspired to present their particular assessments of GDR literature, each undermining the view of the other. This book should enable the reader to question stereotypes, free his or her perception from ideological overkill and appreciate a side of East German and GDR literature respectively that has been unrepresented in German cultural history – that of East German fictional *Nachkriegssurrealismus* (post-war Surrealism).

Notes

1. See Hans Magnus Enzensberger, 'Aporien der Avantgarde'. In: *Einzelheiten II. Poesie und Politik*. Frankfurt: Suhrkamp, 1964, 5–80; and Peter Bürger, *Theorie der Avantgarde*. Frankfurt: Suhrkamp, 1974.
2. See Mark Polizzotti, *Revolution of the Mind: The Life of André Breton*. Boston: Black Widow Press, 2008; and Dawn Ades et al. (eds), *The International Encyclopedia of Surrealism*, 3 vols. London: Bloomsbury, 2019.
3. Ludwig Richtig, 'Vom Surrealism und von der Katholischen Moderne zum Sozialistischen Realismus in der slowakischen Lyrik'. In: Alfrun Kliems et al. (eds), *Sozialistischer Realismus*. Berlin: Frank & Timme, 2006, 129–50 (129). Cf. Anja Trippner, *Die permanente Avantgarde? Surrealismus in Prag*. Cologne: Böhlau, 2009.
4. Comte de Lautréamont, *The Songs of Maldoror*, trans. R.J. Dent. With illustrations by Salvador Dalí. Washington, DC: Solar Books, 2011 (Canto VI, Verse 3). In German: 'Die zufällige Begegnung von Nähmaschine und Regenschirm auf einem Seziertisch.' This was quoted for the first time in the GDR in the translation of Max Ernst's essay 'Was ist Surrealismus' by Rainer Schlesier. See Karlheinz Barck (ed.), *Surrealismus in Paris 1919–1939. Ein Lesebuch*. Leipzig: Reclam, 1985, 610–13 (611).
5. See endnote 3.
6. Cf. Tessel Bauduin, *Occultism and Western Esotericism: Work and Movement of André Breton*. Amsterdam: University of Amsterdam Press, 2014.
7. See also Alyce Mahon, *Surrealism and the Politics of Eros, 1938–1968*. London: Thames & Hudson, 2005; and Michael Löwy, *Morning Star: Surrealism, Marxism, Anarchism, Situationism, Utopia*. Austin: University of Texas Press, 2009.
8. 'Die Verrückung und die vollständige Aushebung logische Bezugssysteme.' ('The dislocation and complete excavation of logical reference systems.') All translations, if not otherwise indicated, are by Paul Clements. See Lothar Lang, *Surrealismus und Buchkunst*. Leipzig: Edition Leipzig, 1993, 14.
9. Uwe M. Schneede, *Die Kunst des Surrealismus. Malerei, Skulptur, Fotografie, Film*. Munich: Beck, 2006, 80.
10. Cf. Mari Carmen Ramirez and Héctor Olea, *Inverted Utopias: Avant-Garde Art in Latin America*. New Haven and London: Yale University Press, 2004.
11. Schneede, *Die Kunst des Surrealismus*, 80.
12. Ibid., 81. See also the Conclusion of this book.

13. See http://herzattacke.net/historie (assessed on 27 September 2019).
14. Johann Thun, 'Der Kreis um das Jahrbuch *Speichen* als Vermittler des Surrealismus in Deutschland'. In: Karina Schuller and Isabel Fischer (eds), *Der Surrealismus in Deutschland (?). Interdisziplinäre Studien*. Münster: Wissenschaftliche Schriften der WUU Münster, 2016, 219–36.
15. Fritz J. Raddatz, 'Zur Entwicklung der Literatur in der DDR'. In: Manfred Durzak (ed.), *Die deutsche Literatur der Gegenwart. Aspekte und Tendenzen*. Stuttgart: Reclam, 1971, 337–65.
16. Mererid Puw Davies, *Writing and the West German Protest Movements: The Textual Revolution*. London: imlr books, 2016, 105–38.
17. David Bathrick, *The Powers of Speech: The Politics of Culture in the GDR*. Lincoln and London: University of Nebraska Press, 1995, 19–21 (19). I use the term 'monosemia', introduced as 'Monosemie' by Peter V. Zima in 'Der Mythos der Monosemie. Parteilichkeit und künstlerischer Standpunkt'. In: Hans-Jürgen Schmitt (ed.), *Einführung in Theorie und Funktion der DDR-Literatur*. Stuttgart: Metzler, 1975, 77–107.
18. The Dutch painter and the modern Surrealists have a lot in common: a similar visual expression and narrative. But was Bosch the predecessor or even the 'grandfather' of Surrealism, as is often stated? André Breton did not mention him in the 1924 *First Surrealist Manifesto*. Other Surrealists, like Max Ernst and René Magritte, saw Bosch and Breughel as their inspiration. See Gerta Moray, 'Miró, Bosch and Fantasy Painting', *The Burlington Magazine* 113 (1971) 820: 387–91; and Wallace Fowlie, *Age of Surrealism*. Bloomington: Indiana University Press, 1960, 174 and 190.
19. See, among others, Bert Papenfuß and Ronald Lippok (eds), *Psychonautikon Prenzlauer Berg*. Fürth: starfruit publications, 2015.
20. I will focus on fictional literature in the SBZ and the GDR, similar to the beginnings of the historical avant-garde movement Surrealism in Paris, which was also characterized by a transcultural overlap. See the catalogue *Max Ernst, Zeichendieb. Eine Ausstellung der Nationalgalerie, Sammlung Scharf-Gerstenberg, Staatliche Museen zu Berlin*. Bonn: VG Bild-Kunst and Berlin: Staatliche Museen zu Berlin, 2019, 23.
21. It should also be noted that in the visual arts, Magic Realism was a German phenomenon that derived from Italian metaphysical painters such as Giorgio de Chirico and Carlo Carrá. It is argued that Paul Klee and Max Ernst came across it independently, as did the art historian Franz Roh and the circle of artists related to Magic Realism. Roh introduced the term *Magischer Realismus* in 1925 in parallel with that of *Neue Sachlichkeit* (New Austerity) coined by his friend Gustav Friedrich Hartlaub. Cf. Matthew Cale and Katy Wan (eds), *Magic Realism: Art in Weimar Germany 1919–33*. London: Tate, 2018, 7–19 (8). The list of visual artists from the GDR who were associated with Surrealism is impressive. It includes the names Hermann Glöckner, Carlfriedrich Claus, Horst Hussel, Hans Ticha, Günther Hornig, Rolf X. Schröder and Angela Hampel. See also Chapter 7.
22. Paul Kaiser and Claudia Petzold, *Boheme und Diktatur in der DDR. Gruppen, Konflikte, Quartiere; 1970–1989*. Berlin: Fannei & Walz, 1997.
23. Manfred Berger (ed.), *Kulturpolitisches Wörterbuch*. Berlin: Dietz, 1970.
24. Ulrike Goeschen, *Vom sozialistischen Realismus zur Kunst im Sozialismus. Die Rezeption der Moderne in Kunst und Kunstwissenschaft der DDR*. Berlin: Duncker & Humblot, 2001, 9.
25. Enzensberger, 'Aporien der Avantgarde' and Bürger, *Theorie der Avantgarde*.
26. Karlheinz Barck, Dieter Schlenstedt and Wolfgang Thierse (eds), *Künstlerische Avantgarde. Annäherungen an ein unabgeschlossenes Kapitel*. Berlin: Akademie Verlag, 1979.

27. Cf. Michael Sobotta, *Berlin in frühen Farbfotografien: 1936 bis 1943*. Erfurt: Sutton Verlag, 2015; and Alexander and Alice Nakhimovsky, *Witness to History: The Photographs of Yevgeny Khaidei*. New York: Aperture, 1997.
28. The movie was first screened in Germany in 1952 in a Munich film club, and it was only shown on German television in 1978.
29. The cycle *Das zerstörte Dresden* (The Ruined Dresden), which consists of over 150 bourdon tube drawings, has been held by the Dresdner Kupferstich-Kabinett (Dresden Etching Cabinet) since 1959.
30. Lothar Lang, *Malerei und Graphik in der DDR*. Leipzig: Reclam, 1983, 28.
31. Ingrid Pfeiffer et al., *A.R. Penck. Werke 1961–2001*. Düsseldorf: Richter, 2007.
32. Cf. Gerrit-Jan Berendse, 'Zu neuen Ufern: Lyrik der "Sächsischen Dichterschule" im Spiegel der Elbe'. In: Margy Gerber et al. (eds), *Studies in GDR Culture and Society: 10 Selected Papers from the Fifteenth New Hampshire Symposium on the German Democratic Republic*. Lanham: University Press of America, 1991, 197–212 (199).
33. Victor Klemperer, *Tagebücher 1945*, ed. Walter Nowojski. Berlin: Aufbau Verlag, 1995, 37. Translated by Martin Chalmers in *To the Bitter End: The Diaries of Victor Klemperer 1942–1945*. London: Weidenfeld & Nicolson, 1999, 393. Ellipis added for copyright reasons.
34. Kurt Vonnegut, *Slaughterhouse-Five or The Children's Crusade: A Duty-Dance with Death*. London: Vintage, 2000, 159–62. Ellipses added for copyright reasons.
35. Wolfgang Borchert, *Draußen vor der Tür*. In: *Das Gesamtwerk*. Hamburg: Rowohlt, 1980, 122–23. Translation by David Porter in Borchert, *The Man Outside*. New York: New Directions, 1971, 100. Ellipses added for copyright reasons.
36. Marianne Schmidt, *Wolfgang Borchert. Analysen und Aspekte*. Halle/Saale: Mitteldeutscher Verlag, 1974; and Peter Rühmkorf, *Wolfgang Borchert mit Selbstzeugnissen und Bilddokumenten*. Reinbek: Rowohlt, 1997.
37. Manfred Jäger, *Kultur und Politik in der DDR 1945–1990*. Cologne: Edition Deutschland Archiv, 1995, 5.
38. See Adolf Endler, *Dies Sirren. Gespräche mit Renatus Deckert*. Göttingen: Wallstein, 2010, 98.
39. Berendse, '"Dank Breton". Surrealismus und kulturelles Gedächtnis in Adolf Endlers Lyrik'. In: Karen Leeder (ed.), *Schaltstelle. Neue deutsche Lyik im Dialog*. Amsterdam: Rodopi, 2007, 73–95 (89).
40. *Athena* 2 (1947–48) 2: 46–8.
41. Ibid., 46.
42. The German writers represented in *Athena* were, among others, Wolfgang Bächler, Max Frisch, Paul Gurk, Karl Krolow, Elisabeth Langgässer, Thomas Mann, Wolfdietrich Schnurre and Anna Seghers. In the early 1950s Edgar Jené and Max Hölzer edited *Surrealistische Publikationen*, published by Verlag Josef Haid in Klagenfurt. Its subtitle was 'Texte und Bilder der Surrealisten aller Länder', and it promoted *Nachkriegssurrealismus* (post-war Surrealism) and featured, for example, Czech post-1945 Surrealism, Paul Celan, Max Ernst, Dorothea Tanning, Dieter Wyss and Max Hölzer.
43. Held by the Bundesbeauftragte für die Unterlagen des Staatssicherheitsdienstes der ehemaligen Deutschen Demokratischen Republik (Federal Commissioner for the Records of the State Security Service of the former German Democratic Republic, BStU).
44. Timothy Garton Ash, 'Preface', *Oxford German Studies* 38(3) (2009): 234–35 (234).

Chapter 1

THE FATE OF THE AVANT-GARDE IN POST-WAR GERMANY

The end of twelve years of Nazi dictatorship posed a variety of difficult questions concerning Germany's future and, not least, its cultural future. It is evident that the shock and trauma of 1945 constituted an identity crisis, which Germans and their new governmental structures were compelled to experience and attempt to resolve before moving on. In the final volume of his trilogy on the history of Nazi Germany, Cambridge historian Richard J. Evans emphasizes that despite the need of many Germans for normalization and continuity after the catastrophic schism in the twentieth century, following Hitler's suicide and the subsequent unconditional surrender on 7 May 1945, a fresh start was out of the question. In the long shadow of the Third Reich, a 'Zero Hour' was simply impossible to achieve, because too many aspects of the previous barbarism were rooted in German history. Equally difficult was the task of ensuring that the atrocities of the war were not revived in the new post-1945 era. Particularly in the Western Occupied Zones, large sections of German education, jurisdiction and the economy continued to be administered and delivered by former Nazis. Evans even claims that in West Germany, re-employment had a hidden agenda. He argues that in spite of attempts at denazification it was not possible to 'ban all 6.5 million members of the party from employment in positions of responsibility'. He continues:

> The need for the expertise of judges, doctors, lawyers, scientists, engineers, bankers and many others was too great. … The professions closed ranks and deflected criticism of their behaviour in the Third Reich, and a veil of silence

descended over complicity, not to be lifted until after the leading participants retired, towards the end of the century.[1]

It was not only through the Nuremberg and the later Auschwitz trials, and the achievements of Israel's Mossad and other secret services, that former Nazis were held accountable for their brutalities. In the FRG and West Berlin, the fanaticism of the so-called 'Achtundsechziger' (Nineteen-Sixty-Eighters) also played an important role in unmasking former Nazis and revealing the contaminated history of the old Germany on which the new was being built. In the GDR, '1968' was of a different quality altogether, as we will see in Chapter 3.

Circumventing the official lines of communication was illegal, and since many previous members of the NSDAP became important participants in establishing the SBZ and the GDR, the past of many of its citizens was simply ignored. The SED's most effective measure was convincing old Nazis of the benefits of the new ideology and putting it into practice. In Germany, 'Zero Hour' was either delayed or did not happen at all. Instead, it was bound to become a myth.

Difficulties with reconstruction and rebuilding were not limited to the West or to the areas just mentioned. This denial of the concept of Zero Hour prevented a fresh start in 1945. This was also true for West German culture, according to Friedhelm Kröll in the *Hanser Sozialgeschichte der deutschen Literatur* (Hanser Social History of German Literature), an authoritative volume on the social history of German-language literary fiction. Kröll describes '1945' as a missed opportunity for the FRG. Writers emerging from 'Inner Emigration' either continued as if nothing had happened; or literary traditions from other Western cultures became fashionable and were recycled. For a long time, no real change occurred in the teaching of contemporary culture and politics in schools and universities.[2] Despite the Communists' strong belief in their foundation myth of anti-Fascism and 'construction'[3] (as evidenced in their national anthem), continuation had become common practice in the East under Walter Ulbricht (as in the West under Konrad Adenauer – albeit under different circumstances and with contrasting motives).

The main reason for this cautious manoeuvring was that both camps feared experimentation. The deepest pitfalls for cultural politics were found in the shattered cultural landscape the Third Reich had left behind: how to deal with what the Nazis had categorized as *Entartete Kunst* or degenerate art, predominantly associated with the exhibition of 19 July 1937 in Munich, which had been followed by similar events in other German and Austrian cities?[4] The adjective 'degenerate' was also used to denounce fictional literature that did not support the so-called National Socialist

revolution and the new *Volksgesinnung* (national ethos) in the 1930s and 1940s. It stems from the noun 'degeneracy', used in the fields of biology and medicine, for example, to identify structurally dissimilar components that can perform similar functions. In the second half of the nineteenth century, the medical term indicated the condition of those people who had departed from the 'normal' because of 'shattered nerves', 'inherited abnormalities' or 'behavioural or sexual excess'. It was seen as the beginning of a process that would ultimately lead to annihilation. The physician Max Nordau popularized the term in his book *Entartung* (Degeneration) in 1892, where, as a non-artist, he applied it to late nineteenth-century art.[5] Nordau's definition was later adopted by the Nazis.

As Stephanie Barron points out, the works displayed in the exhibition of 'degenerate art' 'were assembled for the purpose of clarifying for the German public, by defamation and derision, exactly what type of modern art was unacceptable to the Reich and was thus "un-German"'.[6] Forbidden fruits, however, are always the most beguiling, as was the case with Germans in the Third Reich: Peter Guenter, an American arts student who visited both the *Entartete Kunst* exhibition and the counter-exhibition *Grosse Deutsche Kunstausstellung* (Great German Art Exhibition) in Munich in July 1937, reported that the pro-Nazi *Kunstausstellung* was seen by only 420,000 people, while two million visitors were interested in the avant-garde exhibition, the largest show of this kind in the twentieth century.[7] The design of the 'Degenerate Art' exhibition was simultaneously original and morbid in its employment of techniques of juxtaposition that had been introduced by the architect and racial theorist Paul Schultze-Naumburg, who worked for the new government.[8] He had characterized modern art as 'unhealthy' by setting examples of modern art alongside photographs of deformed and diseased people. By doing so, he implied that they were models for the appearances seen in modern art, in the paintings of Otto Dix, for example, and in the sculptures of Ernst Barlach.

Four years before this public expression of the regime's denunciation of avant-garde visual culture, 10 May 1933 became infamous as the day of the burning of the books. Jewish and 'deviant writings' were not the only works thrown into the flames. Also burned were works of those associated with Modernism, from internationally renowned writers such as Bertolt Brecht, Thomas Mann and Alfred Döblin to German avant-gardist poets like Kurt Schwitters, Hans Arp and Paula Ludwig. This literature was classified as decadent, subversive and harmful to the nation. On 9 November in that same year, Nazi censorship in cultural matters was established after the cultural landscape had previously undergone a totalitarian *Gleichschaltung* (phasing) that was intended to result in a *Gleichklang* (unison) that respected the people's will for the radical changes.[9]

In this first chapter, we will assess the problematic history of the sustainability of a literary scene in the GDR that was either associated with or founded on the historical avant-garde. The question for the German cultural functionaries in the Eastern as well as Western zones was how to deal with the fate of the avant-garde, formerly classified as deviant, and censored, burned and publicly denounced in Nazi Germany. As emphasized in the Introduction – and in spite of Enzensberger's and Bürger's reservations, and their concerns about the lack of political impact on current affairs of today's avant-garde – my hypothesis is that the post-war avant-garde had a utopian basis on which it was able to fight a new, yet radically different kind of authoritarianism, especially on the East side of the border or Wall.[10] Released from the terror of oppressive Nazi cultural politics, the avant-garde faced a future with new challenges. The question was, for better or for worse?

As stated in the Introduction, this investigation focuses mainly on textual documents published between 1945 and 1990 with reference to the visual and other creative arts. After marking a definite split between German culture in the East and the West, we will examine the role of Georg Lukács in post-war Central and Eastern Europe. Then, the recycling of the Expressionism/Realism debate of the mid-1930s, which reappeared twenty years later in the GDR in the form of the Formalism Campaigns, will be evaluated.

Markers of Division

If one is asked to select a particular year that accurately reflects the division between the cultural politics of East and West Germany, several options present themselves. As a matter of fact, plenty of markers in the nations' curricula vitae offer themselves for determining the particulars of the specific cultural-political mechanisms. Not only do they imply the difference between the ideologies in East and West Germany, but they also emphasize aesthetic differences within the GDR itself.

One such key year is 1955. This marker appears to be one of the decisive peaks of the tensions between East and West in both political and cultural matters, and one which prompted a clear division on a bilateral level. The conflict between two antagonistic and competing aesthetics became obvious in Germany. In that year, when it came to their military alliances, both German nations chose to follow separate roads. At the same time, Cold War rhetoric fanned the flames of ideological conflict on each side. While the GDR was enmeshed in the Formalism Campaigns that would eventually lead to the supremacy of Socialist Realism, the FRG displayed

its exuberant cultural liberalism to the wider world. In each case art and literature became propaganda vehicles intended to display and reinforce the two respective ideologies.

In its *documenta* exhibitions the Federal Republic promoted the renaissance, after an absence of twelve years, of the avant-garde. The first *documenta* opened on 15 July 1955 in the West German city of Kassel (near the border with the GDR) and was the first exhibition of post-war Modernism. It made it publicly known that the FRG dared to reconnect with a Modernist legacy that had been suppressed in Nazi Germany. The event attracted 13,000 visitors and exhibited a total of 670 works by 142 artists, mostly from West Germany, France and Italy.[11] But while the classical main currents of the avant-garde – Expressionism, Futurism, Constructivism and Cubism – were represented, it was noticeable that explicitly political and subversive movements like Dada (and its artists John Heartfield and George Grosz) were missing. The Surrealist movement was represented, although artists who had been politically outspoken or those who had affiliations with Central and Eastern Europe, for example with the *Nadrealism* movement in Czechoslovakia, were not. The Surrealists on show were Giorgio de Chirico, Marc Chagall, Max Ernst, Hans Arp and Pablo Picasso – each of them an artist with an established international reputation. The major absentee in the 1955 show, however, was the initiator of and 'engine' behind Surrealism, André Breton. The *documenta* might have been the realization of a vision of the curator, Arnold Bode, to revive the ruined former cultural centre of Kassel and to resuscitate a long-suppressed Modernist and avant-garde art. At the same time, its location, in the rebuilt Museum Fridericianum, broadcast a message over the Inner German border: the oldest museum on the European continent (built in the spirit of the Enlightenment in 1779) was linked to Modernism. The exhibition revealed that German cultural heritage should not reject the avant-garde, but that the latter should instead become a constituent part of it. Only in 1977, a year after the internationally condemned expulsion of poet and singer Wolf Biermann, were GDR artists from, among others, the so-called Neue Leipziger Schule (New Leipzig School) – with the 'big four', Hans Mayer-Foreyt, Bernhard Heisig, Werner Tübke and Wolfgang Mattheuer, as its most well-known representatives – selected to participate in the *documenta* 6, under the banner 'Weite und Vielfalt der schöpferischen Möglichkeiten des sozialistischen Realismus' (Width and Diversity of Socialist Realism's Creative Potentials). In the GDR, these artists – or anybody else for that matter – would have been associated with something like the artistic avant-garde. In SED-speak, the term 'avant-garde' was not restricted to art, but instead characterized the status of the official labour unions, consolidated in the Freie Deutsche Gewerkschaftsbund (Free

German Union, FDGB). It was intended to be the *Transmissionsriemen* (transmission belt) between the Party and the workers, and to enhance efficiency in the Socialist industrial world.[12]

It is undeniable that the *documenta* was a response to events on the other side of the border. In 1955, cultural politics in the GDR were at the peak of the Formalism Campaigns. The GDR prided itself as the champion of socialist aesthetics. Not only was there a major exhibition of Soviet art in the Academy of Arts in Berlin (organized by the East German Ministry of Culture), but the two-part movie *Ernst Thälmann* also made a pertinent statement. The first part, *Sohn seiner Klasse* (*Son of his Class*), premiered on 9 March 1954; the sequel *Führer seiner Klasse* (*Leader of his Class*) on 7 October 1955. The film, based on the life of the leader of the German Communist Party during much of the Weimar Republic, conveys not only the foundation myth of the GDR as the only and true communist and anti-Fascist German state, ten years after the end of the Second World War. It also exhibits another ideological statement through its aesthetic concept. Since the film director Kurt Maetzig and each of the political functionaries, Willi Bredel and Michael Tschesno-Hell, were bound to the principles of Socialist Realism, the film's message was clearly prejudiced. In this respect it received a polarized reception. On 7 October 1954, the director, both functionaries, the cinematographer Karl Plintzner and the actor Günther Simon (who played the protagonist) were all awarded East Germany's highest cultural award, the National Prize, First Class. Minister of Culture Johannes R. Becher called *Sohn seiner Klasse* a 'national heroic epic', and a 'masterful depiction of history'.[13] As was to be expected, in the FRG, where the film was also screened, a harsh critique of the movie's ideology followed. In the eyes of West German critics, the anti-formalistic approach of the GDR's state-owned film studio, the Deutsche Film-Aktiengesellschaft (DEFA), had become out of date, not least following the death in 1953 of the protector of the Socialist Realist orthodoxy, Joseph Stalin. (To be fair, the realities of Stalin's misuse of power were only made public three years later.) In an anonymous *Spiegel* review from 31 March 1954, the film's actual purpose was perceived as nothing more than communist propaganda, in line with Cold War rhetoric. One critic even called it 'a machine of hate'.[14]

How was it possible, then, for the SBZ, later the GDR, to denounce the avant-garde in a socialist zone – and later in a sovereign nation – that celebrated itself as the first anti-Fascist German state, a nation replacing a regime that had itself terrorized the avant-garde? The tone of the denunciation of the avant-garde in the eastern part of post-1945 Europe echoed the strident Nazi outcry against decadence and Modernism. This apparent linguistic continuity confirms Klemperer's observation in his widely admired

LTI (1947) – his investigation of the language of the Third Reich – where he emphasizes the '*Hartnäckigkeit*' (tenacity) of the German language.[15] A further factor was the endorsement of avant-garde visual and textual culture in the neighbouring Western bloc. The excessive praise in the GDR at the time of the *Thälmann* film's release and the unambiguous propaganda stunt was part of the Formalism Campaigns. The reason for these crusades seemed obvious, according to David Bathrick. He identifies the dilemma confronting the SED in the early 1950s:

> Of particular difficulty for the SED at this time was the enormously seductive impact of Western mass media and avant-garde art movements upon the cultural life of East Germany. In the now famous document of the Central Committee of March 1951 entitled 'The Struggle against Formalism in Art and Literature,' outlines of cultural contestation were spelled out that were to dominate and structure the terms of political discourse until the end of the decade. Emanating from the West, it was argued, were the destructive influences of 'decadence' and 'kitsch,' which brutalized the taste of the broad masses of people and 'fulfilled a concrete function in the interest of anti-humanist imperialism and its politics of war-mongering.'[16]

When it comes to the fate of the avant-garde in the twentieth century, uncomfortable parallels arose between the issues in Hitler's Germany – discussed in the Expressionism/Realism debates by exiled writers – and the Formalism Campaigns in the GDR. In particular, the parallel between the Nazi category of *Entartete Kunst* and the GDR's dealings with Formalism was an embarrassment for a nation that had presented itself to the entire world as anti-Fascist Germany. It was the sociologist Günter Erbe who dared to point out something to which contemporary research had turned a blind eye. Shortly after the so-called *Historikerstreit* (the 1980s historians' quarrel) he pointed out that

> Die Kampagne des Jahres 1936 gegen Formalismus [in the Expressionism/Realism debate in *Das Wort*] und 'Entartung der Kunst' nahm die Nazi-Kampagne des Jahres 1937 gegen die moderne Kunst vorweg und erfüllte mit ihrer rituellen Berufung auf den Geschmack des Lesers eine ähnliche Funktion wie der Appell an das gesunde deutsche Volksempfinden im Dritten Reich.[17]

The campaign in 1936 against Formalism [in the Expressionism/Realism debate in the journal *Das Wort*] and 'degenerate art' anticipated the Nazi campaign in 1937 that disputed modern art and met with its ritual appeal on the taste of the reader a similar function as the appeal on the popular feeling of Germans in the 'Third Reich'.

However, Nazi and SED cultural politics cannot and should not be simply and mistakenly aligned. The apparent similarities in vocabulary – as Brecht had also noticed as a theatre director – are not only linked to the ideological specifications of that time, but also to an apparently timeless history of the concepts of beauty and taste, its iconography and the continuation of an anti-bourgeois rhetoric in Germany. As Alfred Kurella, who worked in SED cultural politics, once admitted in an interview, he preferred Thomas Mann to the GDR-'owned' Bertolt Brecht.[18]

Was there a third, less antagonistic way? Yes; 1955 also offers blurred boundaries, which can be related to some of the avant-garde aspirations in the GDR. One incident heralded a critical future opportunity when it comes to assessing the position of Surrealism in the GDR: the move of Adolf Endler from West to East Germany. In 1955, the year before the KPD was banned in West Germany, the 25-year-old poet Endler decided to settle in the GDR. His decision was prompted by his desire to avoid prosecution in the West, because as a teenager he had worked as one of the Party's illegal currency couriers. The SED rewarded the ambitious young comrade writer with a place in the Institute of Literature in Leipzig, which had been established in the same year. His hopes for recognition as a poet and his dream of becoming the East German Mayakovsky were, however, soon disappointed. He never graduated and his ambivalent relationship with the country of his choice began at this point. Without intending it, he was in the process of becoming a Trojan Horse, carrying the Surrealism that he released about twenty years later into the GDR. Endler, as a follower of Breton, will be considered in more detail in Chapter 5. It will be argued that from 1974 onwards he was the nerve centre of Surrealism.

In that same year an unintentionally avant-garde artefact was published in the GDR: Brecht's *Kriegsfibel* (*War Primer*). This montage project corresponded with the GDR anti-Fascist programme, but at the same time, it was antithetical to the principles of Socialist Realism. Current research in cultural studies has revealed that the juxtaposition of firm engagement with and detachment from hegemony contributes immensely to the quality of a literary voice in totalitarian regimes. In *The Powers of Speech*, Bathrick explores the political dimension of the interchange between active participation in state activities and writers' aloofness. For him, the real provocation towards the state and its master discourse does not lie in a plain dissident attitude, but rather in the ambivalence to be found in the difference between solidarity with Marxist ideas and the sharp and uncompromising critique of anything limiting intellectual activity: thus, a constant dialogue with the master discourse is achieved. This dissimilarity was misinterpreted as ambiguity and therefore a lack of solidarity, and thus politically relevant.[19] Werner Hecht points out that Brecht's effort to initiate a dialogue between

the master discourse and so-called 'deviant' aesthetics defines the complex situations he had to deal with, for example during his efforts to publish the *Kriegsfibel*, in which the montage techniques of John Heartfield had been applied.[20] What should be kept in mind, however, is Brecht's confidence in the importance of establishing an experimental avant-gardist *Grundhaltung*; a basic anti-Socialist Realist attitude that continued until the late 1980s.

During the Cold War, tensions between the East and West built up in all areas. These were not only between the two ideological camps – divided by the Iron Curtain and Berlin Wall – but also *within* the GDR. Indeed, before the end of the Second World War, a linguistic war had already been declared unofficially, but it took almost a decade before the divide was cemented. What occurred, after what Manfred Jäger has called the 'Storm and Stress period' between 1945 and 1949, was a continuation of the Expressionism/Realism debates, with Georg Lukács as the principal protagonist. His theory of realism, developed during the first decades of the twentieth century, continued to influence GDR cultural politics even after he had become, for almost fifteen years, a *persona non grata* following his involvement in the Hungarian uprising of 1956. The SED's opposition to an experimental and abstract *Grundhaltung* in literature was overshadowed by the more spectacular expeditions against Formalism in music and visual art.

Formalism Campaigns against Literature

Under instruction from the Communist Party of the Soviet Union (CPSU), shortly after 1945, the representation of reality became one of the fundamental ideological principles of cultural politics in the SBZ (1945–49). This principle was to be adopted by the cultural authorities in the GDR. The entire Formalism debate of the 1950s was meant to promote Socialist Realism and to denounce Western-like avant-garde and modern art that could lead only to a detested 'imperialistic cannibalism'.[21] The argument concerning the danger of decadence and cosmopolitics was initiated by the German cultural functionary Fritz Erpenbeck in the journal *Theater der Zeit*, following the leader of the SMAD, Alexander Dymschitz. Dymschitz had already written on 29 September 1948 in the daily *Neues Deutschland* that 'We condemn Formalism in the arts because it is an expression of hopelessness in a bourgeois society that cultivates and finds refuge in formal aesthetics.'[22] As the discussions in the Soviet Union had previously shown, Formalism equalled (mainly European) avant-garde art.[23]

Examples of 'successful' Formalism Campaigns were to be found in all artistic areas. The cases in the visual art world, however, have always been most spectacular and illustrative, as for example the one involving Ernst

Barlach. The Barlach case is significant because it pinpoints not only the convergence of the Formalism Campaigns and Nazi aesthetic and political judgements, but also the connection between visual and textual culture in the GDR. Barlach experienced the downgrading of his work in Nazi Germany. In 1934, in common with a number of other modern cultural luminaries, he had signed the 'Declaration for Adolf Hitler!' in which the artist expressed his dismay at being labelled a Cultural Bolshevist. This, in turn, led to his work not being recognized by the Nazi regime. The declaration was designed to declare Hitler the Führer of Germany; that is, it was a direct glorification of the new regime. Despite longing for acceptance, however, Barlach continued as an outcast and, represented by only one sculpture, his censored book and four drawings, he ended up in the Degenerate Art exhibition of 1937.[24] Barlach died in 1938 but his work remained marginalized.

Nothing changed in the GDR. Indeed, after a year-long battle with the authorities, Bertolt Brecht managed to organize a Barlach exhibition in the Deutsche Akademie der Künste in 1954, arguing that Barlach should be included in the ranks of Socialist artists.[25] The cultural functionary Wilhelm Girnus intervened and picked up where the Nazis had left off. Girnus publicly criticized Barlach's art, seeing it now as an example of Formalism. In common with many others, Barlach was taboo in the public domain, perceived as pessimistic and without a positive vision for the future in the GDR.[26] Despite Brecht's earlier support, it was only in 1963 that the writer Franz Fühmann took the initiative of defending him in the short story, 'Barlach in Güstrow'.[27]

The solidarity of the literary scene (practitioners, publishers and academics) with the first victims of the Formalism Campaigns indicates a collective fear of a radical and negative change in the cultural life in the young GDR. At the end of the so-called Storm and Stress phase, this transformation became apparent when it was announced at the First Party Congress of the SED in 1948 that culture was expected to support the economy and that writers should turn into managers, or *Planer und Lenker*. The aspirations of the Party were received sarcastically by writers after the Literary Institute in Leipzig was renamed the Johannes R. Becher Institut für Literatur after the death of the first Minister of Culture in 1958. Because Becher was ultimately responsible for the Formalism Campaigns, the writers' school was scornfully called the *hyperformalistische Retortenexperiment* (Hyperformalist Retort Experiment).[28] The proposed alignment of the acts of writing and of actively leading a new nation seemed an unrealistic endeavour.

While Brecht was engaged in defending Barlach, he faced his own indictments when, in 1951, the Fifth Congress of the SED followed Erpenbeck and Dymschitz's earlier warnings and initiated a large-scale cleansing of

the country's cultural life, also known as the *Säuberungsaktion* (Cleansing Action). The Congress nominated Hans Lauter to initiate the war on Formalism. Brecht was one of the first victims of the new cultural politics, as Hecht explains in *Mühen der Ebenen* (Troubles of the Planes, 2013) – a detailed investigation, based on previously unseen archive documentary material. Hecht's book frequently points out that Paul Dessau's music for Brecht's opera, *Das Verhör des Lukullus* (*The Trial of Lucullus*, published in 1940) was crushed by cultural functionaries. To Lauter's ears the music was unmelodic and inharmonious and, owing to its percussion, led to nothing but earache.[29] After many arguments, Brecht was forced to adapt his opera and rename it *Die Verurteilung des Lukullus* (*The Condemnation of Lucullus*, staged in 1951). Throughout his life, Brecht was confronted by continuous setbacks. The same is to be said of his friend and colleague Hanns Eisler, as we will see in Chapter 2.[30]

From 1951, an array of censorship mechanisms was ubiquitous: published books were again pulped; in the theatre, plays were taken out of the repertoire; in libraries, books were removed either because of their pacifist content, or because of their alleged decadent and cosmopolitical orientation. The writer and librarian Günter de Bruyn reported that those works of modern literature that had survived the Third Reich, either by accident or after the 'treacherous' activities of some of his colleagues, now fell victim to the wave of Formalism Campaigns and ended up in the paper mills.[31] Literature associated with the concept of realism and approved by the *Literaturpapst* (Literature Pope) of Socialist Realism, Georg Lukács, was all that was worth holding on to.

As recent publications reveal, Lukács never became a Stalinist dogmatist incarnate. True, his name is associated with critical rigour and intransigence, but in this his was no different to the gravity of other contributors in the theoretical debates on Marxist aesthetics who believed that theirs was the right way. As with Brecht, for example, dogmatic positions were inspired by the quest for philosophical solutions appropriate for the political age in which they lived – the transition from Capitalism to Socialism. But for Brecht, the Hungarian's theories were anachronistic since they derived from the nineteenth-century idea of realism of, for example, Honoré de Balzac and in particular his novel sequence *La Comédie Humaine* (1829–47). According to Brecht, Lukács implied that there was no room for artistic experiments such as montage, alienation, dream worlds, internal monologues or fragmentation. In *Lukács and Brecht* (1985), David Pike argues that both were arrogant and narcissistic, and 'they both used it to claim exclusivity for their respective theoretical approaches'.[32] But Lukács' voice became the most dominant in GDR cultural politics because his ideas were espoused by East German functionaries such as Erpenbeck, Lauter, Bredel and Kurella, who

had been fellow exiles in Moscow. Brecht, on the other hand, had settled in California. After returning to Berlin, the Moscow group was matchless in helping to guide the Formalism Campaigns and to implement the theoretical foundation of Socialist Realism, which they had debated in the 1930s, and to which writers such as Brecht fell victim. Lukács cast a long shadow.

Georg Lukács as a Constant

Indeed, the Formalism Campaigns were recycled versions of the earlier Expressionism/Realism debates. In cultural terms it seemed that it was the 1930s all over again. Back then, working in the Marx-Engels Institute during his Moscow exile, Lukács began to develop his Marxist aesthetics. Later (after a year's break in Berlin in 1931) he contributed to the periodicals *Literaturny Kritik*, *Internationale Literatur* (edited by Johannes R. Becher) and *Das Wort* (initially Paris-based and edited by Bertolt Brecht, Willi Bredel and Lion Feuchtwanger). The original editorship of the latter was soon changed: Bredel left for Spain in 1937 to join the International Brigades fighting Franco and the other two went into exile. They were replaced by Erpenbeck and Kurella. In *Das Wort*, the debate concerning the connection between Expressionism and Fascism was pursued in 1937 and 1938, triggered by Kurella, who had published an article in issue 9 under the pseudonym Bernhard Ziegler. In this article he referred to a review by Klaus Mann, appearing in the same issue, of the expressionist poet Gottfried Benn. Kurella attacks Benn's involvement in National Socialist cultural politics in order to condemn the alliance between Expressionism and Fascism. Kurella's point of reference was not so much Mann's review but, instead, a much more comprehensive analysis of the rise and decline of German Expressionism by Lukács, published in the journal *Internationale Literatur* in 1934.

Almost all authors involved in the debate which followed Kurella's inaugural piece in *Das Wort* positioned themselves against him and Lukács by arguing that abstraction in literature was an international phenomenon which had, in many cases, resulted in aesthetic innovations in European culture. The avant-garde radically changed twentieth-century art, but Lukács' critique hardened into a doctrine.[33]

Most opponents of Lukács' combination of Marxism and anti-Modernist realism, expressed in his *Theory of the Novel* (1916) and *History and Class Consciousness* (1923), claimed that his theories came close to dogmatism. In his assessment of contemporary literature and the use of the *monologue intérieur* device, Lukács drew a clear line between those who should be considered his allies and those who were not. He made a sharp distinction

between the Modernists James Joyce and Thomas Mann. Lukács was not so much interested in their talents and skills but much more in their world views, which he called *Weltanschauung*:

> It would be absurd, in view of Joyce's artistic ambitions and his manifest abilities, to qualify the exaggerated attention he gives to the detailed recording of sense-data, and his comparative neglect of ideas and emotions, as artistic failure. All this was in conformity with Joyce's artistic intentions; and, by the use of such techniques he may be said to have achieved them satisfactorily. But between Joyce's intentions and those of Thomas Mann there is a total opposition. The perpetually oscillating patterns of sense and memory-data, their powerfully charged – but aimless and directionless – fields of force, give rise to an epic structure which is *static*, reflecting a belief in the basically static character of events.[34]

These opposing ideologies constitute two schools of literature, and ultimately they come down to the image of man. Lukács found in the work of Joyce, Kafka, Musil and Döblin a representation of the human condition which was fragmented and abstract. His criticism of what he perceived as this significant weakness was in line with Marxist aesthetics, which sought to challenge and eventually to eclipse the conventional bourgeois world. In their work these Modernists are disgusted with a static view of the world; the characters they present display tendencies towards a 'diminished objectivity', 'disintegration of personality' and thus 'angst'.[35] For this reason, it seemed almost unavoidable for Lukács to counter Walter Benjamin, who – as a Marxist – was not only a critical friend of the works of Kafka but also a promoter of French Surrealists in Germany. Surrealism (in the form *Sürrealismus* for Benjamin) had a resilient influence on intellectual life in the final years of the Weimar Republic,[36] which, according to Lukács, incorporated only negative characteristics and ultimately led to 'a disintegrating society'.

The ultimate goal of the *Volksfront* – the broad popular resistance against Hitler – was to win the battle against Fascism. Writers had chosen the pen as their weapon against Nazism. For many German Marxist writers, the Soviets were eventually to break the deadlock, in particular after the destruction of Germany's 6th army at the Battle of Stalingrad in 1942–43 – an event that, Klaus Völker convincingly argues, turned writers like Brecht into 'anti-Stalinist Stalinists'.[37] In order to convince more intellectuals of the necessity of following the path of Socialist Realism, Lukács bombarded the readers of *Das Wort* with his essays on realism. To support his case he could refer to the minutes of the First All-Union Congress of Soviet Writers in 1934, where Socialist Realism was ratified as the official style – about fifteen years after Anatoly Lunacharsky had decided the direction of art in the newly created

Soviet Union, following confrontations between rival artistic groups and writers' leagues.

At the height of Stalin's power in the mid-1930s, the Socialist Realism style was established in response to the attempts by Maxim Gorki and Nikola Bukharin to jettison crude propagandist art and literature and to raise the standards of artistic craftsmanship. The organizer of the Congress, and at that time Stalin's anticipated successor, Andrei Zhdanov, 'insisted on purely utilitarian, Party-directed literature and derived the principles of Socialist Realism from Stalin's pronouncements'.[38] Since political power was firmly in the hands of Stalinists, Zhdanov's views prevailed and became the artists' and writers' manual for orthodox observance of the principles of Socialist Realism. The goal of Socialist Realism was to foster the development of a culture that would accurately depict communist values in the light of *Partiynost* (party spirit), and which would lead eventually to the emancipation of the proletariat through the use of realistic imagery. This soon replaced the concept of *Weltanschauung*. In spite of Lukács' efforts he was not able to convince Brecht among many other intellectuals. Theodor W. Adorno was one of the first to articulate his dismay by scornfully characterizing the literature written in the style of Socialist Realism as 'boy-meets-tractor literature'.[39]

Lukács' starting point had always been the question 'What is Man'? His main criticism of the fashionable Modernism in the first decades of the twentieth century was that the flood of anti-realistic literature was losing the sight of humanity. Béla Királyfalvi points out:

> Among the most important characteristics of 'modernist' literature that he finds anti-realistic (and for this reason often anti-humanistic) are extreme and arbitrary subjectivity, distortion without a point of reference, the portrayal of 'pure' essence or allegorically projected abstractions, undue emphasis on the phenomenal, mysticism, and the incomplete, even 'crippled' portrayal of man. The list should suggest that the body of literature extensively criticized includes not only ephemeral trends and vogues, such as dadaism and surrealism, but also major and significant styles, including naturalism, expressionism, existential literature, and the so called absurd.[40]

Lukács' fanaticism did not cause him to become a de facto Stalinist. Friend and scholar István Eörsi confirms, in his autobiographical sketch of 1983, that Lukács fought a battle on two fronts, and that after the start of the Second World War and his involvement in the Communist Party in Hungary, he lived in a state of oscillation between the extremes of deviance and collaboration. He is portrayed as a tactician who managed to find a balance between loyalty to political ideology and intellectual freedom. At the end of his days, Lukács admits that during his adult life he had often

seen himself as a guerrilla or partisan in the Communist Party, opposing dogmatism.[41]

In the post-Stalin era, in 1956 and 1968, he continued his war on two fronts in which his credo was not to oppose power but to bring about reform. Throughout his career, Georg Lukács defended a 'critical realism', which, rather more cautiously, rebuked the programmatic definition of realism by the Communist Party to which his heart belonged.[42] His work in Soviet exile continued, however, as an invisible critical friend of the new regime in East Berlin. He had returned to Hungary himself and had taken part in establishing a new government.

Lukács in the GDR

Lukács was not completely invisible in the GDR, particularly because he would not have wanted to miss the opportunity to meet Thomas Mann during the Goethe anniversary on 28 August 1949 in Weimar. For him, both Goethe and Mann were heroes of realism in German literature whom he praised as the champions of humanism. Although Lukács' earlier writings were not published in the GDR, his views on the negative effects of Modernism had a gigantic impact on GDR cultural theory. His ideas on realism were fundamental in the conception of the cultural identity of the young German nation. Indeed, in the 1940s and 1950s, various others who could promote socialist literature in the GDR were mentioned: Franz Mehring, Rosa Luxemburg, Karl Krauss and, of course, Lenin. But Lukács was seen to be able to convince the readership of the necessity of substituting Modernism with German Classicism. While for the cultural functionaries in the SBZ and the GDR this was a revolutionary coup, for most artists and writers it represented a major setback.

Most of the Communist cultural functionaries in East Germany had worked with the 'invisible man' from Hungary during their Soviet exile in Moscow. Thus, there was a link between Lukács and East Germany; a link which remained strong and almost unbreakable – even after 1956, when he was unwelcome until his rehabilitation in 1971. East German Communists had fallen for him because, in addition to his focus on German heritage, he fanatically propagated Stalin's iron grip on culture, Socialist Realism. Lukács upheld the conformist code of Socialist Realism, identifying it as 'rationalist *Kulturpolitik*' during and after the Second World War.[43] To go against these cultural directives was considered an inexcusable sin in the GDR. Socialist Realism retained its primacy even thirty years later, after Stalin's death and after his successor Nikita S. Khrushchev's 'secret' denunciation, on 24 February 1958, of Stalin's terror. Despite the fact that not

all of Lukács' books were published in the GDR, his writings in the 1930s and 1940s on realism were fundamental in the conception of this nation that had to be reintroduced to Goethe, Schiller and all other classics. At this point it is probably imperative to emphasize that Lukács was not the inventor of Socialist Realism but, rather, its godfather.

In the early years of the GDR, alternatives to Socialist Realism were also in evidence. One example was the publication of *Das Magazin*, which was originally established in 1924, and which continued to appear under the imprint of *Das Neue Berlin* after the foundation of the GDR. Edited by Heinz H. Schmidt and Hilde Eisler, it became known as 'The New Yorker of the East', although it was hard to come by. It was known in the GDR as *Bückware* (sold under the counter). Frequent contributors to the journal, which also featured American short stories, were Brecht, Eisler and the caricaturist Herbert Sandberg.[44] In 1954 the publishing house Eulenspiegel-Verlag, which specialized in satire, was founded. A year later, in his capacity as a member of the Academy of Arts, Brecht submitted his *Kriegsfibel* to Eulenspiegel-Verlag. Another relatively free, albeit sharply controlled, haven was the journal *Sinn und Form*, launched by the former expressionist poet and now first Minister of Culture, Becher. From 1949 until 1962, it became a counter-forum to Soviet cultural politics under its editor-in-chief, Peter Huchel. The editor of the journal *Bildende Kunst* (Visual Art), Herbert Sandberg, was responsible for publishing the Soviet writer Ilja Ehrenburg's praise for Pablo Picasso in 1956. Picasso was also known for his involvement in the Surrealism movement between 1924 and 1936, and for his fight for world peace. Ehrenburg had called Picasso a 'Friedenskämpfer' (freedom fighter), which ought to have made him and his art welcome in the context of the GDR.[45]

These cultural indicators reveal that Georg Lukács was not the solitary miracle-worker. In Caroline Gallée's seminal research on Lukács' significance and his position in the GDR's literary and intellectual world, the failures of his distinct and incalculable presence become apparent. Gallée pinpoints the fluctuations in the assessment of Modernism. In the time of the Party's sharpest critique of non-realist fictional literature in the early 1950s, Lukács became both hunter and quarry, because for some Soviet functionaries his commitment to the Hungarian Communist Party and his interest in Soviet literature were questionable.[46] There was a decline in his popularity; he was held responsible for any negative criticism of Socialist Realism, especially now it became apparent that GDR writers were attracted by the forbidden fruits Lukács had dangled before them.[47] Concern about his cultural trustworthiness only grew in the decades to come.

With the end of the Formalism Campaigns his authority on cultural matters in the GDR began to crumble. At the time of the 'secret' revelation

of Stalin's terror during the Twentieth Party Congress of the CPSU and the Hungarian Uprising of 1956, anti-Stalinist opposition also developed in the GDR. This radically changed everything. The two most eminent persons who were seen as conspirators against the state – Wolfgang Harich and Walter Janka – happened to be at the head of Lukács' German publishing house, Aufbau Verlag. And, although the SED itself refrained from interfering in internal affairs (in contrast to in 1968 in Prague), it applauded the Soviet move against dissidents such as Lukács. The SED attempted to prevent similar actions within its own borders by denouncing secret meetings of dissidents such as those in the Petöfi Club in Budapest, a cultural society hosting gatherings of the supporters of the dissident leader Imre Nagy – among them Lukács. This was the metaphorical Sword of Damocles hanging over groups like the Sächsische Dichterschule, when Georg Maurer warned his students at the Johannes R. Becher Institute of Literature against their establishing an informal Klopstock Society by reminding them that they did not want to end up like the Petöfi Club.[48]

Lukács' position was in limbo during these years, partly because he was associated with the so-called Harich-Janka group, which was on trial for counter-revolutionary conspiracy. The group was subsequently imprisoned. In 1955, Erpenbeck had edited a Festschrift for Lukács' seventieth birthday. After 1956, Hans Koch (who was to become one of the most outspoken cultural functionaries in the 1960s) called Lukács' theories 'anti-Marxist' and, consequently, demanded that they be ignored.[49] But, as wounds healed and the phase of indignation eventually disappeared, an old antagonist of the Hungarian reappeared, someone who was in the process of becoming immensely popular with readers and even fashionable among writers and academics: Franz Kafka.

Kafka and Lukács were the two non-German writers who managed most profoundly to reach German readers. In Chapter 3, the significance of Kafka in the context of '1968' in the GDR will be examined. Although in the past, Lukács had been the fiercest weapon in the battle against Kafka and Modernism, he played only a minor role in combatting the so-called *Kafkaisten* (Kafkaists). As an unwelcome person, Lukács' writings went unpublished throughout the 1960s. His fundamental ideas, though, were still latent and were influential in the orthodox rejoinders of Alexander Abusch, Minister of Culture between 1958 and 1961. The dormant Lukács had a huge impact on the wording when Kafka was denounced as a representative of decadence and of the avant-garde.[50] In spite of the clear message from the promoters of cultural politics that Kafka had no place in Communism, the 'forbidden fruits' had been tasted, were well savoured and even became addictive for writers. The 1963 Kafka Conference was followed by the Eleventh Plenum of the Central Committee of the SED two years

later, from which a new period of Stalinization originated. Also known as the Kahlschlag Plenum (Clear-Cutting Plenum) it resolved that the GDR should finally be freed from all bourgeois and 'nihilistic elements': 'die DDR ist ein sauberer Staat' (the GDR is a clean nation) was the triumphant declaration from Erich Honecker – who was now emerging and who was soon to become the new Communist leader.

In 1970, a year before his death, Georg Lukács was awarded the Goethe Prize of the city of Frankfurt am Main in the Federal Republic of Germany. One year later he was rehabilitated and reinstated as a member of the Communist Party of Hungary. The renewed interest in him did not mean a renewed application of his theories on realism in the GDR. But there was a historical interest in his doctrine, as Werner Mittenzwei underlines in his assessment in *Dialog und Kontroverse mit Georg Lukács* (Dialogue and Controversy with Georg Lukács, 1975). None of the collaborators in the volume were associated with the past orthodoxy, but it became clear that Lukács could not be neglected in GDR literary studies.[51]

Nor, however, was he nothing more than a dusty Cold War relic; he became useful again. At the height of the neo-avant-garde activities in the GDR – seen by Paul Kaiser and Claudia Petzold as a juxtaposition of bohemia and dictatorship[52] – Lukács was revived. In the 1980s, four major works, including *Die Eigenschaft des Ästhetischen* (On Aesthetics, 1987) and *Zur Kritik der faschistischen Ideologie* (The Critique of Fascist Ideology, 1989), were published by Aufbau Verlag. In what can be understood as the final counter-measures against a new wave of the avant-garde, these were merely the last twitches of a culturally rich and lively, yet now perishing, nation.

Conclusion

We have argued that due to the evolution of the discussion on aesthetics, plus the extremely difficult matter of dealing with the Nazi cultural past, an appropriate creative and, at the same time, theoretical setting for the avant-garde (either pro or contra) was shaped in the GDR. The heated debates on controversies boiled down to two extremes – Socialist Realism versus the avant-garde – and continued to erupt into the cultural landscape of the GDR. Before assessing a surrealist mindset or the recycling of surrealist images and *sujets*, we can already formulate the hypothesis that the avant-garde was well positioned in the GDR. In a culture that was expected to favour Socialist Realism as the background to a vivid movement and, at the same time, to revise a twelve-year history of discrimination and suppression, the avant-garde had found a hospitable place to regenerate in Central and Eastern Europe. This also implies that before an investigation

into Surrealism in the GDR can be undertaken, the initial Expressionism/ Realism debates need to be re-examined. Here, the focus must be on the renaissance of their principal issues – the fight against Formalism and its continuation in the GDR. Indeed, while the actual number of authors who applied a surrealist mindset is low, they should not be neglected. They managed to construct an alternative to the dominant dogma of Socialist Realism. This alternative – the constant oscillation between engagement with and distance from the prevailing power structures in the GDR – will be explored in the chapters that follow.

Notes

1. Richard J. Evans, *The Third Reich at War 1939–1945*. London: Allen Lane, 2008, 749. Evans' US-American colleague, Richard Overy, discusses some of the ambiguities in creating a political and economic new start in the post-1945 vacuum and concludes that a reconstruction was never to be straightforward. See Richard Overy, 'Interwar, War, Post-War: Was there a Zero Hour in 1945?' In: Dan Stone (ed.), *The Oxford Handbook of Postwar European History*. Oxford: Oxford University Press, 2012, 61–78. Also see Wolfgang Malanowski, *1945. Deutschland in der Stunde Null*. Hamburg: Rowohlt, 1985.
2. Friedhelm Kröll, 'Literatur und Sozialisation'. In: Rolf Grimminger (ed.), *Hanser Sozialgeschichte der deutschen Literatur vom 16. Jahrhundert bis zur Gegenwart*, vol. 10. Munich and Vienna: Hanser, 1986, 164–76.
3. Wolfgang Emmerich, 'The GDR and its Literature: An Overview'. In: Karen Leeder (ed.), *Rereading East Germany: The Literature and Film of the GDR*. Cambridge: Cambridge University Press, 2015, 8–34 (13–19).
4. Stephanie Barron (ed.), *'Degenerate Art': The Fate of the Avant-Garde in Nazi Germany*. Los Angeles: Adams, 1991; and, in contrast, Reinhard Müller-Mehlis, *Die Kunst im Dritten Reich*. Munich: Heyne, 1976.
5. Max Nordau, *Degeneration*, ed. George L. Mosse. Lincoln and London: University of Nebraska Press, 1993. In 2017, the son of art historian and Nazi art dealer Hildebrand Gurlitt publicly displayed an until-then-unseen collection of what Nazis had labelled 'degenerate art'. See https://www.theguardian.com/world/2017/oct/27/works-hoarded-by-son-of-nazi-art-dealer-cornelius-gurlitt-to-go-on-public-display (accessed on 25 November 2017).
6. Barron (ed.), *'Degenerate Art'*, 9. According to Barron, the exhibition's popularity has never been matched by any other exhibition of modern art. Cf. Lucy Wasensteiner and Martin Faass (eds), *Defending 'Degenerate' Art. London 1938. Mit Kandinsky, Liebermann und Nolde gegen Hitler*. Wädeswil: NIMBUS, 2018. It is suggested by the curators of the reconstructed *London 1938* exhibition in Liebermann Villa in Berlin that the second exhibition of the *Grosse Deutsche Kunstausstellung* in Munich was a reaction to the anti-German press in Britain.
7. Peter Guenther, 'Three Days in Munich, July 1937'. In: Ibid., p. 36. Guenther studied art history and was to become a long-time chair of the Arts Department at the University of Houston.

8. Ibid., 11. In 1925, he had already attacked and ridiculed Bauhaus in his *ABC des Bauens*, then published *Kunst und Rasse* in 1928 and *Kunst aus Blut und Boden* in 1934.
9. See Jan-Pieter Barbian, 'Nationalsozialismus und Literaturpolitik'. In: Rolf Grimminger (ed.), *Hanser Sozialgeschichte der deutschen Literatur vom 16. Jahrhundert bis zur Gegenwart*, vol. 9. Munich and Vienna: Hanser, 2009, 53–98.
10. As argued by Mererid Puw Davies for the FRG in her aforementioned study, *Writing and the West German Protest Movements*, from 2016.
11. *Documenta. Kunst des XX. Jahrhunderts. Internationale Ausstellung im Museum Fridericianum in Kassel*. Munich: Prestel, 1955.
12. Emmerich, 'Literatur des sozialistischen Aufbaus (1949–61)'. In: *Kleine Literaturgeschichte der DDR. Erweiterte Neuausgabe*. Leipzig: Gustav Kiepenheuer, 1996, 114.
13. Thilo Gabelmann, *Thälmann ist niemals gefallen? Eine Legende stirbt*. Berlin: Das Neue Berlin, 1996, 290.
14. 'Mit kernigem Silberblick', *Der Spiegel*, 9 November 1955. See also John Davidson and Sabine Hake (eds), *Framing the Fifties: Cinema in a Divided Germany*. Oxford and New York: Berghahn Books, 2007.
15. LTI stands for *Lingua Tertii Imperii*, Language of the Third Reich. See Victor Klemperer, *LTI. Notizbuch eines Philologen*. Leipzig: Reclam, 1987, 143. The GDR dissident writer Jürgen Fuchs had envisaged writing a book on the so-called 'LQI', the language of the Fourth Reich (i.e. the GDR). He was inspired by Klemperer's *LTI*. See his *Gedächtnisprotokolle. November '79 bis September '77*. Hamburg: Rowohlt, 1990.
16. Bathrick, *The Powers of Speech*, 177–78.
17. Günter Erbe, *Die verfemte Moderne. Die Auseinandersetzung mit dem 'Modernismus' in Kulturpolitik, Literaturwissenschaft und Literatur der DDR*. Opladen: Westdeutscher Verlag, 1993, 43. My translation. The *Historikerstreit* was an intellectual and political controversy in the late 1980s in West Germany about how best to remember Nazi Germany and the Holocaust. At some point, the discussions in various media focused on the parallels between the Nazi death camps and the gulags during the Stalinist system. See Richard J. Evans, *Hitler's Shadow: West German Historians and the Attempt to Escape the Nazi Past*. London: I.B. Tauris, 1989.
18. Jäger, *Kultur und Politik in der DDR*, 21.
19. Bathrick, 'The Writer and the Public Sphere'. In: *The Powers of Speech*, 27–56.
20. Werner Hecht, *Die Mühen der Ebenen. Brecht und die DDR*. Berlin: Aufbau Verlag, 2013, 232–48.
21. Emmerich, 'Literatur des sozialistischen Aufbaus', 119.
22. Fritz Erpenbeck, 'Formalismus und Dekadenz. Einige Gedanken aus Anlaß einer mißglückten Diskussion', *Theater der Zeit* 4(4) (1949): 1–8; and Elimar Schubbe (ed.), *Dokumente zur Kunst-, Literatur- und Kulturpolitik der SED*. Stuttgart: Seewald, 1972, 95: 'Wir wenden uns gegen eine formalistische Kunst, die als Ausdruck der Ausweglosigkeit der bürgerlichen Gesellschaft ihre Zuflucht in ästhetische Formkultivierung nimmt.' My translation.
23. Moyra Haslett, *Marxist Literary and Cultural Theories*. New York: St. Martin's Press, 2000, 92–94.
24. Jonathan Petropoulos, *Artists under Hitler: Collaboration and Survival in Nazi Germany*. New Haven and London: Yale University Press, 2014, 148. Barlach's book was entitled *Zeichnungen. Mit einer Einführung von Paul Fechter* and was published in Munich by Piper in 1935.

25. Gudrun Klatt, 'Schwierigkeiten mit der Avantgarde. Beobachtungen zum Umgang mit dem Erbe der sozialistischen Avantgarde während der Übergangsperiode in der DDR'. In: Barck, Schlenstedt and Thierse (eds), *Künstlerische Avantgarde. Annäherungen an ein unabgeschlossenes Kapitel.* Berlin: Akademie Verlag, 1979, 257–71 (267).
26. Maike Steinkamp, *Das unerwünschte Erbe. Die Rezeption 'entarteter' Kunst in Kunstkritik, Ausstellungen und Museen der SED und früheren DDR.* Berlin: Akademie Verlag, 2008, 41, 259 and 274.
27. Franz Fühmann, 'Barlach in Güstrow'. In: *König Ödipus. Gesammelte Erzählungen.* Berlin and Weimar: Aufbau Verlag, 1968. In 1966 the story was adapted into a movie, but was only released after a long story of implementing censorship in 1972.
28. Emmerich, 'Literatur des sozialistischen Aufbaus', 116.
29. Hecht, *Die Mühen der Ebenen*, 95.
30. Ibid., 129–45; and Jürgen Schebera, *Hanns Eisler. Eine Biografie.* Berlin: Henschel, 1981.
31. Quoted in Emmerich, 'Literatur des sozialistischen Aufbaus', 119.
32. David Pike, *Lukács and Brecht.* Chapel Hill and London: The University of North Carolina Press, 1985, xi.
33. Detlev Schöttker, 'Expressionismus, Realismus und Avantgarde – literatur- und medienästhetische Debatten im sowjetischen Exil'. In: Grimminger (ed.), *Hanser Sozialgeschichte der deutschen Literatur*, 230–44.
34. Georg Lukács, 'The Ideology of Modernism'. In: Arpad Kadarkay (ed.), *The Lukács Reader.* Oxford: Blackwell, 1995, 187–209 (188).
35. Ibid., 204.
36. Linda Maeding, 'Zwischen Traum und Erwachen: Walter Benjamins Surrealismus-Rezeption', *Revista de Filología Alemana* 20 (2012): 11–28.
37. Klaus Völker, '"Und kein Führer führt aus dem Salat". Brecht, der antistalinistische "Stalinist"'. In: Therese Hörnigk and Alexander Stephan (eds), *Rot gleich Braun? Nationalsozialismus und Stalinismus bei Brecht und Zeitgenossen.* Berlin: Theater der Zeit, 2000, 127–52.
38. Herman Ermolaev, *Soviet Literary Theories 1917–1934. A Genesis of Socialist Realism.* Berkeley and Los Angeles: University of California Press, 1963, 6.
39. See Ronald Taylor (ed.), *Adorno, Benjamin, Bloch, Brecht, Lukács, Aesthetics and Politics.* London: Verso, 1980, 173–87.
40. Béla Királyfalvi, *The Aesthetics of György Lukács.* Princeton and London: Princeton University Press, 1975, 62.
41. Estván Eörsi, 'The Right of the Last Word'. In: *Georg Lukács: Record of a Life. An Autobiographical Sketch.* London: Verso, 1983, 120.
42. See Haslett, *Marxist Literary and Cultural Theories*, 87–88.
43. Bathrick, *The Powers of Speech*, 169.
44. Cf. Karin Thomas, *Kunst in Deutschland seit 1945.* Cologne: DuMont, 2002, 80.
45. Ibid., 92–94. Shortly before Brecht's death, Picasso designed the peace dove that later became part of the stage equipment of the Berliner Ensemble, after the Surrealist writer Louis Aragon commissioned him.
46. Caroline Gallée, *Georg Lukács. Seine Stellung und Bedeutung im literarischen Leben der SBZ/DDR 1945–1985.* Tübingen: Stauffenburg Verlag, 1996, 48.
47. Ibid., 429. An example of this heresy was Brecht's *Kriegsfibel*, since its form was based on the photomontages of the Dadaist John Heartfield.
48. Heinz Czechowski, 'Im Tor der Sächsischen Dichterschule'. In: *Die Pole der Erinnerung. Autobiographie.* Düsseldorf: Grupello, 2006, 122–33 (124).

49. Gallée, *Georg Lukács*, 166.
50. See ibid., 237–38. This negative characterization could also be found in Helmut Richter, *Franz Kafka. Werk und Entwurf.* Berlin: Rütten & Loening, 1962, 27.
51. Werner Mittenzwei (ed.), *Dialog and Kontroverse mit Georg Lukács*. Leipzig: Reclam, 1975. See also the review by Peter Uwe Hohendahl in *GDR Bulletin* 2(4) (1976) 4: 1–2.
52. See Kaiser and Petzold, *Boheme und Diktatur in der DDR*, 18–23.

Chapter 2

RETURN OF THE AVANT-GARDE?

Brecht & Co. in the GDR

Decades before the building of the Wall on 13 August 1961, an invisible protective wall had already been erected in cultural terms to prevent Western-style Modernism entering the SBZ and subsequently the GDR. Modernist and avant-garde writings were to be condemned as formalist. Not all efforts, however, to revitalize the historical avant-garde in the 1950s were futile. In this chapter, Bertolt Brecht's efforts to introduce the avant-garde to the SBZ and the GDR, and his sustained defence of its programmes at the peak of the Formalism debate in the late 1940s and early 1950s, will be emphasized. Brecht's intervention initiated a dialogue between two mutually exclusive aesthetics: Socialist Realism and the avant-garde's non-realistic art and literature. Indeed, his activities made him the first spokesperson of the avant-garde in the GDR. These activities are not only associated with the publication of his montage-project *Kriegsfibel* in the GDR. In particular, there will be an analysis of his protective attitude and support for former members of his *Freundeskreis* (circle of friends) who eventually settled in the GDR, which made him the guardian of the avant-garde. Most of these individuals, such as Hanns Eisler, Paul Dessau and John Heartfield, were directly linked to experimental artistic movements in the 1920s and 1930s.

Brecht and the Avant-Garde

Brecht had no interest in claiming the label avant-garde for his own work, since his innovations in the arts did not break with any previous 'ism' but

rather more generally broke with the way art is received by its audience. Brecht related this new way of perception with the concept that he termed *Materialästhetik*. To quote Werner Mittenzwei:

> Die avantgardistische Formenrevolte wie der politische Inhaltsfetischismus verloren für ihn ihren Streitwert. Bewegungen dieser Art wurden von ihm einfach anerkannt, aber die grundlegende Veränderung davon nicht erwartet. Insofern emanzipierte sich die Materialästhetik von dem Form-Inhalt-Streit der zwanziger Jahre, von den Neuerungsproblemen der Avantgarde ebenso wie von den Tendenzlosungen der revolutionären proletarischen Literatur.[1]

The avant-garde rebellion against conventional forms, such as the fetishism of political content, lost its strength. Brecht merely accepted movements like these but did not expect radical changes. In that way, the *Materialästhetik* differed from the fight between content and form in the 1920s, from the problems of innovation of the avant-garde and the frequent changes in political slogans in revolutionary proletarian literature.

On the other hand, he was greatly interested in applying innovative techniques. As Karlheinz Barck suggested in 1979, Brecht emphasized the importance of surrealist visual art as an alienation technique in the conversation on dramatic techniques in *Der Messingkauf* (*The Messingkauf Dialogues*). The experimental avant-garde images, in particular those of Surrealist painters, are compared with his alienation techniques, since their intention is to stimulate the viewer to reassess the current physical world:

> Diese komplizierten und raffinierten Maler sind sozusagen die Primitiven einer neuen Kunstform. Sie versuchen den Betrachter zu schockieren, indem sie seine Assoziationen aufhalten, enttäuschen, in Unordnung bringen, etwa dadurch, daß eine Frau an der Hand statt Finger Augen hat. Sowohl dann, wenn es sich um Symbole handelt (Frau sieht mit Händen), als auch dann, wenn nur einfach die Extremität nicht der Erwartung nach ausläuft, tritt ein gewisser Schock ein, und Hand und Auge werden verfremdet. Gerade indem die Hand keine Hand mehr ist, entsteht eine Vorstellung Hand, die mehr mit der gewöhnlichen Funktion dieses Instruments zu tun hat als jenes ästhetische Dekorativum, das man auf 10 000 Gemälden angetroffen hat.[2]

These complex and sophisticated painters are the primitives, so to speak, of a new art form. They try to shock their observers by hampering, confusing and disappointing their associations – by attaching eyes instead of fingers to a woman's hand, for instance. Whether this has to do with symbolism (a woman seeing with her hands) or whether it's just a matter of her extremities not conforming to expectations, a certain degree of shock is produced, and both hand and eye are estranged. The very fact that the hand is no longer a

hand gives rise to a concept of *hand* which has more to do with the everyday function of this instrument than that aesthetic decoration we've seen on ten thousand canvases.

For Brecht, however, the shock effects induced by the Surrealist artist do not provoke a new assessment of reality, as a *V-Effekt* is intended to generate, but instead are merely a confirmation of a dysfunctional society. According to John J. White, Surrealism for Brecht might be part of a *Verfremdung* heritage, but is of a completely other order.[3] For Brecht, the artistic products of this avant-garde movement rather present a severe malfunction in society, which was consequently considered a productive new way of seeing in modernity, not a model for fellow artists to copy or to be inspired by.[4]

Brecht's Returning Friends

Not all of Bertolt Brecht's exiled friends actually returned to the Eastern part of Germany after the Second World War. No matter, however, to which zone (or, later, to which country) they returned, they all maintained contact in one way or another. All collaborated with Brecht in the 1950s. Further, they either influenced each other's work or depended on each other's support – and especially on Brecht's. In other words, Brecht's *Freundeskreis* from the 1920s and 1930s was restored and seemed to be functioning again some twenty-five years later. As Wieland Herzfelde and Werner Mittenzwei argue in their essays on the circle's teamwork, the bond between them was initially created through a shared interest in aesthetics, particularly in Brecht's *Materialästhetik*.[5] This is a theory which he developed around 1930, while he was working on his didactic plays. It examines aesthetics in relation to dramatic production and performance at a time when both the general cultural-political atmosphere and the audience in the late Weimar Republic came gradually to reject his work. Brecht was aware that his ideas regarding his concept of *Materialästhetik* would never catch on. Many were even repelled by these new plays, mainly because works such as *Die Maßnahme* (*The Measures Taken*) were perceived as pro-Stalinist.[6] Consequently, he needed the support of those of his peers who shared similar ideological and aesthetic ideas. Apart from this practical paradigm, Brecht – as is known – held the belief that no one individual, by him or herself, would be able to revolutionize the arts. It would require a collective effort. As a result, he formed the *Freundeskreis der Materialästhetik*.

As well as Brecht, this group consisted of his colleague the theatre director Erwin Piscator, the composer Hanns Eisler and the visual artists

John Heartfield and George Grosz.[7] There was also support from Otto Dix and Paul Dessau. Others sympathetic towards the new aesthetics were intellectuals and writers such as Walter Benjamin, Ernst Ottwalt and Bernard von Brentano. After what Brecht saw as the almost emblematic high point of the teamwork spirit in the mid-1920s in Berlin, with associates such as Elizabeth Hauptmann, Casper Neher and Lion Feuchtwanger, his interest and his collectivism expanded and focused on the interconnections between production and performance. This new aesthetics attracted new members of his group, who then continued their collaboration in East Germany. By then, however, the entire concept of *Materialästhetik* had long been dropped. The central point here is that in both the Soviet Occupied Zone, and, later, the German Democratic Republic, Brecht became the strongest link in the weakest chain in socialist cultural history: the avant-garde. But first, the avant-garde had to return to Germany, at a time when the early tensions between artists and the state became obvious.

Brecht's poem 'Über die Bezeichnung Emigranten' (On the Label Emigrant), from his *Svenborger Gedichte*, provides an insight into the transitory situation in which exiles found themselves, unable to call their new destinations home: 'Unruhig sitzen wir so, möglichst nahe den Grenzen/ Wartend des Tags der Rückkehr, jede kleinste Veränderung/Jenseits der Grenze beobachtend …/Aber keiner von uns/Wird hier bleiben …' (Restlessly we sit, as near as we can to the borders/Awaiting the day of our return, watching every smallest change/Across the border …/But not one of us/Will settle here …).[8] Brecht, Eisler, Heartfield and Dessau, who returned from their respective places of exile in the USA and Great Britain, had an extra burden to carry when coming back to the Germany of their choice. In the eastern part of Germany, GDR officials were especially suspicious of émigrés who wanted to return 'late' from exile in the West: 'As a result of a resolution passed on August 24 (1951) by the Socialist Unity Part of Germany and its Central Party Control Commission, all "Western emigrants" … are suspected of "treasonable connections" to Western secret service agencies.'[9]

In addition to their non-conformism with the cultural straitjacket, as defined by Stalinists, of Socialist Realism, they were regarded suspiciously because they had lived and worked in countries with which the GDR was now fighting a Cold War. In Eisler's case, SED functionaries in the austere East Berlin must have fantasized about his ostensible attachment to the Californian lifestyle, and believed that an attraction of this kind could be found in his *Johann Faustus* opera libretto: 'Zurückgekehrt – leider zurückgekehrt,/find ich die Heimat wieder grau und kalt/… Wie hab ich sie gern verlassen!/… Vergangenes bedenkend kann ich kaum sagen, es war schön./ Und doch –/Atlanta, ungeheuer leuchtet deine Sonne' (Now that I'm back

home, more's the pity,/the country seems as grey and cold as before, ... How glad I was to get away! ... Looking back on what happened,/I can hardly call it a treat./And yet –/Atlanta, your sun shines with infinite splendor!).[10] These fantasies in the minds of GDR officials of a sunny California were, of course, ludicrous, because Eisler, probably more than anyone else, wanted to become part of the *Aufbau* (construction) of a new Germany as soon as possible. The obvious irony could have been found in the use of the word 'Atlanta', the place Faust and Mephisto want to travel to, referring to the myth of the uninhabitable sunken city. This irony had already become clear in Eisler's musical arrangements of Brecht's *Hollywood Elegies* (1942). This ironic jest was either overlooked, or more likely, sailed over the heads of the German Cold Warriors. Another official faux pas concerned Eisler's 'Brief nach Westdeutschland' (Letter to West Germany), which he wanted to publish in the West German journal *Melos* in September 1951. The journal was blacklisted because of its anti-socialist and formalist content.[11] However, in this letter Eisler was actually promoting to the West the idea of socialist art and the ambitions of the SED. But his intentions were not appreciated, and in the end he needed the help of the SED leader Walter Ulbricht to save his skin.[12]

Similarly, Heartfield faced harsh accusations because of his contacts with the 'enemy', in his case the American Noel Field, director of the International Relief Action Committee for Victims of the Nazi Regime, in England. In 1990, Stefan Heym revealed that during his exile, Heartfield had never met the agent Field, but that he did know his brother Hermann Field, a dentist who once put two fillings in his teeth in London.[13] The official view of the ruling Communist party, the SED, however, was as follows:

> Die herrschenden Kreis Großbritanniens bemühten sich seit dem Ende des ersten Weltkrieges, Deutschland in ein Hauptbollwerk gegen die junge Sowjetunion zu verwandeln. Obwohl sie wußten, daß das außenpolitische Programm der Hitlerfaschisten auch die britischen Interessen direkt bedrohte, begrüßten sie den Machtantritt des Faschismus in Deutschland in der Hoffnung, dessen außenpolitische Aktivitäten auf die Bekämpfung der UdSSR und der demokratischen Bewegung beschränken zu können. Die britische Außenpolitik war daher durch das Appeasement, die faktische Unterstützung der faschistischen Machthaber und die offene Feindschaft zur Sowjetunion, gekennzeichnet.[14]

After the war the ruling class in Great Britain wanted to turn Germany into a major stronghold against the fledgling Soviet Union. In spite of the fact that they were aware that the foreign policy of the Nazis could also directly threaten British interests, they welcomed the seizure of power of the Fascists. They

hoped that their foreign policies would combat the Soviet Union and downgrade its democratic development. The British foreign policy was, for this reason, defined by appeasement and the actual support of the Fascists, thus an open enemy of the Soviets.

Heartfield – prior to his full acceptance, and later his rehabilitation and even elevation to the status of figurehead for GDR art – faced two other obstacles providing him with valid reasons for a belated move to the GDR in 1950. These were his poor health and a confession in a letter of 1 October 1945 to his sister-in law, Gertrud Herzfelde: 'Das(s) [sic] wir zurückkehren werden, betrachten wir als unsere Pflicht. Da wir die englische Bevölkerung sehr lieben gelernt haben und London uns eine besonders lieb gewordene Stadt geworden ist, ist es nur unser Pflichtgefühl, das(s) [sic] uns zurückkehren heisst' (That we will return, we see as our duty. Because we learned to appreciate the English and love London, it is simply our duty that called us to return).[15]

As for Brecht himself, he seemed, as Stephen Parker argues in his biography, to have left one foot in the USA: 'Brecht wanted just one Broadway success for all his efforts in the US years.'[16] Of course, Parker refers to the troublesome production of *Life of Galileo*, with Charles Laughton in the title role. Brecht had already demonstrated in his *Hollywood Elegies* and elsewhere his disgust with the many years of exile in the USA. On the other hand, Santa Monica was the only enclave in which a productive collaboration with Eisler, for example, was possible; it was also where, in the nearby Pacific Palisades, he was able to rub shoulders with writers such as Thomas Mann. It stimulated his creative output. Although, writing from the SBZ, Herbert Ihering urged Brecht to return to Berlin since the German public was crying out for his theatre, Brecht remained silent and frequently travelled between Europe and the USA, with New York City as his principal destination. Parker continues:

> The plan for the return to Europe took firm shape when in March 1947 Brecht, Weigel and Barbara had their application accepted for US exit and re-entry visas for Switzerland. Brecht remained cautious about the offer of a theatre for the 1947–8 season, which he clearly understood to be the Theater am Schiffbauerdamm, and was firmly opposed to returning immediately to Germany.[17]

For Brecht and the majority of the returned exiles, there was one key reason for moving to the Communist Germany: the conviction that the socialist political ideology and anti-Fascism would be victorious. As argued in the previous chapter, however, the Formalism Campaigns employed a

similar anti-avant-garde vocabulary as was heard during the period of the Degenerate Art exhibition in Nazi Germany. This must have felt like a slap in the face for the Marxist artists. This was one of the many paradoxes that GDR cultural politics faced during the nation's construction phase.

Cultural Paradise GDR?

GDR cultural politics gave the impression that all would turn out for the best if only the 'elder statesmen of culture' in East Germany would assimilate and behave well. The returning avant-gardists were promised bright and carefree futures, and were pampered during their lifetimes. Brecht, Eisler and Heartfield were awarded the highest order for their cultural achievements, the *Nationalpreis*. Further, they were all nominated and selected as members of the Akademie der Künste, with all its associated privileges. Eisler and Heartfield became professors in higher education institutions. One is tempted to ask whether the former avant-garde artists were actually silenced, and topics such as the absurd and the grotesque were supressed.[18] According to a Stasi report, the critical and provocative art historian Diether Schmidt once stressed that some well-situated artists 'werden fett gefüttert und vergessen das Denken' (were well-nourished and forgot to think).

As mentioned above, Manfred Jäger referred to the first five years in the SBZ as the 'Storm and Stress years', an idyll of cultural pluralism: an application of Lenin's thought that former bourgeois artists and writers needed time to adjust to the new aesthetic framework, following the successful Bolshevik Revolution.[19] In this relative cultural paradise for Marxists between 1945 and 1949, new projects were initiated. The cooperative projects with Brecht, however, began a few years later, when openness was already a thing of the past and, as Werner Hecht points out in his study on Brecht in the GDR, the pressures of the Formalism Campaigns had already kicked in.[20] An example: in 1951, John Heartfield and his brother Wieland Herzfelde worked on the dust jacket of Brecht's volume, *Hundert Gedichte* (One Hundred Poems), which depicted a lion carved from a tea-root, referring to the opening poem, 'Auf einen chinesischen Theewurzellöwen' ('On a Chinese Tea-Root Lion').[21] For the cultural authorities in the young GDR, the brothers' illustration was condemned as 'Formalist' since the end product failed to encourage working people to pursue new political insights and activities. Also, the poem was not fully applicable to the idea of a society based on unequivocal truth. The two options offered in the poem – 'Die Schlechten fürchten deine Klaue./ Die Guten freuen sich deiner Grazie' (The evil fear your sharp claw./The good take pleasure in your grace) – hint at indecisiveness.[22]

The most intriguing of Brecht's collaborations were with the two composers, Eisler and Dessau; not only because of the direct effect of their music on public taste, but also because of its role in the Formalism Campaigns of the early 1950s, which placed it at the heart of the argument about what constituted Realism or avant-garde. In *The Powers of Speech*, Bathrick identifies the dilemma that the SED faced in the early 1950s:

> Of particular difficulty for the SED at this time was the enormously seductive impact of Western mass media and avant-garde art movements upon the cultural life of East Germany. In the now famous document of the Central Committee of March 1951 entitled 'The Struggle against Formalism in Art and Literature,' outlines of cultural contestation were spelled out that were to dominate and structure the terms of political discourse until the end of the decade. Emanating from the West, it was argued, were the destructive influences of 'decadence' and 'kitsch,' which brutalized the taste of the broad masses of people and 'fulfilled a concrete function in the interest of anti-humanist imperialism and its politics of war-mongering.'[23]

Indeed, the Formalism Campaigns were not simply an expression of difference in Cold War aesthetics. Actually, the debate emphasizes the regime's political and cultural legitimization against a neighbouring country that had not – at least in terms of economics – overcome Fascism. As we have seen, however, in contrast to the GDR, the Federal Republic soon embraced avant-garde artists and their works, as the prestigious *documenta* exhibitions have shown.

In 1951, the Central Committee, in their struggle against Formalism in art and literature, denounced the composer Dessau as anti-Socialist because his musical taste did not conform to the cultural hegemony of the GDR at that time. It was thus an example of Formalism:

> Ihre Musik war monoton, unmelodisch, in der Hauptsache von geräuschvollen Schlaginstrumenten bestritten und arm an wirklicher Schöpferkraft. Formalistisch ist auch die Musik der Oper *Das Verhör des Lukullus*. Formalismus und Dekadenz in der Musik zeigen sich in der Zerstörung wahrer Gefühlswerte, im Mangel an humanem Gefühlsinhalt, in verzweifelter Untergangsstimmung, die in weltflüchtiger Mystik, verzerrter Harmonik und verkümmerter Melodik zum Ausdruck kommt.[24]

> Its music was monotonous, not melodious, mainly played on noisy drums and of poor creativity. The music in the opera *The Trial of Lucullus* is also formalistic. Formalism and decadence in music is defined as the destruction of real emotions, as shortcomings of human feelings, desperate doom and gloom, escapist mysticism, distorted harmony and withered melody.

Brecht was forced to take sides. In this case he supported the composer. In the GDR of the 1950s, Brecht took the side of the ostracized avant-garde, and thus became the true representative of non-realistic artwork that the cultural functionaries had branded as outlandish. In order to maintain this role, however, he had to give his blessing to the prevailing system, as he had shown during the June 1953 crisis. This was a dangerous position that the playwright and poet forged into a tactic, as is partly documented in his *Buckower Elegien (Buckow Elegies)*.[25] The elegies are in no way related to an avant-garde style, but their mixture of styles, themes and topics simultaneously juxtaposes Brecht's optimistic view of a bright socialist future and his attitude to the severe political disillusionment he and his colleagues faced in the 1950s. The result was an unconventional and outdated writing style for that period, in this case classical Greek verse, that was confronted by current political affairs.[26] The juxtaposition had a similar effect to his support of the avant-garde during the Formalism Campaigns, in his dealings with the official condemnation of new work by Dessau and Eisler.

Brecht supported the avant-garde but managed to conceal his enthusiasm. An example: after the Western press had given positive reviews to the premier of *Das Verhör des Lukullus*, the tactician Brecht made sure that the salt of its success was not rubbed into the wounds of SED cultural functionaries. Instead, he thanked the relevant cultural agencies in East Berlin for giving him the opportunity to use the facilities and resources of the capital city. Brecht did not condemn the authorities; instead, he applauded the fact that an entire government was interested in (especially his) art. Thus, he was not speaking of censorship or other restrictions, but instead of 'interest', as opposed to the 'anything goes' attitude in the West.[27]

Another strand in the Formalism Campaigns concerned German cultural heritage. Brecht and Eisler's so-called formalistic distortion of Goethe's *Faust* was perceived as an affront to the German *Kulturerbe*, or cultural heritage. Again, what happened in relation to Brecht's *Urfaust* and Eisler's *Johann Faustus* is not of direct concern here. What matters is the way in which Brecht dealt with the precarious situation. In the context of Brecht's involvement, the *Faustus* debate is not a repetition of the *Lucullus* debate but rather a step towards a more direct confrontation with GDR power: on 27 May 1953, he read his '12 Thesen zur 'Faustus'-Diskussion' (Twelve Theses to the 'Faustus'-Discussion) during the third so-called Wednesday meeting. There, for the first time, Brecht publicly denounced Formalism and spoke out against the dogma of Socialist Realism. By doing this, he exposed himself to a risky situation, since he could only try to shelter his followers while simultaneously supporting the system.[28]

At the same time, a major dilemma occurred: while officially the principal instrument of legitimization during the founding process of the GDR was

anti-Fascism, Brecht saw that the GDR's efforts to fight avant-garde art and literature did not differ much from Nazi policies during their degenerate art campaigns. One of the predicaments in the 1950s for Brecht was the alignment of Marxist and Nazi cultural politics. More concretely, the recycling of pre-1945 cultural matters in the SBZ/GDR appeared flawed, since the ideological borders seemed porous.

Recycling, or the Power of Repetition

In any discussion of the return of the avant-garde to post-war Germany, and Brecht's role in defending representatives of non-Socialist Realist art, a multitude of recycling processes have to be considered. There is the recycling of 1920s and 1930s avant-garde movements, of the Expressionism-versus-Realism debate of 1936–37 and of Nazi cultural politics in the context of Communist culture. Recycling is the process of making productive use of an object that has outlived its original function. It is an act of repetition with a new outcome – an idea proposed by cultural theorist Hal Foster in the 1990s, in the context of his critique of Peter Bürger's 1974 *Theorie der Avantgarde*. Foster claims that for Bürger, both the historical and the neo-avant-garde failed, and that the avant-garde project echoes Karl Marx's *The Eighteenth Brumaire of Louis Bonaparte* from 1852, proposing the idea that all great events of world history occur twice, the first time as tragedy, the second time as farce. The farce for Bürger is that the avant-garde never achieved its aim: '[T]he aim of the avant-garde for Bürger is to destroy the institution of autonomous art in order to reconnect art and life.'[29] The destruction of art as an institution, however, never occurred, neither in the 1920s and 1930s nor in the post-war neo-avant-garde. For Bürger, the avant-garde project fails and cannot be repeated in a new historical context. Foster, however, takes another approach, agreeing with the Slovenian philosopher Slavoj Žižek when he argues that repetition does not imply repeating the same mistakes which will once more result in failure. It is rather a reinterpretation of the old, a reinvention; not so much a repetition but a continuation can be observed. Triggered by the concept of repetition, continuation implies a smooth, almost organic unfolding of techniques linked to cultural heritage, a process of teaching and learning, so to speak. These repetitions and imitations, of course, are in the danger area of epigonism and mimicry replacing originality in the arts, but they are essential for cultural durability.[30] This sturdiness Brecht wished to reinstate with his *Freundeskreis* in the GDR.

Brecht strove for a continuation of old techniques in a new political and cultural environment. Did he succeed in reconnecting the past with

the present as Foster and Žižek envisaged? Needless to say, in the 1950s, when some of his friends joined him in the new Germany, they worked on a variety of new projects and new challenges were faced. What held the group together was not only the range of very interesting endeavours on which visual artists, composers and writers interacted. The cultural-political events around 1950 glued the activities together. The so-called Formalism Campaigns seemed to tie up the energies of the *Freundeskreis* most of the time, albeit in a destructive way. As mentioned above, the most crucial and controversial matter during the 1940s and 1950s was the *Ideengemeinschaft*, or surprising duplication of the conflicting ideological camps of Fascist and Communist cultural politics. Brecht himself pointed out the links regarding the similarities in Communist and National Socialist terminology, with specific reference to the term 'Volk' during the *Lukullus* debate and the Fifth Congress in 1951: 'Der Begriff "Volk" sei ein Nazibegriff. Die Beziehungen der Kunst zum Volk seien Unsinn. Kampf gegen Formalismus und Dekadenz sei eine nazistische Sache' (The term *Volk* is believed to be a Nazi term. The relationship between the arts and the people is nonsense. The fight against Formalism and decadence is a Nazi issue).[31] Brecht's choice of the subjunctive form may underline his cautious and tactical attitude.

Conclusion

In the Formalism debates, Heartfield, Dessau and Eisler did not stand up to the authorities, as Brecht had done after having been 'terrorized' by the new cultural politics himself. After they had come to the GDR to work in and with a new Socialist society, they became ensnared in the system. They were muzzled. To revisit the metaphor of recycling: the returning avant-garde might have been used by the GDR authorities, if only they could have been transformed into anything useful. Brecht, on the other hand, proved to be immensely reusable. He feared neither Party functionaries nor German classics such as Goethe. Without being an avant-gardist himself, Brecht became the standard-bearer of the avant-garde in the GDR during the Formalism Campaigns, since the returned avant-gardists themselves had failed to do so. In the *Arbeitsbuch*, his assistant Käthe Rülicke (who worked at the Berliner Ensemble from 1950 onwards) recalls some of Brecht's thoughts that captured the zeitgeist. Brecht notes: 'Künste müssen in unserer Zeit zurückstehen' (The arts have to stand back nowadays), and in his typical telegram style, 'Formalismusdebatten Zeichen für Tiefstand der Kunst' (Formalism debates, a sign of the low in the arts).[32] But these notes, contentious in the GDR, were never published while Brecht was alive.

As a mediator, Brecht was able to 'protect' the avant-garde, even after his death, and the returned avant-garde 'survived' until 1979, when Dessau, as their last representative, died. Brecht became a Marxist who upheld the ideology his country developed. He agitated in this grey area and his dissident voice was heard due to its ambivalent, and thus subversive, character.

Hecht points out that Brecht's effort to initiate a dialogue between the master discourse and the so-called deviant aesthetics defines the complexity he faced during, for example, his efforts to publish the *Kriegsfibel*, in which the montage techniques of John Heartfield had been applied.[33] I would go further by claiming that Brecht's negotiation efforts 'lowered' the protective wall between Socialist Realism and the avant-garde for generations to come, and motivated artists and writers to establish an experimental avant-gardist *Grundhaltung*, or basic attitude, till the late 1980s. The following chapters will show examples of how this dialogue was engaged: in the GDR, Brecht personified this attitude and passed it on to generations of writers to come, as Uwe Kolbe argues in his 2016 portrait *Brecht*, in which he sees the contemporary writers Heiner Müller, Thomas Brasch, Volker Braun and representatives of the Sächsische Dichterschule as those who continued the avant-gardist *Grundgedanke* (fundamental attitude), and as the 'kleineren Brecht-Nachahmer' (those minor Brecht imitators) who became the basis of the home-grown avant-garde in a post-Brecht GDR.[34]

Notes

1. Werner Mittenzwei, 'Brecht und der Freundeskreis der Materialästhetik. Kunstentwürfe zu Beginn der dreißiger Jahre und ihre Schicksale'. In: Klaus Siebenhaar and Hermann Haarmann (eds), *Preis der Vernunft. Literatur und Kunst zwischen Aufklärung, Widerstand und Anpassung. Festschrift für Walter Huder.* Berlin and Vienna: Medusa, 1982, 67–83 (69). Translations all mine if not mentioned otherwise. The author thanks Paul Clements for his help.
2. Bertolt Brecht, *Werke. Große kommentierte Berliner und Frankfurter Ausgabe*, vol. 22.2. Berlin: Aufbau Verlag/Frankfurt: Suhrkamp, 1988–98, 824–25. Translation by Steve Giles in Tom Kuhn et al. (eds), *Brecht on Performance: Messingkauf and Modelbooks.* London: Bloomsbury, 2014, 110–11.
3. John J. White, *Bertolt Brecht's Dramatic Theory.* Rochester: Camden House, 2004, 283.
4. Karlheinz Barck, 'Diffferenzierungen der Beziehungen zwischen künstlerischen und politischen Avantgarde. Blickrichtung; französischer Avantgarde'. In: Karlheinz Barck et al. (eds), *Künstlerische Avantgarde. Annäherungen an ein unabgeschlossenes Kapitel.* Berlin: Akademie Verlag, 1979, 191–219 (218).
5. Wieland Herzfelde, 'George Grosz, John Heartfield, Erwin Piscator, Dada und die Folgen oder die Macht der Freundschaft', *Sinn und Form* 23(6) (1971): 1224–51; and Mittenzwei, 'Brecht und der Freundeskreis', 67–83.

6. William Rasch, 'Theories of the Partisan. *Die Maßnahme* and the Politics of Revolution', *Brecht Yearbook* 24 (1999): 331–43. See also Klaus-Dieter Krabiel, *Brecht's Lehrstücke. Entstehung und Entwicklung eines Spieltyps*. Stuttgart and Weimar: Metzler, 1993.
7. Mittenzwei, 'Brecht und der Freundeskreis', 73.
8. Brecht, *Werke*, vol. 12, 81. Translation by Tom Kuhn and David Constantine in *The Collected Poems of Bertolt Brecht*. New York and London: W.W. Norton, 2019, 730.
9. Peter Pachnicke and Klaus Honnef (eds), *John Heartfield*. New York: Abrams, 1992, 313.
10. Hanns Eisler, *Johann Faustus. Fassung letzter Hand*, ed. Hans Bunge. Berlin: Henschel, 1983, 83. Translation by Peter Palmer, in David Blake (ed.), *Hanns Eisler: A Miscellany*. Luxembourg: Harwood, 1995, 328.
11. Hanns Eisler-Archiv, Akademie der Künste, Berlin: 'in einigen *Melos*-Nummern waren ausgesprochen antisowjetische und feindliche Artikel aufgenommen worden. Wohlgemerkt nicht etwa nur Arbeiten, die den Formalismus westlicher Prägung verteidigten, sondern beleidigende Angriffe auf die Sowjetunion und die DDR' (in some issues of *Melos*, pronounced anti-Soviet and hostile articles had been included. Not only works that defended the formalists' Western character, but also insulting attacks on the Soviet Union and the GDR).
12. Jürgen Schebera, *Hanns Eisler. Eine Biografie*. Berlin: Henschel, 1981, 154.
13. Pachnicke and Honnef, *John Heartfield*, 314; and Stefan Heym, *Nachruf*. Frankfurt: S. Fischer, 1990, 554–55.
14. Birgid Leske and Marion Reinisch, 'Exil in Großbritannien'. In: Ludwig Hoffmann et al. (eds), *Exil in der Tschechoslowakei, in Großbritannien, Skandinavien und in Palästina*. Leipzig: Reclam, 1980, 147–305 (154).
15. John Heartfield-Archiv of the Akademie der Künste, Berlin.
16. Stephen Parker, *Bertolt Brecht: A Literary Life*. London: Bloomsbury, 2014, 495.
17. Ibid., 499.
18. In the 1950s, Heartfield publicly distanced himself from his Dada past; see the Erhard Frommhold-Archiv at the Akademie der Künste.
19. Jäger, *Kultur und Politik in der DDR*, 5.
20. See Hecht, *Die Mühen der Ebenen*.
21. Brecht, *Hundert Gedichte 1918–1950*. Berlin: Aufbau Verlag, 1952, 299. Heartfield also designed the editions of Brecht's *Plays and Poems*, published by Aufbau Verlag in East Berlin. See footnotes 113–18 in Sabine Berendse and Paul Clements (eds and trans.), *Brecht, Music and Culture: Hanns Eisler in Conversation with Hans Bunge*. London: Bloomsbury, 2014, 268.
22. David Evans and Sylvia Gohl, *Photomontage: A Political Weapon*. London: Gordon Fraser, 1986, 19. Translation by Kuhn and Constantine in *The Collected Poems of Bertolt Brecht*, 1002.
23. Bathrick, *The Powers of Speech*, 177–78.
24. Hans Lauter, *Der Kampf gegen den Formalismus in Kunst und Literatur, für eine fortschrittliche deutsche Kultur*. Berlin: Dietz, 1951, 155.
25. See Berendse, 'Twentieth-Century Poetry'. In: Andrew J. Webber (ed.), *Cambridge Companion to the Literature of Berlin*. Cambridge: Cambridge University Press, 2017, 245–63 (253).
26. As demonstrated in Jürgen Link, 'Klassik als List, oder über die Schwierigkeiten des späten Brecht beim Schreiben der Wahrheit'. In: Jan Knopf (ed.), *Interpretationen. Gedichte von Bertolt Brecht*. Stuttgart: Reclam, 1995, 162–63.

27. Joachim Lucchesi (ed.), *Das Verhör in der Oper. Die Debatte um die Aufführung Das Verhör des Lukullus von Bertolt Brecht und Paul Dessau*. Berlin: BasisDruck, 1993, 25–26.
28. Hecht, *Die Mühen der Ebenen*, 141–42.
29. Hal Foster, *The Return of the Real: The Avant-Garde at the End of the Century*. Cambridge, MA and London: MIT Press, 1996, 15.
30. Gert Mattenklott, 'Epigonalität'. In: *Blindgänger. Physiognomische Essais*. Frankfurt: Suhrkamp, 1986, 72–100.
31. Mittenzwei, *Die Intellektuellen. Literatur und Politik in Ostdeutschland 1945–2000*. Berlin: Aufbau Verlag, 2003, 114.
32. Hecht, *Die Mühen der Ebenen*, 92–93. My translations. Rülicke started working at the Berliner Ensemble in 1950.
33. Ibid., 232–38.
34. Cf. Uwe Kolbe, *Brecht*. Frankfurt: S. Fischer, 2016, 104–27 and 145–58. See also the review of Kolbe's book by Karen Leeder in *The Brecht Yearbook* 41 (2017): 299.

Chapter 3

'1968' IN THE GDR

Franz Kafka and the Prague Spring

Although the German Democratic Republic experienced its own 'Long Sixties', events of the year 1968 in the GDR have been under-researched, neglected in scholarship or considered as less spectacular than those in the West – and, consequently, overlooked.[1] Recent publications on the topic by Mary Fulbrook, Stefan Wolle and Susanne Rinner are of high quality but, admittedly, they document fairly mundane political matters: the introduction of a revised education bill, for example, intended to prevent student protests at GDR universities, or other similar bureaucratic measures. Meanwhile, the country was learning about *les événements* in Paris, the serious disturbances in West Berlin and the Soviet tanks rolling through Prague; occurrences to which '1968' owes its iconic status in Europe.[2] Despite individual interventions by, for example, the young writer Thomas Brasch,[3] the singer Bettina Wegner and the dramatist Adolf Dresen[4] – each of whom courageously stood up against the Stalinist-driven regime in the GDR – the prevailing moods during the events of '1968' seem to have been resignation and impotence. Ulrich Bock, who studied at the University of Jena in 1968, described the few who rebelled as 'mosaic pieces which pull the GDR out of its sad gray and give it some color'.[5] But these dissident voices constituted only a miniature revolutionary generation, quite unlike the *Achtundsechziger* and their revolutionary psyche in the aftermath of the 'Long Sixties' of the Federal Republic of Germany. With the construction of the Berlin Wall in 1961, the GDR had built a protective barrier, preventing the voices of rebellious West German students being heard. Consequently, in the GDR a different kind of revolutionary mindset and range of other

dissenting voices may be identified, distinct from those of the Nineteen-Sixty-Eighters in the Federal Republic of Germany. The notion of Utopia, featured in the philosophy of Ernst Bloch (who had left the GDR in 1961) certainly influenced the thinking of intellectuals, but failed to spread to the East German streets. Apart from a few relatively minor disturbances – the occasional confrontation with the inflexible authorities and a handful of unsuccessful attempts to change the political system in the powerhouse of East Berlin – nothing happened in the GDR that could compare with the extreme and dramatic ways in which societies elsewhere were 'rocked' in 1968, even threatening existing power structures.[6] One of the major differences between East and West Germany was that in the GDR, anti-Fascism had been raised officially to the status of the nation's foundation myth, with the result that a clash between baby boomers and their parents was not on the agenda. The older generation could not possibly be held responsible for the Nazi terror, could it? As well as the effectiveness of the statutory foundation myth, which Wolfgang Emmerich characterized as an incontrovertible concept for GDR intellectuals,[7] the continuity of the dogma of Socialist Realism was guaranteed. This was promoted during the 11. Plemum des ZK der SED in 1965, or the Kahlschlag (Clear-Cutting) Conference as it was called later.[8] This conference hypothesized the *Verhärtung der Eisenzeit* (Hardening of the Iron Phase): the publication of new directives intended to muzzle any experimental voices referring to Modernism in any of its past or present forms.[9]

It is noteworthy that even the bloodiest and most politically extreme events in other parts of the world – the clashes between police and students on the Paris barricades, the bloody riots in West Berlin, Berkeley, Tokyo and Prague – shared one constant quality: fantasy. An unconstrained imagination was to become the most powerful tool in the struggle against the status quo. In this chapter, it will be shown that it is in this way that '1968' in the GDR corresponds to the paradigm shifts elsewhere in the world. It was determined by a radical change in aesthetics, in which the Surrealist tone could not be ignored, even in that part of the world in which the French movement of the Situationist International – Surrealism's true successor – was non-existent.

Nevertheless, the Paris graffiti 'Tout pouvoir à l'imagination' (All power to the imagination) during the first wave of demonstrations in the West was also heard in Communist-dominated Central and Eastern Europe, although far less frequently articulated in public. It is commonly held that '1968' in the GDR cannot be detached from what was happening in Czechoslovakia – or, as it was called between 1946 and 1990, the CSSR – and that the Prague Spring had a powerful impact on those who anticipated reforms in their own country.[10] The Prague Spring began as a music

festival, which attracted, among others, the American beat poet Allen Ginsberg, who was crowned 'King of the May' by Prague students and who subsequently became *persona non grata* to the Czech and other Central and Eastern European authorities.[11] That earlier major confirmation of the process of Stalinization, the 1956 Hungarian uprising, was also directly associated with cultural events: meetings of dissidents (like Georg Lukács) in the so-called Petőfi Club. The club was named after one of the key figures in the Hungarian bourgeois revolution of 1848, the Hungarian nationalist poet and liberal revolutionary, Sándor Petőfi. Culture and deviance, fantasy and power might seem to be unlikely bedfellows in the long run, as the West German intellectual Karl Heinz Bohrer argues when he reflects on the post-'1968' Western world. It is, nevertheless, noticeable that poets, musicians and various other cultural participants were close to the centre of many political – albeit often unsuccessful – changes.[12] Was this also the case in 1968 in the GDR? In what way is opposition or 'deviant' thinking in the GDR related to cultural events? How powerful was art? While investigating these questions, it is necessary to look back and review the cultural foundations, as the literary scholar Hans Mayer has suggested in *Deutsche Literatur 1945–1984*. Mayer argues that '1968' should not simply be considered as the beginning of a new era but, rather, as the outcome of previous events in cultural history, which enable us to launch the new. One should focus on the process rather than on the end result.[13] Mayer's approach – based on so-called 'process philosophy'[14] – is a fruitful way to assess the place the GDR has in the context of the global events in that period of contemporary world history. The present publications on '1968' in the GDR have one major shortcoming: the fixation on the final outcome of it all, rather than an investigation of the individual steps in the process in the GDR and its hinterland.

The most radical changes in cultural attitudes in the 1960s are to be found in the innovative steps taken to represent reality in an alternative way in visual art and literature. The GDR experienced an avant-garde resurrection, much like the close relationship between German Romanticism of the nineteenth century and the 1960s protest movements that, as the West German sociologist Wolfgang Kraushaar once declared, 'floated on a giant romantic cloud.'[15] Indeed, culture and social change also went hand-in-hand in the GDR. In this case, however, the common denominator was the confrontation with the dogma of Socialist Realism. As argued earlier, shortly after 1945, under instruction from the Communist Party of the Soviet Union, the representation of reality was to become one of the fundamental ideological principles of cultural politics in the SBZ. This principle was also promoted later by the cultural authorities in the GDR. At the height of Stalin's power in the mid-1930s, Socialist Realism

was established in response to the attempts of Maxim Gorki and Nikola Bukharin to jettison crude propagandist art and literature, and to raise the standards of artistic craft. The fanatical Stalinist Andrei Zhdanov 'insisted on purely utilitarian, Party-directed literature and derived the principles of socialist realism from Stalin's utterances'.[16] Since political power was firmly in the hands of Stalinists, Zhdanov's views prevailed and became the artists' and writers' manual for orthodox adherence to the principles of Socialist Realism. This conformist code was to be upheld by Lukács, who proclaimed it as 'rationalist *Kulturpolitik*'.[17] To go against these cultural directives was considered inexcusable in the GDR. Socialist Realism retained its primacy thirty years later, even after Stalin's death and his successor Nikita S. Khrushchev's 'secret' 1956 denunciation of Stalin's terror. The discussion of the 1950s Formalism Campaigns has shown the impact of the Stalinist directives on GDR cultural policy in, for example, the cases of Bertolt Brecht, Hanns Eisler and the former Dadaist John Heartfield.[18] During and after the period of Stalinization, and in spite of some minor liberalizations in Central and Eastern European countries, the East German cultural authorities decided to defend the principles of Socialist Realist dogmatism with great resolve.

The rigid enforcement of these principles adversely affected all cultural expression. It caused unprecedented ideological and artistic uniformity and made literature and visual art a tool of the Party.[19] As a result, Socialist Realism remained a product of Stalin's era. It was only as recently as 1988 that the Verband Bildender Künstler in der DDR (League of Fine Art in the GDR) officially departed from this Stalinist doctrine.[20] The 1960s had already offered many new options in the representation of reality, which were themselves diverse alternatives to the dogma of Socialist Realism. Before the GDR's final decade, in most of the larger cities there could be observed a myriad of countercultural manifestations, which radically changed the make-up of East German cultural politics forever. It is important to note, however, that the GDR artists and writers who offered these alternatives never pretended to replace the official *Lehre*, the cultural guidelines. They did not consider themselves dissidents, acting outside the parameters of GDR cultural politics. Instead, they set out to extend ways of representation, pointing out the multifarious shades of grey in Socialist Realism when de-Stalinization was replaced by re-Stalinization. From the early days of the GDR, one of the most powerful and extreme alternatives to the doctrine of Socialist Realism was Surrealism, since it proved to be the most thorough antidote. Avant-garde art and literature was implanted as a 'bug of rebelliousness', as Wolle characterized the Western spirit of '1968' in his study *Der Traum von der Revolte* (The Dream of the Revolt) of 2008.[21] In the times of Stalinization, with its patches of *Eiszeit*, for example

after the Hungarian Uprising of 1956, many writers and artists desperately sought ways to free themselves from the shackles of Socialist Realism. One of the alternatives, one of the 'forbidden fruits' once condemned by Lukács, was Franz Kafka. He was to become identified with subversive thinking in the GDR.

The spectrum of GDR culture comprises a variety of colours and cannot be defined in binary terms of black and white. It has been described by the Indian cultural theorist Homi K. Bhabha as a 'culture in-between', because the Marxist context within which East Germans worked and lived was never repudiated.[22] In contrast to in Czechoslovakia, Surrealism was not reinstated in the GDR, and the new advances never had the dominance which prevailed in the East German neighbour, i.e. Czechoslovakia. Current in GDR culture, however, were traces of avant-garde cultural deviancy, such as the Surrealism advances by writers such as Fritz Rudolf Fries, Adolf Endler, Wolfgang Hilbig, Heiner Müller and Elke Erb, whose literature demonstrates a hybrid state.

First Advocates of the Avant-Garde: Hans Mayer and Stephan Hermlin

As early as 1947, on the eve of the Cold War, Hans Mayer, professor of literature at the University of Leipzig until 1963, and his friend Stephan Hermlin, poet and translator of French verse, promoted modern world literature in the GDR. They emphasized the importance of integrating Modernism and the avant-garde into the East German canon, thus promoting the concept of coexistence in a cultural environment which had been defined by Stalinists. In their co-authored book *Ansichten über einige Bücher und Schriftsteller*, referred to in the Introduction, Hermlin boldly announced the importance of Surrealism as a manifestation of Modernist art and literature that should be respected and promoted in the SBZ. Each of the authors emphasize the necessity of embracing international tendencies in fiction and expanding the narrow ideological framework of the German Soviet zone:

> So formte sich dann im Verlauf des Jahres 1946 aus unseren wöchentlichen Buchreferaten und Berichten so etwas wie ein Abriß der modernen internationalen Literatur.[23]

> Our weekly reviews and briefings from 1946 resulted in a kind of outline of modern international fiction.

Mayer and Hermlin did not encounter any resistance during these years. Indeed, freedom and the opportunity to promote non-realistic art and literature were characteristic of the years shortly after the Second World War. Until about 1950, the authorities were pragmatic and relaxed in their approach to cultural policy. In the first years after the Bolshevik Revolution, we have already noted that a similar lightness of political touch was permitted by the Soviet authorities.[24] From the beginning of the Cold War, however, a Stalinist cultural framework was imposed upon the GDR. The accusation of Formalism became a feared weapon in the arguments employed against artists and writers who adopted foreign, non-realistic styles, such as – as Hermlin already had hinted – Surrealism. But in 1951, at the Congress for Young Artists, and in the eye of the storm of the Formalism debate, the poet was compelled to distance himself from his support of the avant-garde and Modernism.[25]

In spite of the fact that those GDR artists who embraced the possibilities of Modernism did not see themselves as mounting a direct challenge to the prevailing orthodoxies, any cultural experimentation and the pursuit of any new forms of expression were regarded, in official circles, as a direct confrontation with the cultural establishment. Further, they were seen as an assault on the all-pervading principles, and indeed the very artefacts, of Socialist Realism. Mayer and Hermlin were the first GDR intellectuals to recognize the varieties of new and different modes of representation, and were to continue to intervene in cultural politics – most notably when it came to the problematic issue of rehabilitating Franz Kafka in the Communist world. This was a daunting task, since Kafka was a writer who – as the Soviet authorities, with some justification, feared – was an enormous influence on the ideas of the 'revanchists' at the frontline of the Prague Spring. The focus of the international community on Kafka, and in particular the unorthodox opinions expressed by delegates at the 1963 Kafka Conference, had a significant effect on changes in Central and Eastern European culture, with far-reaching consequences for the political milieu of the 1960s.

Even as late as 1947, Hermlin was permitted to show his appreciation of Kafka, linking him with Paul Éluard and the spirit of Surrealism.[26] Soon, however, Kafka became a ticking bomb in both cultural and political matters. The Central Committee of the Communist Party of the Soviet Union was convinced that the pernicious influence of Kafka was responsible for all the troublesome reformist activities, the unrest and the student protests in Central and Eastern Europe, especially in Czechoslovakia in 1968, and for the growing power of the reformer Alexander Dubček. Kafka's analysis of the deadening effects of bureaucracy had a permanent seismic impact. Anti-authoritarian issues might have played a crucial role

in the former CSSR. In the GDR they were embedded in its literature, and Kafka became the main engine with which to question power.[27]

In the Stalinist climate, Kafka became an important talisman against state repression. From the perspective of the authorities, some GDR writers, including Anna Seghers, Günter Kunert, Reiner Kunze, Wolfgang Hilbig, Gert Neumann and Klaus Schlesinger, became representatives of *Kafkaesque* fiction and were denounced as 'Kafkaists'.[28] Kafka portrays apparatchiks, but he also demonstrates ways to counter the nightmare of a faceless and inflexible bureaucracy in any kind of society. His central concept of *Entfremdung*, or alienation, became a powerful tool in the exposure of any dogmatic system.[29] Kafka's talent for unmasking power was a welcome and uncomfortable tool for questioning the establishment – the *SED-Kader* – in the GDR, also because he was directly linked to the 'forbidden fruit' of Surrealism. André Breton had introduced the Surrealists in Prague to 'their' fellow townsman Kafka. Editions of his work were published in the Czech language; his novel *The Castle*, in an edition to be published in 1968, was subtitled by the Czechs 'A Surrealist Novel'.[30]

Who's Afraid of Franz Kafka?

Breton's notion of a state of continuous cultural and political revolution was reintroduced after the Second World War by the Czech Surrealists. Consequently, they defined their art as 'operative', in the sense that they attempted to push back restrictive boundaries and defy conventions, while at the same time remaining true to their Marxist convictions. Surrealism was pivotal in the political hotspots in this area of Europe. In 1956, following Khrushchev's official condemnation of Stalin's crimes, writers and artists who were inspired by Surrealism, or *Nadrealism*, were at the forefront of attempts at de-Stalinization in Czechoslovakia, most notably by means of a pamphlet co-signed by fifteen members of the surrealist group from France. This publication declared 'that it was surely because the attacks upon the Revolution both as an idea and as a fact that it [the Surrealist Movement] had been fiercely anti-Stalinist for twenty years, without ever abandoning its revolutionary goal'.[31] After the Second World War, in spite of their predominantly Marxist ideology, most of the writers and artists, many of them French Surrealists, joined their colleagues in their confrontation with the cultural politics and harsh, restrictive practices of the Communist Party in those Central and Eastern European countries under the yoke. They were particularly critical of the way the Soviets crushed any form of what they saw as dissidence or cultural deviance. Following pronouncements in the Second Surrealist Manifesto of 1929, the Czech artists

reaffirmed their opposition to bourgeois culture and institutionalized art. Issue 5 of the periodical *L'Archibus* was published in Prague in 1968 as a special edition. The first page was stamped with blue letters spelling out the word 'Czechoslovakia'. It featured a collective essay written in Prague in September, a month after the Soviet invasion, by Czech Surrealists who had left the capital. It also printed an essay entitled 'The Prague Platform' from April 1968, signed by twenty-eight members of the French Surrealist movement, as well as other foreign Surrealists. The 'Platform' proposed seven points for consideration 'not as dogma but, on the contrary, as suggestions adaptable to given circumstances'. The authors had not only the outcome of the Prague Spring in mind, since they declared that they hoped to 'expand the dialogue with any and all individuals and organized movements that have helped bring repressive systems to their knees'. Addressing oppressed writers and artists all over the world, the Platform reiterated that the Surrealists' explicit role was 'to liberate the powers and desires held captive in the unconscious'.[32] This captivity was related to repressive political systems on both sides of the Iron Curtain, and did not refer only to the limitations of any individual artist or writer.

As mentioned above, Surrealism, or indeed, the recycling of any kind of the historical avant-garde – not least the writings of Kafka – were feared by Communist authorities.[33] Cultural functionaries in the Soviet Union were quick to relate any negative connotations associated with agents of power to the shortcomings of Capitalist societies, thereby shifting the blame and denying any deficiencies of their own.

> Das Phänomen Kafka in der Sowjetunion ist außerordentlich, die Geschichte der Weltliteratur in der Neuzeit kennt kaum etwas ähnliches. Ein unbekannter fremder Schriftsteller wird als getarnter Mitkämpfer aufgefaßt, seine Werke werden heimlich, unter Lebensgefahr abgetippt und verbreitet, er erringt die größte Ehre: das Zensurverbot. Auf geheimnisvolle Weise ist es Kafka gelungen, gesellschaftliche und politische Vorgänge und menschliche Schicksale in einem ihm völlig fremden Land zu prophezeien und eine unbekannte Zukunft in parabelartigen Romanen getreu widerzuspiegeln.[34]

> The phenomenon of Kafka in the Soviet Union is remarkable, almost unheard of in world literature in modern times. An unknown foreign writer is viewed as a disguised comrade-in-arms, his texts are being copied and distributed in secret. By doing so, Kafka reaches the highest achievement: censorship. In a mystical way, he succeeds in predicting events in society, politics and in human fate in an absolutely foreign country. His predictions refer exactly to an unknown future in his parable-like novels.

In the 1960s, Kafka's notion of *Entfremdung* was as hotly debated in intellectual circles in Central and Eastern Europe as it was during the International Kafka Conference in Liblice Castle in 1963. This was organized by Eduard Goldstücker, professor of German at the Charles University in Prague. From the records of the proceedings of the conference, it is clear that Kafka was reread for more than academic purposes, to motivate scholars to review his writing.[35] The conference was far more a political than a simply literary event, because Kafka's interpretation of reality went far beyond the rationalist dogma of Socialist Realism. High on the agenda was whether Kafka's writings should become part of the curriculum in schools and universities in the Communist world. Klaus Hermsdorf underlines in his 2006 essay 'Kafka in der DDR' that the writer became the spiritual source of reforms of Communism not only in the CSSR but also in the GDR.[36]

The Liblice conference welcomed academics from Hungary, Yugoslavia, Poland and the GDR. It was also attended by Communists from France and Austria. Most urgently considered was the reintroduction of Kafka's writing in the Communist world. This was the cause of some Communist authorities' nervous response when it came to openly debating *Entfremdung*. Not only did they emphasize that the concept of alienation was exclusively associated with the Capitalist world; the new interpretations of Kafka were accurately connected to the efforts for reform in Prague. The GDR responded to Kafka's idiosyncratic way of representing his world with the customary so-called 'Palmström' logic: an assertion that something cannot be true because it goes beyond the logic of a dogma.[37] In their arrogance, the GDR authorities had more cards to deal: they ignored Hans Mayer's internationally celebrated status as an expert on Kafka and Modernism.[38] With both his profound knowledge and his controversial opinions, Mayer would have stirred up the academic world of Central and Eastern Europe. By admitting him, the organizers would have permitted a Trojan Horse to enter the Citadel. Instead, his assistant at Leipzig University, Helmut Richter, was recommended to be one of the members of the GDR delegation and was subsequently invited to attend the conference. Richter was one of four GDR delegates, along with Hermsdorf, Werner Mittenzwei and Ernst Schumacher. The writer Anna Seghers was also part of the GDR delegation but did not actively participate. Her voice was to be heard in the texts she published later.[39]

Ignoring Mayer's insights, Richter denied that Kafka had any influence on GDR society, and in particular on the younger generation of writers. He disregarded any of the Kafkaesque voices which had demonstrated the importance of concepts such as *Entfremdung* in his country.[40] Arguments

for and against Kafka could also be read at home. Both before and after the conference, several publications on Kafka were released by writers, academics and cultural functionaries. Some of them saluted the Czech writer, while others attacked him. Examples from the pro-Kafka group include the poem 'Interfragmentarium' by Günter Kunert[41] and Ernst Fischer's essays against dogmatism – both published in the 1962 issue of the journal *Sinn und Form*, edited by Peter Huchel. These rehabilitations were sharply countered a year later in the same periodical, now edited by Huchel's successor, the hardliner Bodo Uhse. In *Sinn und Form*, under new management, an early negative poetic portrait of Kafka by the Czechoslovakian-German writer Louis Fürnberg was published.[42] The fiercest backlash, however, came from Alfred Kurella, the GDR's highest cultural official in the 1960s. Kurella's intervention must be interpreted as an unashamed attempt at re-Stalinization, in which on three separate occasions he disparages the importance of the conference. His main target was the contribution of the French delegate, Roger Garaudy, entitled 'Kafka, die modern Kunst und wir' (Kafka, Modern Art and Us), which was transcribed and distributed unofficially in the GDR shortly after the conference.[43] The Communist and anti-dogmatist Garaudy defines concepts of realism from the perspective of Kafka's analyses, unrelated to the social class to which he happens to belong. Garaudy – together with Fischer and their Czech hosts – praised Kafka's Modernism, his determination and his ability to deliver insights into the lives of the oppressed. In Garaudy's opinion, Kafka expressed solidarity with the outsiders with whom he identified himself.[44] For this reason, his conclusions did not correspond with the GDR's official discourses:

> Kafka ist kein Revolutionär. Er weckt in den Menschen das Bewußtsein ihrer Entfremdung, sein Werk macht die Unterdrückung durch ihr Sich-Bewußtwerden noch unerträglicher, doch er ruft nicht zum Kampf auf und zeigt keine Perspektive. Er enthüllt ein Drama, ohne dessen Lösung zu sehen. Er haßt aus aller Kraft den Unterdrückungsapparat und dessen Vortäuschung, daß seine Macht von Gott stamme.
>
> Wenn Kafkas Botschaft heute noch so lebendig ist, wenn so viele Männer und Frauen in ihm ihre Probleme und das Bild ihres Lebens wiederfinden, so kommt das daher, daß wir noch immer in einer Welt der Entfremdung leben und auch die sozialistische Welt – selbst, wenn sie die Perspektive der Beseitigung der Entfremdung des Menschen und das Kommen eines vollkommenden Menschen zeigt – sich erst in der ersten Etappe ihres Kampfes befindet und ihre Widersprüche und ihre Entfremdung noch in sich hat.[45]
>
> Kafka is not a revolutionary. He inspires people and makes them aware of their alienation, and his writing irritates because it exposes and makes real the

suppression, and is thus unbearable. He does not call for a fight, does not show any perspective. He unveils a drama without a solution. He hates – from the bottom of his heart – the apparatus of suppression and its pretence that its power comes from God. The reason Kafka's message is still relevant today, why so many men and women can recognize themselves in his imagery, is that the world, including the socialist world, is still one of alienation – even if it struts about as an ideal world without contradictions and alienation.

In keeping with Stalinist orthodoxy, the label that GDR officials were eager to use to stigmatize the literature characterized by Garaudy was 'decadence'. In the Cold War era of the 1960s, Kafka faced official exclusion, whereas scholars such as Garaudy, Fischer and Mayer offered the concept of coexistence – a tricky and adventurous undertaking, as Mayer later admitted, in the context of the GDR's monosemic controls:

> Literatur ist nicht möglich ohne Kenntnis der modernen Literatur …, so muß die Auseinandersetzung mit der modernen Kunst und Literatur in weitestem Umfang endlich einmal beginnen. [Es sollte versucht werden,] eine freie offene experimentierfreudige Kunst mit einem rigiden in sich eingekappselten ideologischen System in Einklang zu bringen.[46]

> Literature cannot exist without knowledge of Modern literature …. Discussing modern art and literature in the broadest sense should begin. (It should be tried) a reconciliation of open, experimental art and a strict, bounded ideological system.

While a limited edition of Kafka appeared in the GDR in 1965, his writing did not become widely available until 1983. In each case, Klaus Hermsdorf – conference delegate and promoter of Franz Kafka – signed off as editor.[47]

Kafka had already become widely available in Czechoslovakia in the 1960s, where his work was associated with Surrealism. As early as 1956, seven years before the Liblice Kafka Conference, and twelve years before the events of the Prague Spring, Maja Goth had investigated the Kafka–Surrealism link. Here, there are no indications of any connections or relationships between the French and Czech Surrealist groups, even though the French Surrealists themselves often referred to Kafka as one of their spiritual fathers. In 1937, for example, André Breton introduced Kafka in an essay in the journal *Minotaure*, and subsequently in other journals such as *La Nef*. Kafka is also represented in Breton's *Anthology of Black Humour* (1940) with extracts from the eerie *Metamorphosis*, among other stories.[48] The Paris Surrealists constantly emphasized their emotional relationship with Kafka, not least because of the link between dream sequences and real events in his Prague:

Die Grenzen zwischen Bewußtsein und Unbewußtheit verwischen sich in Kafkas Welt und hat teil an der Surrealität. ... Die Phantastik Kafkas infiltriert die Wirklichkeit und wird zu deren Bestandteil. ... Kafkas Welt enthält zweifellos realistische Elemente: Revolte, Verzweiflung, irrationelle Phänomene, so daß die Surrealisten sich dank der häufigen Ähnlichkeit der Stimmung angezogen fühlen mußten.[49]

The borders between consciousness and the unconscious state become blurred in Kafka's world and take part of 'surreality'. Kafka's fantastic world penetrates reality and becomes part of it. There is no doubt that Kafka's world bears realistic elements: revolts, desperation, irrational moments, so that Surrealists were attracted by the atmospheric similarities.

In GDR cultural politics, Surrealism or any kind of historical avant-garde was dismissed as non-realistic decadence. The fanatical backlash of GDR functionaries against the avant-garde was a reaction to its being seen as an assault upon the sanctuary of Socialist Realism, which, at all costs, needed to be protected.[50] The story of the relationship of this cultural orthodoxy with the so-called historical avant-garde is complex, since each individual state in Communist Central and Eastern Europe had its own specific characteristics and cultural-political background. East Germany bore the heavy burden of the twelve years of Nazi cultural politics at a time when the GDR authorities boldly claimed to have wiped the slate clean. Dealing with abstract, non-realistic art and literature placed the GDR in a dilemma. It was supposed to have swept away Nazi policies of marginalizing abstract art and of stigmatizing it as degenerate. At the same time, it was obliged to follow the dogma of Socialist Realism, which – as discussed in Chapter 1 – was based on similar premises. This heritage creates a difficulty when discussing the incompatibility of Modernism, the avant-garde and Socialist Realism in the German Democratic Republic.

Conclusion

Searching for ways to avoid the image of the total absorption of Soviet cultural directives in the GDR, the latter's functionaries also focused on another cultural heritage, rather than directing their attention solely towards Socialist Realism. As we saw in the previous chapter, an additional important signpost for avoiding concepts such as Modernism and the avant-garde was the emphasis on the traditions of *Humanismus*, on German Classicism and on the philosophical principles of the Enlightenment, in which the ideals of rationalism are key. This emphasis in cultural life stood in stark

contrast to the irrationalism and mythology that was associated with the terror Fascism had provoked in German society. In the aftermath of the Expressionism debate of the 1930s, some Communist fanatics associated Fascism with Modernism and the avant-garde. Georg Lukács, initiator of the Expressionism debate, later articulated the policy of the GDR's central cultural agency, the Kulturbund der DDR, that the writing styles of Goethe, Schiller, Lessing and Kant were realistic models of writing and were, therefore, truthful. *Humanismus* became synonymous at first with realism, then with Socialist Realism, and, finally, in *Wider den mißverstandenen Realismus* (Against the Misunderstood Realism, 1958), with 'critical realism' – in contrast to the abstract and dissolute *Weltanschauung*, which was the 'decadent' world view of the Modernists and avant-gardists in the first decades of the twentieth century.[51]

The Cold War took various forms, not least as a fierce linguistic battle.[52] In the words of Lukács the choice was reduced to the 'glorious Faust and the dung beetle Gregor Samsa'.[53] For the *sauberer Staat* – as the GDR frequently and proudly presented itself – this was a straightforward choice. In the introduction to the 1983 Kafka edition in the GDR, Hermsdorf drew a very interesting parallel between Kafka's topical father–son relationships and the way East Germany's young generation of writers dealt with power in their own country during the Cold War, and particularly in '1968'. What is often featured in Kafka's stories is a *Haßliebe* (love–hate relationship) between sons and their fathers. In contrast with such a relationship is the much more hostile attitude of the Expressionists who were active at the same time. This was repeated, about fifty years later, by the angry young men and women in West Germany who focused on violence and surprise.[54] So why, then, were youngsters in the GDR attracted to Kafka in the 1960s? Hermsdorf's answer comes close to a better understanding of what GDR culture was, and relates to '1968'. It was not a straightforward rejection of what the state had to offer, nor did it involve collaboration. The most subversive attitude of those called 'Kafkaists', and of others who scorned despotism, was a constant negotiation between the Übervater (dominant father figure) and his sons and daughters, in order for the young ones not to end up like most of Kafka's protagonists. In this way, they could not be confined to a fixed position. That was the rebellious act.

Those who were called 'Hippies' in the West were 'Kafkaists' in the East, and instead of direct confrontation they focused on dialogue. That was the ultimate rebellion in a nation that seemed to be defined only by monologue.

Notes

1. Why '1968' in inverted commas? While the actual turbulence lasted only two years in West Germany and West Berlin, the term 'Long Sixties' remains current. This is not only because of what happened in that timeframe, but immediately before and after that as well. The half-century of its afterlife needs to be considered.
2. Mary Fulbrook, *Power and Society in the GDR, 1961–1979: The 'Normalisation of the Rule'?* New York and Oxford: Berghahn Books, 2013; Stefan Wolle, *Der Traum von der Revolte. Die DDR 1968.* Berlin: Ch. Links, 2008; and Susanne Rinner, *The German Student Movement and the Literary Imagination: Transnational Memories of Protest and Dissent.* New York and Oxford: Berghahn Books, 2013. Laudable is the exhibition *Aufbruch und Protest. 1968 in Prag, Berlin, Leipzig und Dresden* in the Sächsische Akademie der Künste in 2018, organized by Klaus Michael.
3. See the documentary *Familie Brasch* (The Brasch Family, 2018), available at https://www.familie-brasch-film.de (accessed on 17 August 2018).
4. Adolf Dresen, 'Der Fall Faust. 1968: Der letzte öffentliche Theater-Skandal in der DDR', *Der Freitag*, 19 November 1999. See https://www.freitag.de/autoren/der-freitag/der-fall-faust (accessed on 17 August 2018).
5. Quoted in Ingo Cornils, *Writing the Revolution: The Construction of '1968' in Germany.* Rochester: Camden House, 2016, 190.
6. Cf. Mark Kurlansky, *1968: The Year that Rocked the World.* London: Vintage, 2005. The exception was the thorough revision of the education bill in the GDR's constitution (paragraphs 9–18).
7. Emmerich, 'The GDR and its Literature'.
8. Günter Agde (ed.), *Kahlschlag. Das 11. Plenum des ZK der SED 1965. Studien und Dokumente.* Berlin: Aufbau Verlag, 1991.
9. The conference in 1965 was an attempt to deal with the crisis that the SED had manoeuvred itself into by closing itself off from Western cultural history and presence in the 1950s and early 1960s, in particularly in film, other visual art and literature, but also in scientific work. Cf. Emmerich, *Kleine Literaturgeschichte der DDR*, 183. In 1965, Christa Wolf was the only female speaker at the 11th Plenum of the Central Committee to speak out against a restrictive cultural policy that was also intended to silence avant-gardists (in all fields of the arts). Her 1968 text *Nachdenken über Christa T. (Reflection on Christa T.)* bears witness to her political activism. See Agde, *Kahlschlag*, 334–44 and Christa Wolf, *Nachdenken über Christa T.* Berlin and Weimar: Aufbau Verlag, 1972. After criticism and discussion of the manuscript, Wolf's publication was delayed by about four years and backdated to 1968. See also Therese Hörnigk, *Christa Wolf.* Göttingen: Steidl, 1989, 115–32 and 132–41.
10. In the interview between the Italian journalist Gaetano Scadocoavia and dissident Robert Havemann for the daily *Il Giorno* on 9 October 1968, the interviewee emphasized the impact of the Czechoslovakian occurrences on the GDR. Havemann would have preferred that the happenings in the CSSR motivated GDR citizens to discuss matters of democracy in their socialist state publicly. The interview was recorded by the Stasi. See BStU, MfS-ZAIG Nr. 33330, 37–41.
11. Berendse, *Grenz-Fallstudien. Essays zum Topos Prenzlauer Berg in der DDR-Literatur.* Berlin: Erich Schmidt, 1999, 11–12.
12. Karl Heinz Bohrer, '1968: Die Phantasie an die Macht? Studentenbewegung – Walter Benjamin – Surrealismus', *Merkur* 12 (1997): 1069–80 (1069).
13. Hans Mayer, *Deutsche Literatur 1945–1984.* Berlin: Siedler, 1988, 245.

14. See Johanna Seibt, 'Process Philosophy'. In: Edward N. Zalta (ed.), *The Stanford Encyclopedia of Philosophy* (Summer 2020 Edition), https://plato.stanford.edu/entries/process-philosophy/ (accessed on 20 October 2020).
15. Wolfgang Kraushaar, *Achtundsechzig: Eine Bilanz*. Berlin: Propyläen, 2008, 258–68.
16. Ermolaev, *Soviet Literary Theories*, 6.
17. Bathrick, *The Powers of Speech*, 169.
18. Ibid., 177–82.
19. See Ermolaev, *Soviet Literary Theories*, 7.
20. Ulrike Goeschen, *Vom sozialistischen Realismus zur Kunst im Sozialismus. Die Rezeption der Moderne in Kunst und Kunstwissenschaft der DDR*. Berlin: Duncker & Humblot, 2001, 9.
21. Cornils, *Writing the Revolution*, 192.
22. Homi K. Bhabha, 'Culture's In-Between'. In: Stuart Hall and Paul du Gay (eds), *Questions of Cultural Identity*. London: Sage Publications, 1996, 53–60.
23. Hermlin and Mayer, *Ansichten über einige Bücher und Schriftsteller*, 7 and 193–97.
24. Jäger, *Kultur und Politik in der DDR*, 7–9.
25. Erbe, *Die verfemte Moderne*, 154–67 (158).
26. Hermlin, 'Franz Kafka'. In: Mayer and Hermlin, *Ansichten*, 158–63. In the West German edition, published by Limes Verlag in the same year, the Kafka chapter is omitted.
27. Cf. Norbert Winkler and Wolfgang Kraus (eds), *Franz Kafka in der kommunistischen Welt. Kafka-Symposium 1991 – Klosterneuburg*. Vienna: Böhlau, 1993, 104.
28. Angelika Winnen, *Kafka-Rezeption in der Literatur in der DDR. Produktive Lektüren von Anna Seghers, Klaus Schlesinger, Gert Neumann und Wolfgang Hilbig*. Würzburg: Königshausen & Neumann, 2006, 18. Examples of the writings and impact of later 'Kafkaists' are Gert Neumann's novel *Elf Uhr* (published in 1981 with the West German publisher S. Fischer) and the poetry and short stories of Wolfgang Hilbig. See Chapter 6.
29. With this term, philosophers like Jean-Jacques Rousseau and Karl Marx indicated the growing distance between humans and their natural habitat.
30. Jaroslav Dresler, 'Die Verwirrungen der Zungen. Franz Kafka im Spiegel kommunistischer Kritik', *Osteuropa* 10(7–8) (1960): 473–81 (473).
31. Gérard Durozoi, *History of the Surrealist Movement*, trans. Alison Anderson. Chicago and London: University of Chicago Press, 2002, 581.
32. Ibid., 641.
33. The phrase found in the heading of this section is adopted from the essay title 'Who's Afraid of Franz Kafka? Kafka Criticism in the Soviet Union', by Emily Tall, *Slavic Review* 35(3) (1976): 484–503.
34. Efim Etkind, 'Kafka in sowjetischer Sicht'. In: Claude David (ed.), *Franz Kafka. Themen und Probleme*. Göttingen: Vandenhoeck & Ruprecht, 1980, 229–37 (237).
35. Eduard Goldstücker et al. (eds), *Franz Kafka aus Prager Sicht 1963*. Prague: Verlag der tschechoslowakischen Akademie der Wissenschaften, 1965.
36. Klaus Hermsdorf, *Kafka in der DDR. Erinnerung eines Beteiligten*. Berlin: Theater der Zeit, 2006, 221.
37. Palmström is a fictional character in Christian Morgenstern's poetry. See Wim Tigges, *An Anatomy of Literary Nonsense*. Amsterdam: Rodopi, 1988, 208.
38. See, for example, Mayer, 'Kafka und kein Ende? Das Werk des Prager Dichters im Kreuzfeuer der Interpreten', *Die Zeit*, 13 January 1961.
39. See Winnen, *Kafka-Rezeption in der Literatur in der DDR*.

40. Ibid., 29–30; and Erhard Bahr, 'Kafka und der Prager Frühling'. In: Heinz Politzer (ed.), *Franz Kafka*. Darmstadt: Wissenschaftliche Buchgesellschaft, 1973, 516–38 (522).
41. Günter Kunert's poem 'Interfragmentarium' was demonstratively subtitled 'Zu Franz K.s. Werk' and links to one of Kafka's most striking characteristics, the visualization of the invisible.
42. Kunert, 'Interfragmentarium', *Sinn und Form* 14(3) (1962): 272–73, later in Kunert, *Verkündung des Wetters*. Munich and Vienna: Hanser, 1966, 80–82; Ernst Fischer, 'Franz Kafka', *Sinn und Form* 14(4) (1962): 497–553; Louis Fürnberg, 'Leben und Sterben F.K.s', *Sinn und Form* 15(2–3) (1963): 415–28, later in *Lebenslied. Gedichte aus dem Nachlaß*. Berlin: Aufbau Verlag, 1963, 112–14. Fürnberg was known for his propaganda verses, for example for the sanctioning lines 'Die Partei, die Partei hat immer recht' (The Party, the Party is always right).
43. Alfred Kurella, 'Der Frühling, die Schwalben von Franz Kafka. Bemerkungen zu einem literaturwissenschaftlichen Kolloquium', *Sonntag* 31 (1963), later published in *Kritik in der Zeit. Literaturkritik der DDR 1945–1975*. vol. 1. Halle and Leipzig: Mitteldeutscher Verlag, 1978, 383. There are many diary entries on the concept of *Entfremdung* in the context of the Kafka conference. See Alfred Kurella, *Das Eigene und das Fremde. Beiträge zum sozialistischen Humanismus*, ed. Hans Koch. Berlin: Dietz Verlag, 1981, 470–82. The comments of the French Communist Garaudy at the Kafka conference play a central role in these. See also Ulrich Pfeil, *Die 'anderen' deutsch-französischen Beziehungen. Die DDR und Frankreich 1949–1990*. Cologne: Böhlau, 2004, 261–66.
44. Hans Mayer, *Aussenseiter*. Frankfurt: Suhrkamp, 1975, 444.
45. Roger Garaudy, 'Kafka, die modern Kunst und wir'. In: Eduard Goldstücker et al. (eds), *Franz Kafka aus Prager Sicht 1963*. Prague: Verlag der tschechoslowakischen Akademie der Wissenschaften, 1965, 199–207 (205).
46. Hans Mayer, *Zur deutschen Literatur der Zeit*. Reinbek: Rowohlt, 1956, 129–30.
47. Franz Kafka, *Amerika*, ed. Klaus Hermsdorf. Berlin: Aufbau Verlag, 1967; and *Das erzählerische Werk*. Band 1 + 2, ed. Klaus Hermsdorf. Berlin: Rüttingen & Löning, 1983. In 1965, the first edition was published as a *Lizenzausgabe* of the West German publisher S. Fischer Verlag in a print run of 5,000 copies. Cf. Elke Scherstjanoi (ed.), *Zwei Staaten, zwei Literaturen? Das internationale Kolloquium des Schriftstellerverbands in der DDR, Dezember 1964. Eine Dokumentation*. Munich: Oldenbourg Verlag, 2008.
48. André Breton (ed.), *Anthologie des Schwarzen Humors*. Munich: Rogner & Bernhard, 1979, 416–34.
49. Maja Goth, 'Der Surrealismus und Franz Kafka'. In: Heinz Politzer (ed.), *Franz Kafka*. Darmstadt: Wissenschaftliche Buchgesellschaft, 1973, 240, 244 and 248.
50. Erbe, *Die verfemte Moderne*, 36.
51. Georg Lukács, *The Destruction of Reason*, trans. Peter Palmer. Alantic Highlands: Humanities, 1981; and Georg Lukács, *Wider den mißverstandenen Realismus*. Hamburg: Claassen, 1958, 11 and 531.
52. Cf. Lynn B. Hindts and Theodor O. Windt, Jr, *The Cold War as Rhetoric: The Beginnings, 1945–1950*. New York: Praeger Publishers, 1991.
53. Daniel J. Farrelly, *Goethe in East Germany, 1949–1989: Towards a History of Goethe Reception in the GDR*. Columbia: Camden House, 1998, 9.
54. Hermsdorf, 'Einführung'. In: *Franz Kafka. Das erzählerische Werk. Volume 1*. Berlin: Rütten & Loening, 1983, 5–65 (36).

Chapter 4

FLIRTING WITH THE ENEMY

The Absurd and Grotesque in 1960s Poetry

The previous chapters explored the historical antecedents and development of the avant-garde in the GDR within the context of the state-endorsed cultural orthodoxy of Socialist Realism. We came to the conclusion that the cultural position was not as clear cut as both ideological fronts projected. In this hazy Cold War framework, the distinction between realistic and experimental writing was often difficult to determine. In the next five chapters, we turn our attention to the responses to the circumstances within which individual artists produced their work. Within the context of the severely restrictive measures imposed by GDR politicians, we will explore the means employed by artists who sought to avoid an uncompromising dissident status while distancing themselves from collaboration with the state authorities. By evading the irreconcilable differences in the cultural landscape, writers – like other artists – were dancing on a tightrope and placing themselves in an impossibly uncomfortable position, as depicted by Trak Wendisch in his 1984 painting *Seiltänzer* (Rope Dancer).[1] While they were performing this tricky balancing act, the artists in question placed themselves in a vulnerable position. In reality, the state accused artists and writers of indecision, of moving both backwards and forwards simultaneously. In this way, the cultural authorities found them to be vague, shadowy figures and, consequently, to be subversive. In this chapter, the focus will be on poetry written in the 1960s by, among others, Uwe Greßmann, Karl Mickel, Adolf Endler, Richard Leising and Wolf Biermann. In their work a number of alternatives to the authorized aesthetics of Socialist Realism can be seen. In some cases a surrealist attitude or spirit (related to the avant-gardist *Grundhaltung*,

discussed in Chapter 1) presents itself so overtly that it managed to unmask some of the cultural and political restrictions that this decade had in store.

The Poetry Wave

Culturally, the 1960s in the GDR was the most chaotic and, at the same time, most productive decade in the country's forty-one-year existence. It is hardly surprising that the proceedings in this decade were fundamentally dissimilar to the events taking place in the West. Although the exceptional explosion of experimentation with different – sometimes opposing – styles might appear similar to what was happening all over Europe, this should not prevent us from looking more closely at the uniqueness of the East German cultural context in the 1960s. One of the distinctive features of the high-quality work produced in this decade is the protection of (even marginal) suggestions of dissident or illegal voices, and the circumvention of state control, an activity that risked the possibility of total exclusion, as was the case with Wolf Biermann. In the wake of the inquisitorial 11. Plenum des ZK der SED in 1965 – eleven years before his forced expatriation – Biermann became not only a flamboyant and critical voice in the GDR, he also deliberately deviated from the approved cultural norms and sidestepped the orthodoxy of Socialist Realism. Biermann was not alone among the artists of his generation in his practice of juxtaposing different writing styles and techniques, of intermingling traditions from cultural history and, last but not least, of incorporating alien voices through translation. In the West German literary scene of the 1960s, Biermann and other critical writers (Adolf Endler, Elke Erb and Sarah Kirsch among others) became household names and could be found in leading literary journals – in *die horen*, *Alternative* and *Akzente* for example.

In late 1962, in the run-up to the Eleventh Congress, the poet Peter Huchel was sidelined by the authorities for his apparent 'flirting with the enemy'. While editing the journal *Sinn und Form*, the official forum of the Academy of Arts since 1949, he was accused of transnational (in SED speak, 'cosmopolitan') ambitions. As was noted in the previous chapter, the authorities were appalled by his decision to publish pro-Kafka and anti-dogmatism essays in the journal's 1962 edition. They removed him from his post. As a reaction against the regime's measure, his colleague Stephan Hermlin, a promoter of European Modernism, organized a poetry reading on the evening of 11 December 1962, at which the previously unheard – and, according to some official functionaries, deviant – poetic voices of poets born around 1930 were introduced. The evening's slogan was 'Junge Lyrik: unbekannt und unveröffentlicht' (Young Poetry: Unknown and

Unpublished). This poetry reading in the East Berlin Academy of Arts is recognized as a watershed event in the history of GDR literature. It initiated what later became known as the *Lyrikwelle* (Poetry Wave). A new generation of poets experimented with different styles and blended poetic voices from the baroque to the avant-garde. This mixture of historical and contemporary lyrical correspondences was to become a characteristic feature of a group of poets that later became known as the Sächsische Dichterschule. These poets were abundantly represented at the poetry reading in December 1962.[2]

As secretary of the Poetry Section of the Academy of Arts of the GDR, Hermlin launched his subdued protest by demonstrating that this new generation of poets shared similar deviant aesthetic intentions to those of the recently deposed Huchel. For the first time, young and outspoken poets such as Biermann, Mickel, Kirsch, Kurt Bartsch, B.K. Tragelehn and Volker Braun gave public readings from mostly unpublished work, exposing readers to unusual new voices; voices which were sometimes archaic but always, in the eyes of the GDR authorities, 'outlawed'. We must, however, realize that these poets were far from being or becoming dissidents. In most cases they had welcomed the GDR as a new society and had even embraced the construction of the Berlin Wall as a consequence of the Cold War and a manifestation of an independent cultural nation.[3] Contrary to common belief, many of the culturally active artists in the GDR saw the Wall as a symbol of emancipation. Adolf Endler expressed this view in an interview he gave shortly before his death in the Summer of 2009:

> Wir alle ... dachten, daß danach die große Debatte und die Befreiung der Literatur von all den Dogmen und Ideologien stattfinden würde. Das klingt heute paradox, aber damals haben das die meisten von uns wirklich geglaubt. Alsbald mußten wir jedoch feststellen, daß diese große Auseinandersetzung keineswegs stattfand, sondern daß die Mauer benutzt wurde, um alles zu zerschlagen und zu zerknüppeln.[4]

> All of us ... thought this would invite the great debate and that the liberation from dogma and ideologies would begin from now. From today's perspective this sounds paradoxical but most of us had this belief. But it soon became apparent that no great debate had been initiated and that, instead, the Wall was used to destroy and crush everything.

The highs and lows Endler refers to were to become a common feature in the GDR cultural scene in the 1960s. They became even more daunting after the so-called Kahlschlag (Clear-Cutting) conference of 1965, as was pointed out in the previous chapter. Writers and visual artists were searching for an appropriate response to the cultural inquisition of the 1960s. Looking

for alternatives beyond the Socialist Realism mould, however, was criminalized after the worst of the 1950s Formalism Campaigns was over. One way of liberating oneself from the suffocating atmosphere of cultural conformity and, at the same time, avoiding censorship and self-censorship was the incorporation of a variety of styles in the writing. This diffusion avoided exclusiveness. One such diffusive technique was the poets' celebration of absurdity and foolishness, as found in the poetry of Mickel and Leising, and also in the ludic texts represented in the unpublished 'Lob der Torheit' (In Praise of Folly), a proposed anthology of translated foreign and East German poetry edited by Sieglinde and Fritz Mierau. As we will see, all these textual innovations interfered with the ostensibly steady course on which cultural politics were set. All this cultural disorder eventually lead to an apotheosis offered by *l'enfant terrible* Biermann in a 1968 poem using André Breton's infamous shooting imagery.[5]

In the world of poetry in the 1960s there was another, perhaps clandestine way of dealing with accusations of deviance, and avoiding either state- or self-censorship. One kind of literature that could not simply be banned by the so-called Literaturgesellschaft/Leseland was Soviet poetry.[6] And as part of the Poetry Wave, users of the practice of *Nachdichtung* (free adaptation, based on literal translation) embraced that officially sanctioned Russian and Soviet poetry, and also included verse of a less conformist calibre. As Heinz Kahlau correctly observed, Russian-language poetry had become a special point of focus for the young generation of poets.[7] Adaptations of Russian-language poetry from the Soviet Union facilitated an awareness of new aesthetic concepts. Further, it familiarized poets and readers with a new culture of political engagement in another socialist country. Particularly significant was the emergence of the reaction against the periods of re-Stalinization in the post-1945 Soviet Union and, in particular, the public distancing from the terror established in the name of Joseph Stalin after 1956. In a hedonistic way – typical of the poets in the Sächsische Dichterschule – these foreign discourses were consumed and reproduced by GDR poets, in what one could call an act of poetic cannibalism.

As a scholar of Slavonic literatures, Fritz Mierau played a significant role in the reception of Russian and Soviet poets in the GDR. With his anthology, *Mitternachtstrolleybus. Neue Sowjetische Lyrik* (Midnight Trolleybus: New Soviet Poetry, 1965), Mierau not only presented contemporary Russian-language poets, he also introduced to the public the new generation of GDR poets, because they were participants in the *Nachdichtung*. In his Afterword, Mierau points out the significance of the practice of *Nachdichten*. He emphasizes the close relationship between translator and translated poet in this practice, and the impact of crossing

the border in both geopolitical and cultural terms.[8] The crossing of the cultural border was of huge significance when associating GDR poetry with Surrealism and other isms in European literary history, since most of the Russian and Soviet poets Mierau selected for his anthology were linked to the historical avant-garde. This is particularly pertinent with reference to Alexander Blok, Anna Akhmatova, Osip Manderstam and Velimir Khlebnikov,[9] and also to Marina Tsvtaeva.[10]

During the 1960s, Socialist Realism gradually became a damaged and inactive brand in the GDR because it was constantly confronted by its alternatives. These alternatives were not only the prose of writers such as Irmtraud Morgner and Fritz Rudolf Fries, but also the unconventional verses of a new young generation of poets that were heard along with those of the imported Russian avant-garde via *Nachdichtung*. In many Central and Eastern European Communist countries, the widely publicized processes of de-Stalinization in the mid-1950s and later 1960s created room for new initiatives in literature and the visual arts. These initiatives in periods of thaw (in German, *Tauzeit*), were combined with determined efforts at re-Stalinization (*Eiszeit*).[11] In cultural matters, rapid oscillations between freeze and thaw were striking. In the GDR, literary and visual artists became very confident in dealing with a diverse range of expectations – in Endler's words, 'the highs and lows'. They found themselves either sandwiched between political and aesthetic demands, or balancing on a thin tightrope.

After the failed Formalism Campaigns, Stalinism in the GDR was revitalized in 1959, and it became official, five years later, during the conference in the city of Bitterfeld. These campaigns paved the way for a five-year-long Bitterfelder Weg (Bitterfeld Way), an initiative of the publishing house Mitteldeutscher Verlag, and sanctioned by the highest levels of Government and Party. The Bitterfeld Way proposed the forging together of literature and labour, in order to dissolve the conventional divide. This appeared to be a true avant-gardist ideal. In reality, however, it was a way of recreating or standardizing a culturally pre-eminent, demotic, national Socialist Realist art. Despite the Bitterfelder Weg's slogan, 'Greif zur Feder, Kumpel, die sozialistische deutsche Nationalkultur braucht dich!' (Take up your pen, mate, the socialist German national culture needs you), the authorities' intention was not to smuggle in an idea of an artistic avant-garde. Instead, they intended to undermine the writers' and artists' desire for autonomy. Simultaneously, this initiative was meant to counter efforts in the Federal Republic of Germany to constitute a similar unity between labour and literature, of which the so-called Dortmunder Gruppe 61 was an example and in which the novelist Max von der Grün played an important role.[12]

Indeed, the GDR authorities did not confine their attention either to the formulation of an abstract ideology of Socialism or to merely depicting

its heroes of factory and farm. They rather focused, with the assistance of literature and the visual arts, on the introduction of a new ideology. The increased application and integration of science and technology in the GDR's developing industry became the new subject in artefacts. These were to be a depiction of East Germany's (delayed) *Wirtschaftswunder* (economic miracle), in which the term 'avant-garde' had an entirely different meaning, as was pointed out in Chapter 1. Writers and artists were requested to play a major part in this new development. The ventures, showcased in the early 1960s, were the application of a theory, a pact between labour and the arts. This ought to have been seen as a huge success for the government that had managed successfully to promote its ideology by means of art and literature.

Many artists and writers, however, turned their backs on this kind of amiability, and so the ideals of the Bitterfelder Weg were never actually realized in the way the authorities had imagined. The writer Franz Fühmann, for example, complained that this submissiveness would downgrade him to the status of a reporter: strolling along the factory floor with his typewriter strapped to his belly would turn him into a true Socialist Realist. The state's attempts at re-Stalinization were answered by poets with what the Puerto Rican poet and scholar Iris M. Zavala calls a 'counter-hegemonic subversion of monologic power'.[13]

Poets' Uprisings

Indeed, the idea that GDR art and literature merely displayed realistic representations of the *Arbeiter- und Bauernstaat* (Workers' and Farmers' State) is an outdated Cold War notion. Particularly in the second decade of the twenty-first century, the many studies and exhibitions following German unification have shown how inaccurate and narrow this view is.[14] Nevertheless, this idea prevailed. The reason for its persistence is possibly a lack of information or an unwillingness to rethink and challenge stereotypes. Of course, in the case of GDR fiction, the time had arrived to reread East German literature written between 1945 and 1990.

This rereading facilitates new insights into contemporary German literary history. Further, it has not only resulted in exposing inaccurate representations of the link between Communism and the arts; it has at the same time resulted in a reading of, and renewed focus on, those alternative milieus in GDR art and literature which were for various reasons hidden. In the 1960s, for example, the creation of alternative fictional worlds was suppressed by official cultural politics. Despite the fact that they were less visible, these alternative narratives existed. Some of the obscured texts and poets in the

GDR's *Dichtergarten* (poets' garden) will be presented here. This term was coined by Gerhard Wolf to describe the peak of lyrical interactions during this decade's industrial developments and growing economic prospects. Beyond the cultural islands onto which some poets retreated (or were forced to retreat), the state tried to link the hype of technology with cultural change to include the opponents in its 'industrial revolution'. One of the results was the 1966 conference organized by the Central Committee of the SED on the interrelationships between the technological and cultural revolutions. The interconnection of contradictory worlds became a central consideration of the poetry written during the so-called *Forum* debate in that same year. Also in 1966, two of the poets introduced by Hermlin in 1962 published the anthology *In diesem besseren Land* (In this Better Nation).[15] Following in the footsteps of the outcast Huchel, the editors, Mickel and Endler, presented a mixture of old and new voices. The anthology's title is far from a blunt propaganda stunt. Instead, it praises the multitude of different, sometimes conflicting, voices which are presented throughout the history of the GDR. These had made the nation a 'better' place in which to write poetry. Indeed, for both editors this was very much a remnant of the optimism which followed shortly after the construction of the Wall: the promised liberalization and creation of a cultural haven. During this year (which Holger Brohm called a *Schwellenjahr*, or emerging year, for poetry), a debate was held in the student newspaper *Forum*.[16] The participants were young poets and dogmatic functionaries. They were later joined by the more liberal-thinking scholars Dieter Schiller and Dieter Schlenstedt. All entered the discussions with great enthusiasm. But they were also anxious about the distinctiveness of their profession and its protection from potential pollution by alien discourses (technology and science). Needless to say, these multifaceted debates were sharply observed by official cultural agencies, ever eager to identify and correct any transgressions. Ten years before the *Forum* discussions, Hans Mayer had warned of the deceptive analogies between the world of science and the arts. In his carefully formulated attempt to protect literature, he alluded to Stalin's slogan from the 1930s, which had set out the principles of Socialist Realism:

> Sind Schriftsteller wirklich Ingenieure der menschlichen Seele ? ... Die Analogie von Technik und Naturwissenschaft, auf die Arbeit der Schriftsteller angewendet, zieht Verarmung mit sich ... Hier sind meiner Ansicht nach die spezifischen Arbeitsmöglichkeiten der Wissenschaft und der Kunst verwechselt worden.[17]

> Are writers really engineers of the human soul? ... The analogy of technology and science, adopted in the world of a writer necessitates impoverishment. In my view, and because of the specific conditions, it's either science or art.

During the 1966 debate, the comments of the young poets were interpreted by the authorities, with some justification, as insulting, particularly because the speakers chose deliberately to ignore the seriousness of the new official strategy. Hans Koch, the dreaded chief ideologue of the 1960s, pulled out all the stops in his attempt to convince the young artists that they were barking up the wrong tree. Koch, together with other cultural functionaries who participated in the debate, was confronted by the laconic attitudes of the newcomers. Sarah Kirsch, for example, dared to assert that she had experienced no difference whatsoever in writing both before and after the technological revolution. In each case, she added, in the city where she lived there was no good-quality cognac on sale and no carbon paper could be found.[18]

The poems also published in the journal can easily be interpreted as the products of rebellious disobedience and, therefore, as outright rebellion. They did not, however, aim at destabilizing the state. The poems not only undermined faith in Socialist Realism, they also questioned the blind trust in the advantages of this new scientific focus. What follows is an analysis of four poems which departed from the SED's confidence in progress and which were linked to other avant-garde movements, including Surrealism. These are Karl Mickel's 'Der See' (The Lake), Adolf Endler's '*Ja geh*' (Yes go), Richard Leising's 'Homo Sapiens' and Uwe Greßmann's 'Schildas Bierulk' (Gothamite Beerspoof). We will also investigate the project of the anthology 'Lob der Torheit' (In Praise of Folly), later renamed 'Karneval' (Carnival), between 1964 and 1968.

'Der See' was perceived as an affront because it clearly deviates from the conventionally accepted ways of representing reality. At the same time, the poem is associated with the historical avant-garde. It introduces its readers to an uninhabitable environment with a profusion of bizarre, grotesque imagery in a science- and rationality-obsessed GDR. The poem depicts a dream world with its origins in the utopian vision of the Russian poet, Velimir Khlebnikov, who recommended understanding the world by consuming it.[19] Mickel's vision might well be close to the once-popular fashion for Futurism, around 1915, but his landscapes remind us of Surrealist settings in the paintings of Max Ernst. Mickel's imagery encompasses features such as the *grindigen Wundrändern* (scabby edges of the wound) and the unequivocal presence of an unreal *Mischwesen* (a hybrid being, part human, part animal).[20] Fifty years after Khlebnikov, Mickel's utopian vision was once more to be found, now in the GDR. The final stanza in Mickel's poem demonstrates this urge for unconventional representation:

Also
bleibt einzig das Leersaufen
Übrig, in Tamerlans Spur, der soff sich aus Feindschädel-

Pokalen eins an …
So faß ich die Bäume („hoffentlich halten die Wurzeln!")
Und reiße die Mulde empor, schräg in die Wolkenwand
Zerr ich den See, ich saufe, die Lippen zerspringen
Ich saufe, ich saufe, ich sauf – wohin mit den Abwässern!
See, schartige Schüssel, gefüllt mit Fischleibern …[21]

So
what lasts is to empty
the lake in the way Tamburlaine did, who got drunk
when drinking from the enemies' skulls …
Now I hold on to the trees ('hopefully the roots endure!')
And I tear up the pan diagonally into the clouds
tear up the lake, I booze till my lips burst
I drink, I drink, I drink – where should the sewage go!
Lake, ragged bowl, filled with fish bodies …

Chaotic movements in an unrealistic setting, the introduction of a *Mischwesen* and the hedonistic lifestyle announce an alternative way of addressing and experiencing reality by the scientist who features in the poem. Since it did not reflect the reality the GDR was looking for, this was not what science was supposed to look like. Further, by his employment of an unconventional method, the scientist eventually gets to the bottom of things. Here, the intention to shock is crucial, not least through the undermining of convention through an intensely alternative style of writing. The most provocative issue in the new poetry of the 1960s presents, according to Homi K. Bhabha, a world 'in between'. In this world there is an absence of a solid foundation; there is a cultural and political setting that is impossible to determine with any certainty. It becomes a balancing act.[22]

A similar motif can be observed in some of Endler's poems from the 1960s. Endler's poetry, which was influenced by Surrealism throughout his writing career, gradually became more overtly surrealistic in the works published from the late 1960s, at which point he was about to become an influential mentor in the following decade for a new generation of poets in Prenzlauer Berg.[23] We will focus on this in the following chapter. But there are some earlier indications of a positive absorption of Surrealism in his poetry, particularly when the two worlds that became the poet's home are inhabited simultaneously – as in his 1965 poem '*Ja geh*'. The revised 1980 version, however, reveals a preference for the unconventional underground life:

Ja geh Ich hol mir mit dem Straßenpumpenschwengel
Zum Trost die Stimmen jener zweiten Stadt nach oben

Der Rattennacht *Ja geh mein ausgedienter Engel*
Nicht Dich die Stadt der Ratten will ich künftig loben
Einwohner zähl sie hundertmalachthunderttausend

...

Ich lausch entzückt den GOAL wenn sie gut angebissen
Wie fern *ja geh* die Welt der Alexanderplätze
Mich laß die Rattenschauze die hier meine hissen[24]

Yes go I hoist with the street pump handle
The voices of the city below to comfort me
The night of the rats *Yes go angel that served me well*
Not you, the rat city I want to praise in the future
Population counts hundredtimeseighthundredthousand

...

I enjoy listening to the rats' striking
How far away *yes go* is the world of the Alexander Platzes
Let me have their gobs I hoist

Both Endler and Mickel exhibit movements between and within different worlds, a characteristic of Surrealism where the boundaries between the real and dream worlds are superimposed or dissolve altogether. Becoming aware of leaping between the two worlds was a concrete manifestation of the departure from Socialist Realist orthodoxy – in Endler's words, 'the world of the Alexander Platzes' – of consumerism and GDR-style amusement. The poets were connecting a conduction wire between the hugely separate worlds of the avant-garde and the orthodoxy of Socialist Realism.[25] For the poets representing the Sächsische Dichterschule, for example, this spark of anarchy within a rigorously organized state was sufficiently provocative to cause the censoring or sabotage of free speech. Although the poets did not make public statements or write manifestos, they vigorously contested the dogma of Socialist Realism and presented alternatives. These alternatives flew in the face of Koch's three sacred principles: *Parteilichkeit* (ideological loyalty), *Volksverbundenheit* (solidarity with the masses) and *Verständlichkeit* (intelligibility) – the remnants of the diminishing dogma of Socialist Realism. Poetry of the 1960s which was orientated towards a modern outlook and a modern voice espoused other principles, which were closer to what Mayer refers to as *Außenseiter*, those outcasts on the periphery of society: Jews, homosexuals and women. Without diminishing the importance of these people's status, Mayer's term can also refer to those marginalized by the

hegemony of the so-called Real existierender Sozialismus: the anti-social, the jester, the clown and the dreamer. A nation that defined itself on a set of rickety socialist morals soon realized that its endeavours were about to become a lost cause.

Leising's poem 'Homo Sapiens' confronts a GDR convinced of its idealized, ascetic, Communist way of life. He adds to the many verses written in the 1960s in praise of a hedonistic lifestyle. At the same time he challenges the harshness of the Leseland, as the state celebrated itself. Leising penetrates the thin layer of consumerism, and questions the way in which an ideology treats its people and restricts any of their choices that might stray beyond the conventional:

> Der Mensch lebt nicht vom Brot allein
> Er will auch sein Rettich und Eisbein.
> Unsertäglichbrot genügt ihn nich
> Er will auch einen Brotaufstrich.
>
> ...
>
> Zu einem richtigen Arbeiterstaat
> Gehört ein richtiger Kartoffelsalat.
>
> ...[26]

> Man does not live by bread alone
> He wants his horseradish and Knuckle as well.
> Just bread is not enough
> He also wants his butter.
>
> ...
>
> To a real nation of labourers
> belongs a really good potato salad.
>
> ...

Going beyond the limits of what was expected could be reflected in fictional spaces where moral expectations could be trashed and superseded by new principles. The *Zehn Gebote der Sozialistischen Moral* (Ten Commandments of Socialist Morality) were never taken seriously by East Germans, but their publication in 1963, two years before the inquisitorial 11. Plenum des ZK – referred to above – once more demonstrated the state's aspirations to silence deviant voices. The commandments did not differ much from petit-bourgeois morals. The poet Uwe Greßmann recognized

this and then continued to ridicule the GDR in his posthumously published lyrical project *Schilda Komplex* (Gothamite Complex, 1998). With distinctive naivety, Greßmann proposes a world that is free from dogmas, but that on the other hand does not inevitably end up in a blurred and dreamy condition. His poetry introduced an assumed naïve context, within which he often addressed the reality of cultural and political policies in the 1960s. For Greßmann, Party discipline did not differ very much from a bourgeois attitude towards life. The *Schilda Komplex*, for example, demonstrates this petit-bourgeois attitude

> Im Bierkrug zu Schilda da wars
> Da sangen wir vom Becher
> Eine Hymne der Hankel war ein Er.
> Und einer dem das nicht so schmeckte
> Der kippte einfach um
> Und lief auf dem Tisch jenes Landes
> Mann so ein Bier Mann
> so ein Bier Mann
> so ein Bier war das
> Eine heitere Runde und beugte sich darüber
> Die Tischdecke näher zu betrachten.
>
> …[27]

> In Schilda's local there it was
> were we were singing about the cup
> a hymn about the handle who was a he.
> And somebody who did not like that
> He just tipped over
> And walked on the country's table
> O man that kind of beer man
> that kind of beer man
> that kind of beer it was
> A cheerful round and leaned over it
> To inspect the tablecloth from close-by.
>
> …

Greßmann's hallmark is his naivety. This was not mere simplicity; instead, it was a conscious method of unmasking the country's surreal disposition. The surreal was also the poet's focus when creating alternative realities to the Real existierender Sozialismus, in his cosmology and fantasy worlds, for example, archived in Berlin's Academy of Arts.[28] The *Schilda* poems, published in 1998, whilst addressing the petit-bourgeois mentality in the

GDR (known as Gothamite or *Schildbürger*), portray a surreal milieu in the socialist state. In this poem, Greßmann clearly exposes the way the poet-singer Wolf Biermann became the subject of an inquisition during the 1965 Plenum. He was the victim of a thorough interrogation by officials such as the Minister of Culture, Johannes R. Becher, who in the poem is disguised as part of an intoxicated mob of drinkers.

In the midst of the official attempt to reinforce the principles of Socialist Realism, there was another backlash. This was the project of Sieglinde and Fritz Mierau on the carnival discourse, intended to result in the publication of an anthology of GDR and international poetry. This anthology was never published, but the cry for new ways of fighting the restrictions was unmistakable even though it was heard only by a small in-group.[29] In what follows, the activities of the Germanist Sieglinde and the Slavist Fritz will be examined.

The Mierau Project

The editors of this project aimed to extend the hedonistic drinking and body culture in poetry to a subversive radicalization of the GDR's cultural hegemony.[30] The project was initially entitled *Lob der Torheit* (1964–66), but was later called *Garten der irdischen Lüste* (The Garden of Earthly Delights, 1966–68) and finally, *Karneval* (1968). The changing titles indicate the actual objective of the editors, which was a radical denunciation of Socialist Realism. But at the same time, their approach was cautious. By evoking the painting of Hieronymus Bosch and the writings of François Rabelais, the titles make reference to two of the spiritual fathers of Surrealism, but not to the historical avant-garde movement itself, which had, of course, been denounced by official cultural politics.[31] Even the echoes of Surrealism had a damaging effect on the GDR's cultural politics. In a letter to selected potential contributors, the editors wrote: 'IN PRAISE OF FOLLY. Following Erasmus of Rotterdam, we have named a book that tells of the wisdom of fools in texts and pictures from all times.'[32] The reading of all sixty-nine poems provides a selection of the history of international poetry in which cheerfulness is predominant, but also in which reality is defiantly reinterpreted. Realism is not tailored in accordance to rational or socialist measures. Instead, it appears grotesque – a game of carnivalesque reversal of the official world. Most of the texts deal with the radical subjectivism of individuals who find it difficult to cope with a world that is thought to be absurd. The absurdities are made to appear ridiculous with foolish *naiveté*. The poetry is characterized by a sense of fun, cheerfulness and sensuality, with dream protocols and surrealistic ways of speaking that subvert controlled language.

The introductory poem is by Paul Éluard; it describes the ambivalence of life but the conclusion remains positive.

It becomes clear that the constant revision of the Carnival Project gradually weakened its explosive power. Within half a decade, an increasing number of poems by young, critical East German authors were removed from the manuscript in order to accommodate the anticipated wishes of the publishers. This private project, therefore, documents a narrative of self-censorship. Most of the texts in the planned anthology were already published in the GDR. Nevertheless, the book was not allowed to surf on the fashionable wave of poetry in the 1960s, particularly because of the concentration of divergent views presented, even though from today's perspective they appear harmless. In the final version, only three poems by GDR poets representing the national folly discourse were included: works by Johannes Bobrowski, Sarah Kirsch and Rainer Kirsch. The publishers were unsympathetic, and the reaction of the Jewish exile and, later, GDR author Arnold Zweig to the request to contribute to the proposed anthology is a telling indication of the cultural-political climate of that time. In a letter dated 9 December 1964, Zweig wrote to the Mieraus:

> Hoffentlich ist es Ihnen eingefallen, daß wir in unserer Sprache das 'Lob der Torheit' nicht singen können, ohne das Dritte Reich zu gedenken, das seine tausend Jahre in zwölf durchgaloppierte. Der Leichenhaufen, den es hinterließ und die Witwen und Waisen, die dazu gehörten, machen es mir unmöglich, selbst bei so freundlichen Sonnenschein wie dem heutigen mehr zu sagen als diese Worte der Mißbilligung.[33]

> Hopefully, it occurred to you by now that in Germany we can no longer speak of 'in praise of folly' without commemorating the Third Reich, which galloped through its Thousand years in twelve. The pile of corpses left behind, and the widows and orphans that belonged to them, make it impossible for me to say anything more than the words of disapproval, even in the sunshine as bright as today's.

Equating foolishness with the terror of German Fascism was taken as a sign of the prevailing mood in the orthodox realm by highly esteemed anti-Fascists, even beyond the GDR, and is close to the mentality of the mid-1930s Expressionist/Realism debate, as discussed above. In this freezing climate, to publish an anthology of folly was unthinkable, even though it was due to appear, eventually, in a greatly diluted form. The project was discontinued in 1968. The collection was condemned to become the first *samizdat* production of GDR literature, as a mere five copies were printed and distributed only among friends.[34]

The Apotheosis of 1968

GDR culture can broadly be viewed as a confrontation between bleak reality and seductive non-realistic imagery. As we have seen, Bhabha defined the contrast between reality and utopia as a creative hybrid place. Surprisingly, it is there that GDR culture can be located. In many East German literary texts of the 1960s, intertextual stimulation became paramount; dialogues between various voices were given a platform and exclusivity was denied. For the repetition or recycling of the 'old' supported the aesthetics of *Unschärfe* (Frank Hörnigk).[35] The overlapping of different discourses enabled the creation of a mysterious 'world in-between'. For Mickel and Endler, the dialogue fluctuates between an appropriate way of representing the world and its absolute opposite. On the one hand, we have what might be expected from an objective researcher and a rational citizen of Berlin; on the other, there is the appropriation of nature and the adoption of a subcultural lifestyle, in which avant-garde discourses play a central role.

The recycling of Modernist or avant-garde work during GDR Stalinism, or *Eiszeit*, was particularly crucial when resisting indoctrination and the stifling of dissident voices. As Hal Foster has argued, in the context of the debate over the neo-avant-garde and postmodernism in the 1970s, the revisiting of the historical avant-garde movement, Surrealism, is a political act. Anja Tippner claims much the same in her work on Surrealism in post-1945 Czechoslovakia.[36] The concept of repetition was first introduced as a direct response to the argument proposed by the authority on Surrealism, Peter Bürger, in his seminal *Theorie der Avantgarde*. In 1974, Bürger defined the historical avant-garde as a unique phenomenon. It had targeted the *Institution Kunst*, the institutional status of art, and caused it to tumble; it had been a self-criticism of artistic behaviour and museology in the bourgeois context. It could not be repeated in other settings.[37] As mentioned in Chapter 2, Bürger dismissed the notion of a sovereign neo-avant-garde: postmodernism. His book is a direct reaction to the temptations of the neo-avant-garde in the cultural ambience of postmodernism and the radical changes which took place in the late 1960s. By protecting the heritage of the historical avant-garde in Western Europe, however, and in particular in his field of expertise, Surrealism, he ignored the entire idea of influencing the minds of others and the revisiting of existing ideologies: 'The revival of art as an institution and the revival of the category "work" suggests that today [since the second half of the twentieth century] the avant-garde is already historical.'[38] For this reason, there has been much criticism of Bürger following the translation of his book in 1984 in the birthplace of postmodernism, the USA. Indeed, East German artists and writers contradict Bürger's claim that this art movement attempts to preserve the label

of neo-avant-garde. Characteristic of postmodernism is its combination of avant-garde with more conventional styles. Because of this cultural mobility, it prompts us to revise our concept of the cultural context in the GDR. This idea will be revisited in Chapter 9 when discussing the status of Bürger's work in GDR academia.

The power of repetition was highlighted in 1968, when the literary world was ultimately conjoined with politics. As argued in the previous chapter, the fiercest opponent of official GDR cultural politics in the 1960s was the absent Franz Kafka. But the regime's worst current nightmare was Wolf Biermann. The cultural authorities thought that he needed to be muzzled. One of the most controversial issues associated with his work was his relentless mobility in cultural matters. Biermann presented multiple dialogues with deviant voices, often from the West. These included the North American beat generation.[39] With reference to the youthful upheavals just a few kilometres from East Berlin, his affinity with the cultural and political affairs of his previous home country had been another key reason to marginalize him, in order to prevent the infiltration of dissident views that might ultimately prove impossible to contain. The authorities were especially nervous after Robert Havemann, Professor of Physical Chemistry at Humboldt University – and an academic celebrity – gave his lectures on dialectics without dogmatism in 1963. He became a mentor for the student Biermann, who gradually acquired the status of an outsider in the official GDR cultural scene.[40] To make matters worse in the eyes of the authorities, he commented on violent events in West Berlin, most notably the attempted murder of Rudi Dutschke on 11 April 1968. With hindsight, Dutschke is regarded as an icon of the 1968 movement in Germany. He was viewed by the suspicious East German government, however, as an anti-authoritarian student and former citizen of the GDR, who could exert an undesirably persuasive influence on potential East German reformists. In his lyrics, Biermann denounces the attempted murder of the West Berlin student leader and accuses politicians in the Federal Republic of Germany and in West Berlin of complicity in attempting to silence a reformer. This part of the song would not have been frowned on. But in all his texts, Biermann consistently applies the idea of Germany to both East and West, and for this reason his fifth stanza would have been seen as highly subversive. In it, he warns East German dissenters to learn from the tragedy in the West: 'Wenn wir uns nicht wehren/Wirst du der Nächste sein//Ach Deutschland, deine Mörder' (When you don't resist/You will be next//Oh, Germany, your murderers). The Party's view of Biermann's interventions was one of consistent misunderstanding. Further fuel to the flames was provided by the publication of his lyrics on 31 May 1968 in the newspaper *Prager Volkszeitung*. The first indication of subversion was that this medium

was directly related to an 'unpredictable' member of the Warsaw Pact, the reforming Czechoslovakia under Alexander Dubček, at the height of the Prague Spring. Available in the GDR, this German-Czech newspaper was promptly banned after the Soviet invasion of Prague in August 1968. But the greatest (although apparently less politically subversive) blunder which provoked the authorities was the use of imagery that alluded to Surrealism.[41] One of the pockets of artistic resistance can be observed in the second stanza, which offers the grotesque image of a human body part as a gun:

Des zweiten Schusses Schütze
Im Schöneberger Haus
Sein *Mund* war ja die Mündung
Da kam die Kugel raus![42]

The shooter of the second shot
was in the council in Schöneberg
his *mouth* was the barrel
the bullet left from there!

This stanza clearly demonstrates the humanization of an object, a device that can often be found in surrealist poetry, attempting to go beyond the elaborate consciousness of symbolism and into the very source of poetic imagination. The interpretation of reality by the realists fell into disfavour when it was considered imperfect, transitory and impure. Many Surrealists represented a fundamental rejection of reality.[43] Another palpable subject that united the Surrealists, and which is also to be found in Biermann's verses, is related to the concept of 'the abject', as defined by Julia Kristeva in 1982. In Biermann's morbid lyrics it seems impossible to distinguish between the object (gun) and the subject, Klaus Schütz, who was mayor of West Berlin from 1967 to 1977. The two are subsumed. What Kristeva would call the 'power of horror' fascinates while at the same time causing exasperation.[44]

Conclusion

Wolf Biermann and his fellow poets of the 1960s have never been defined as constituents of Surrealism per se. Nevertheless, he and many of his contemporaries used elements of the grotesque, the absurd and the irrational, and consequently they flew in the face of prevailing cultural dogmas. The appeal of Biermann in both East and West Germany was his juxtaposition of realism and non-realism, of traditional songs and ballads praising anti-Fascism,

and his tapping into innovative techniques, thus sharing the ostracized Modernist heritage. Erich Honecker, whose wife had first invited Biermann to be part of the nurturing of a new Socialist Germany in the 1950s, was about to expatriate the *enfant terrible* of the GDR on 16 November 1976. This cardinal mistake, to which he later admitted, was to be the beginning of the end.[45] Biermann's texts provide evidence of a subtle artistic resistance, associating real events in *West* Berlin with strange, unconventional imagery in the literature of the GDR. As noted above, the mere reference to the act of shooting connects Biermann to André Breton's earlier provocations. In his Second Surrealist Manifesto of 1929, Breton appeals:

> The simplest Surrealist act consists of dashing down the street, pistol in hand, and firing blindly, as fast as you can pull the trigger, into the crowd. Anyone who, at least once in his life, has not dreamed of thus putting an end to the petty system of debasement and cretinization, in effect, has a well-defined place in that crowd with his belly at barrel-level.[46]

East German writers and artists did not take this step towards an explicit dissemination of anarchy. But, then again, they resisted the obvious by avoiding a blatant confrontation between Socialist Realism and Surrealism, and by presenting instead an often diffuse, unconventional and explosive mixture in which a constant dialogue with alien voices can be heard. In this way, the canon of GDR culture vacillated between the extremes of de- and re-Stalinization for the forty-one years of its existence.

All the poets discussed in this chapter may be regarded as 'satellites', orbiting around the central figure who, from the late 1960s, must be considered the chief 'engine' behind Surrealism in the GDR: Adolf Endler. He will be the subject of the next chapter.

Notes

1. Also called Trakia Wendisch; see www.sueddeutsche.de/kultur/selbstportraets-das-wahre-gesicht-1.3721952 (accessed on 19 February 2018). See also the catalogue of the exhibition on artists in the GDR in Museum Barberini, *Hinter der Maske. Künstler in der DDR*, eds. Ortrud Westheider and Michael Philipp. Munich: Prestel Verlag, 2017.
2. Cf. Leon Hempel, *Stillstand und Bewegung. Hoher Stil in der Lyrik Ost- und Westdeutschlands*. Berlin: GegenSatz Verlag, 2011; Gerrit-Jan Berendse, *Die 'Sächsische Dichterschule'. Lyrik in der DDR der sechziger und siebziger Jahre*. Frankfurt: Lang, 1990; and Alan G. Ng, *GDR Poetry's 'Geburtsstunde' as Historical Artifact*, Ph.D. thesis. Madison, WI: University of Wisconsin-Madison, 2002, www.alan-ng.net/lyrikabend/dissertation/e-book.pdf (accessed on 19 February 2018).

3. Robert Straube, *Veränderte Landschaften. Landschaftsbilder in Lyrik aus der DDR*. Bielefeld: transcript Verlag, 2016, 208; and Berendse, 'The Politics of Dialogue', 143–59 (149).
4. Endler, *Dies Sirren*, 171. If not indicated otherwise, all translations mine with the help of Paul Clements.
5. 'The simplest Surrealist act consists of dashing down into the street, pistol in hand, and firing blindly, as fast as you can pull the trigger, into the crowd.' In the 'Second Manifesto of Surrealism', published in *La Révolution surréaliste* 15 (1929), later in Alex Danchev (ed.), *100 Artists' Manifestos: From the Futurists to the Stuckists*. London: Penguin, 2011. Breton's quote was reused by the West German poet Rolf Dieter Brinkmann in 1969 during a public discussion, attacking the critic Marcel Reich-Ranicki. See Wolfgang Rüger, 'Direkt aus der Mitte von Nirgendwo. Bruchstücke zu Leben und Werk von Rolf Dieter Brinkmann.' In: Gunter Geduldig and Marco Sagurna (eds), *too much. Das lange Leben des Rolf Dieter Brinkmann*. Aachen: Alano Verlag, 1994, 72.
6. The term Literaturgesellschaft was introduced by Johannes R. Becher in 1950, and changed to the word Leseland, rated as less ideological, in the 1980s. This should demonstrate the increase in interest in classical and contemporary literature. However, this was not merely a cultural propaganda stunt, as it was not only reserved for GDR fiction. See the entry 'Leseland' by Helmut Peitsch in Michael Opitz and Michael Hofmann (eds), *Metzler Lexikon DDR-Literatur. Autoren – Institutionen – Debatten*. Stuttgart and Weimar: Metzler, 2009, 189–91.
7. The poet Heinz Kahlau declared the 1960s as the renaissance of *Nachdichtung* in the GDR. Kahlau, 'Über die Kunst des Nachdichtens', cited in Berendse, *Die 'Sächsische Dichterschule'*, 122–29.
8. Fritz Mierau (ed.), *Mitternachtstrolleybus. Neue Sowjetische Lyrik*. Berlin: Verlag Neues Leben, 1965.
9. On the practice of translation/*Nachdichtung* of Russian and Soviet poets in the GDR, see Jürgen Lehmann, *Russische Literatur in Deutschland. Ihre Rezeption durch deutschsprachige Schriftsteller und Kritiker vom 18. Jahrhundert bis zur Gegenwart*. Stuttgart: Metzler, 2015, 255–70.
10. On the translations of the poetry of Tsvetaeva by the GDR poet Elke Erb, see Esther Hool, *Den Klang übersetzen. Elke Erb als Dichterin und Marina Zwetajewas Nachdichterin*, Ph.D. thesis. Utrecht: University of Utrecht, 2019.
11. See Timothy Brown and Lorena Anton (eds), *Between the Avant-Garde and the Everyday: Subversive Politics in Europe from 1957 to the Present*. New York and Oxford: Berghahn Books, 2011.
12. Horst Redeker, *Abbildung und Aktion. Versuch über die Dialektik des Realismus*. Halle: Mitteldeutscher Verlag, 1966; and Ute Gerhard (ed.), *Schreibarbeiten an den Rändern der Literatur: die Dortmunder Gruppe 61*. Essen: Klartext, 2012.
13. Iris M. Zavala, 'Bakhtin and Otherness: Social Heterogenity', *Critical Studies* 2(2) (1990): 77–89 (84).
14. See, for example, the exhibitions *Abschied von Ikarus. Bildwelten in der DDR – neu gesehen*. (Weimar, 2013) and *Hinter der Maske. Künstler in der DDR* (Potsdam, 2017). Some research projects in the UK resulted in new insights into fictional literature and film, for example Karen Leeder (ed.), *Rereading East Germany: The Literature and Film of the GDR*. Cambridge: Cambridge University Press, 2015.
15. Adolf Endler and Karl Mickel (eds), *In diesem besseren Land. Gedichte der Deutschen Demokratischen Republik seit 1945*. Halle: Mitteldeutscher Verlag, 1966.

16. Holger Brohm, *Die Koordinaten im Kopf. Gutachterwesen und Literaturkritikin der DDR in den 1960er Jahren. Fallbeispiel Kritik*. Berlin: Lukas Verlag, 2001, 93.
17. Cited in Schubbe, *Dokumente zur Kunst-, Literatur- und Kulturpolitik der SED*, 437 (Dokument 131).
18. *Forum* 10 (1966), cited in Berendse, *Die 'Sächsische Dichterschule'*, 18. For a thorough analysis of the debate, see Anthonya Visser, *'Blumen ins Eis'. Lyrische und literaturkritische Innovationen in der DDR: Zum kommunikativen Spannungsfeld ab Mitte der 60er Jahre*. Amsterdam: Rodopi, 1994.
19. Berendse, 'Gefundenes Fressen; Karl Mickels Kannibalismus', *Sinn und Form* 6 (1991): 1142–50.
20. See Louis Aragon, 'Libertinage, die Ausschweifung'. In: Karlheinz Barck (ed.), *Surrealismus in Paris 1919–1939. Ein Lesebuch*. Leipzig: Reclam, 1985, 398–407; and Rainer Zuch, 'Max Ernst, der *König der Vögel* und die mythischen Tiere des Surrealismus', *Kunsttexte.de* 2 (2014): 1–13.
21. Karl Mickel, *Schriften 1. Gedichte 1957–1974*. Halle: Mitteldeutscher Verlag, 1990, 74. Ellipses added for copyright reasons.
22. Homi K. Bhabha, *The Location of Culture*. London: Routledge, 1994, 37. See Berendse, 'Die *Akte Endler*. Eine Gedichtsammlung: Verlegerisches "Gefumel" oder gelungene Zivilisationskritik der späten DDR?' In: Ingrid Sonntag (ed.), *An den Grenzen des Möglichen. Reclam Leipzig 1945–1991*. Berlin: Ch. Links, 2016, 474–82 (474 and 481).
23. Berendse, 'Dank Breton', 73–95.
24. Endler, *Die Gedichte*, ed. Robert Gillett and Astrid Köhler. Göttingen: Wallstein, 2019, 20. Ellipses added for copyright reasons.
25. Cf. Derek Sayer, *Prague, Capital of the Twentieth Century: A Surrealist History*. Princeton and Oxford: Princeton University Press, 2013, p. 115.
26. Richard Leising, 'Homo Sapiens'. In: *Gebrochen deutsch. Gedichte*. Munich: Langewiesche-Brandt, 1990, 12. Ellipses added for copyright reasons.
27. Uwe Greßmann, 'Schildas Bierulk'. In: *Schilda Komplex*, ed. Andreas Koziol. Berlin: Edition qwert zui opü, 1998, 11–13 (11). Ellipses added for copyright reasons.
28. In July 1992 I did research on the *Nachlaß* of Uwe Greßmann in what was then called the *Literaturarchive der deutschen Akademie der Künste zu Berlin*. Aside from his adaptations, translations, letters and unpublished poetry (e.g. the later-published *Schilda Komplex*) many grotesque drawings can be found.
29. Fritz Mierau, 'Russen in der UB Leipzig. Karlheinz Barck zum Gedächtnis'. In: Ingrid Sonntag (ed.), *An den Grenzen des Möglichen. Reclam Leipzig 1945–1911*. Berlin: Ch. Links, 2016, 285–89 (289).
30. Cf. Anneli Hartmann, *Lyrik-Anthologien als Indikator des literarischen und gesellschaftlichen Prozesses in der DDR (1949–1971)*. Frankfurt: Lang, 1983.
31. See the entries on the European artistic avant-garde in Manfred Berger (ed.), *Kulturhistorisches Wörterbuch*. Berlin: Dietz, 1978.
32. Fritz Mierau and Sieglinde Mierau (eds), 'Lob der Torheit', *Herzattacke. Literatur- und Kunstzeitschrift* 31(1) (2019): 190–220 (192).
33. Berendse, 'Das Karnevalprojekt. Chronik eines mißlungenen Lyrik-Experiments 1964–1968', *Wirkendes Wort* 2 (2000): 230–47 (247). Copies of the original typescript and the mentioned letters are with the author. The complete anthology and correspondence was published for the first time two years after Fritz Mierau's death in 2017, in the journal *Herzattacke. Literatur- und Kunstzeitschrift* 31(1) (2019): 190–220. Zweig's letter is to be found on p. 194.
34. Sonntag, *An den Grenzen des Möglichen*, 288–89.

35. See the Conclusion of this book.
36. Anja Tippner, *Die permanente Avantgarde? Surrealismus in Prag*. Cologne: Böhlau, 2009, 287.
37. Bürger, *Theory of the Avant-Garde*, trans. Michael Shaw. Minneapolis: University of Minnesota Press, 1984, 25.
38. Ibid., 57.
39. Berendse, 'Fremde Vögel in Ostberlin. Alternative Lebens- und Schreibweisen 1960–1990'. In: *Grenz-Fallstudien. Essays zum Topos Prenzlauer Berg in der DDR-Literatur*. Berlin: Erich Schmidt, 1999, 9–29.
40. Roland Berbig et al. (eds), *In Sachen Biermann. Protokolle, Berichte und Briefe zu den Folgen einer Ausbürgerung*. Berlin: Ch. Links, 1994, 124–25 and 211–12; Jay Rosellini, *Wolf Biermann*. Munich: Beck, 1992, 84–95.
41. Wolf Biermann was invited to perform his song at the Burg Waldeck-Festival in Hunsrück, West Germany, but he was not allowed to attend because of the *Berufsverbot* (occupational ban) in 1965 after the Eleventh Party Conference. His friend Walter Mossmann sang the song instead. See www.songlexikon.de/songs/dreikugelnaufrudidutschke (accessed on 26 March 2015).
42. Biermann, 'Drei Kugeln auf Rudi Dutschke', originally published in *Prager Volkszeitung*, 31 May 1968 and on the EP *Vier neue Lieder*. Berlin: Wagenbachs Quartplatte, 1968. Later republished in *Alle Lieder*. Cologne: Kiepenheuer & Witsch, 1991, 210–11.
43. Fowlie, *Age of Surrealism*, 17–18.
44. Julia Kristeva, *Powers of Horror: An Essay on Abjection*, trans. L.S. Roudiez. New York: Columbia University Press, 1982.
45. Berendse, 'Biermann-Ausbürgerung'. In: Opitz and Hofmann (eds), *Metzler Lexikon DDR-Literatur. Autoren – Institutionen – Debatten*. Stuttgart and Weimar: Metzler, 2009, 39.
46. See endnote 5, and Jonathan P. Eburne, *Surrealism and the Art of Crime*. Ithaca and London: Cornell University Press, 2008, 6.

Chapter 5

THE GDR'S SURREALIST NERVE CENTRE

Adolf Endler's Strange *Nebbich* World

In 1955, the year before the KPD was banned in West Germany, the 25-year-old Adolf Endler decided to settle in the GDR in order to avoid prosecution. As a teenager, he had worked as one of the Party's illegal currency couriers. The SED rewarded the ambitious young comrade writer with a place in the Institute of Literature in Leipzig, later renamed after the former Expressionist poet and former Minister of Culture of the GDR, Johannes R. Becher.[1] His hopes for recognition as a poet and his dream of becoming the East German Mayakovsky were, however, soon disappointed. He never graduated. Instead, he set his mind on refining his discrete poetic voice inside a socialist state where Socialist Realism was championed as the primary style of writing. Endler's ambivalent relationship with the GDR, and particularly with its cultural politics, began at this point. He joined those leading writers who began to question the government's ideological values and its repressive structures of power, which until then had not been interrogated. But in contrast to 'intellectuals such as Kunert, Braun, Müller, Wolf and Morgner, [who] while critical of official ideology, would … choose to ground their critiques in the language of a deviant Marxism', Endler opted to use an alternative discourse for his deviance.[2] His choice of writing style was very different from that of most of his colleagues; it related to the historical avant-garde. Endler became the GDR's most creative representative of Surrealism.

The aim of this chapter is the analysis of the life and letters of the writer who represented Surrealist endeavours in the GDR from the early 1970s onwards, and whose presence was most intensely felt throughout the

nation's final decade. A Stasi file on Endler refers to a conversation between the writer and the head of the publishing house Mitteldeutscher Verlag, Dr Eberhard Günther, on the possibility of publishing a new book after the volume *Das Sandkorn* (The Grain of Sand) appeared under its imprint in 1974. It is reported that Endler characterized his poems as 'phantasmagorisch bzw. surrealistisch' (phantasmagoric or surrealistic respectively). In the conversation Endler admitted that in 1979 he had been excluded from the Writers' Association of the GDR, and declared that this fact had led him to various considerations. He indicated that in retrospect, he considered this step to be justified, 'da er sich nicht mehr zu einer sozialistisch-realistischen Literaturauffassung bekenne, sondern Anhänger eines "surrealistischen Prinzip" geworden wäre' (since he no longer professed a socialist-realistic literary conception, but had become a follower of a 'surrealistic principle').[3]

His autobiography, *Nebbich*, published in 2005, consists of fragments of memory which recall a life in letters, attended by a surrealist flavour in the manner of André Breton half a century earlier. Breton's and Endler's memory sequences – each, in recent research, related to theoretical concepts of the autobiographical – will be examined here in order to unearth the space where literature and life meet. Endler's memory of events denies chronology and is condensed into anecdotal sketches, framed by clusters of conventional recollection. In common with the avant-gardists such as Hanns Eisler and John Heartfield, who settled in the SBZ and GDR respectively, Adolf Endler also imported non-realistic aesthetics which were alternatives to the cultural-political dogma of Socialist Realism. In contrast to Brecht's circle of friends facing the Formalism Campaigns (as discussed in Chapter 2), Adolf Endler did not abandon his avant-garde enterprise in the face of the Party's active disapproval. Instead, he forged his eccentric poetics into a fierce weapon.

Born in Düsseldorf in 1930, Adolf Endler was to become both one of the most creative and simultaneously most divergent East German poets, not least because of his notorious presentation of himself as an outsider. He refused to conform to the conventions of the country in which he had chosen to live and work. His outsider status paved the way for the fantasy world which he later created, and especially for the bizarre characters of his fiction. He took the isolation of his own 'I' – albeit a poetic 'I' – so far that he traduced his own name. In his poem 'Traumsplitter' (Dream Fragments), written in 1952–53 and frequently revised, he rejected his detested first name with a cry of despair: 'JA, ICH BIN DER HITLER' (YES, I AM HITLER).[4] In several newspaper interviews, Endler revealed the reason for his questionable relationship with his name. It is obvious why he wanted to get rid of his forename Adolf, but he was equally ill-at-ease with his surname, Endler, which, he confessed, reminded him of *Endsieg* and such things.[5] In

his 1980s prose, the masochistic treatment of his name takes grotesque forms. He appears as Eddi 'Pferdefuß' Endler (Eddi 'Satan' Endler), AE and finally, in total transformation, Ole Erdfladn, Dore Elfland, Alfred Nolde, Lea Nordfeld and Dr E. Ladenfol. The author's name, expressed as anagrams and consequently obliterated, becomes the means to illuminate the relationship between the poet, the poet's world and the actual prevailing social conditions. When, after the mid-1960s, it became clear to Endler that his project to befriend the 'art-loving Germany' – the satirical name he gave to the GDR[6] – had failed, a new identity was created which manifested itself principally in phantasmagoria. The official world gave way to a series of imaginary and outrageous poetic worlds which existed on the periphery of the Leseland, the name the GDR had adopted in the 1980s to portray itself as a society that was to be founded on knowledge and education. Endler's anti-heroes, who were habitués of such districts as Prenzlauer Berg and Mitte in Endler's fictitious Berlin, continued to claim their places in the 1990s and the early twenty-first century in (now-unified) German literature. They were to be found at the margins of society. As is recorded, for example, in the final section of his collected poetry *Der Pudding der Apokalypse* (The Custard of the Apocalypse, 1999), these outsiders that feature in the surreal prose and poetry – in Endler's 'Nebbich' world – have survived the German Wende. The vagabonds from past decades find themselves in the new age, where they try to establish themselves as its true chroniclers. It needs to be noted, however, that Endler could develop his eccentric voice only as a key member of the Sächsische Dichterschule.

The Saxon School of Poets

In no other period of German cultural history did politics and culture clash with such volatility as in the 1960s, on the East German 'battlefield of poetry'. But paradoxically, most poets experienced the hardening of the Party's line on cultural matters as creatively productive. Endler was no exception. In the icy ideological climate of 1966, as described in the previous chapter, Endler managed to edit and publish with Karl Mickel the anthology *In diesem besseren Land*, which appeared at first glance to express solidarity with the state's assertion that post-1945, there was a 'better' Germany in comparison with the cultural situation on the other side of the Wall. On the other hand, the editors used the volume to promote the dissident voices of a new generation of poets, born in the 1930s, who spoke out against the official Socialist Realist dogma. Endler became his generation's most prolific and strident spokesman, as he showed in his 1972 *Sinn und Form* essay on contemporary poetry, which triggered an assortment of discussion.[7] In the

following debates, he had two intentions: he wished both to support the work of those who were as yet unknown and, at the same time, to present an alternative version of GDR culture in the late Ulbricht and early Honecker eras. Endler subsequently typified the writings of many of his fellow artists of the time as a collective effort, at least in poetry, to conduct a free exchange of ideas.[8]

Despite the spread of Socialist Realism over most of the cultural life of Eastern Europe, new research has revealed that it was successfully undermined by troubled writers and artists.[9] Endler's deviance was expressed by his ignoring directives from the cultural-political authorities and by his choosing, instead, alternative ways of communicating with his peers. The Sächsische Dichterschule was a loose group of younger poets who revitalized the voice of poetry in the GDR. This was the view of Michael Hamburger, who, two years before the group had been named, applauded the young writers for the quality of literature they had produced in an artistically hostile environment. Hamburger observed the heavy traffic of correspondence between individual poets, a kind of clandestine intertextual project which bound the young artists together in a condition which, conversely, led to the isolation of individual deviant minds.[10] His colleague in exile in Britain, Erich Fried, drew attention to the subversive nature of this new writing in his review of the anthology *In diesem besseren Land* for BBC Radio.[11] The counter-poetics of what could be described as *Wir-Gefühl* (we-feeling) brought together individual writers whose diverse voices were in permanent dialogue, consuming each others' work and reading friends' manuscripts during their frequent private meetings. On the other hand, the dynamic activities of this East German version of the West German Gruppe 47 (Group 47) were on the verge of coming to an end. The dissolution of the group was not, as one might expect, attributable to state intervention. The major cause of the break-up was the high quality and distinctiveness of individual idiosyncratic voices and minds, which seemed to contradict everything associated with a collective project. In 1978, the year Endler coined the name Sächsische Dichterschule, the group had already begun to disintegrate. Individual members had either left the country voluntarily or by force, following Wolf Biermann's forced expatriation in 1976. Some had simply moved on and were involved in new projects.

Throughout his life, Endler listened out for new dissident voices, and in the 1980s he found the so-called Prenzlauer Berg Connection, a group of young artists who had lived in the GDR since birth; in Uwe Kolbe's phrase they were the 'ones born within'.[12] In establishing new lines of communication with younger artists who, like himself, were swimming against the tide of the prevailing cultural orthodoxy, Endler took care to preserve his own distinct identity. He did not become assimilated. Instead, he created

an alternative world; an enigmatic landscape in which the grotesque, the surreal and the farcical formed the backdrop to the lives of the many fictitious characters he invented to inhabit it. From this standpoint, Endler eyed with suspicion the actual day-to-day mechanics of Socialism, as well as the works of Berlin's subcultures, which were no less real. As he communicates with his own imaginary outsiders, vagabonds, drunks and bootleggers he sets up his own Free State, the diffuse composition of which may be accurately described as subversive. Some of Endler's fictitious disreputables will be introduced and come alive in what follows.

Being the Outsider

From the 1950s to the present there are three principal themes to be found in Endler's poetry.[13] These are: being the outsider; political engagement; and their culmination in the creation of his surreal 'Nebbich' world. Central to each of these is Endler's restless impulse for dialogue. In the GDR, Endler did not confront the state with dissidence, but instead with dialogue – a much more radical concept in a climate of orthodoxy.[14] Most of his poetry of the 1960s and early 1970s, and later his 'Nebbich' prose, shows a particular partiality for hostile environments within which the poet and his outsider crew comfortably squat. In the 1974 volume *Das Sandkorn*, for example, he constructed a landscape of dilapidated ruins which became the distinctive backdrop of his poetry. The aesthetics of ugliness – when beauty manifests itself in ruins, when rags become finery, when the sublime wallows in the mire and when futility is welcomed as liberation – are closely intertwined with Pablo Neruda's notion of 'impure poetry'.[15] The peripheral existence of Endler's characters fluctuates between an expression of the existential distress of real people living outside the centre of power and an imagined existence beyond the edge.

Essential to Endler's writing of this period is his increasing celebration of his outsider status, exemplified by the poem 'Akte Endler' (The Endler File) from 1976:

1
Wäscht sich oft nicht Zahnausfall Stinkt stark aus dem Rachen / Auch schweißfuß Liest die Tageszeitungen auf dem Klo /
... Wäscht sich
nur flüchtig wenn überhaupt .../ Hält
sich noch nicht einmal ...
/ Vor ganz
häßlichen Worten über unseren Johnannes R / Becher zurück

und vor allem dessen Sonettkunst

2
EtceteraetceteraMenschetcetera
Eine Anthologie zweibändig nichts als Bedenken
… für die privilegiertesten Leser
Charaktere die absolut nichts mehr umschmeißt[16]

1
Doesn't wash often Tooth loss Smells strongly from the mouth
/ Even sweaty foot Reads the newspaper on the loo /
… Washes
only casually if at all And …/ Doesn't
hold back not even …
/ From the
meanest words about our Johannes R / Becher
and especially about his sonnet art

2
EtceteraetceteraManetcetera
An anthology, two volumes full of concern
… only for the most privileged readers
Characters who absolutely can't be upset anymore

It will come as no surprise that this poem was perceived as scandalous. Principally, of course, its disrespectful manhandling of the GDR's Poet Laureate and former Minister of Culture was bound to cause official censure. But perhaps even more offensive was Endler's writing style: fragmented, grotesque and just plain rude. For example: in his spelling of the name Johannes R. Becher, it can be read as 'Johannes Erbrecher' (Vomiting Johannes).

The 'loo motif' created in the 1980s continues in the poems of the 1990s, in which Endler's constant companions from earlier times reappear. In the poem 'Nach der Wende' (After the Wende) this theme makes a rundown appearance. The careers of once-established rascals from the 'underground', known throughout the city – like Alfred Nolde, for example – have now been eradicated.

Kommt aus dem Damenklo
Mit diesem superben Strauß
Welker Rosen zurück,

…

Das Herz unsres Viertels,
Mit diesem superben Strauß

Welker Rosen zurück,
Seiner Ohrläppchen ledig,
Beider zum Glück
(Des Gleichgewichts wegen)[17]

Returns from the women's loo
With this superb bunch
Of withered roses,
...

The heart of our quarter,
With this superb bunch
Of withered roses,
Lacking his earlobes,
Both luckily
(because of the balance)

More than merely an aesthetic label, Endler's self-designation as an outsider was an existential reality. On 7 June 1979, he was expelled from the Writers' Union together with eight others as they spoke out against the GDR's decision to expatriate Biermann, and the insensitive handling of the subsequent wave of protests.[18] Officially, Endler was punished for sending a letter of concern to Erich Honecker. Co-signatories were Kurt Bartsch, Klaus Poche, Karl-Heinz Schubert and Klaus Schlesinger.[19] Afterwards, no significant reviews of his original work were published in the GDR, not even when the prestigious publishing house Reclam, in Leipzig, brought out his volume *Akte Endler* (1981 and 1988).[20] If he was ever praised in his own country, it was almost exclusively for his adaptations of Georgian, Armenian and Russian poetry.[21] In West Germany, until he was eventually taken into the fold of German Literature, he was widely praised simply for being a dissident. Elsewhere, however, Endler had long held pride of place in the gallery of German poets. He could never complain of being ignored. Portraits of him abound in the work of other writers. In 1966, for example, he took up ideological arms and battled courageously against the cultural authorities in the pages of the journal *Forum*. During this turbulent period, colleagues and friends supported him; they continued calling him 'poet' and they placed his outsider lifestyle on a pedestal. Their portraits of Endler consist mainly of fragments, or are made up of Endler quotations. In this way they mimicked the technique which Endler himself had developed and refined to a level of artistic perfection in his poetry.

After Endler was expelled from the East German Writers' Union for his Biermann protest, he became associated with a much younger generation of marginalized writers and artists who were active in the subcultural quarters of all major cities in the GDR. In the last years of the Republic,

he was welcomed as mentor of what he had termed the Prenzlauer Berg Connection in Berlin, where neo-avant-garde projects were the main attraction. Most of these were organized by the entrepreneur Sascha Anderson, who, as was revealed in 1991, was a Stasi spy, or IM.[22] In the many *samizdat* journals such as *Ariadnefabrik* and *Liane*, most of Endler's works appeared for the first time, often in the form of carbon copies. His main focus in this new creative phase was the introduction and promotion of surrealist ways of writing. For him, as for fellow nonconformist artists and poets, Socialist Realism was to be displaced by a subversive set of poetics.[23] At the same time, West German literary journals published fragments of his work in progress. One of his first appearances in the West was in 1981 in the periodical *Freibeuter*: 'Momente eines Aufklärungsreferats über meinen in Entstehung begriffenen Roman *Nebbich*' (Excerpts of a Investigating Paper on My Novel in Progress, *Nebbich*). This and similar texts allude to 'Nebbich', Endler's novel under construction which projects a GDR of the future. They all resemble each other because of their rather strange, grotesque content and experimental syntax. Freed from both the enjoyments and displeasures of writing in a Stalinist-driven state, they reveal the dark sides of Socialist Realism, while at the same time satirically portraying the ridiculous stereotypes surrounding a presumably rigid and inhuman future Communist state. The science fiction-like prose, of course, seems an accurate picture of Endler's contemporary GDR.

A Dissident Political Engagement

Another major theme in Endler's poetry is his political commitment. Although he never aligned himself with party-political ideologies, he was always guided by his own moral precepts. His rebellious nature was already evident in the 1950s when he condemned the collective amnesia in West Germany in his poem 'Postkarte an M.S. in Dinslaken' (Postcard to M.S. in Dinslaken):

> Unter dem Lampenschirm aus Menschenhaut
> Haben sie singend gesessen
> Dessen erinnern sie sich nicht mehr
> Aber das ihnen ein Pole die Armbanduhr geklaut
> Hat ein Tommy die Geldbörse leer
> …
> Das werden sie niemals vergessen[24]

> Beneath the lamp shade made from human skin

They have been sitting and singing
They don't remember that any more
But, that a Pole stole a watch from them
A Tommy emptied a purse
...
They will certainly never forget.

Selective memory and amnesia, which typified the political climate of the Adenauer era, provided fertile ground for the critical literature of both West and East Germany by revealing a hitherto hidden reality. Another stimulus for Endler, who played with the idea of becoming a professional writer after the war, was the governing Christian Democratic Union's strikingly obvious hostility to art.

In his writing, Endler's continuous protests regarding offences against humanity never became merely a dutiful exercise for him. In the remarkable poem 'Santiago' from the volume *Das Sandkorn*, which was published in the same year as Chile's President Salvador Allende was overthrown by a bloody military coup, Endler sounds a note which is consistent throughout all his work:

Sie mußten sich auf den Boden
des Stadions legen
Arbeiter
...

Um ihnen das Rückgrat zu brechen
Über sie weg

Ich hefte den Durchschlag dieser Notiz
In all meine Mappen
Bei jeder Arbeit muß ich sie
Wiederfinden
...[25]

They had to lie down on the ground
of the stadium
Workers
...
To break their back bone
Over them
I staple a copy of this note
In all my folders
So that every time I work
I find it again
...

His political poetry is in sharp contrast to the ubiquitous, shallow agitprop chants which glorified the state. It is the same with his poems of the mid-1970s, which describe the battlefields of South East Asia from a standpoint well beyond the SED's official position of solidarity with the North Vietnamese.

The Surreal 'Nebbich' World

This section will examine those features which fashion the interaction between life and writing in Endler's 'Nebbich' project and which prevail throughout his entire work. After a close reading, it will focus first on what Iris Zavala calls 'counter-hegemonic subversion of monological power'.[26] Second, it will investigate the surrealist foundations of *Nebbich*, and compare the core of Endler's anti-autobiography to Breton's aversion to allowing his readers insights into his private life.

Endler's prose and poetry create the atmosphere of a gloomy underworld inhabited by laughter-provoking caricatures with the capability to transform humour into sanity. The reader must take this weird creation seriously and, through the lenses of its outrageous absurdity, become involved in a critical revaluation of the 'real' world. The constant shifts between the real and the fictitious establish a carnivalesque milieu in Berlin, based on the intersection of topography and morality. Endler's Berlin is caught in the disparate spaces between an upper- and an underworld, and is represented by a range of discordant voices. With assistance from surrealist writers and the North American beat poets, Endler is able, as Walter Benjamin once wrote in his eminent 1929 *Sürrealismus* essay, to rediscover the mystery of everyday life and to reveal to his readers the absurd in society.[27] Endler's series *Aus den Heften des Irren Fürsten M.* (From the Notebooks of the Lunatic Prince M.), written at the end of the 1970s, are important cultural-historical documents in which Breton's surrealist model is reanimated. Black humour and the 'montage principle' produce an experimental field without barriers or limitations. In the collections *Ohne Nennung von Gründen* (Without Giving Reasons, 1985), *Schichtenflotz* (Coal Seam, 1987) and *Vorbildlich schleimlösend* (Exemplary Expectorant, 1990) Endler's alter egos, Bobbi 'Bumke' Bergermann and Bubi Blazezak, live their lives in disorderly oases of aesthetic and political anarchy.[28]

Written in the 1980s for underground journals in the Prenzlauer Berg and other urban scenes, both imagined writers feature in his prose.[29] Indeed, both fictitious characters can be seen as alter egos of Endler. Throughout the texts, however, it becomes obvious that the author distances himself from both, in the way that he – as the writer of the non-existing novel

'Nebbich' – claims to be the editor of the literary output of, and correspondence between, Blazezak and Bergermann. Both were active in the 1980s and 1990s, whereas the editor Endler, enjoying his McLUHANS OLD WHISKEY, is browsing through, reading and paraphrasing their writings (collected in a sea bag) in Devils Lake, North Dakota in the early twenty-first century. To complicate things, Endler notes that it is actually Bobbi 'Bumke' Bergermann who collected the selected works of Bubi Blazezak, in the KOSABLA, or Kommittee zur Pflege und Weiterentwicklung der Sammlungen Blazezak (Committee for the Maintenance and Development of the Blazezak Collection).

We are told that Bubi Blazezak's 'real' name is Robert Blazezak, and that he was under surveillance because he was the leader of a subversive sect that allegedly sprayed graffiti on buildings in East Berlin with slogans such as 'Ficken ist gesund' (Fucking is Healthy).[30] The 'Blazezakian aura' of the writings also accommodates Endler's poetics, particularly in his writing from the 1970s and 1980s. Endler sets his stories in a future GDR, but in the process of writing, he did not anticipate the end of the GDR. For this reason, the surreal tales are about the GDR as it existed until 1989. Alternating between the fictitious and the empirical, between the Real existierender Sozialismus and his protagonists' *Halbträume* (half dreams), the narrator creates a free zone in which he is able to question current affairs without directly offending the regime.

The laughter, the sniggering and mockery, the protagonists' bizarre contortions and the singing, jumping and swinging always contain a political component. In a 1980 interview with Gregor Laschen and Ton Naaijkens, Endler said that owing to very complex and last-but-not-least social motifs, his work has been a non-stop battle with everything written and set in stone, even if it came from his own pen.[31] Throughout the 1980s there were many opportunities for him to undertake ventures which would stimulate his 'battle with everything written and set in stone'. Furthermore, through his association with the young artists of the Prenzlauer Berg Connection, he collaborated on the anthology *Surrealismus in Paris, 1919–1939*, edited by the Romanist Karlheinz Barck, for whom he translated Philippe Soupault and André Breton, and 'discovered' Breton's *Anthology of Black Humour* (1940); he commended the latter as a handbook, or even a bible, on how to survive in the regime. In a cheerful game of opposites, the rigid authoritarian conditions of the GDR were made, to paraphrase Karl Marx, to dance.[32]

One of the ways in which Endler causes even the most intractable aspects of the GDR to dance is demonstrated in his treatment of the Berlin Wall, which is simultaneously provocative and playful. For example, during one of his strolls to the post office, Bobbi 'Bumke' Bergermann notices a group of tourists clustered on one of the observation posts on the western side

of the Wall. He feels as though he is being observed, like a member of an endangered species. Is Bobbi Bergermann expected to show off his tricks to the voyeuristic crowd?

> An dieser Ecke unter der westlichen Zuschauertraube fühlt man sich immer wieder in die Lage versetzt, nicht nur ein BÜRGER DER DDR zu *sein*, sondern außerdem den BÜRGER DER DDR zu *spielen*, den Gang des DDR-Bürgers, die Kopfhaltung des DDR-Bürgers, die Art und Weise, in der der DDR-Bürger seine Kleidung trägt – so auch unsereins (weshalb hat noch niemand 'Bravo!, Da Capo!' gerufen?)[33]

> On this corner, under the gaze of the western spectators, you don't always feel as if you *are* A CITIZEN OF THE GDR but that you have to *pretend to be* A CITIZEN OF THE GDR, acting out the way GDR citizens walk, how they hold their heads and wear their clothes – as I do (why has nobody screamed 'Bravo, da capo' yet?)

But Endler's satire goes further in its glorification of life on the communist side of the Wall when Bobbi exclaims, 'Die DDR' and puts his thumb and index finger together, inside out, against his heart-shaped lips: 'Die DDR – Zucker!' (the GDR – sweet!). Who could believe such an exaggeration?

This bizarre cameo illustrates both the limitations on freedom of expression in the GDR and Endler's understanding of the awkwardness of the way in which the West perceived the East German state. It goes to the heart of Endler's precarious balancing act. On the one hand, he was completely at one with Marxist ideology and the fundamental principles of the GDR, while on the other, he understood how ridiculous the GDR could appear, even to those within it. Endler's ear is finely tuned to the voice of the state and the racket from the street. He seeks and finds in the manifold dramatis personae of his picaresque adventures the absurdities not only of everyday life in the socialist republic but also those of the apparently normal entirety of Germany. Endler is one of the very few East German poets who were able to transform their criticism into a hard-hitting art form, shot through with delicious humour. As his colleague Wolfgang Hilbig once said, 'Jedesmal, wenn man etwas von Dir liest, glaubt man, man müsse sich augenblicklich totlachen. Doch dann merkt man plötzlich, daß man schon tot war und daß man sich wieder lebendig belacht hat' (Every time I read something you've written I think I'm going to die of laughter. But then suddenly I realize that I was already dead and have laughed myself back into life).[34]

In Endler's earlier prose texts, the term 'nebbich' is used frequently. It is a word of Yiddish origin which communicates a laid-back attitude towards life, its meaning being roughly equivalent to 'whatever' in current vernacular. In Endler's usage, the word refers to both fictitious and empirical

lives, the differences between which – one should emphasize – are often hard to distinguish. 'Nebbich' was claimed to be the working title of the narrator's work in progress, and should have been, according to the author, the ultimate novel on the real GDR. According to his predictions, the completed novel was to number over seven thousand pages. This fragment in *Freibeuter* was to be included in the colossal 'Nebbich' project, and is cited here as a foretaste of what can be found in Endler's 'roller-coaster' prose of the late 1970s and early 1980s:

> Meine Damen und Herren, liebe Freunde meiner Dichtkunst und meines Altersstils, nicht zuletzt auch du, unsere gute alte fette Oma Wanze! Ein Stück *Konterpropaganda* ist es, na gut, nicht ausschließlich, wenn ich an diesem verschwiegenen, vom Üblichen weggewinkelten Ort – 1055 Berlin, Rycke-Straße 28, 4 Treppen, bei Poppe! – neuerlich feststelle, übrigens nun wirklich zum letzten Mal: Bubi Blazezak, Zentralfigur der ersten Bände meines Romanwerks NEBBICH, hat die Gaststätte OBERKAHN, welche vor kurzem den Autor vollkommen grundlos mit Lokalverbot belegt hat, wenigstens zu Lebzeiten niemals betreten![35]

> Ladies and gentlemen, dear friends of my poetry and my age style, not least also you, our good old fat grandma bug! It is a piece of counter propaganda, well, not exclusively, if I am in this secretive, angled away from the usual place – 1055 Berlin, Rycke Street 28, 4 stairs, with Poppe! – again, notice, by the way, really for the last time that Bubi Blazezak, central figure of the first volumes of my novel NEBBICH, has never entered the pub OBERKAHN during his lifetime, from which the author has been grounded for completely groundless reasons!

One of the main characteristics of this curious prose is that it refuses to discriminate between historical and imaginary locations, events and characters. It denotes a constant muddying of the borderlines between fiction and autobiography, a theme which is repeated in Endler's entire work and which protected him from the grasp of those authorities who accused him of undermining socialist ideology with his merely private deviance. The unsettling, absurd yet comical narrative not only avoids the lure of Socialist Realism, it also undermines the reader's ability to locate the sources of the stories. On the other hand, it is very obvious that they draw on real events. All conventional narrative forms are challenged and manifest themselves in a condition of total chaos. The creation of alternative East German urban settings and the performance of hilarious situations allude to various narratives offered by modern European and North American literature. A mixture of Viennese *Kaffeehaus* literature à la Peter Altenberg, the absurdism of Surrealism and the vagabondism of the beat generation's road novels

dominates Endler's subcultural texture.[36] One other major reference point is Carl Sternheim's literary caricatures of petit-bourgeois life during the Wilhelmine era and the first decade of the Weimar Republic. In his play *Der Nebbich* (1922), for example, Sternheim emphasizes the temporality of the idyllic bourgeois milieu which he desperately wants to preserve and use as his protection against the evil world outside. The contrasting unidyllic activities in Endler's literary caricatures contain similar satirical elements, lurking in the shadows of the 'idyllic' reality of the GDR and safeguarding an alternative lifestyle.

After Germany's unification, Endler left the areas of Mitte and Prenzlauer Berg and extended his readership by republishing. He made his name with bestsellers such as *Tarzan am Prenzlauer Berg* (Tarzan at Prenzlauer Berg, 1994) and his collected poetry, *Der Pudding der Apokalypse*. A novel *Nebbich*, frequently proclaimed by the author since the late 1970s, has never been published. In 2005, however, a book entitled *Nebbich* was published, its subtitle promising not a novel but instead an autobiography, or 'Eine deutsche Karriere' (A German Career). Interestingly, Endler's book accompanied the publication of various other autobiographies written by those associated with the Sächsische Dichterschule, such as *Tartarenhochzeit* (Tartar Wedding, 2003) by Sarah Kirsch, *Lachmunds Freunde* (Lachmund's Friends, 2006) by Karl Mickel and *Die Pole der Erinnerung* (The Pole of Memory, 2006) by Heinz Czechowski. All of these new memory texts have their own strategies for working through the cultural and political history of the GDR and its particular constraints on life and letters. Endler's *Nebbich*, however, is less a recollection of memories of the author's private life and more a genuine Surrealist document of the twenty-first century.

Endler's private life was so full of exciting events and escapades that it could easily have been the material for a conventional autobiography. He lived through many of the highs and lows in German history. As a teenager, he witnessed the collapse of the Hitler regime and experienced the Cold War division of post-war Germany when he turned twenty. Later, as an angry young man, he endured the restrictions of the Adenauer era and, after his move to the GDR in 1955, the realities of Ulbricht's dictatorship. After unification he remained active as a promoter of East German literature. He was a founder, with his wife Brigitte Endler-Schreier, of the literary club Orphlid & Co. in Berlin-Mitte. In spite of the prospect of offering information in his autobiography about his interaction with history, which might have offered major insights about Germany's past, no new revelations of unknown details in Endler's private life are provided in *Nebbich*. The book has other aspirations.

In the many positive reviews *Nebbich* received, there were traces of disappointment. Beat Mazenauer, for example, in a critique published in the

weekly *Freitag*, lamented that almost no mention of Endler's move to the GDR in 1955 can be found. There is only a reference to the schism in 1963–64, when the pathos of constructing a new socialist society turned into laughing and overt sarcasm.[37] Two of Germany's influential literary critics, Fritz J. Raddatz and Martin Lüdke, published negative assessments, arguing that the main problem with the book was that it was a redundant repetition of Endler's previously published works. Raddatz opens his critique with a statement of disappointment.[38]

Lüdke is similarly harsh in his assessment when he calls *Nebbich* 'a most interesting but secondary work; at the same time not very convincing and not very original'.[39] Indeed, we are still waiting for answers to the questions of what motivated the writer to emigrate to East Germany one year before the KPD was banned in August 1956, and how he assessed his student years at the Literatur-Institut in Leipzig. Nothing is revealed about his alcoholism, his marriage to fellow poet Elke Erb, their son Konrad or any unknown details about fellow members of the Sächsische Dichterschule. On the subject of the secret lives of some of the young Prenzlauer Berg poets he knew in the 1980s, he also remains silent. According to the conventions of autobiography, we should expect a coherent shaping of the past. At the same time, we have learned from Georges Gusdorf that autobiography is a 'solidly established literary genre' that 'shows us not the objective stages of a career ... but ... reveals instead the effort of a creator to give meaning to his own mythical tale'.[40] My argument is that the surrealistically styled autobiography *Nebbich* offers both: Endler is a myth-maker par excellence, and he uses the book to depict the struggle with the multiple shadows of his fictional characters, as he has done frequently in his literary miniatures. He thus avoids disclosing any facts about his real life. On the other hand, *Nebbich* is composed in a way that encourages us to read it as a realistic self-portrait – Endler's 'deutsche Karriere' – because his comments on the strange happenings in his prose insinuate an intimate relationship between the fictional personnel and its creator. This ebb and flow between the real and the unreal is a key component of contemporary surrealist writing, as Endler's autobiography demonstrates.

Endler's Collage

Nebbich begins conventionally enough by recalling the passions of a young boy – 'E.' – who collects shells after each Allied air raid on cities in the Ruhr area in 1944. The story continues by recounting how his hobby grew to include collecting books that he found in the debris.

Bücher, halb verbrannt, angekohlt, feucht, verdreckt: 'Vom Kaiserhof zur Reichskanzlei; Deutsche Frauen, deutsche Treue; Der Gasmann; Reiter in deutscher Nacht.' – Mit elf, mit zwölf hat E. Bomben- und Flaksplitter gesammelt und getauscht gleich Rühmkorf oder Wosnessenski, die es beide für mitteilungswert hielten. Als er 13 Jahre alt wurde, war E. zum Sammler von Broschüren und Büchern geworden, wie sie nach jedem Luftangriff verwaist in den schwelenden Trümmern herumgeflattert sind.[41]

Books, half burnt, charred, damp, dirty: 'From the Kaiserhof to the Reich Chancellery; German Women, German Loyalty; The Gas Man; Horseman in German Night.' – At eleven, at twelve E. collected and exchanged bomb and flak splinters as Rühmkorf or Voznesensky did, who both thought it was worthy to tell others. When he turned 13, E. had become a collector of pamphlets and books, fluttering in the smouldering debris after each air raid.

The memory of this dramatic sequence in E.'s life is directly related to writings. The titles mentioned in the quotation refer to Joseph Goebbels' *Vom Kaiserhof zur Reichskanzlei eine historische Darstellung in Tagebuchblättern* (From the Kaiserhof to the Reich Chancellery: A Historical Documentation in Diary Entries, 1934), Marie Luise Bartz's *Deutsche Frauen deutsche Treue. Gedächtnisfeier für Königin Luise von Preußen* (German Women, German Loyalty: Commemoration for Queen Louise of Prussia, 1910), Heinrich Spoerl's *Der Gasmann. Ein heiterer Roman* (The Gas Man: A Cheerful Novel, 1940), and Hanns Heinz Ewers's *Reiter in deutscher Nacht* (Horseman in German Night, 1932). In most instances, though, these found items are heavily damaged or even destroyed. Most of the products of his obsession have been lost, and, according to E., only some lists with titles (also partly ruined) have survived:

Manche der Bücher mußten auf dem Hängeboden getrocknet, manche neu zusammengeklammert, zusammengeklebt werden, nicht wenige blieben Halb- oder Viertelbücher, und alle sind nun dahin, dahin … Erhalten haben sich Reste der Listen, halb verbrannt, ausgekohlt, feucht verdreckt; Zeugnisse des Beginns einer Sammler-Karriere der anderen Art.[42]

Some of the books had to be dried on the loft, some were clung together, glued together, quite a few remained half- or quarter-books, and all are now gone … Remains of the lists have been preserved, half burned, charred, damply soiled; Testimonies of the beginning of a collector's career of a different kind.

The introductory chapter of *Nebbich* is a promising opening to a conventional autobiography, and indeed, the memories of the teenager E. are extended in the work's final chapter. The latter contains recollections of a young boy of 14 or 15 who returns home after the war had ended: 'Von

Hanau her, Frankfurts südliche Peripherie und der Taunus blieben rechts liegen, auf offenem Güterwagen mit hundert anderen Heimkehrern' (From Hanau, Frankfurt's southern periphery and the Taunus remained to the right, on an open freight car with a hundred other returnees).[43] During the long and exhausting journey back to his home town, E. meets somebody with whom he is about to share his (short) life story:

> Neben mir hatte während der ganzen Fahrt und schweigend ein stoppelbärtiger grauer Gelehrten-Typ gestanden, manchmal gelegen, dann wieder gestanden, welcher sich vis-à-vis dem Loreley-Felsen – schärfer sehe ich es als alles übrige jetzt – doch endlich zum Rauchen entschloß und – der lederne Tabaksbeutel, aufgespreizt mit Zeigefinger und Daumen, schwang hin und her vor dem stoppligen Kinn – sich die Pfeife mit Krüllschnitt vollstopfte: so bedächtig, so wägend, als wäre es für Monate oder für Jahre oder als ginge bald etwas anderes los, das keine Zeit lassen würde für das Öffnen des Tabaksbeutels, kein bißchen Zeit. – 'Wie alt magst du sein' – Ich war vierzehn. – 'Im nächsten September werde ich fünfzehn!'[44]

> Beside me, a stubble-bearded grey scholar-type had stood, sometimes lying, and then standing again, who, vis-à-vis the Loreley rock – sharper than I see it all now – finally decided to smoke and – the leather tobacco pouch, spread out with forefinger and thumb, swung back and forth in front of the stubby chin – stuffed the pipe with crowing cut: so thoughtful, so weighty, as if it were for months or years or something else was going on, that would leave no time for opening the purse, no time. – 'How old are you?' – I was fourteen. – 'I'll be fifteen next September!'

It is the first time in *Nebbich* that somebody makes an effort to speak out. The boy finally finds somebody to talk to, is ready to get his story off his chest and present it to the reader. But the boy's first six words are rudely interrupted by the narrator. The present intercepts the past when the narrator prevents the boy from continuing the conversation and informing us about his life. The teenager – is it E., or is it the younger Endler, who was 73 when the book was published, or is it just another fictional character from Endler's vast arsenal of anti-heroes? – is silenced: '"Nein!, nicht!!!" will ich Dreiundsiebzigjähriger es fuchtelnd zum Schweigen bringen, das Kind' ('No, not!!!', I, the seventy-three-year-old, fanatically want to silence the child).[45] With this outburst, Endler ends the story about young E. This is also the final sentence of the entire book, after the narrator prevents the promising start from developing into the kind of autobiography that, according to John Sturrock, should let life and events parade before the eyes of the reader.[46] No such thing happens in *Nebbich*.

Of course, between these six framing pages, there are a further 283 pages of *Nebbich*. Between the first autobiographical notions of the 13-year-old E. (two pages in the first chapter) and the interrupted 14-year-old (in the final chapter's four last pages), forty other texts remain, presenting a kaleidoscope of colourful (and in some cases, republished) prose fragments written in the 1970s and 1980s. After 1990, most of these texts were revised and often extended, as the author indicates by revealing the exact date of each revision. They consist of detailed descriptions of the various carnivalesque adventures of Endler's colourful alter egos, Bubi Blazezak and Bobbi 'Bumke' Bergermann, of recollections of brief, mainly unpleasant encounters with East German officials, and of intense discussions with fellow poets such as Elke Erb, Sarah Kirsch, Peter Huchel, Erich Arendt and Inge Müller. In addition, Endler quotes from material found in his Stasi file, which he accessed after 1990, and sheds new light on the reception of his work in the East German state. All these texts – the literary prose and the memoirs – are combined or mixed, which allows fiction to interact with reality and prevents *Nebbich* from presenting a monopolistic and coherent profile. This dialogue between reality and fiction – in Mikhail Bakhtin's definition, a 'Tower-of-Babel mixing' of social speech types and individual voices[47] – becomes extremely complex, since Endler manages to hide his identity behind a multitude of different characters, whose names often appear to be anagrams of his own, such as Ede Nordfall and Dore Elfland.

The 'dialogic interaction', to borrow a term from Bakhtin's theory of dialogism, enables Endler to turn the voices he recorded in Berlin – where he staged his amalgamated virtual and factual adventures – into a state of socio-ideological contradictions. The Bakhtinian focus is the first angle from which Endler's *Nebbich* will be examined. Bakhtin implies that once languages and persons alien to the literary world have entered a literary text and formed a discourse, it becomes virtually impossible to distinguish them from other languages absorbed in the text. In the 1930s, this Russian literary scholar introduced the notion that every work of literature – to be more exact, every single word – is multi-voiced, and can echo the range of discourses throughout the text. In this process of dialogue, words are not only exchanged, they also collide, and may change their meaning and alter their context. Literature is in a constant state of 'hybridization', as it determines the mixture of languages within the limitations of a single utterance. A literary text displays a community of alien voices which become forged into a new narrative. There is, therefore, more than one truth or authority. Bakhtin creates a democratic world – a utopia he reserves for the novel and other shorter prose. The application of Bakhtin's cultural critique should be seen as subversive in the GDR, or in any other totalitarian state, since it

set out a cultural and social hybrid text which 'give[s] voice to "still weak" voices in their struggle against the dominant monologism'.⁴⁸

> The ... model of communication that Bakhtin suggests invokes the effectiveness of human actions as a criterion with which it is possible and justifiable to verify knowledge. It treats 'truth' as the relation between voices and the reality to which each refers. The strong emphases on self-consciousness and on speech as discourse-address are of capital importance as cultural critiques [for example] to minorities' voices inside dominant (hegemonic) societies.⁴⁹

All words in fiction contain a so-called polyphonic interplay of various characters' voices, and no world view is given superiority over any others, not even the voice that can be identified as that of the author. As far as *Nebbich* is concerned, this polyphony assists the author in his mission to avoid producing an authorized autobiography. Instead, he offers a collage of prose miniatures, entries in his diary, fragmented memories that constantly change between the empirical and fictitious world. Additionally, a range of distinct individual narrative strands – which Bakhtin calls 'character zones' – is introduced. The many narratives of Endler's alter egos, the sociolects of Berliners and the jargon of Party functionaries, to name a small selection of voices, build the structure *à collage*. Ambivalence is therefore a prime factor in *Nebbich* and constitutes a framework that not only has a direct political impact but, above all, resists the single voice which is usually the hallmark of conventional autobiographies. The absence of a central narrator and the constant dialogue between reality and fiction counteracts cultural hegemony. When it comes to the authorship of his own narrative, Endler extends his agitations in the GDR past into the present.

Yet contrary to what Raddatz and Lüdke claim in their reviews, *Nebbich* is not merely an additional volume of 'Endleresque' prose. The book is, above all, an important surrealist document. Surrealism is one of the major characteristics of Endler's prose and poetry, and also the most prevailing as a structural principle of *Nebbich*. The book is an anti-autobiography, moulded by surrealist poetics, and it fulfils major criteria such as the principle of montage and the denial of the artist's godlike viewpoint.⁵⁰ Endler never disguised his admiration for and interaction with the surrealist movement. He shared this position with fellow writers such as Greßmann, Mickel, the young poets Frank-Wolf Matthies and Bert Papenfuß, and with the eccentric avant-garde visual artist Carlfriedrich Claus. These artists all joined Endler's aesthetic subversions by adopting the surrealist notion of the writer not being in control of his own discourse. In *Nebbich*, Endler alludes to the Paris-based Surrealists by citing their manifestos and literary works; he also dedicates entire chapters to Paul Klee and Breton. He even exchanges

identities with Breton and fantasizes about the prospect of contributing to the illustrious 1940 *Anthology of Black Humour*.

Writing in the Breton Mode

Endler has an obvious aversion to intimate confidences, and the reader searching for personal details will be disappointed. Yet while drawing attention to his devotion to Surrealism, he presents a way of life; in surrealist terms, this means a way of producing art and literature. This simultaneous cultural commitment and genuine aversion to autobiographies has been convincingly documented by the godfather of Surrealism, André Breton, in his *Conversations* of 1952. The volume *Conversations* – originally entitled *Entretiens* – contains a series of interviews with Breton in which he deceives readers by promising an autobiography but at the same time denying them any direct access to his private life.

> Breton is convinced that surrealist behaviour cannot exist with the stability of personality we judge normal, ... he demands that 'The Self be treated in the same way as the object, that a formal restriction be invoked against the "I am."'[51]

The Breton scholar and translator of the English version of *Entretiens*, Mark Polizzotti, emphasizes in his introduction that this particular stocktaking was 'the closest Breton ever came to writing his intellectual autobiography, albeit a rather selective one', mainly because:

> Breton had an aversion to intimate confidences, and the reader will find few personal details here: not a word about his childhood; and despite his insistence on the importance of love, barely an allusion to his three wives or dozen love affairs.[52]

In a way similar to Breton's strategy of excluding private details, Endler redirects the focus of the reader of *Nebbich* to his prose, which he has revised over the years. He pushes the conventional memory texts to the fringes of the book. In other words, his statement is that his career is thus defined, and that any real event or experience has been assimilated and moulded into a piece of literature, following Bakhtin's chain of thought.

Throughout his work, Endler convincingly exhibits the life-equals-writing equation by embedding the literary collages within a conventional autobiographical framework and by effectively merging both entities. He thus prevents clear demarcations between fiction and autobiography and, by so

doing, dazzles readers of his prose by persistently confronting them with the ever-shifting margins. The reader can detect only what have been called 'aspects of the fictional within the autobiographical',[53] and, for that matter, full life experiences configured in a literary format. Endler anticipated what is now perceived to be the cutting edge of research on postmodern life writing, namely the impossibility of distinguishing between both narratives.

The writer of *Nebbich* – to note a third major characteristic of the volume – constructs a tentative self-portrait, similar to those of visual artists whose many revised 'painted autobiographies' not only document the various stages in their lives but also convey multiple improvements in their skills. Art historians have argued convincingly that Dutch Masters such as Rembrandt and modern painters like Vincent van Gogh did not have the urgent impulse to display vanity when painting their many self-portraits, but rather redefined and refined their technical abilities. The artist's external appearance conveys essential information about his work. Rembrandt, for example, used his painted likeness to display pictorial innovations with colour, light and space. His self-portraits also reveal his freedom of handling, which was regarded as bizarre, and his idiosyncratic ideas about finish. The process of experimentation enhanced Rembrandt's complex visual language. The unfinished self-portraits better express the artist's actual thought by giving an insight in the creative process. Endler's prose can be read in similar terms. This is not to pretend that Rembrandt's or Van Gogh's work has the same aesthetic status as Adolf Endler's, but rather to stress similarities in their production of an image of the Self. The crucial difference is that the self-portraits of the Dutch Masters are clearly self-referential, whereas Endler's recycled work merges autobiography and fiction. The result of the multiple revisions of the visual self conveys not merely mastery but, primarily, a sense of the ephemeral.

> In his lifetime Rembrandt painted over a hundred self-portraits, seventy of them full studies. Viewed as a whole, they form a serial image, like frames in a strip of movie film. ... Van Gogh also painted numerous self-portraits, many as a form of therapy. ... With both artists the important element is uncertainty – they ask themselves no consistent questions, find no clear answers, and so continue to revise their self-portraits. Unable to take an overview, they create a series of tentative pictures, each more inclusive than the last. The artists have neither preached nor performed; theirs is the *poetic* act of continuing self-study.[54]

As William Howarth argues, most 'poetic autobiographers' can also draw only tentative, experimental self-portraits: 'They share equally strong doubts Uncertain of the present, they study the past for some explanations

of their later difficulties'.[55] Endler's fragmented, often grotesque prose works display a similar evolution, revised every time they reappear in new forms. He also wished to avoid the impression that the text, published previously, is the ultimate form or that it represents the author's Self. This ephemeral strategy affected the narrative of *Nebbich*. It pretends to be an autobiography, but rather than reporting on events or revealing the author's state of mind, it transfers reality into fictional entities that accompany his seemingly never-ending creative process. The result of this constant revision of the investigation into the borderlines between, and exchange of, life and writing is the blurring of the contours of the real person, Adolf Endler.

Conclusion

'Nichts kriegt man richtig fertig – und sein Leben schon garnicht!' (one is never able to finish anything, certainly not one's own life) – this seems to be Endler's motto.[56] Indeed, Endler's writing can be characterized as unfinished, repetitive, inclusive and tentative, featuring a mixture of real and fictional events and characters ranging from his miniature East Berlin biotope to settings from world literature. And since he tends to substitute his writing for his curriculum vitae, his life is presented in a similarly unstable manner. Yet this book offers more than the filtering of the writer's own experiences in literary texts. *Nebbich* is a convincing cultural document on another level altogether.

The ultimate objective of *Nebbich* is to refresh memory of the writer's subversive survival skills in the final decades of the GDR and, at the same time, to demonstrate the obstacles on the road to coming to terms with his and Germany's past – a road of detours and pitfalls. Each time the author revises this prose and adds corrections to older versions he creates a new montage by following the ephemeral logic of the avant-garde, or to be more precise, of Surrealism.[57] This is how Endler presents his life and letters, and his relationship to politics and history. His memory of events in Germany's past denies chronology, reduced instead to sketching anecdotes, flanked by a couple of scraps of conventional recollections of the boy, 'E'. Endler's memory and autobiographical process are directly linked to his particular fictional writings. New studies on life writing suggest that memory constantly negotiates the space encountered in the act of writing. The Icelandic scholar Gunnthórunn Gudmundsdóttir, for example, argues that the role of memory cannot be ignored in the study of writing (whether fiction or autobiography). Memory is a vital element in the attempt to investigate the textual construction of the Self and of identity:

> Fiction is in a way inherent to memory, as remembering constitutes a continuing process that changes with time. Memory is always a product of circumstances, experience, the passing of time, memory's public aspects, its connection to other people, and the changing perspective of the remembering itself. Memory is the *raison d'être* of autobiography, so therefore one must conclude that the fictional processes ... are inherent to the autobiographical process itself.[58]

In the case of Endler's narrative, the amalgamation of fictional and autobiographical discourses affects the archaeological process in such a way that his prose refuses to offer coherent structures of memories. These structures could be used for a new wave of cultural memory of East German politics, thereby resisting the current 'overwhelming presence of memory in contemporary identity debates'.[59] Instead, Endler highlights obstacles to the individual act of remembering and reflects the cracked road of Germany's past in a genuine way. *Nebbich* was published fifteen years after German reunification, fifty years after Endler's move to East Germany, and sixty years after the end of the Third Reich. His private life and letters coincide with that of a nation that had to experience divisions, differences, insecurities, unfinished business, and, in many cases, still-unanswered questions.

The persistent promoting of surrealist poetics signals Endler's contribution to the important process of private and collective *Vergangenheitsbewältigung* (coming to terms with the past). The poet demonstrates a politics of memory in which he fuses past and present. Endler's old and new prose and poetry not only map the author's process of life writing but, at the same time, help confront the reader with the hybrid framework of the complex cultural environments that characterized the thirty years of his stunning career. It is in the German Democratic Republic and in the old and new Federal Republic of Germany that Endler plants his disjointed and fragmented memories, gathering small bits and pieces of his past, as did the teenager who, in the first chapter of *Nebbich*, collected bomb shells and later read scattered pages which culminated in an 'Autobiographie aus Splittern' (An Autobiography out of Fragments). Endler retrieves the discovered printed objects from this past and presents them as his life. In this respect, this book is neither merely a repetition of previous writing nor even a major document of post-war Surrealism. It proves to be an authentic representation of the writer's discrete memory processes, as does most of his work. It demonstrates the problematic mechanics of retrospective conceptions stemming from the author's idiosyncrasy. Recalling the past is a disjointed process, as Aleida Assmann writes in her *Erinnerungsräume* (Memorial Rooms, 1999), and it inevitably evokes postponement, deformation, distortion and adjustment.[60] For his part, Endler's surrealist project creates a cultural location where readers are invited to excavate the many pieces of a German puzzle in disarray.

Notes

1. Endler, *Dies Sirren*, 133–39.
2. Bathrick, *The Powers of Speech*, 226.
3. BStU, MfS, BV Berlin, Abt. XX, Nr. 4539 T. 2/3, 115.
4. Endler, *Uns überholte der Zugvögelflug. Alte und neue Gedichte*. Aschenleben: Verlag UN ART IG, 2004, 23.
5. Cf. Cornelia Geißler, '"ich möchte schon, dass man lacht." Ein Gespräch mit dem Dichter Adolf Endler über Poesie und Literaturbetrieb', *Berliner Zeitung*, 26 January 2000; and Evelyn Finger, 'Das Museum bin ich: Ein Gespräch mit Adolf Endler', *Die Zeit*, 29 June 2006. See also http://zeus.zeit.de/2006/27/endler-interview (accessed on 26 Sept. 2006).
6. The GDR praised itself for being *kunstfreundlich*, in particular after Erich Honecker had announced in 1971 that from then on art and literature would be taboo-free. See Jäger, *Kultur und Politik in der DDR*, 139–62. Endler questioned this.
7. Endler, 'Im Zeichen der Inkonsequenz. Über Hans Richters Aufsatzsammlung "Verse, Dichter, Wirklichkeiten"', *Sinn und Form* 6 (1971): 1358–66.
8. Endler, 'DDR-Lyrik Mitte der Siebziger. Fragment einer Rezension', *Amsterdamer Beiträge zur neueren Germanistik* 7 (1978): 67–95. See Berendse, *Die 'Sächsische' Dichterschule*.
9. René Bílik, 'Drei Fragen an den Sozialistischen Realismus'. In: Alfrun Kliems et al. (eds), *Sozialistischer Realismus. Lyrik des 20. Jahrhunderts in Ost-Mittel-Europa II*. Berlin: Frank & Timme, 2006, 31.
10. Michael Hamburger, 'In the Corvine Mode', *Times Literary Supplement*, 21 May 1976, 622.
11. Erich Fried, 'In diesem besseren Land. Buchbesprechung'. In: Michael Lewin (ed.), *Gedanken in und an Deutschland. Essays und Reden*. Vienna: Europa Verlag, 1988, 28.
12. Cf. Kolbe, *Hineingeboren. Gedichte 1975–1979*. Frankfurt: Suhrkamp, 1982.
13. See the review of the 2019 collection of poems, *Die Gedichte*, edited by Robert Gillett and Astrid Köhler: 'Endlich Endler' by Jürgen Verdofsky in the *Frankfurter Rundschau*, 15 November 2019.
14. Berendse, 'The Politics of Dialogue', 143–59.
15. On Pablo Neruda's notion of 'impure poetry', see Hamburger, *The Truth of Poetry: Tensions in Modern Poetry from Baudelaire to the 1960s*. Harmsworth: Penguin, 1969, 243.
16. Endler, *Die Gedichte*, eds. Robert Gillett and Astrid Köhler. Göttingen: Wallstein, 2019, 74. My translation, with the help of Paul Clements and Sabine Berendse. Ellipses added for copyright reasons.
17. Ibid., 186. Ellipses added for copyright reasons.
18. The other banned writers were Erwin Strittmatter, Stefan Heym, Joachim Seyppel, Karl-Heinz Jakobs, Rolf Schneider, Dieter Schubert, Klaus Poche, Klaus Schlesinger and Kurt Bartsch. Cf. 'Neun Schriftsteller in der DDR gemaßregelt', *Frankfurter Rundschau*, 9 June 1979 and Stasi file BStU, HA XX ZMA 4130, Volume 7.
19. See the group photo in my edited volume *KRAWARNEWALL. Über Adolf Endler*. Leipzig: Reclam, 1997.
20. Berendse, 'Die *Akte Endler*', 474–82.
21. Cf. Endler, *Kleiner kaukasischer Divan: Von Georgien erzählen*, ed. Brigitte Schreier-Endler. Göttingen: Wallstein, 2018.
22. Kaiser and Petzold, *Boheme und Diktatur in der DDR*, 220 and 351.

23. Berendse, '"Dank Breton"', 75–77.
24. Endler, *Die Gedichte*, 213. Ellipses added for copyright reasons.
25. Ibid., 36. Ellipses added for copyright reasons.
26. Zavala, 'M. Bakhtin and Otherness', 84.
27. Walter Benjamin, 'Der Sürrealismus: die letzte Momentaufnahme der europäischen Intelligenz'. In: *Gesammelte Werke*, eds. Rolf Tiedemann and Hermann Schweppenhäuser. Frankfurt: Suhrkamp, 1977–99, 295–310.
28. See Endler's *Ohne Nennung von Gründen. Vermischtes aus dem poetischen Werk des Bobbi 'Bumke' Bergermann*. Berlin: Rotbuch, 1985; *Schichtenflotz. Papiere aus dem Seesack eines Hundertjährigen*. Berlin: Rotbuch, 1987; and *Vorbildlich schleimlösend. Nachrichten aus einer Hauptstadt 1972–2008*. Berlin: Rotbuch, 1990.
29. Leeder, *Breaking Boundaries: A New Generation of Poets in the GDR*. Oxford and New York: Oxford University Press, 1996.
30. Endler, *Vorbildlich schleimlösend*, 11.
31. Gregor Laschen and Ton Naaijkens, 'Gespräch mit Adolf Endler', *Deutsche Bücher* 1 (1981): 1–18.
32. Berendse, 'Fremdkörper in der Verlagslandschaft in der Spätphase der DDR', *Wirkendes Wort* 1 (2013): 111–20 (114–15).
33. Endler, *Citatteria & Zackendullst. Notizen, Fragmente, Zitate*. Berlin: Ackerstraße 1990, 66–67. This publication includes vignettes by the artist Horst Hussel (1934–2017), who was considered a surrealist visual artist in the GDR. Translation by Paul Clements and Sabine Berendse.
34. Quoted from Wolfgang Hilbig, 'Der Wille zur Macht ist Feigheit'. In: Berendse, *KRAWARNEWALL*, 24. My translation. See also my article 'Laughed Back to Life', in the *Times Literary Supplement*, 31 May 2013, 15.
35. Endler, 'Momente eines Aufklärungsreferats über meinen in Entstehung begriffenen Roman *Nebbich*', *Freibeuter* 9 (1981): 115. My translation. In the Stasi archive, the report on the readings in the apartment of Gert Poppe can be found, as well as the title of the manuscript from which Endler reads. It is phonetically spelled 'Bubi-Blazzesack'. BStU, MfS, BV Berlin, Abt. XX Nr. 4539, Teil 1/3, 3–4.
36. Berendse, 'Karneval in der DDR. Ansätze postmodernen Schreibens 1960–1990'. In: Henk Harbers (ed.), *Postmoderne Literatur in deutscher Sprache. Eine Ästhetik des Widerstands?* Amsterdam and Atlanta: Rodopi, 2000, 250.
37. Beat Mazenauer, 'Höhere Sirenen befahlen', *Freitag*, 18 March 2005, http://www.freitag.de/2005/11/05112102.php (accessed on 26 Sept. 2006).
38. Fritz J. Raddatz in *Die Zeit*, 17 March 2005.
39. Martin Lüdke, 'Bohemien im Arbeiter- und Bauernstaat: Kaum mehr nachvollziehbare Bewusstseinslage', *Frankfurter Rundschau*, 1 June 2005, http://www.fr-Online/in_und_ausland/kultur_und_medien/ literatur/?cm_cnt=68355 (accessed on 26 September 2006).
40. Georges Gusdorf, 'Conditions and Limits of Autobiography'. In: James Olney (ed.), *Autobiography: Essays Theoretical and Critical*. Princeton: Princeton University Press, 1980, 48. Some more details on Endler's life were revealed in the interviews with Renatus Deckert. Cf. Endler, *Dies Sirren*.
41. Endler, *Nebbich. Eine deutsche Karriere*. Göttingen: Wallstein, 2005, 7. My translation.
42. Ibid., 8.
43. Ibid., 284.
44. Ibid., 286–87.
45. Ibid., 287.

46. John Sturrock, *The Language of Autobiography: Studies in the First Person Singular*. Cambridge: Cambridge University Press, 1993, 2.
47. Mikhail M. Bakhtin, *Discourse in the Novel, The Dialogic Imagination: Four Essays*, ed. Michael Holquist. Austin: University of Texas Press, 1981, 262.
48. Zavala, 'M. Bakhtin and Otherness', 86.
49. Ibid.
50. Bürger, *Theory of the Avant-Garde*, 73–82.
51. Mary Ann Caws, *The Poetry of Dada and Surrealism: Aragon, Breton, Tzara, Eluard and Desnos*. Princeton: Princeton University Press, 1970, 78.
52. Breton, *Conversations: The Autobiography of Surrealism. 1952. With André Parinaud et al*, trans. and introduced by Mark Polizzotti. New York: Paragon House, 1993, xiii.
53. Gunnthórunn Gudmundsdóttir, *Borderlines: Autobiography and Fiction in Postmodern Life Writing*. Atlanta and Amsterdam: Rodopi, 2003, 5.
54. William L. Howarth, 'Some Principles of Autobiography'. In: James Olney (ed.), *Autobiography: Essays Theoretical and Critical*. Princeton: Princeton University Press, 1980, 104–5.
55. Ibid., 105.
56. Endler, *Nebbich*, 38.
57. Caws, *The Poetry of Dada and Surrealism*, 93.
58. Gudmundsdóttir, *Borderlines*, 54.
59. Anne Fuchs and Mary Cosgrove, 'Introduction', *German Life and Letters* (*Special Issue: Memory Contests: Cultural Memory, Hybridity and Identity in German Discourses since 1990*) 2 (2006): 165.
60. Aleida Assmann, *Erinnerungsräume. Formen und Wandlungen des kulturellen Gedächtnisses*. Munich: Beck, 1999, 29.

Chapter 6

WOLFGANG HILBIG'S LANDSCAPES 'WHERE THE MINOTAURS GRAZE'

While the word 'Surrealism' occurs throughout this study, it has become clear that in the context of the cultural histories of the SBZ and, later, the GDR, it is both a contradictory and an evocative term. It does not indicate that there was such a thing as an established avant-garde movement. There are, however, multitudinous traces of Surrealism in GDR fiction. The aesthetics of Surrealism expose the fluidity of the material world by representing traditional, formal expressions in ways that are fragmented or distorted. Surrealism brings the world of things into an unfamiliar, non-realistic context. This art form was, of course, profoundly offensive to ideological fanatics. Surrealists reproduce details partly transformed into a strange condition by rearranging them in surprising ways that destabilize reality. Their world, in which the boundaries between human, animal, plant and inanimate object, for example, are suspended, exerts a magical effect. One of the first writers who denied the traditional rules of conventional narrative and produced the first examples of what became known as écriture automatique was, as mentioned in the Introduction, the Uruguay-born French poet Lautréamont, who in *The Songs of Maldoror* (1868) created a world of infernal cruelty that broke all nineteenth-century literary conventions. In six Cantos, Lautréamont – pseudonym of Isidore Lucien Ducasse – introduced a hero and ego figure as the incarnation of ultimate evil. Discovered by chance by the poet Philippe Soupault in 1920, these verses inspired visual artists such as Man Ray, René Magritte, Max Ernst, Hans Arp, André Masson, Joan Miró, Yves Tanguy, and, in particular, Salvador Dalí; the latter is known by many as the godfather of surrealist visual art. For his macabre, partly ironic and often absurd turn of spirit,

Lautréamont was honoured with a place in the *Anthology of Black Humour* by André Breton in 1940, in 1947 and, finally, in the definitive edition of 1966.[1] Surrealism, as it were, formed the link to the more radical variants of German literary Modernism, Expressionism and Dadaism, which from at least 1937 had been condemned as 'degenerate art' in the Third Reich. The fact that an artistic and literary form had been anathema to the Nazis did not imply its automatic acceptance in East German culture, where the Ulbricht government endeavoured to present its artists and writers to the world. On the contrary, as we have seen in Chapter 1, the cultural Nestor, Georg Lukács, whose influence extended until 1956, had condemned Modernism as merely a *Schattenbild* (silhouette) of the bright official literature created within any socialist state.[2] In this regard, while Lautréamont was not included as part of their official cultural heritage, his work nevertheless seemed to have a close intertextual tie with some East Germans – including, for example, the poet and prose writer Wolfgang Hilbig, and the playwright Heiner Müller, in line with the latter's aesthetics of evil.[3]

In this chapter I will focus on a close reading of Hilbig's key text, 'Alte Abdeckerei' (Old Knackery, written around 1980 and published in 1992), with reference to the writer whose work was the focus of the previous chapter, Adolf Endler, who many consider to be the godfather of surrealist fiction in the GDR. Here, I will explore the characteristics of Hilbig's prose, in which the simultaneity of pre-modern literary forms (in particular mythology), of references to contemporary historical events in Germany (the Third Reich and the Holocaust)[4] and of modernity in fictional literature (Kafka and Surrealism) become apparent. This combination became a constant in Hilbig's fiction of the 1970s and 1980s. Hilbig designed textually strange and grotesque landscapes parallel to, and in particular beneath, the GDR. The concatenation of these references generates a complex European or even global network of meanings.[5] Making reference to different traditions in his prose and poetry, Hilbig managed to portray the GDR as a perishing, surreal entity, and has continued to do so even after 1990 in a unified Germany – the inauguration of which soon became known as the Berlin Republic.[6] The surreal in his prose, however, originates from the creation of his morbid and fantastical terrains in existing, primarily Saxon, areas. Strange things happen there.

Before embarking on an analysis of 'Alte Abdeckerei', it is important to place this work in a wider context by examining the work of two writers who, in the 1960s and 1970s, were forceful voices in the GDR in the creation of an alternative to Socialist Realism, and who can be associated with a surreal or magical realism. The narratives of Fritz Rudolf Fries and, in another way, Irmtraud Morgner are two such dissonant voices. In their own original ways they displayed an alternative to the GDR reality by

creating new, unconventional milieus, without denying the reality of their existing socialist state.

Preceding Surreal Worlds in GDR Fiction

During the final decades of the GDR, the writings of Hilbig and Endler, as well as Mickel, Erb and other writers previously discussed, cultivated and promoted surrealistic scenarios. In my opinion, these figures followed in the footsteps of a previous generation of writers: that of Fritz Rudolf Fries and Irmtraud Morgner, whose aesthetics were hard to pin down owing to their unpredictable manoeuvres between medieval, Renaissance and modern literary models – manoeuvres which the cultural authorities found almost vertiginous. Older and younger generations became outcasts in the eyes of those officials who had once endorsed Formalism in the 1950s and who seemed to continue to do so in its long shadow. One of the models that concentrated on filtering surreal aspects from daily life in the GDR was Fries's *Der Weg nach Oobliadooh* (*The Road to Oobliadooh*), which has been characterized as the GDR's first modern novel. This novel was published in 1966 by the prestigious West German Suhrkamp Verlag with the help of Fries's former student friend and fellow writer, Uwe Johnson, who had emigrated to the West. The book did not appear in the GDR until 1989. The novel – its title referring to the protagonists' love of Dizzy Gillespie's jazz – tells the story of two friends, Paasch and Arlecq, who, in addition to their shared love of jazz, are searching for a life that they have difficulties finding in both East and West after the war: 'Komme mir vor, als ob ich einen Fuß links und den andern rechts der Sektorengrenze hätte.' (I feel as if I have one foot on the left and the other on the right side of the boundary between East and West Berlin)[7]. In the tradition of the sixteenth-century *Schelmenroman* (picaresque novel), both friends fail to attain a happy life. Fries's prose is sometimes hard to follow when he refers to and quotes Modernist authors such as Kurt Schwitters and Gottfried Benn. Paasch and Arlecq accept the status of the outsider. Fries would never have called his writing surrealistic, not least because his interests lay primarily in Hispanic, and not French, culture.[8] At the same time, however, together with the novel's dissident sequences, the absurd and grotesque become obvious. An example can be found in the meetings between the protagonists and God: 'Gott grüßte nach links und nach rechts, lüftete den Hut nach West und nach Ost, ohne Ansehen der Parteizugehörigkeit. Gott war objektiv, total, niemals totalitär' (God, greeting to the left and to the right, lifted his hat to the West and East, regardless of party affiliation. God was objective, totally, never totalitarian).[9] Fries's references to European culture favour the absurd and grotesque.

Whether or not Fries intended to be surrealistic, the novel combines different writing styles and imageries, something alien to the cultural orthodoxy designed by GDR political fanatics. In the 1960s, one of the country's post-war ideological peaks, flirting with jazz, originating in the Deep South of the United States of America and thus so detached from East German culture, was not only surreal, it was also provocative. Central to the joint passion for the 'land of Oo-bla-dee', where – as Gillespie's lyrics read – they 'knew a wonderful princess', is a code for Utopia and, ultimately, for the fulfilment of a life without restrictions. The novel's imageries range from magical realism and a dream landscape to hyper-realistic depictions of life in the city of Leipzig and other major cities, as well as in the West Berlin of the 1960s. Fries, in common with other GDR writers, dared to display what Wolfgang Emmerich calls a 'non-Socialist Modernity'; this refers, after the narrowing of East Germany's cultural mindset, to the opening of the gates to flexible expression without departing from Communist ideals.[10] It was never Fries's intention to become a dissident or an enemy of the state. Nevertheless, he sparked fear in the minds of cultural functionaries, since his display of versatility was seen as evidence of his indoctrination by Western thought.

Like Surrealism and magical realism, the picaresque did not conform to the cultural model created by the GDR authorities. In the cultural environment sandwiched between two significant conferences – the Eleventh (Kahlschlag) Plenum of 1965 and, four years later, the sixth Schriftstellerkongreß (Writers' Congress) – the works of non-conformist writers such as Fries were judged to be unacceptable in the East German literary world.[11] Into this new, hostile cultural landscape of the second half of the 1960s came Erich Honecker's famous declaration in December 1971 that in literature and the arts, taboos should be eliminated. Between the promised liberalizations announced by the new SED leader, however, and the new hardening of cultural policies five years later following the expatriation of Wolf Biermann,[12] GDR writers and artists recognized that the need to reshuffle the parameters of reality in the German socialist state was of upmost importance. For this reason, the only writing that can be taken seriously between the 1960s and 1970s must be read as the ultimate alternative, as journeys into the surreal world. Surreal landscapes, featuring sometimes-ludicrous and partly farcical settings and characterizations, also became part of the work of Irmtraud Morgner, another writer influenced by Hispanic culture.

The blend of the real and the fantastical and the exploration of feminist themes in Morgner's books was a fresh wind blowing through East German literature, but her work turned out to be politically explosive. In her study *Entering History* (2004), Silke von der Emde traces a 'place between

dissidence and affirmation as she articulated in her novels'.[13] The joy of aesthetic experimentation peaks in 1974 in Morgner's seven-hundred-page bestseller *Leben und Abenteuer der Trobadora Beatrice nach Zeugnissen ihrer Spielfrau Laura* (*Life and Adventures of Trobadora Beatrice as Chronicled by her Minstrel Laura*). The novel portrays fragmented, surreal landscapes in a blend of medieval and contemporary settings. As well as providing a feminist critique of GDR Socialism, science, history and aesthetic theory, it is a highly entertaining adventure story. In May 1968, after an eight-hundred-year sleep, the main protagonist Beatrice awakens in her Provence château. Caught in an alienated world, she finds work and in Paris in the aftermath of the student uprisings. She then travels to the GDR (recommended to her as the 'promised land for women').[14] There she meets Laura Salman, a trolley driver, writer and single mother who becomes her minstrel and alter ego later. In addition, Beatrice is on a quest to find a unicorn, whereas Laura is on maternity leave in Berlin. The pair often require black-magic interventions by the Beautiful Melusine, a female folk spirit, half dragon and half woman.[15] Morgner creates a combination of genres and text types, including documentary material, poems, fairy tales, interviews, letters, newspaper reports, theoretical texts, excerpts from earlier books of her own, pieces by other writers and parodies of typical GDR genres. The writer attempts to write women into history and to retell great myths from a feminist perspective. The novel opens with the words 'Of course this country is a land of miracles',[16] a slogan that cautiously signifies the existence of a continuous experimental fictional literature in the GDR.

Rather than simply critical, Morgner's novels are eccentric and satirically grotesque. Her texts are full of fantastical impossibilities; they demand attention to detail, sensitivity to allusion and open-mindedness towards cultural references. Her aim is to see the world anew. As Marina Elisabeth Eidecker has argued, Morgner used a fantastic realism, mainly in her late avant-garde novels, which has links with fiction in repressive societies in Latin America. As the project 'GDR' demonstrates, following the construction of the Wall, social complications and the erosion of Communist ideals were not allowed to be openly discussed. According to Eidecker, Morgner's new poetics combined fantasy and montage.[17] As a result, a new aesthetic approach other than the orthodoxy of Socialist Realism had to be selected – a new attitude towards reality.

Needless to say, Morgner's miracles and Fries's picaresque scenarios did not constitute Surrealism in the GDR. What they did, however, was pave a way for surreal imagery in the prose and poetry of Endler and Hilbig.[18] In the following I will present a close reading of Hilbig's prose text 'Alte Abdeckerei' and demonstrate the various layers of the alternative to GDR reality that he presents.

The Underworld of a Visible-Invisible Writer

Hilbig was never taken seriously as a writer by the GDR cultural authorities. He was, as Ingrid Sonntag argues, *abwesend* (absent) in his own country in the 1980s.[19] Even so, Hilbig published texts and translations of poetry and prose in the volume *Stimme Stimme* in 1983, as well as *Nachdichtungen* (free adaptations) of texts by Paul Éluard and Michel Leiris for Karlheinz Barck's key anthology *Surrealismus in Paris* in 1985.[20] Hilbig's work was, somewhat surprisingly, published by Reclam Verlag, one of the GDR's official publishing houses. Indeed, Hilbig was one of the few writers who, while never becoming fully accepted, was 'tolerated'. On the other hand, he did not himself wish to become part of the official GDR cultural milieu. As Michael Opitz argues in his biography, Hilbig denied the officially endorsed understanding of realism.[21] Being both visible and invisible at the same time was something he had in common with his colleagues Endler and Gert Neumann, the latter also his close friend. Endler wrote a perceptive afterword to the writings published in *zwischen den paradiesen* (Between the Paradises) shortly after German reunification. In his reflections on this collection of Hilbig's prose and poetry, he highlights the appeal of Surrealism to his fellow writer by emphasizing the 'schwarz-humoristischen Presentation' (black-humorous presentation) in Hilbig's writings.[22] At the same time, it needs to be emphasized that Hilbig, in common with many other writers who happened to be in the blind spot of official GDR cultural policy, was published in the many *samizdat* journals and other semi-illegal outlets that existed in the final years of the state.

Strikingly, in spite of the fact that the story 'Alte Abdeckerei' is central to the argument of Endler's afterword, the most significant text in Hilbig's oeuvre is not represented in the 1992 volume because of copyright issues.[23] One obvious indication of Endler's interest in this particular work, which is based on material Hilbig collected in the final decades of the GDR and displays a surreal setting, is the use of a direct quotation from the story in the afterword's first epigraph: '… oh, ich sah Rosen auf den Ausscheidungen verendeter Tiere wachsen' (oh, I saw roses growing on the excrements of dead animals).[24] Hilbig presents an *Ästhetik des Häßlichen* (Aesthetics of the Ugly), in a similar vein to the Surrealists, and, as I have shown elsewhere, to Endler later in his so-called 'unreine Poesie' (impure poetry).[25] The different approaches in their rejections of Socialist Realism as a method or ideal for writing and their turning toward Surrealism should be noted.

Indeed, because of their common poetics, Endler and Hilbig shared the status of outlaws in the GDR, combining a 'typical' (in GDR terms, 'anti-social') biography and the application of modernity in their writings. The interaction of the real and the unreal, the factual and the fictional

worlds, resulted, as Helmut Böttiger has argued, in their status as *personae non gratae*. They were simultaneously both absent and present. Hardly published in their homeland, they were instead present in West German publishing houses and appreciated in the literary world of the West, and they simultaneously appeared in the *Kleinzeitschriften* (semi-legal 'little journals') in the underground Prenzlauer Berg scene.[26] The shady zones of the underground were a common denominator for both writers. The fascination with absence is of key significance, particularly in Hilbig's writings, as the title of his first volume of poetry, published in 1979, indicates: *abwesenheit* (absence).[27] The term *verschwinden* (disappear) frequently appears in his prose, and the condition of not being present, being displaced, removed or disappeared, is a constant theme in his work. This is not only related to Hilbig's own life – his father, a Wehrmacht soldier in 1942, was reported as missing during the battle of Stalingrad and never returned home[28] – but is also related to his *Doppelexistenz* (double life), a status that made him absent for GDR readers. At the same time, he was a manual worker. He worked as a stoker, or sometimes as a waiter, and consequently, he was not present as a writer either.[29] In the East German literary world he was invisible. It was only in 1980, after a long search for recognition and following his publication in the FRG, that he was welcomed in the GDR, thanks to the efforts of Franz Fühmann.[30]

In the final decade of the GDR, Endler and Hilbig were two of the poets and prose writers most able to articulate a surreal environment in their homeland. As indicated earlier, Endler established a fictional bohemian or underground world, full of imaginary outsiders, vagabonds, drunks and bootleggers who weakened the supposedly strong foundations of East German society. He set up his own Free State in East Berlin, in which Bobbi 'Bumke' Bergermann and Bubi Blazezak feature and behave outrageously and, as a consequence, undermine the system. Hilbig, too, created a new reality parallel to the actual reality of Socialism in Saxony; here, the protagonist C., who works in a variety of different occupations and at the same time is a writer, steps out of GDR reality into an outlandish, surreal dream world. As well as designing an alternative space, Hilbig also displays Germany's horrific association with the Holocaust, as 'Alte Abdeckerei' illustrates. This association was, in the main, a taboo in daily life in the GDR and was exposed by the writer for the first time:

> ... oh Land, vergleichbar einer Bienenwabe von Massengräbern, Land mit Philosophen die Massengräber abdeckend, auferstanden aus Ruinen über den Massengräbern, über den Massengräbern der Diktatur des Proletariats, über

den Massengräbern der allmächtigen Lehre Lenins, oh über den Massengräbern von 'Wissen-ist-Macht' ...³¹

... oh land, like a honeycomb of mass graves, land with philosophers covering the mass graves, from the Ruins newly Risen over the mass graves, over the mass graves of the dictatorship of the proletariat, over the mass graves of the all-powerful doctrine of Lenin, oh over the mass graves of 'knowledge-is-power' ...

In the sketches of C.'s wanderings through the Saxon territories, all kind of relics from the past pop up: rail tracks, a *Rampe* (platform) and meat hooks, among other things. These vestiges belong to the knackers' yard, but also go further back in time, since they communicate echoes of the notions of absence and disappearance, and the horrific events in the Nazi death camps. Each in its own way, both the FRG and the GDR experienced difficulties in dealing with this dark aspect of the twentieth-century past. The problematic and frequently interrupted streams of memory involved in attempting to come to terms with the Holocaust were often silenced by the authorities.³² Instead, it was non-official institutions like the Church, or writers such as Sarah Kirsch, Jurek Becker and Wolfgang Hilbig, who articulated the difficulties of coping with the past. Hilbig made the reader aware of the omissions in GDR historiography, and his judgements should be applauded.

Hilbig's critique of a closed and repressive society can be found in most of his pre- and post-Wende stories: in 'Der Brief' (The Letter, 1981), 'Anfang eines Traums' (Beginning of a Dream, 1990), 'Er, nicht ich' (Him, Not Me, 1981/91), 'Alte Abdeckerei' and 'Der dunkle Mann' (The Dark Man, 2003), all tales which depict eerie images of the writer's present and past reality.³³ This hidden underworld is made visible in a Kafkaesque spirit. Emanating from his experience as a worker in the ailing industrial companies of the GDR and his observation of their final decline in the post-reunification period, Hilbig's texts proliferate into the surreal landscape of a tremendous imagination, in which his linguistic ability comes to light. The following longer extract illustrates the linguistic athleticism of the writer:

Alte Abdeckerei, sterngestirnter Umfluß. Alte Abdeckerei unter dem Dach ratloser Gedanken, ratloses Geklapper altüberdachter Gedanken, alte Abmacherei. Nachtgedachte Gedanken, gestirnt: altes Abgeklapper, das Gestirn bedeckt. Und Wolken, altes Geräusch: Rauchgerinn hinter Wolkenstirn, windiges Dach von Abgewölken, das die Sterne deckt. Unten aber der Fische gewundenes Licht: wie Sternenschrift, gewunden und mit sachtem Zirpen aus der Luft gefallen. Vorbei an Winkeln dichtgedrängter

Häuser, vorbei an Straßen, schneller fallend und verschwunden. Im entlichteten Fluß verschwunden, im versunkenen Fluß, wolkenüberdacht, und schwindend mit den Wassern in die Nacht. In die Nacht der Kohle, mit den Wassern schreibend in die Nacht der Kohle, unsichtbar, und flüsternd, zirpend in die Finsternisse, mit den Wassern wissend, wie der sterngestirnter Stierfluß leuchtend, dünend und unterm Dach der finsteren Wolkendecke, weit ins Ferne fließend. Fern in Weiten fließend, sinkend, schwindend, alte Abdenkerei. Altes Sternenzirpen, Schriftgezirp, mit Fischen flüchtend, Fischgezirp und Fischgeschrift, durch das Wasserfenster blickend, alte Abschreiberei. Alte Abfinsterei, stiergehörnt durch Weidenschatten schwenkend Alteckerei ... Alterei ...

Und endlich an einigen untergegangenen Ruinen vorüber, an Germania II vorüber, wo in der Flut die Sternbilder spielen, wo die Minotauren weiden.[34]

Old Knackery, luminary flow. Old Knackery under the roof of clueless thoughts, clueless rattle of old covered thoughts, old Bargaining. Nightly thoughts under the stars: old Scour covering the stars. And clouds, old Noise: the blazing smoke behind a cloudy front, windy roof of falling clouds that cover the stars. But below the winding light of the fish: like a starry script, winding and falling with a gentle chirping from the air. Passing the corners of closely packed houses, passing streets, rapidly falling and disappearing. Disappeared in the dimmed river, in the submerged river, cloud-covered, and dwindling with the waters into the night. In the night of the coal, writing with the waters into the night of the coal, invisible, and whispering, chirping into the darkness, close to the waters, like the river of the bull, glowing, thinning and under the roof of the dark cloud cover Old corner ... Old ...

And finally passing some perished ruins, passing Germania II, where in the flood plays the constellations, where the Minotaurs graze.

The creativity of Hilbig's poetic language, which imitates that of concrete poetry, dissolves the geography of the realistic landscape through which the protagonist strolls. The affected imagery transforms into a totally new context, in which reality and mythology conjoin and transform into the surreal. The soap factory, Germany II and the Minotaurs are central elements in the story.

In Book VIII of his great work *Metamorphoses*, the Roman poet Ovid describes the Minotaur as a mythical creature, 'part man and part bull'. The image of the Minotaur was drawn by Pablo Picasso in 1928 and seems to have inspired many Surrealists, becoming their 'emblem'. The drawing became the cover of *Minotaure*, the French surrealist magazine which appeared from 1933 until 1939.[35] For this reason alone, Hilbig can be seen as a fine example of surrealist writing in the GDR. His denial of realism, the focus on a protagonist who is lost in a dream world, and the wanderings in an eerie landscape are obvious indicators. The unanticipated spatial and

temporal shifts in the geological landscape are clear signs to alert the reader to a different assembly of non-realistic poetics. Four discrete elements can be specifically identified in almost all of Hilbig's prose: firstly, closed and narrow spaces (cellars and caves); then, a hellish environment in which heat, damp, ash and death prevail; third, the coming to terms with Germany's contemporary history, either that of the Holocaust or, in another category, with the GDR itself; and, finally, the discovering of a new language. This last concern is something Hilbig shared with his friend and fellow writer in Leipzig, Gert Neumann. In his *Die Schuld der Worte* (The Guild of Words, 1979),[36] Neumann forcefully questioned the conventional language used by GDR authorities, which he believed polluted people's thinking and obscured the search for truth in fiction. In the 1980s, many writers of the then younger generation, who also experienced this cultural burden on their artistic creativity, dared to challenge the East Berlin authorities – some openly, others in a more camouflaged way.[37]

Hilbig first tried to oppose the GDR's newspeak by applying the language used by followers of German Romanticism, who favoured a fantastic *Territorium* or 'environment' (in his terms) in which strange and frequently bizarre events take place. Even Hilbig's choice of colours evoked Romantic settings for the reader – an insult in GDR cultural politics. As Opitz argues, Hilbig was fascinated by Novalis's novel *Heinrich von Ofterdingen* (1800) and his concept of the 'Blaue Blume' (blue flower). He started working on his own 'Die Blaue Blume' in 1970, but after a decade and after completing many different versions, he abandoned the project and reorientated his poetics by claiming that 'Die Poesie ist verloren' (the poetry is lost). Putting his dreamlike events into words demanded the creation of a new language: 'Es bedarf einer magischen Sprache, einer Sprache, die die Romantik beerbt und die zugleich in der Moderne wurzelt. In ihr müsste das Wunderbare ebenso seinen Platz haben wie das Surreale' (It requires a magical language, a language that inherits Romanticism and is rooted in modernity at the same time. In it, the wonderful should have its place as well as the surreal).[38] Hilbig began to engage with a more Kafkaesque poetic, and at the same time was drawn to the Surrealists and their predecessor and model, Lautréamont, as suggested by the first two stanzas of the poem 'episode' from 1977:

im duster kesselhaus im licht
rußiger lampen plötzlich auf dem brikettberg
saß ein grüner fasan
 ein prächtiger clown
 ...
 so war er herrlicher und schöner

> als ein surrealistischer regenschirm auf einer nähmaschine
> …[39]

in the dark boiler house in the light
sooty lamps suddenly on the pile of coals
sat a green pheasant
 a magnificent clown
…
 so he was more glorious and beautiful
than a surrealistic umbrella on a sewing machine
…

As Hilbig's prose and poetry demonstrate, the process of searching for an alternative and better GDR, the application of a new modus operandi to describe realism and the creation of a new language are interlinked in his aesthetics. The concentrated writing opens a door to a surreal geography, an eerie environment in which scandalous adventures and encounters take place. Hilbig creates a beastly underworld where there are cellars, corridors, cesspools, shafts, the cadavers of cattle and traces of the remnants of death camps. This uncanny and distressing panorama is framed by ghastly natural settings, such as 'ein Glimmen stankdurchseuchter Rauchschaden' (a smouldering stench-soaked smoke).[40] Hilbig illustrates the parallels between his Saxon habitat and the entire country by employing a register of death and decay in his vocabulary: he characterizes the GDR as the 'Kadaver der Republik' (cadaver of the republic).[41] Eventually, as we have seen, these new linguistic potencies create an innovative poetic voice – and an authentic one, reached via the tortuous procedure of going through the various guilt-cellars of the German past.

Conclusion

In the 1980s, Hilbig was one of the writers from the older generation who was associated with both the artistic scene of the GDR's younger writers and artists and with underground publications such as *ariadnefabrik* (Ariadne Factory), *schaden* (Damage), *verwendung* (Usage), *liane* (Vines) and *entwerter/oder* (Validate/Or). As somebody whose background was as a manual labourer, and who, as his biographers argue, suffered from an inferiority complex,[42] he was uneasy with the bohemian lifestyle of the so-called Prenzlauer Berg Connection with which he was later associated. The reason for this close connection must have been his wish to create his unique underworld, with the corresponding intention of eroding the official

version of reality. For Hilbig reality is absent – is, in fact, rejected. This absence, however, exists on different levels. When we read the story 'Alte Abdeckerei', the underground is, in the mind of the protagonist, one that retains its direct links with the real world, with both the German past and daily life under the Real existierender Sozialismus. The protagonist is not visible to the outside world, but is instead at home in a world caught in between: a place where he is allowed to write but not publish which he calls a *Provisorium* (provisional place). This place exists as a morbid, eerie landscape in which the main character is confronted with the German collective memory, another dimension of *abwesenheit*.

It has been argued that Hilbig's modernity is unthinkable without the GDR – or as Böttiger argues, 'seine Besonderheit ist es, DDR-Literatur als Literatur der Moderne denken zu können' (he made us aware to think of GDR literature as a literature of the modern age);

> Nicht nur in sich geschlossenen, großen Erzählungen wie 'Die Weiber' und 'Alte Abdeckerei', auch lange Passagen in den beiden Romanen *Eine Übertragung* und *'Ich'* sind Traumsequenzen. Sie folgen der Logik des Traums, mit Doppelgängern und Wiedergängern, mit dem eigenen Bewußtsein in einem fremden Körper und die minutiöse Beschreibung von Körperfunktionen, Untersuchungen mit fremden Material, gehören zur unverwechselbaren Farbe von Hilbigs Prosa, ihrer monströsen Sinnlichkeit.[43]

> Not only in self-contained, great narratives like 'Die Weiber' and 'Alte Abdeckerei', but also passages in the two novels *Eine Übertragung* and *'Ich'* are dream equinoxes. They follow the logic of the dream, with doppelgangers and revenants, with their own consciousness in a foreign body and the detailed description of bodily functions, examinations with foreign material, belong to the immutable characteristics of Hilbert's prose, its monstrous sensuality.

In 2007, the year of Hilbig's death, the journal *Herzattacke* issued a special issue to celebrate his seventieth birthday, with texts by Arthur Rimbaud, Stéphane Mallarmé and the Surrealist René Char, among others. Until their premature deaths, both Hilbig and Endler, as the two most prolific Surrealists in GDR fiction, were frequently associated with this journal.

The two writers on whom the final chapters of this book will focus are also associated with Surrealism, but were less articulate in this choice. They were, however, still significant avant-garde voices in the Socialist Realism-dominated culture of the GDR. Furthermore, their feminine approaches turned GDR reality into a surreal space in a different way.

Notes

1. J.H. Matthews, *Towards the Poetics of Surrealism*. Syracuse: Syracuse University Press, 1976, 28–44.
2. Cf. Helmut Böttiger, 'Monströse Sinnlichkeiten, negative Utopie. Wolfgang Hilbig's DDR-Modern'. In: Heinz Ludwig Arnold (ed.), *Wolfgang Hilbig*. Göttingen: edition text + kritik, 1994, 52–61 (57).
3. Kai Bremer, 'Erholung durch Störung. Zum Status surrealistischer Malerei und Literatur bei Heiner Müller'. In: Friederike Reents (ed.), *Surrealismus in der deutschsprachigen Literatur*. Berlin and New York: de Gruyter, 2009, 206–10.
4. See, for example, Terrisse Bénédicte, 'Du Coup de Grisou à la Apocalypse: Explosion Politique dans "Alte Abdeckerei" (1991) de Wolfgang Hilbig'. In: Georges Felten et al. (eds), *L'explosion en Point de Mire/Die Explosion vor Augen*. Würzburg: Königshausen & Neumann, 2013. 317–34; and Paul Cooke, *Speaking the Taboo: A Study of the Work of Wolfgang Hilbig*. Amsterdam and Atlanta: Rodopi, 2000.
5. See Bärbel Heisig, *'Briefe voller Zitate aus dem Vergessen'. Intertexualität im Werk Wolfgang Hilbigs*. Frankfurt: Peter Lang, 1996, 153.
6. Cf. Stuart Taberner (ed.), *Contemporary German Fiction: Writing in the Berlin Republic*. Cambridge: Cambridge University Press, 2007.
7. Fritz Rudolf Fries, *Der Weg nach Oobliadooh. Roman*. Frankfurt: Suhrkamp, 1966, 214. My translation.
8. Michael Töteberg, 'Vom Träumen und Trinken. Fritz Rudolf Fries: *Der Weg nach Oobliadooh*'. In: Karl Deiritz and Hannes Krauss (eds), *Verrat an der Kunst? Rückblicke auf die DDR-Literatur*. Berlin and Weimar: Aufbau Verlag, 1993, 206.
9. Fries, *Der Weg nach Oobliadooh*, 64.
10. Emmerich, 'Unterwegs im Widerspruch gegen Entmündigng und instrumentelle Vernunft (1961–71)'. In: *Kleine Literaturgeschichte der DDR*, 174–214.
11. See Agde, *Kahlschlag*; and Sabine Pamperrien, *Versuch am untauglichen Objekt. Der Schriftstellerverband der DDR im Dienst der sozialistischen Ideologie*. Frankfurt: Lang, 2004.
12. Kaiser and Petzold, 'Perlen vor die Säue. Hippies, Lauben, Sommergäste. Das Prinzip Hoffnung – die Entstehung der DDR-Boheme'. In: *Boheme und Diktatur in der DDR. Gruppen, Konflikte, Quartiere 1970–1989*. Berlin: Fannei & Walz, 1997, 24. For the enormous cultural impact surrounding the expatriation of Biermann, see, for example, the previous chapter and my entries in Opitz and Hofmann, *Metzler Lexikon DDR-Literatur*, 38–41.
13. Silke von der Emde, *Entering History: Feminist Dialogues in Irmtraud Morgner's Prose*. Oxford: Lang, 2004, 11.
14. Cf. Norbert Frei, *1968. Jugendrevolte und globaler Protest*. Munich: DTV, 2008; for a focus on the GDR, see Chapter 3 in this book and the exhibition *Aufbruch und Protest. 1968 in Prag, Berlin, Leipzig und Dresden* in the Sächsische Akademie der Künste in 2018, organized by Klaus Michael.
15. Cf. Boria Sax, *The Serpent and the Swan: Animal Brides in Literature and Folklore*. Knoxville: University of Tennessee Press, 1998.
16. Irmtraud Morgner, *The Life and Adventures of Trobadora Beatrice as Chronicled by her Minstrel Laura*, trans. Jeanette Clausen. Lincoln and London: University of Nebraska Press, 2000, 3. Originally entitled *Leben und Abenteuer der Trobadora Beatriz nach Zeugnissen ihrer Spielfrau Laura* and published by Aufbau Verlag in 1974.

17. Martina Elisabeth Eidecker, *Sinnsuche und Trauerarbeit. Funktionen von Schreiben in Irmtraud Morgners Werk*. Hildesheim: Olms, 1998, 3–9.
18. As they also did for the writings of the playwright Heiner Müller, as can be noted in the Hydra scene in his *Herakles 2*, in the poem and story 'Der Vater' (The Father) and in the absurd scenes featured in many of his plays.
19. Ingrid Sonntag, 'Wurde Hilbigs *Stimme Stimme* auf der Leipziger Buchmesse ausgestellt?' In: Carmen Laux and Patricia F. Zeckert (eds), *Flachware. Fußnoten der Leipziger Buchwissenschaft*. Leipzig and London: Plöttner, 2012, 39–50. Hilbig's first publication in 1979 is entitled *abwesenheit* (absence).
20. See Chapter 5 on Endler's translations for Karlheinz Barck's anthology. See also Thomas Böhme, 'Wie was es möglich? Zu Wolfgang Hilbigs Erstveröffentlichung in der DDR'. In Ingrid Sonntag (ed.), *An den Grenzen des Möglichen. Reclam Leipzig 1945–1991*. Berlin: Ch. Links, 2016, 455–56. In 1980 the most authoritative literary journal in the GDR, *Sinn und Form*, published seven poems by Hilbig on the recommendation of the writer Franz Fühmann. See Michael Opitz, *Wolfgang Hilbig. Eine Biographie*. Frankfurt: S. Fischer, 2017, 585.
21. Ibid., 323.
22. Endler, 'Hölle/Maelstrom/Abwesenheit. Fragmente über Wolfgang Hilbig'. In: Wolfgang Hilbig, *zwischen den paradiesen. Prosa Lyrik*, mit einem Essay von Adolf Endler, ed. Thorsten Ahrend. Leipzig: Reclam, 1992, 313–44 (340).
23. This is according to the information provided by the editor Thorsten Ahrend on 22 May 2019.
24. Endler, 'Hölle/Maelstrom/Abwesenheit', 313; and Wolfgang Hilbig, *Werke. Erzählungen*, eds. Jörg Bong and Oliver Vogel. Frankfurt: S. Fischer, 2010, 185.
25. Cf. Berendse, 'Adolf Endler'. In: Ursula Heukenkamp and Peter Geist (eds), *Deutschsprachige Lyriker des 20. Jahrhunderts*. Berlin: Erich Schmidt, 2007, 494–502 (496).
26. See Böttiger, 'Monströse Sinnlichkeiten, negative Utopie', 52–61.
27. Wolfgang Hilbig, *abwesenheit. gedichte*. Frankfurt: S. Fischer, 1979.
28. Opitz, *Wolfgang Hilbig*, 50.
29. See his essay 'Die Arbeiter' (the workers) from 1975, in *zwischen den paradiesen*, 17–30.
30. Opitz, *Wolfgang Hilbig*, 398–402, 405–7 and 421–24.
31. Hilbig, 'Alte Abdeckerei'. In: *Werke. Erzählungen*, 113–202 (175–76).
32. Anna Wolff-Poweska, 'The German Democratic Republic's Attitude Towards the Nazi-Past', *Pzeglad Zachodni* 1 (2011): 73–102.
33. Cf. André Steiner, *Das narrative Selbst. Studien zum Erzählwerk Wolfgang Hilbigs. Erzählungen 1979–1991. Romane 1989–2000*. Frankfurt: Lang, 2008.
34. Hilbig, 'Alte Abdeckerei', 200–1 and 201–2. Ellipses added for copyright reasons.
35. On the significance of the mythological figure of the Minotaur in Surrealism, see Nanette Rissler-Pipka, 'Picasso und sein Minotaure'. In: Isabel Maurer Queipo et al. (eds), *Die grausamen Spiele des 'Minotaure'. Intermediale Analysen einer surrealistischen Zeitschrift*. Bielefeld: Transcript, 2005, 39–70 (40–1).
36. Gert Neumann, *Die Schuld der Worte*. Frankfurt: S. Fischer, 1979/Rostock: Hinstorff, 1989.
37. Cf. Benjamin Robinson, *The Skin of the System: On Germany's Socialist Modernity*. Redwood City: Stanford University Press, 2009.
38. Quoted in Opitz, *Wolfgang Hilbig*, 306.
39. Hilbig, 'episode'. In: *abwesenheit*, 77 and *zwischen den paradiesen*, 270. My translation. Ellipses added for copyright reasons. In his *Songs of Maldoror*, Lautréamont describes

a young boy as being as 'beautiful as the chance meeting on a dissecting-table of a sewing-machine and an umbrella'. Similarly, Breton often used this line as an example of Surrealist dislocation. See the first pages in the Introduction.
40. Hilbig, 'Alte Abdeckerei', 166.
41. Ibid., 178.
42. See Chapter 4, entitled 'Buchstabenmüde', in Opitz, *Wolfgang Hilbig*, 273–94. Cf. Karen Lohse, *Wolfgang Hilbig. Eine motivische Biographie*. Leipzig: Plöttner, 2008; and Margret Franzlik, *Erinnerung an Wolfgang Hilbig*. Berlin: Transit Verlag, 2014.
43. Böttiger, 'Monströse Sinnlichkeiten, negative Utopie', 58.

Chapter 7

'FLIP-OUT-ELKE'

Elke Erb's Surrealistic Poetry

While the work of many artists in the Prenzlauer Berg and other urban art and literature scenes in the GDR had its origins in local, Germany-based concerns, the poet Elke Erb was one of the few whose endeavours possess an international perspective. According to some American critics, for example, Erb's poetic narrative is linked to surrealistic poetics. Such critics came to this conclusion after reviewing the volume *Mountains in Berlin*, a collection of Erb's poetry previously published in the GDR and translated into English by Rosmarie Waldrop in 1995.[1] In that same year Erb was awarded the Erich-Fried-Preis in Vienna; in her formal speech praising Erb's work, her colleague and friend Friederike Mayröcker highlighted the way that in Erb's verse, the pure reality-view, in the tradition of Fried, metamorphoses seamlessly into linguistic embellishments that are close to Surrealism. For Mayröcker, the intimate relationship between the concrete and its opposite in Erb's poetry is characteristic of her work. More recently, another colleague – the Berlin-based poet Nico Bleutge – drew attention to another distinctive quality, emphasizing that Erb's process of poetic creation is similar to the practice of a *Herantasten*, or careful search, which is not directed towards a complete understanding but instead accumulates an array of possibilities during the pursuit. Meditations, associations, dreams, memories and the unconscious are fundamental elements that define Erb's texts, leading to a process-oriented writing that Erb herself calls *Werkstück*.[2] Her poems are never completed, and contradictory elements are set against each other, resisting further definition. Deliberate incompleteness and disquiet contradict a rational vision of reality. These are also among some of the attributes

of Surrealism.³ Indeed, Surrealism is sometimes defined as the release of the creative potential of the unconscious mind, based on Sigmund Freud's psychological studies. And if surrealist art and literature display an irrational juxtaposition of random images, Erb should definitely be associated with this historical avant-garde movement. Her lyrical language, however, goes beyond such a register, as it manages to create subjects which by their linguistic design deny any written solidity. In order to prevent any linguistic stagnation with the original Surrealism movement, she makes use of the *Sprachschutt* (rubble of language) found the GDR and in particular of the language of power and control – as she admitted to Birgit Dahlke in an interview in the late 1990s.⁴ Language, including her own, is perceived as organic material, a sovereign living body: textual images are no longer controlled by the author but have a life and mind of their own. For this reason they may be understood as absurd and grotesque by the reader.

On the other hand, Erb surrounds herself with real things, mostly household objects; with tables, chairs and wardrobes, which are all moving around in her flat, communicating with each other, with the poet and with the reader. In other words, her own linguistic ventures manage to estrange reality, as is evident in the poem 'Die vier durchgestrichenen Versuche' (The Four Erased Attempts), an extract from which is quoted here:

Den Augen die Taschenlampe,
den Füßen der Pfad.
...

Die Schritte waren Schritte im Weglosen – auf einem Pfad.
Die Füße waren nicht meine Füße, sondern die eines Pfades.
...

In den Augen der Füße: die Taschenlampe.
In den Füßen der Augen: der Pfad.⁵

The eyes the flashlight
the feet the path.
...

The steps were steps in the pathless – on a path.
My feet were not my feet but those of a path.
...

In the eyes of the feet: the flashlight.
In the feet of the eyes: the path.

This poem was privately published in the GDR in the 1984 volume *Winkelzüge*. One year after the unification of West and East Germany, the

volume was republished by the Galrev publishing house. In the 1980s, Galrev had prominently featured the East German neo-avant-garde, particularly in East Berlin. The poems in the Galrev edition of *Winkelzüge oder Nicht vermutete, aufschlussreiche Verhältnisse* (Crisscrossing or Unsuspected, Revealing Conditions) were accompanied by the work of the visual artist Angela Hampel, whose bizarre images are reminiscent of the surrealist revival in post-war Europe, an antidote to the still-prevailing norm of Socialist Realism. Her conceptual references back to Modernism succeed in alienating realistic imageries by adding absurd manifestations. In 1984, a book of her work was published independently.

Paradoxically, and as this book argues throughout, the Communist Arbeiter- und Bauernstaat (Workers' and Farmers' State) had become a cradle of home-grown post-war surrealist writing and visual art. Artistic examples can be identified before the rise to international prominence of Neo Rauch (the household name for East German Surrealism after 1990). Among these – to name a few, and each with varying degrees of affiliations – are Hermann Glöckner, Carlfriedrich Claus, Horst Hussel, Hans Ticha, Günther Hornig, Rolf X. Schröder and Angela Hampel in the visual arts; and in literature, Irmtraud Morgner, Adolf Endler, Erich Arendt, Fritz Rudolf Fries, Wolfgang Hilbig, Kerstin Hensel, Gabriele Stötzer and Elke Erb. For many, associating Erb with Surrealism may verge on an oversimplification of both the complex issue of transporting the historical avant-garde movement to the present and of the specifics of Erb's poetic work.[6] Indeed, her poetry has much more to offer than a reflective connection to this well-known and well-defined literary category of the past. When looking at Erb's relationship with Surrealism, it is far more fruitful to explore new ways of relating the poet to the historical avant-garde group of the early twentieth century than to conveniently and mechanically describe her writing as being part of it. The specifics of Erb's poetry referred to above compel us to rethink our reading of it. With reference to both Surrealism and the reflections of Bleutge above, her poems will be read in this chapter as *Denkbewegungen* (thought processes or movements) through the *Sprachschutt* that instantly allows for new associations and enables us to create new connections, without necessarily arriving at definite conclusions. The movement of Erb's thoughts and poetic language are in constant flux, each inviting the reader to engage with her while never obtaining the satisfaction of receiving conclusive answers. Her poetics result in an 'openness' wherein different textual endeavours are sought and confront each other. This characteristic may apply to a great deal of poetry; the fact is, however, that this was poetry written in a state that was defined only by monologue. It needs, therefore, to be defined as subversive.

In the second part of this chapter, we will attempt to analyse the poem 'Das Unternehmen Schreiben' (The Act of Writing) – a work that, in my opinion, is at the core of the volume *Winkelzüge* and, indeed, is central to Erb's entire poetic output of the late 1980s, in the midst of the political turmoil of the pre-Wende period. First, however, more general insights into Erb's poetic language and her place in German cultural history will be examined. Finally, we will briefly investigate Erb's application of the Surrealists' most celebrated device in fictional literature, écriture automatique, in her post-Wende volume *Sonanz. 5-Minuten-Notate* (Sonance. 5-Minute Notifications), published in 2007.

Erb's Place in GDR Cultural History

In 1948, Elke Erb moved with her parents to the SBZ, where until the early 1960s she studied German, History and Pedagogy at the University of Halle. After graduation, and before becoming a self-employed writer, she worked as an editor for the publishing house Mitteldeutscher Verlag. In that decade she was involved in the intense public discussions which were about to define the GDR's political and cultural landscape indefinitely. These public discussions did not just influence her own writing; they also inspired her to become part of the previously discussed *Forum* debates in 1966 on the interrelationships between technological and cultural developments, in particular in the work of the (then) young generation of writers (that is, her own). From the 1960s, one topic became the dominant preoccupation of GDR society: the relationship between labour and culture. Throughout her life in the GDR, Erb's potent contributions were not only focused on stimulating innovation in the poetic endeavours of her generation, but also, about two decades later, on supporting and promoting the artistic underground scenes in major East German cities, such as that in Prenzlauer Berg.[7] In his monograph on the link between the GDR's rigid cultural politics and literary innovation, *The Power of Speech*, Bathrick argues that this apparently independent artistic movement, or 'second culture', in the 1980s 'had seemingly transcended the confines of a feckless clinch with the SED's power structure'.[8] In that context, Erb, in spite of the resistance of some of her colleagues, held high the banner of neo-avant-gardist experimental literature. She was simultaneously both within and outside the bohemian underground culture of the GDR.

Following the rejections of a recycling of the historical avant-garde by Enzensberger in the 1960s and Bürger in the 1970s, in the 1980s it was the turn of their East German colleague, Volker Braun, to play down this ostensibly persistent post-war phenomenon, which he did by ridiculing

Erb's involvement in the East German countercultures as their *Szene-Mutter* (Mother of the Arts Scenes).[9] In spite of the negative connotations in the West of the recycling of the past, and particularly the introduction of what some considered to be second-rate postmodern offshoots of the historical avant-garde (such as the late-1960s translations of beat poetry by the West German poet Rolf Dieter Brinkmann), the neo-avant-garde remained significant in the cultural life of the GDR.[10] Although no avant-garde movements were developed in the GDR (or if any appeared, they were nipped in the bud), alternatives to the governing dogma of Socialist Realism in East German writing were revealed in traces of the surreal and of Dada in the narratives, the metaphors and even in the excursions into dream worlds employed.[11] Indeed, in a range of texts published in the GDR – and also shortly after the Second World War in the SBZ – a productive tension between the rational and the irrational can be detected. As argued above, this tension is also to be found in Erb's poetry, without its being directly associated with any previous artistic movements.

Throughout her long active years of writing from 1966, it seems that Erb remained surprisingly persistent to her idiolect; at the same time, however, she frequently opted for new forms and techniques, and her decision to initiate so-called 'procedural writing' in the second half of the 1980s was perhaps her *coup de grâce*, for which she was awarded the Peter Huchel Prize in 1988. Her continuous delight in experimentation was crowned with her reception of the prestigious Ernst Jandl Prize in 2013, and eventually with the most important literary prize for the German language, the Georg Büchner Prize, in 2020. The constant in her work is the surrealist principle of dislocation that unsettles the reader's certainty about the work's whereabouts – whether in reality or beyond. Following in the footsteps of Friedrich de la Motte-Fouqué, E.T.A. Hoffmann, Ingeborg Bachmann, Mayröcker and some surrealist writers, the East German Erb rejoices in the hybrid.

Needless to say, in any political and cultural context, this assertion of deliberate vagueness is subversive, especially when the verses are accompanied by drafts and comments, a method that denies the reader definitive clarification or reflection.[12] These extra-literary products are not committed to lucidity. On the contrary, the poet's intention is the avoidance of description or explanation. In the prose text 'Kleist', in the volume *Der Faden der Geduld* (The Thread of Patience, 1978), her abrupt intermingling and equally sudden abandoning of the consequent concoction leads to reality being tested.[13] In this story, Erb begins then ends three dialogues, leaving the reader in the dark, as Kleist does in his 1810 essay 'Über das Marionettentheater' (On the Puppet Theatre). In the long interview with the author that concludes *Der Faden der Geduld*, Christa Wolf rightly argues, 'Hier wird nicht mehr erzählt' (There's no narration here). Erb replies, 'Angewiesen nur auf das

Sprachmaterial' (Here, I am dependent on the language material alone).[14] The spell that seemed to emanate from the material in the earlier texts now shifts to language itself: 'Sind Worte unter sich, entscheiden *sie*' (If words are among themselves, *they* decide).[15] Erb's language is a reflection on the character of her poetry. The reader is constantly trying to make sense of jarring, irrational sequences, as is the case with the deciphering of surrealistic visual art and literature.

The act of self-questioning also occurs during Erb's frequent poetic dialogues with female colleagues, for example in the intertextual discourse with her Austrian colleague Mayröcker in *Unschuld, du Licht meiner Augen* (Innocence, Light of my Eyes, 1994). With Mayröcker, as with language, she is 'per du' (coequal). In common with Elaine Scarry's in *The Body in Pain* (1985), Erb's poetry focuses on the complex relationship between language and physical experience. Erb has managed to create a poetic voice that cannot be ignored in contemporary Europe. In 1997, Dahlke emphasized in particular the body-poetics of those poets – alive or dead – with a similar writing style, such as Gabriele Stötzer, Annett Gröschner, Barbara Köhler, Kerstin Hensel and Cornelia Schleime, but also Emily Dickinson, Rosemarie Waldrop, Anna Akhmatova, Marina Tsvetaeva, Sarah Kirsch and Inge Müller. The communication processes the poet developed and expanded in this 'female bonding' is linked to her experiences of dialogism in the Sächsische Dichterschule in the 1960s and 1970s. The poetry of this group, of which Erb was an influential member, emphasized the concept of dialogue in a political system fixated on authoritarian monologue, and was an antidote to the habitual directives that the GDR authorities produced. Consequently, it created alternative spaces for public speech.[16]

According to the commentaries which accompany the poems in Erb's *Winkelzüge*, a constant in the dyspeptic process of understanding predominates: confusion and complicated thought processes are not polished, but rather presented in an obstinate and unruly format, as a sample from the poem 'Eine Woche Pause' (A Week's Intermission) illustrates:

…

Du erwartest die unbewußte Leistung, nimmst du dir vor:
Das muß ich mir erst mal überschlafen.

Und du übergehst sie, wenn du hinzufügst:
Morgen sieht ja vielleicht die Sache schon anders aus.

Ich möchte sie nicht übergehen.
…

als ob ich beinlos sei für sie,
schreite ich sie nicht aus.

Ich möchte – bewußt? intuitiv? aktiv? ungeteilt? – bewußt!
der Autor auch meiner unbewußten Arbeit sein![17]
...

You expect the unconscious performance, do you imagine:
I have to sleep over that first.
And you pass it when you add:
Tomorrow maybe things look different.

I do not want to transfer it.
...

as if I were legless for her,
I do not go out with her.

I want – consciously? intuitive? active? undivided? – deliberately!
to be the author of my unconscious work!

Bert Papenfuß – once a central figure in the Prenzlauer Berg scene – observes in his 2017 poem, 'Schonen erweitert. Für Flip-out-Elke' (Extended Reprieve: To Flip-out Elke), that the poet has not changed since the 1980s: 'Elke Erb war, ist und bleibt ausgeflippt. Dem Teufel sei's gedankt' (Elke Erb was, is and stays freaked-out. Thank the devil).[18] Annett Gröschner emphasizes that Papenfuß's poem needs to be read as a homage. She states that in all Erb's poems, two discourses constantly meet: her unsentimental handling of the process of writing, and her attempt to break linguistic and societal rules.[19] Furthermore, Erb is searching for a dialogue with similar feminine aesthetics to hers. This is apparent, for example, in her *Unschuld* volume, which does not refer so much to the content and discussion of women's concerns, but rather reflects her predilection for the unfinished, for mixtures and for fragments – things that are sometimes regarded as feminine characteristics in writing.[20]

On the topic of women's writing and, in particular, on the special status conferred to her by others at the 'Men's Club' in Prenzlauer Berg, Erb assumed a somewhat reluctant position. This was chiefly because she did not like the clichéd title *Szene-Mutter*, which was rashly applied to her during GDR times. She succeeds in correcting Braun's dismissive view in an extensive essay on the avant-garde and feminism which was included in the 1995 volume *Der wilde Forst, der tiefe Wald* (The Wild Forest, the Deep Woods). Two years later, she discussed in an interview Braun's characterization in his 'Rimbaud' essay, and her attitude toward the 'princes of

the Prenzlauer Berg', as she satirically called them.²¹ The main purpose of this *Der wilde Forst* volume was to underscore the importance of poetry in times dominated by media attention and hostility towards the genre. Poetry conveys not only a counter-world but also acts as therapy. As Erb stated in an interview for the magazine *L'image* in 1992: 'Schreiben ist geistiges Atmen. Man kommt auf Dauer nicht damit aus, immer irgendwelchen Ersatz zu leben. ... Poesie [ist] für mich die bündigste und gründlichste Form der Erkenntnis' (Writing is spiritual breathing. In the long run one does not expect always to have any substitute to life. ... Poetry is [for me] the most buoyant and most divine form of knowledge).²²

In order to gradually come closer to the fundamentals of some of Erb's questions (rather than revealing answers, if there are any), and to approach her surrealistic core, it might be productive to have a closer look at the poem 'The Act of Writing', from *Winkelzüge*. An analytical exploration of this text facilitates clearer insights into Erb's poetics in the final decade of the GDR.

On the Act of Writing

As she was writing her poetry in a male-dominated culture, there have been attempts to label Erb a feminist. After a thorough investigation into her work, and after a profound interview in the *Women in German Yearbook* of 1997, however, Birgit Dahlke came to the conclusion that the poet could not be labelled as such. Nevertheless, Erb focuses on her gender and often presents an anonymous female person in her poems and commentaries. In the poem 'The Act of Writing', for example, the 'Heldin des Schreibens' (Heroine of Writing) is a core element, and symbolizes the writer's amazement and openness. This capability is essential and demands further exploration because it targets precisely an area where the two worlds which determine us coexist: the conscious and unconscious, 'x' and 'y' in the poem.

> Für das Schreiben als z gilt:
> x und y, das Unbewußte und das Bewußtsein,
> wirken aufeinander in z als zx und zy.
>
> Das heißt, das Schreiben,
> obwohl es ein bewußt geführter Prozeß ist,
>
> gleicht jedem anderen Zusammenhang,
> in dem x und y aufeinander wirken.²³
>
> For writing as z, the following applies:
> x and y, the unconscious and the consciousness,

act on each other in z as zx and zy.

That is, the writing,
although it is a deliberately guided process

is like any other context,
in which x and y interact.

The first stanza employs a vocabulary of science, reflecting Erb's great interest in that field's apparent hostility towards the arts – as can be seen in her commentary 'Die Physiker' (The Physicists) from 23 February 1977. How compatible is this 'other language' with that of poetry? The ultimate avant-garde ideal is the blending of life and art, and in an interview with fellow poet Gregor Laschen,[24] Erb proclaimed, 'Was ich schreibe, das lebe ich' (What I write, I experience).

> Ein gewisses Vergnügen tritt vor mich hin in der Erinnerung, mit dem ich vorgestern jenem mir recht unverständlichen Gespräch der beiden Physiker denn doch gefolgt bin, ein Behagen war es, so erkenne ich, an dem ungestörten Frieden, in dem sich diese Menschen in einer anderen (so wie mir) recht unverständlichen deutschen Sprache eine Weile unterhielten: Die dürfen das. ...[25]

> I feel some contentment when I recall how I overheard and decided to follow the two physicists' unintelligible conversation two days ago. It was the pleasure, I now recognize, in the undisturbed peace in which these people could communicate in their quite unintelligible German language for a short while. They are allowed to do so. ...

This commentary, published in 1978 in the volume of short prose and poetry *Der Faden der Geduld*, not only conveys Erb's tolerance of the exotic strangeness of scientific jargon, it also inveighs against the prevailing orthodox principles of GDR literary criticism, which proposed the eradication of any trace of ambiguity in the socialist Literaturgesellschaft (later renamed and redefined as Leseland DDR, or 'Reading country GDR').[26] Reviewers consistently accused Erb of wilful obscurity, owing to her – as they saw it – impenetrable poetic language. In the socialist realm, impenetrability was taboo. In the judgement of those state functionaries who kept their vigilant eyes on art and literature, Erb had made an inappropriate choice in following the wrong avenue of Germany's cultural heritage. As far as they were concerned, Erb had apparently recycled an outdated and anathematized Modernism. Some of her fellow writers expressed the fear that she would turn into a 'reservation of the *poésie pure*' (Volker Braun[27]) or behave

in an uncommunicative way (Christa Wolf[28]). Needless to say, Stasi officials had their own negative views of the poet:

> Die von ihr bisher erschienenen Gedichte und Prosaarbeiten befassen sich mit Alltagsproblemen, mit Erlebnissen aus der Umwelt, und sind intellektuell akzentuiert, zum Teil schwer verständlich. Gesellschaftskritische, politisch negative Aussagen und Haltungen werden meist nur angedeutet und verschleiert formuliert. Bemerkenswert sind ihre Übersetzungen und Nachdichtungen sowjetischer Literatur, die von ihr verfaßte Lyrik weist sie als mittelmäßiger Schriftstellerin aus mit wenig Originalität und Kreativität.[29]

> The published poems and prose deal with everyday problems, with experiences from the environment, and are intellectually accented, sometimes difficult to understand. Critique of the state, politically negative statements and attitudes are usually only suggested and hidden. Significant are her translations and indulgences of Soviet literature; her own poetry, however, shows her as a mediocre writer with little originality and creativity.

Positive views can be found in the writings of, and in the many statements of solidarity from, other colleagues, for example in lyrical portraits by Sarah Kirsch, Kito Lorenc and Adolf Endler. The literary reception of Elke Erb was and remains polarized.

In the poem 'The Act of Writing', the conscious and unconscious are not only accommodated in a single equation, they also influence each other in the process of writing poetry: 'Von den Zusammenhängen,/in denen x und y aufeinander wirken' (Of the relationships/in which x and y interact). This chain of associations produces a series of speculative connections. The process seems to develop itself irrationally: 'Sinn, den ich (zumindest beim Schreiben) nicht kenne' (the meaning, which (at least while writing) I do not know). The poem is the core of *Winkelzüge*, and it demonstrates a continuous vacillation of focus on the object-world and on the cracks in reality through which the absurd and grotesque appear – and apparently modify actuality.

Amid the politically turbulent changes in the late 1980s, Erb did something extraordinary. The new focus in her work was not a departure from the new conditions she identifies as strange and surreal. Nor was she tempted to imitate the (masculine) language of power. She anticipated the desire for a new reading and implementation, and thus provided an insight into her thinking during this culturally and politically hectic decade. This way of writing provoked amazement, bewilderment, doubt and anger. It also received praise and encouragement. The roads through the 'rubble of language' are reminiscent of procedural writing, similar to the poetry in Erb's volume *Kastanienallee* of 1988. In contrast to that volume, however,

the commentaries in *Winkelzüge* are not listed separately, but are woven into the structure of the text. Language – and, indeed, Erb's own language – is represented as a living entity that evolves like a body:

Aber begriffsstutzig
Kann ich Fiktion und Wirklichkeit nicht unterscheiden
Und bestehe orthodox auf ihrer Identität,
solange ich nicht Blut geleckt habe.[30]

But dumbfounded
Can I not distinguish fiction and reality
And insist on their identity and orthodoxy
as long as I have not tasted blood.

In her *Winkelzüge* poems, by not distinguishing between 'textual life' and 'life texts' Erb smashes literary-scientific taboos. At the same time, she is suspicious of the dangers of interchanging them. The 'heroine' who frequently appears in the poems is identifiable not only as a literary figure, or as writer or viewer, but also as a narrative or lyric ego. She builds on the linguistic structure into which the readers are to be drawn. 'Aber werde ich denn noch lieben?' (But will I still love?) she asks – an understandable fear in an unstable linguistic construct.[31] The heroine, the subject in the dialogues, is the product of writing because, for Erb, the act of writing is identical to living. In his analysis of the late writings of Paul Celan, Thomas C. Connolly asserts that life writing is also the key to this poet, who has been considered as unassailably par excellence. He argues that Celan's poems are 'both wounded by and seeking reality', and ask their readers 'at every encounter, to struggle for new realities and new meanings, to invent new constructions of knowledge'.[32] Erb is in a similar process of constant exploration, and rejects arranging recognized modes of comprehension or the status quo. Her poems ask their readers what they know, and so constantly challenge them.

Reading Erb's poems is made difficult by virtue of the fact that her idiolect is hard to decode. The various textual variants do, however, contain some constants, for example 'Die Schwarzen Seiten' (The Black Pages) and 'Die Zwölf Worte' (The Twelve Words). These act as signposts in a 'forest' of words, and link the many *Holzwege* (off-the-beaten-track pathways), but they do not offer the reader sufficient guidance. In order to get to the core of the 'text-life', Erb uses a question-and-answer system, as employed by computational linguists: linguistic actions are undertaken and analysed, and individual phrases or even morphemes are interrogated, rearranged, exchanged or, in some cases, discarded. At the same time, her language seems to become independent and freed from the syntactic standard – with

the aim only of revealing as many semantic cores as possible. The output therefore produces sentences which in turn act as new data – new material for sentence analysis. In this way, Erb simulates an active cognitive process, a stream of associations. Oddly enough, the fictitious, which derives its life from questions without answers, becomes the real. Erb's poems of the 1980s are never completed; instead, they are updated works, which continue into new texts. The questions (such as 'But will I still love?') are not answered directly, but postponed. The process of questioning humanizes the process, which, however, and to modify Dahlke's words, is infiltrating reality. At the end of 'Das Unternehmen Schreiben', life and writing are united in a constant criss-cross movement; thus, *Winkelzüge*. Writing and finding one's self are no longer separate units. There is no difference between autonomy in everyday life and in writing. The ideal of Surrealism seems to be restored in these 1980s poems when the paradox of 'offene Verbindlichkeit' (open liability) and 'verbindliche Offenheit' (binding openness) prevails. The *Denkbewegungen* set off a stream of associations and create a 'Wortland' (word land) with 'Wörter, die nicht feststellen' (words that are not determining), but instead ask new questions.[33] The result is an unstable yet productive concept that simulates a perpetual motion.

Flirting with Surrealism

Birgit Dahlke has conducted a close reading and thorough analysis of various volumes that Erb published in the 1980s, and she concludes that after the Wende, Erb's surrealistic project has continued – for example in *Sonanz* (2007). From 29 October 2002 until 9 July 2006, Erb set herself a daily exercise of writing down in five minutes, idiosyncratically and without specific purposes, whatever came into her head and under her pen. These are the qualities for which her audience loves her. Among the repetitive motifs, for four years Erb spontaneously wrote about her dreams, experiences, thoughts and obsessions. Manifested in the transcript, the poetic notes act autonomously. The poet confesses that the moment she wrote the verses,

> Erst während der Bearbeitung erkenne ich nach und nach, daß diese halbautomatischen Wortfolgen sogar aktuelle, schlechthin existentielle ebenso wie auch theoretische, Themen/Aufgaben behandelten. und zwar an einem Tag um den andern, fortschreibend. Hell und schnell, im Vergleich etwa zur Traumarbeit, geführt von Reiz und Lust.[34]

> Only gradually did I realize that these semi-automatic phrases even deal with current, absolutely existential and theoretical topics/tasks, bright and fast, in

comparison to the dream work, for example, which are led by stimulus as desire.

The notations echo the surrealist practice of écriture automatique. This technique was derived from the findings of Pierre Janet in his 1889 doctoral thesis on psychological automatism, in which he suggested a new therapy via automatic writing. Breton and Soupault incorporated and culturally adapted his insights in the first surrealist essay, 'Les champs magnétiques' (The Magnetic Fields), published in 1919 in their journal *Littérature* and a year later republished as a book. However, the entire issue of automatic writing, or writing under hypnosis or in a trance retrieving the unconscious, had already been questioned by the movement's own members in 1924, and by the majority of the followers of *Nachkriegssurrealismus* (post-war Surrealism) in both Eastern and Western Europe. Dream sequences in literature and, in particular, the interaction between the conscious and unconscious were considered to offer a more effectively subversive potency to the technique of automatic writing in surrealistic poetics.[35]

In *Sonanz*, Erb chooses a new format for her surrealistic writing – one that pulls together fact and fiction in an innovative way. Yet again, she manages to turn fiction into something alive. In the poems, we read about a lived life, which is reported in diary entries, on postcards and in notes about bus trips, walks and other everyday experiences and activities. Her lived life and thought-poetry are immediately linked. In contemporary German-language poetry, Erb's writing is in the immediate vicinity of new and established language virtuosi such as Mayröcker, Papenfuß, Kachold, Oskar Pastior, Ernst Jandl, Paul Wühr, Arno Schmidt and Ulrike Draesner. In the work of these fellow poets, the paradox of an apparently hermetically closed lyrical discourse demands an interaction with its readers and with colleagues from the European worlds of literature and art.

Isolated images and fragments of conversations and thoughts lack a rational framework. Put together, the isolated notes seem to create an illogical entity. Erb, however, manages to create a credible environment that instates its own rationality outside the real world, and at the same time adds its own logic. Whereas Endler seems to offer a programmatic surrealist concept (as discussed in Chapter 5), Erb manages to create a surrealistic realm by flirting with the main components of this historical avant-garde movement – as is illustrated by this seemingly untranslatable poem, which is very much in the tradition of the European avant-garde in its focus on graphic and phonetic features:

Langstieliges Gebirn Hirn flotte
Flagelaten Flotillen und gar Steinbrech

Saxifraga chrysostomos

Kringelhysrerien Mutteröden & noch & noch
kröteneiiges Gehex Gewäch Gelege
sonnenlos Unterlicht
... [36]

Long-stemmed brain brain-like fleet
Flagellates flotilla and even herbaceous plants
Saxifraga chrysostomos

Circle-like flourishing mother earth & again & again
Toady witchcraft bushy nest
Sunless under light
...

In Erb's 'semi-automatic phrases', an increasing number of strangers (and in some cases these are animals) get lost. Sometimes they introduce themselves as potential interlocutors, and manage to divert conversational situations, monologues and thoughts into new directions. The profusion of new texts in *Meins* (Mine, 2010) and *Das Hündle kam weiter auf drein* (The Little Dog Came Further Inwards, 2011), in which animals frequently appear, is striking. Thus, in the first poem in *Meins*, a dog barks in a neighbouring yard while someone reads texts of the 'difficult and incomprehensible' poet Stéphane Mallarmé. Erb insists that her writing always aligns with life, and with her verses, she re-energizes a surrealistic potential. The constantly renewed urge to innovate poetry is not only praiseworthy, but above all is typical for this poet, who has insisted since the mid-1960s that lyrical discourse is indispensable to everyday speech.

Conclusion

After reunification, Erb remained one of the most prolific German-language poets. Since the 1980s, for example, she has been represented in almost every issue of the West German *Jahrbuch der Lyrik*, with poems that introduced new aesthetic designs. And still, her almost-childlike curiosity exerts a mysterious influence on other colleagues, both young and old. Erb is a prolific writer in the most positive sense of the word. She travels the world, especially German-speaking Europe, and at a ripe old age applies herself to convincing her audiences that poetry should not be buried in a desert or left to moulder in an ivory tower. The attitude that the only concrete thing is the word was born of language and is contagious. The poetry of words, which

was once emphasized in the manifestos of the representatives of concrete poetry, was perfected by Erb in the second half of the twentieth and the first decades of the twenty-first century, and did not become extinct. On the contrary, their aesthetic principles ensured that *Sprachverfassung* (language composition), as Laschen once put it,[37] became the slogan when it comes to assessing Erb's poetry. For this reason, Erb's texts are among the liveliest and most innovative testimonies of contemporary German-language poetry. At the end of 2013, the announcement of a reading of her work in the Literaturwerkstatt Berlin received probably the highest praise, confirming that she is not only a poet but, rather, a poetic institution. Elke Erb is one of the most influential poets of her lifetime. Together with her many prizes, one of her highest accolades is that an assessment of her poetry was featured in issue 214 of the prestigious journal for literature, *Text + Kritik*, in 2017.

Erb's poetry is not a direct descendant of Surrealism, but it draws the reader into a hybrid world in which reality and the dream world, the conscious and unconscious constantly interact. Her verses always strive to discover new layers within reality. Erb faces the dilemma that life and art align: she writes about and ponders daily life(found) objects and conversations. However, the language she uses in her reflections is far from mundane. She confronts the reader with an array of philosophical thoughts that seem to contradict her initial discourse. The verses irritate and motivate at the same time, contributing to a poetic *perpetuum mobile* in which she has created her own contemporary Surrealism.

Notes

1. Elke Erb, *Mountains in Berlin*, Erb's volumes *Gutachten, Der Faden der Geduld* and *Vexierbild* are translated by Rosmarie Waldrop. (Providence: Burning Deck, 1995). Judgements according to Marc Lowenthal in *The Boston Book Review* and Mark Wallace in the *Washington Review*. See Georgina Paul, '*Unschuld, du Licht deiner Augen*: Elke Erb in the Company of Friederike Mayröcker in the Aftermath of German Unification'. In: Karen Leeder (ed.), *Schaltstelle: Neue deutsche Lyrik im Dialog*. Amsterdam and New York, Rodopi, 2007, 139–62; and Gabriele Wix, 'Elke Erb: Leben im Kommentar'. In: Steffen Poppe (ed.), *Elke Erb*. München: edition text + kritik, 2017, 3–11.
2. Nico Bleutge, 'Gedanken wie Reisig zu Füßen. Die Erkenniskraft des Gedichts – vier Umkreisungen zu Elke Erb'. In: Poppe (ed.), *Elke Erb*, 28–37 (31); and Birgit Dahlke, 'Avant-Gardist, Mediator, and … Mentor? Elke Erb', *Women in German Yearbook* 13 (1997): 123–32 (127). The term 'Werkstück' (from the Dutch *werkstuk*) relates to crafting and to the term 'Werkstatt' (studio), often used in the research on Erb. See the chapter 'Elke Erb. Wandlose Werkstätten' in my study *Grenz-Fallstudien*, 99–111.
3. David Hopkins, *Dada and Surrealism: A Very Short Introduction*. Oxford and New York: Oxford University Press, 2004, 65–78.

4. Birgit Dahlke and Elke Erb, 'Not "Man or Woman", But Rather "What Kind of Power Structure Is This?" Elke Erb in Conversation with Birgit Dahlke', *Women in German Yearbook* 13 (1997): 133–50 (149).
5. Erb, *Winkelzüge oder Nichtvermutete aufschlußreiche Verhältnisse*, mit Grafiken von Angela Hampel. Berlin: Druckhaus Galrev, 1991, 96–102 (99). All translations mine, with the help of Paul Clements. Ellipses added for copyright reasons.
6. Cf. Dawn Ades et al. (eds), *The International Encyclopedia of Surrealism*, 3 vols. London: Bloomsbury, 2019,
7. Friederike Eigler, 'At the Margins of East Berlin's "Counter-Culture": Elke Erb's *Winkelzüge* and Gabriele Kachold's *zügel los*', *Women in German Yearbook* 9 (1994): 145–61.
8. See Bathrick, *The Powers of Speech*, 239–40. In hindsight we know about the infiltration of and presence in the 'second culture' by the Stasi and their unofficial collaborators, or IMs for short.
9. See Volker Braun, 'Rimbaud. Ein Psalm der Aktualität', *Sinn und Form* 5 (1985): 978–98. See also Dahlke, 'Elke Erb', 124–25.
10. In the GDR, Brinkmann's poetry was published under the title *Rolltreppen im August* in 1986, in the publisher Volk und Welt's series *Weiße Reihe*.
11. Cf. Detlef Böhnki, *DADA-Rezeption in der DDR-Literatur*. Essen: Verlag Die Blaue Eule, 1989; and Erbe, *Die verfemte Moderne*.
12. Erb, *Gedichte und Kommentare*, eds. Jayne-Ann Igel et al. Leipzig: poetenladen, 2016.
13. Erb, *Der Faden der Geduld*, mit vier Grafiken von Robert Rehfeldt. Mit einem Gespräch zwischen Christa Wolf und Elke Erb. Berlin and Weimar: Aufbau Verlag, 1978, 43–48.
14. Christa Wolf, 'Gespräch mit Elke Erb'. In: Ibid., 109–41 (111 and 137).
15. 'Wortkrieg – Wortfrieden'. In: Ibid., 94.
16. See. Berendse, 'The Politics of Dialogue', 143–59.
17. Erb, 'Eine Woche Pause'. In: *Winkelzüge*, 233–37 (235). Ellipses added for copyright reasons.
18. Bert Papenfuß, 'Schonen erweitert. Für Flip-out-Elke'. In: Steffen Poppe (ed.), *Elke Erb*. Munich: edition text + kritik, 2017, 17.
19. Annett Gröschner, 'Zumutung. Meine frühen Erb-Lektüren'. In: Steffen Poppe (ed.), *Elke Erb*. Munich: edition text + kritik, 2017, 77–81.
20. See the essay by Georgina Paul mentioned in endnote 1.
21. Erb et al., 'Not "Man or Woman", But Rather "What Kind of Power Structure Is This?"', 137.
22. Quoted in *L'image*, 29 March 1992. Also see Jan Kuhlbrodt, 'Von der Beweglichkeit. Genre und Selbstreflexion bei Elke Erb'. In: Steffen Poppe (ed.), *Elke Erb*. Munich: edition text + kritik, 2017, 82–86 (84).
23. Erb, 'Das Unternehmen Schreiben'. In: *Winkelzüge*, 171–76 (171).
24. 'Selbstauskünfte: Was ich schreibe, das lebe ich auch'. In: Reinhard Rübenach (ed.), *Jahrbuch Peter-Huchel-Preis 1988: Elke Erb*. Moos and Baden-Baden: Elster, 1989, 41–56 (42).
25. Erb, *Der Faden der Geduld*, 77–79 (77).
26. Helmut Peitsch, 'Leseland'. In: Michael Opitz and Michael Hofmann (eds), *Metzler Lexikon. DDR-Literatur. Autoren – Institutionen – Debatten*. Stuttgart and Weimar: Metzler, 2009, 189–91.
27. Braun, 'Rimbaud'. After approximately thirty years the poet Bert Papenfuß (together with Ronald Lippok) reflected on this conflict in *Psychonautikon Prenzlauer Berg*. Fürth: starfruit publications, 2015, 85–95, and in his poem mentioned above.

28. Wolf, 'Gespräch mit Elke Erb'. In: Erb, *Der Faden der Geduld*, 109–41.
29. Report on Erb from 1981 by Stasi officer Hauptmann (Captain) Pahl: BStU, MfS, BV Bln, Abt. XX Nr. 1509, 4.
30. Erb, 'Sie stirbt, sie stirbt nicht'. In: *Winkelzüge*, 16–17.
31. Ibid., 9 ff.
32. See Thomas C. Connolly, *Paul Celan's Unfinished Poetics: Reading in the Sous-Oeuvre*. Cambridge: Legenda, 2018, 8.
33. Erb, 'Das Unternehmen Schreiben'. In: *Winkelzüge*, 171–76 (173); and *Sonanz. 5-Minuten-Notaten*. Basel and Weil am Rhein: Urs Engeler Editor, 2007, 30 and 208.
34. Erb, 'Vorbemerkung'. In: *Sonanz*, 7.
35. Cf. Elza Adamowicz, *Surrealist Collage in Text and Image: Dissecting the Exquisite Corpse*. Cambridge: Cambridge University Press, 2008.
36. Erb, '***'. In: *Sonanz*, 205. Ellipses added for copyright reasons.
37. Gregor Laschen, *Lyrik aus der DDR. Anmerkungen zur Sprachverfassung des modernen Gedichts*. Frankfurt: Athenäum-Verlag, 1971.

Chapter 8

GABRIELE STÖTZER UNDER SURVEILLANCE

Feminism and the Avant-Garde

While it appears to have become a matter of general agreement that being a part of the East Berlin – or any other urban East German – underground scene automatically bestowed the status of a (neo-)avant-garde artist, Kaiser and Petzold are more careful in their analysis, and consequently more accurate. In their informative catalogue *Boheme und Diktatur in der DDR* (The Bohemian Scene and Dictatorship in the GDR, 1997) they draw attention to the hazy area between official GDR art and its alternative in the underground: 'Vor allem von 1971 bis 1976 sowie ab der zweiten Hälfte der 80er Jahre sind ... die Schnittmengen und Unschärferelationen zwischen offizieller und inoffizieller Kunst und Kultur beachtlich' (From 1971 to 1976, in particular, and from the second half of the 1980s, the interconnections and uncertain relations between official and unofficial art and culture are considerable).[1] For this reason, I propose to take a closer look at the particular narrative of each individual before coming to any conclusions. As well as the work of known contributors, such as Anderson, Papenfuß, Endler, Erb, Cornelia Schleime and Katja Lange-Müller, it is necessary to evaluate the artistic quality of the products of individual participants in any bohemian scene or semi-legal underground scene.[2] As a further investigation into the link between women, this chapter is dedicated to, and will examine the particular aesthetic ideas of, another female writer and visual artist, the Erfurt-born Gabriele Stötzer. In the 1980s, Stötzer published and exhibited under the names Gabriele Kachold, Kachold-Stötzer and Stötzer-Kachold. After reunification she used the name Stötzer only. As in previous chapters, here it is my intention to review the surrealistic elements in her work. She

was one of many nonconformists who in the 1980s dedicated their work to the neo-avant-garde, and particularly to recycling Dadaism and Surrealism. Her particular focus, however, was a radical feminist approach, which ran counter to both the accepted image of women in GDR society and to the countercultures of the 1980s.

As discussed in Chapter 7, while Elke Erb's poetry was not a clearly defined linear descendant of Surrealism, it draws the reader into a world in which reality and dream, the conscious and unconscious interact and expose new layers of reality. In this way, Erb created her own discrete Surrealism. As we saw, this recycling met with the disapproval of many of her peers and was, indeed, stigmatized as *poésie pure* (Braun). In other quarters, her work was seen as an expression of solidarity with what Biermann later called the 'spätdadaistische Gartenzwerge mit Bleistift und Pinsel' (late Dadaist garden gnomes with pencil and brush).[3] The aim of this chapter is to identify traces of Surrealism in Stötzer's writings. At the same time, her visual work, in particular her short Super 8 movies, in which she combines formal experiments and radical feminist ideas, will be examined. Due to both aspects, her radical feminist tendencies and the experimental nature of her artistic work in the 1980s, the Stasi kept her under surveillance with a code name, 'Toxin' – a designation deliberately selected to indicate her alleged subversion and her venomous influence on others. During the post-Biermann era, in a climate of paranoia, the Stasi labelled many artists and writers who displayed dissident tendencies with code names alluding to hazardous substances, monsters or deceitful figures from religion or mythology. Elke Erb's code name was 'Hydra'.

Modernism and the avant-garde lay behind Stötzer's subversive power. Their influence, which the official GDR cultural authorities greatly feared, spread throughout the entire bohemian subculture. In the eyes of the established order, Stötzer had already 'misbehaved' in the 1970s when she was involved in the protest against the forced expatriation of Biermann. She was classified as one of the 'feindlich-negative Kräfte' (hostile and negative forces) in the GDR, and was arrested, tried and imprisoned.[4]

Stasi Presence and Practice in the 1980s

In 1997, the British historian Timothy Garton Ash published *The File*, and for the first time the work of the Stasi was introduced to a wider English-speaking audience in a popular and non-scholarly way. *The File* refers to Garton Ash's personal history, as recorded in Stasi reports of the late 1970s and early 1980s, when he was a student at the Free University in West Berlin and Humboldt University in the East. After reading his files, he realized

that the observations of the Stasi and his entries in his own diary were two versions of the same life and that, surprisingly, the surveillance should not simply be seen as something undesirable:

> The 'object' described [i.e. young student Garton Ash] with the cold outward eye of the secret policeman and my own subjective, illusive, emotional self-description. But what a gift of memory is a Stasi file. Far better than Proust's madeleine.[5]

The most distressing consequence of any state surveillance must be the fact that after reading their files, people have been confronted with the painful truths that friends, colleagues, neighbours or even family members had betrayed them. With regard to the alleged conspiracies among the East German literary and artistic groups, similar surprising betrayals are to be found in the painstaking reports of the so-called IMs, or Unofficial Collaborators. In the final decades of the GDR's existence, however, there was a change of focus by the authorities when it came to preventing intellectuals, writers and artists from participating in the recycling of the avant-garde and Modernism. The established order perceived the cultural danger that the 'poison' would be disseminated and would strengthen the ideological 'enemy' – to use the Cold War terminology of the Stasi.

Alison Lewis has investigated in detail the difference in approaches to the 'enemy' of Erich Honecker and Walter Ulbricht. In her study *Die Kunst des Verrats* (The Art of Betrayal, 2003), she emphasizes the secret police's zealous determination to restrict the many countercultural activities in the Prenzlauer Berg scene.[6] Since the GDR saw no distinction between artistic and political deviance, a new approach was introduced to contain the supposedly infectious threat more effectively, and to divert the so-called *Zersetzung* (subversion). It became imperative to prevent the possible undermining and eventual elimination of the political status quo. Under Honecker the introduction of new laws – such as the Zollgesetz (Customs Act), the Druckgenehmigungsgesetz (Print Authorization Act) and the Devisengesetz (Foreign Exchange Act) – was combined with the activities of the IMs, whose purpose was to infiltrate groups and to isolate individuals. This strategic combination of statutory prohibitions and *Operative Personenkontrolle* (operational person control) was intended to minimize the scope of alternative artists and writers, to censor and, thus, to prevent their threat to the prevailing dogma of Socialist Realism.[7] Principally because of its unpredictability, the danger deriving from the art scene – or in the case of Garton Ash, foreign intellectuals – was much harder to contain than straightforward political nonconformity.[8] The greatest fear of the GDR was a latent countercultural movement that could lead to events as powerful as

the 1956 uprisings in Budapest or the Prague Spring of 1968 – politically motivated upheavals against a striking cultural backcloth, as discussed in Chapter 3. But even when facing the strength of this kind of rebelliousness, the GDR learned from the Nazi's mistakes in the area of cultural politics. They avoided labelling art and literature which was not in line with the official ideology as 'degenerate'. That said, as we saw in Chapter 1, in the late 1940s and early 1950s, during the so-called Formalism Campaigns, there was a hint of demonizing the offshoots of the avant-garde when terms such as 'decadent', 'bourgeois' and 'non-socialist' were employed in order to condemn any culture that departed from the Socialist Realism doctrine.

Never in a position to assess artistic quality, the Stasi often commissioned experts to write a *Gutachten* (appraisal) on works of interest to them. These reports were often too complicated for laypersons to understand, either because of their ambiguity or their susceptibility to a variety of ideological interpretations. The Stasi's paranoia regarding a potential overthrow of the political system, even by those they convinced to work for them, seemed to be the dominant motif. They considered that the only objective method for containing the allegedly subversive actions of artists and writers was undercover observation, systematically carried out by the Stasi through their unofficial collaborators, who were familiar with the various alternative art scenes. From the evidence of the Stasi records, it is significant that Stötzer – along with Erb and other female writers – were under permanent surveillance by those they trusted. One of the many files on the Erfurt artist and poet states: 'Alle bekannten Personen werden auf Grund von Aktivitäten im Rahmen einer politischen Untergrundtätigkeit unter künstlerisch tätigen Personenkreisen operativ bearbeitet' (All known persons are treated on the basis of activities in the context of a political underground activity among artistically active groups of people).[9]

From the late 1980s, Stötzer was under watch because she was part of a movement called 'Frauen für Veränderung' (Women for Change).[10] In the files relating to the underground and subcultural activities of the post-Biermann phase of the 1980s – particularly in the art scene in Erfurt – there are only occasional references to her and the group's work, because the files mainly consist of reports from non-experts and people outside the in-group who seemed to focus solely on contacts with Western individuals and agencies. Consequently, nothing of any significance was reported on the content of one of the most suspicious projects: video art. The creation of Super 8 movies was very much linked to the application of avant-garde aesthetics in a realm dominated by Socialist Realism. Almost all Stötzer's creative output embodied radical approaches. These included not only the radicalism of her emphasis on displaying femininity, but also the breadth of her use of artistic media, including writing, etching, engraving, weaving,

screen printing, pottery, photography, punk music and video art, in the form of Super 8 film.

In the second half of the 1980s, the distinctions between visual and textual underground culture – or any other art forms for that matter – became redundant. At the same time, the perception grew that the gradual disintegration of the Socialist Realist dogma was in the air. In the sphere of the visual arts, the avant-garde was identified as something unfamiliar and exotic:

> In zunehmendem Maße versuchen feindlich-negative Kräfte mit der Zielsetzung, sich dem Einfluß der Partei bzw. der Arbeit des Verbandes Bildender Künstler zu entziehen und bürgerliche, den sozialistischen Realismus fremde Kunstrichtungen zu propagieren, private Ausstellungen in Ateliers und Privatwohnungen zu organisieren.[11]

> Increasingly, hostile-negative forces attempt to escape the influence of the Party or the work of the Association of Visual Artists and propagate bourgeois art movements alien to Socialist Realism. Private exhibitions in studios and in private homes take place.

In the visual arts, the old vocabulary of the Formalism debates (as discussed in the first three chapters) was trotted out once more, as we read in discussions of 'the bourgeois-decadent' stance of these artists who rejected the ideal of Socialist Realism as the theoretical foundation of their work. In both the numerous unofficial observations and in official reports there is mention of 'constant attacks against the principles of Socialist Realism'.[12] Their growing fear and increasing paranoia in the 1980s compelled the Stasi to set their IMs to work. In their ideological game of cat and mouse they clung to the belief that Socialist Realism was an eternal concept, or at least one that prevailed from its birth in 1932 until its demise in the late 1980s. Karin Thomas, author of *Kunst in Deutschland seit 1945* (Art in Germany since 1945), justifiably asserts that from about 1980, the cultural dogma of Socialist Realism disintegrated and was replaced by the somewhat simpler concept of 'socialist art, which could, in some cases, include non-realistic art.'[13] Although the boundaries between music, textual and visual cultures became blurred in the 1980s, the deputy minister of culture, Klaus Höpcke, who was responsible for GDR fiction and for the running of the country's publishing houses, rejected a *nurkünstlerische* (merely artistic) literature.[14] This, in other words (and as we read previously), was what Braun sneeringly called *poésie pure* in his 'Rimbaud' essay – although, of course, no connections between Braun and the Stasi are suggested. The central question was how to combat effectively the hostile and negative Western tendencies, or any other kind of influence on the alternative art scene in the GDR.

A closer look at the files on Stötzer and her fellow critical and experimental artists in the final years of the GDR reveals that the collapse of 1989 was, paradoxically, neither foreseen nor completely surprising. Many reports of the HA XX (Hauptabteilung or Main Department XX), which was mainly responsible for fighting the political and artistic underground whose presumed intention was to undermine socialist ideology in the arts, note that the political potency and authority of the established associations in the world of the arts and literature were crumbling. HA XX members reported on the absence of leadership or any guidelines in the Akademie der Künste der DDR (Academy of Arts of the GDR). They further noted the waning of commitment to tradition and to the principles of Socialist Realism, and concluded that a combination of these factors would eventually lead to misunderstandings and become 'one of the causes of a lack of political-ideological disputes' within the realm of the SED, leading eventually to the total absence of creativity.[15] The cultural breakdown preceded (and perhaps even caused) the subsequent total collapse.

As more women than Stötzer alone can confirm, in the area of gender issues the GDR was a biosphere of bigotry. There were two underlying strands contributing to Stötzer's difficulties in publicizing and applying feminist ideas in her work. Firstly, the GDR authorities saw feminism as an intellectual movement emanating from the West. Secondly, and somewhat surprisingly, her extreme ideas and unconventional, radical feminist compositions were not welcomed within the confines of the underground. For this reason, this chapter will continue with a general investigation into the way male chauvinism dominated some European and US American countercultures over time. Later, the focus will shift more specifically to the GDR and to Stötzer's work in relation to neo-avant-garde art. It needs to be emphasized, once more, that neither Surrealism nor any other avant-garde movement manifested itself as a fully formed cultural entity. But what I have previously termed 'surrealistic traces' or 'echoes of Surrealism' may be identified as a counter to the stillborn and simultaneously mind-numbing doctrine of Socialist Realism. Although not actively promoted, the influence of Surrealism lurked just beneath the surface. The constant shift between the real and the unreal undermined the official doctrine's sacred cultural status and stability.

Women and the Avant-Garde: A Short Cultural History

The affiliation of women to an avant-garde group did not protect them from various forms of harassment – in particular, psychological harassment. In theory, working within a fashionable artistic movement was to encourage

teamwork on many levels, mixing genres and styles with men and women alike. This cultural 'mayhem' was not only viewed unsympathetically – even aggressively – by the mostly male-dominated authorities, who felt their power to be under threat; interestingly, it was also attacked by some of the male group members.

In 1986, the East German Romanist and connoisseur of Surrealism Karlheinz Barck argued that 'Die Surrealisten waren eine Männergesellschaft' (the Surrealists were a men's club).[16] This oft-repeated cultural and historical judgement was expressed at a time when the GDR was about to create its own dynamic (neo-)avant-garde groups in many major East German cities – a phenomenon unique in Europe. Regrettably, as far as gender issues were concerned, the twentieth century closed in a largely similar fashion as it had begun, since gender inequality prevailed, including in the cultural spheres. Here, the new urban avant-garde groups in the GDR mirrored both the historical avant-garde and the persistent strands of misogyny in our modern society. Peter Böthig, Klaus Michael, Birgit Dahlke and Antonia Grunenberg have thoroughly examined the uniqueness of the vivid (neo-)avant-garde.[17] Dahlke and Grunenberg in particular have examined the ways in which the new East German movements mirrored the historical avant-garde. If one acknowledges the literary avant-garde as part of a subculture which not only departed from conventional cultural norms, but also challenged or destroyed what was seen as socially acceptable and, further, defined new areas for communication, then these characteristics may also be found in the so-called Prenzlauer Berg Connection.[18] With reference to the history of a variety of avant-garde movements, however, it is more than a little surprising that they can also be found to embrace certain inherently ultraconservative and chauvinist elements. To put it plainly, at the point when the avant-garde is defined as an alternative culture, it nevertheless reveals itself to some extent as reflecting generally prevailing social conditions. This is starkly revealed in issues of gender stereotyping, however much a commitment to cultural innovation is otherwise assumed. In his study *Comparative Youth Culture* (1985), Michael Brake argues that there are no signs of emancipatory gender restructuring in many subcultures. He denounces the autonomy of subcultures as a myth, and maintains that the subcultures which arose from the rebellion of sons against their fathers around 1900 do nothing more than mirror 'sexism in society' and render women 'invisible':

> If subcultures are solutions to collectively experienced problems, then traditionally these have been the problems experienced by young men. Consequently, youth culture is very concerned with masculinity. Even where ethnicity complicates subcultural membership, black and brown males turn

to an emphasis on masculinity. As a result, subcultures are male-dominated, masculinist in the sense that they emphasise maleness as a solution to an identity otherwise determined by structural features. ... Here women are also seen as peripheral.[19]

Brake is concerned with the analysis of contemporary youth underground groups in general. In Germany, the origins of women's relationships with the artistic avant-garde of the 1920s – itself a product of various subcultures – have been explored by Inge Stephan, Sigrid Weigel and Marlis Gerhardt, among others.[20] These authors confirm that the historical avant-garde can be defined as a male-dominated movement of revolt, a result of the *fin de siècle* father–son conflict. Women were either cast out from the centre of this artistic rebellion or, more likely, not permitted even to approach it in the first place. Instead, they were tolerated as peripheral spectators and allowed to watch the men prepare for the revolt. As soon as a woman abandoned her decorative role, either as a cultural groupie or – metaphorically speaking – a Harley Davidson pillion rider, and began threateningly to approach the centre of agitation as author or artist, she was subjected to stereotyping intended to put her back in her proper place. 'It's especially the avant-garde movements of this century', writes Gerhardt, which have 'in an extraordinarily persistent way retained the images of Madonnas and whores'.

The Russian poet Anna Akhmatova is an unhappy example of a woman falling victim to this kind of pigeonholing. In the first decade of the twentieth century, Akhmatova was without doubt worshipped (thus, a Madonna) by the members of the avant-garde gents' club – in her case, the so-called Acmeists: Osip Mandelstam, Nikolay Gumilev and others.[21] At the same time, she was accused of intellectual prostitution (and characterized by many of her male peers as a 'whore'). In both cases, her female voice was denied by the males in the avant-gardist group.[22] In terms of giving expression to a female aesthetic, all that was left to the 'tamed' woman writer was a feminization of each of the males' signature writings. Other examples of such marginalization may be found in the cases of Hannah Höch in Dadaism and Diane Di Prima during the activities of the beat generation in the USA. It is, however, conspicuous that the act of imitation helped women to create an identity for female artists, and led to their finding their own female voices.

The issues raised above are associated with the concept of mimicry. 'Mimicry' is the subject of Susan Suleiman's perceptive study *Subversive Intent*,[23] in which she moves beyond the deplorable situation of women as victims of discrimination in the avant-garde by exploring the positive features emanating from their outsider status. Suleiman interprets this as

contributing to the female writers' subversive intention. In conversations with Marguerite Duras and Xavière Gauthier, she explores their status both as women and as artists: a twofold marginalization. Historically, women have been on the periphery of the avant-garde; but for Suleiman, is it only possible to lay siege to the centre from the outside, as the German visual artist Höch and the American poet Di Prima did. And only when there is a conjunction of both male and female discourses does a 'total' avant-garde find its expression.[24]

Hannah Höch was the only woman among twenty-seven artists participating in the 'DADA-fair' in 1920; the DADA men referred to her 'monastic gracefulness'. Höch made mimicry productive by creating a poetic of the 'third gender'. She illustrates this process powerfully in her photomontage *Schnitt mit dem Küchenmesser DADA durch die letzte weimarer Bierbauchepoche Deutschlands* (Cut with the Kitchen Knife Dada Through the Last Weimar Beer-Belly Epoch in Germany), which she produced exclusively for the exhibition at the Berliner Kunsthandlung Otto Burchard.[25] Imitating the photomontage techniques of her male colleagues, such as Heartfield and Grosz, she responded aggressively to the sources by cutting up single male figures and adding them to female icons of everyday life. In this way her montage displays a provocative androgyny.

Thirty years later, the beat generation's only female poet, Diane Di Prima, produced her own original poetry of deviance. In the middle of the 'beatitude', she rejected the romanticized clichés of the bohemian life in the USA of the 1950s by describing men who sought either *On the Road*-style macho adventures (à la James Dean and Marlon Brando) or reproduced the howls of the other writers of their generation. One component of the romanticized cliché was that women, in the course of their sexual liberation, could be relegated to the status either of disposable goods, or at best, of mothers. It is precisely this attitude which may be found in the poetry of Gary Snyder, for example, who disseminates the notion of a macho cult. Di Prima transforms this point of view in her own work. Focusing on physicality, she describes her surrender to a man and her sexual activity in a 'cool' way, and investigates the ensuing consequences of sex, about which the beatniks, who she exposes as playboys, don't want to know. An example may be found in her minutely detailed description of the painful details of an abortion.[26] The liberation of women from male stereotyping and their existence as equal beings are here achieved by the denial of the roles of Madonna or Whore. The clichés are not immediately cast away, however; they are at first accepted, and then submitted to rigorous intellectual interrogation and analysis. What emerges is the image of the woman as a 'subversive' hybrid, blending both human and animal characteristics. We find the same transfiguration in Stötzer's female images in her fiction and films.

In Undine's Name

In the GDR of the late 1970s, in response to a confused climate of simultaneous political rigidity and intellectual impotence – and in the tradition of other international countercultures, even the USA's beat generation[27] – a new cultural scene began to take shape. Its target was the traditional art canon, and exhibitions in private residences, an independent music scene and Super 8 film screenings became the battleground. These East German alternative or underground scenes were also dominated by men. The anthology *Berührung ist nur eine Randerscheinung* (Touch is Just a Marginal Phenomenon, 1984), edited by Elke Erb and Sascha Anderson, is a good example of male domination in the new avant-garde, since it principally featured young bohemian men from the 1980s urban scenes. Of a total of twenty-nine avant-gardists, only four women were represented: Lange-Müller, Schleime, Kachold and Christa Moog. As co-editor, Erb seemed to be apprehensive when it came to equality issues, since she did not draw attention to the under-representation of female writers and artists in the anthology. In 1997, Dahlke observed that

> the category of gender seems not to have played a role in Erb's thinking and writing. ... The relationship between the particularities of the text and the author's gender went beyond the scope of Erb's analysis[28]

Further, as Dahlke concludes in her long interview, Erb does not express an interest in the issue of feminism.[29] Erb refers only once to one of the four female authors whose work appears in the anthology, and that is Gabriele Kachold, who would later publish under her maiden name, Stötzer.[30] Stötzer's reputation on the East German art scene as a radical feminist excluded her from the Prenzlauer Berg men's club, which was clearly not to be a refuge for all dissident voices. Stötzer was denied access to the inner circle of the Prenzlauer Berg Connection; but at the same time, owing to her radical feminist activities, she did not imagine that she would be admitted. To put it another way: Stötzer was obstinate! By constantly changing roles, she intended to avoid being accepted into an East Berlin counterculture that had – in the eyes of the West, at least – become a temple of artistic expression. At least four of Stötzer's avant-garde strategies are evident in her counter-attack against both Socialist Realism *and* the GDR's 'institutionalized' neo-avant-garde. She aspired to be more avant-garde than the East German neo-avant-garde, which as far as she was concerned had already become 'acceptable' by the late 1980s. She tended towards a surrealistic attitude. Her tactics were as follows:

(1) Bridging Art and Life: the violated female subject of her texts – as in 'unbehaust' (homeless) from the 1989 volume *zügel los* (Unrestrained) – who

is endowed with all the characteristics of the existential outsider, calls for the crossing of the borders between the fictitious (the artificial aestheticized female figure) and the empirical (the woman existing in the real world).

> das haus ist mein bauch, ich habe euch den schlüssel dazu gegeben, damit ihr euch die tür öffnen könnt. ihr habt die tür aufgestoßen und die fenster eingetreten, was ihr für brauchbar hieltet mitgenommen, ihr seid durch die räume gegangen mit den blicken nach eigentum, das ihr besessen wolltet. … wenn ich gegangen sein werde, werdet ihr mich suchen, in jedes stinkende loch steckt ihr eure nase und euren schwanz und eure hände mit der sehnsucht nach lust. geilheit in den lüften ohne namen, ausgetrockneter samen an den rändern wegloser straßen, noch in euren skeletten trag ihr eure sehnsucht nach berührung unter die erde.[31]

> The house is my belly, I gave you the key to open the door. you have opened the door and the windows have entered what you thought was useful, you have gone through the rooms with the search for property that you wanted to own. … when I am gone, you will seek me, in every stinking hole you put your nose and your tail and your hands with the longing for lust. horny in the air without names, dried-up seed on the edges of trackless roads, even in your skeleton you carry your yearning for contact under the earth.

Stötzer employs the imagined violence and destruction in this prose text both in acts of actual physical violence and in an indictment of the patriarchal society. Further similar examples are to be found in her prose texts, which since 1983 have served as the basis for performances by 'Undine', the Erfurt theatre group which was founded by Stötzer. These performances, incidentally, were consistently boycotted by the male-dominated East Berlin art scene.[32]

(2) Variety in Style: this double strategy reappears in a different manner in the composition of individual texts in Stötzer's work. Her collections can be read as a conglomerate, assembled from a variety of other texts. This is particularly noticeable when she alternates between two contrasting styles of writing: the provocative or 'evangelical' prose (as in 'unbehaust') and the poetry that is critical of language itself (as in 'harun et horun'). In her perceptive critique of Stötzer's *grenzen los fremd gehen* (Limitless Fornication, 1992), Dahlke observes that the reader has to negotiate between two contrasting registers (as in 'Undine' and *zügel los*, both published in 1989). Dahlke claims that a contradiction can be observed between a programmatically expressed claim to sensuousness and desire, and their strange, arhythmical-monotonous, un-erotic *Gestus*.[33]

(3) Alternating Discourses: in some cases, this deliberate contradiction is combined in a single text, as in the prose poem 'das gesetz der szene' (The

Law of the Alternative Scene), originally published in 1988 and added a year later to Stötzer's volume *grenzen los fremd gehen*. Here, Stötzer imitates the rhetoric of the alternative scene by decoding prefabricated signifiers into unrecognizable ones – without using any punctuation, of course – only to parody them immediately afterwards and to erect warning signs directly before the gates of Prenzlauer Berg.

das gesetz der szene
ist untergetaucht für die oberwelt verloren gestorben geboren
einer anderen gottheit die verführung weiß
die weißen linien aus dem hinterkopflochwegen gehen augenlos die
mögewege lang bekommen fremdhände fremdmünder

...

achtung hier ist szene
achtung hier machen alle alles
achtung hier werden federn gerupft
hier wirst du entwürdigt wie noch nie ...[34]

the law of the scene
was born submerged for the world over lost
another deity knows the seduction
the white lines out of the behind the headhole go the eyeless
long ways get alien mouths

...

Attention here is scene
be careful here everyone does everything
Attention here feathers are plucked
here you will be degraded like never before ...

(4) In Praise of the Hybrid: we encounter the principle of alternation in the form of an individual literary woman: the venerable hybrid figure Undine. The crossing of frontiers can be found in several of the prose texts in which she appears. Following in the tradition of Friedrich de la Motte-Fouqué, E.T.A. Hoffmann and, later, Ingeborg Bachmann, Stötzer makes use of the form of Undine, who, as both nymph and femme fatale, embodies the denunciation of men. Paradoxically, however, it is precisely these men who are her source of life. The wild nymph Undine only assumes human form and acquires a human soul when she marries the knight Huldbrand. But she remains within her element – water – and consequently refuses to be socialized in any way. This coming and going, this enigmatic mystery in a

woman is also what makes her attractive, however. The motif in Bachmann's story 'Undine geht' from 1961 is expressed in a narrative that not only tells a story, but also reflects upon itself. This motif is also to be found in Bachmann's novel *Malina*: the 'I' can prove itself only in the rhythm of approaching and renouncing male antagonisms. Stötzer's 'undink' (absurdity), with a direct reference to Bachmann in the opening sentence, drives the non-existence of place to the extreme when the Undine figure herself dissolves into many identities: 'undine leaves, says undine to undine.' The figure of Undine has no fixed, autonomous identity, because Stötzer is reluctant to reduce her to a single female role. This transitory programme is summarized in the cycle *zügel los*:

> sie war der igel mit den stacheln zwischen den zähnen, am mund, aus der nase und zwischen den händen. sie war immer schon dagewesen und doch nie da, konnte es begreifen und hielt doch nie etwas in der hand, die freunde verließen sie nackt … alle worte verloren für sie wie alle tage und freundinnen ihren rahmen, alles war beliebig, der richtungsort verschiebbar, nichts rasselte im karton, und die war sicher eine kalte freundin wie geliebte, die bilder-buchobjekte suchte, die einfach blödsinnigerweise sah, schielte und schalt.[35]

> she was the hedgehog with the spikes between her teeth, on her mouth, coming out of her nose and between her hands. she was always there but not really there, could understand it and never held anything in the hand, the friends left her naked …. all the words lost their frame for them, like all the days and friends, everything was arbitrary, the direction slid, nothing rattled in the carton, and that was certainly a cold friend like beloved, looking for picture book objects, which just stupidly saw, squinted and scolded.

This subjective insight into the East German alternative art scene, and the denunciation of the Western brand of feminism, is dominated by feelings of aggression and disappointment. Stötzer seems to be pushed to the periphery, and she fights back. In her eyes, the underground scene's cohesion is disintegrating, not so much thanks to the so-called *friedliche Revolution* (peaceful revolution) of November 1989, but to a much earlier self-destructive vigour.

Surrealism and Super 8 Film

In a letter to Christa Wolf, Stötzer admitted that she was searching for the ultimate female persona, who, having transformed the status of the outsider into the potential for a complete denial of male dominance, existed in her poetry and prose.[36] As an opponent of both the alternative scene and,

simultaneously, of the status quo in the GDR, she identifies with the subversive mischief of the fictional character Undine. She frequently exchanges the roles of victim and protagonist, and of woman and man. Further, by virtue of her variation between apparently mutually exclusive writing styles, she conceals her own identity as a writer. There is, however, a price to pay for speaking in strange tongues. Those writing the literary history of East Germany are not at ease with Stötzer. Western literary historiography also largely ignores her work. There are understandable reasons for her exclusion from serious critical analysis. One such reason may be the fact that in the radical tensions between the different registers in some of her texts, meaning is completely obscured. The crossing of frontiers, which Hans Mayer calls the 'archetype of the spoiler' in his standard work *Außenseiter* (Outsider, first published in 1975), was probably the only possibility in the GDR for keeping the promise to speak a 'new free language'.

Alongside Heiner Müller, Christa Wolf and other writers who had been either arrested or harassed by the state during or after the expatriation of Biermann, Stötzer chose to remain in the GDR. These writers were among many who, in spite of the cultural and political restrictions placed upon them, retained their loyalty to their Marxist beliefs.[37] In common with her opponents, particularly those in the Prenzlauer Berg Connection, Stötzer selected a narrative voice that seemed to operate almost as a secret code, known as *Kwehrdeutsch* (athwart German).[38] Patterns of conflict were revealed, in the main, on a linguistic level, where the government's homiletic discourses of everyday functional Socialism had to serve as a template. The language of power was then deconstructed and distorted beyond recognition. The result was that in the language laboratories of East Berlin, avantgarde writing could be received and comprehended almost exclusively by a small in-group, a coterie whose members were trained in literary theory and philosophy. The poem 'harun et horun' serves as an example of this 'new free language'. In its apparently untranslatable verses, the vulgate of ancient Erfurt, the incantation of magic spells and Thuringian dialect are infused and fermented into a kind of witches' amalgam. The end product reads like gibberish:

harun et horun ni sanktu ketrorum

...

rega ni lega nu voti et randum tschi bello vik taram un tschento mik tau
brikta et nogi es tscharum vik kolti in renta du schenka min jana off nand

ekta tu verdi tschandri di hebi ni nogi di vegi an rondu tintschau
un rondu di velo du rambi ün nega ab tarra us jüga imrandu
vok damo die miso in räntu ik vergü tumscha in rau
hak tamte in ventu im mundo di vello in randi tschanta um hanta bellrondo
hin tunti ik vega nu gassa due lega min hindu di fassu un tragu in grab[39]

The verses relate to two medieval magic spells, written in Old High German: the *Mersenburger Zaubersprüche* (Merseburg charms), in which figures of repetition are preferred in order to generate magic powers. At the same time, the Erfurt poet transposes the old German to the present and imitates the *Kwehrdeutsch* favoured by her male Prenzlauer Berg adversaries, who mutilated individual words to the point of incomprehensibility until they found their place on roughly the same level as the *Parteichinesisch* (Party gobbledegook) of the SED. This experimental style of lyrical poetry, published only after reunification, relates to the language of that sage of the 'other' literature, Papenfuß – better known as Bert Papenfuß-Gorek in the second half of the 1980s. This new adopted language, beyond the dominion of official culture, is also to be found in Stötzer's employment of new artistic forms and media – in particular, her short Super 8 films of the early 1980s. These alternative collections were an expression of a new creative individuality.[40] This new phenomenon – running in parallel with experiments in punk music and neo-avant-gardist visual and textual cultures – began beyond the conventions of the East German film industry, the DEFA. They were scrupulously observed by the Stasi, who feared a 'domino effect' and were determined to prevent it. Those experimenting with this new medium – the visual artist Ralf Winkler (alias A.R. Penck), for example, and Schleime – were seeking new modes of artistic expression. Like many members of the Prenzlauer Berg scene, 'these artists did not themselves seek to produce expressively political art or utilize the new technology for political protest but, rather, discovered new realms for creative exploration'.[41] This position, however, did not prevent the politicization of these short films, both by Western critics and politicians and by the Stasi. There were also those on the alternative scene who had the ability to convert the subversive into political ammunition. Reinhild Steingröver cites the most famous and outspoken advocate of the Prenzlauer Berg scene, Gerhard Wolf:

> As Gerhard Wolf pointed out, Super-8 as a medium with its many technical limitations also determined its provisional, experimental status – not primarily as 'great art' of lasting inherent value but important creative impulse 'not made for a large audience but by the authors for themselves'.[42]

For Stötzer, the use of Super 8 not only facilitated a surrealistic narrative, it also promoted one. In the second half of the 1980s, in the wake of her search for the combination of new forms of expression with feminism, she encouraged women's subversive activities in her short films, such as 'Die Austreibung aus dem Paradies' (The Expulsion from Paradise, 1984), 'Frauen-Träume' (Women's Dreams, 1986), 'Trisal' (1986), 'Kentauer' (Centaur, 1986) and 'Signale' (Signals, 1989).[43] In these films, conventional notions of time and space are questioned, allowing dreams and utopian imagery to become reality. The interaction between reality and the unreal during the Super 8 boom challenged the official concept of Socialism, since it was suspected – as could have been seen in the December 1924 journal *La Révolution Surréaliste* – of giving way to the 'kulturelle Herrschaft des Unbewußten' (cultural rule of the unconscious). In this way, the work of GDR artists was in the tradition of Man Ray and of other montage artists who created *Schattenreiche* (realms of shadows), in which the 'subversive hybrid' referred to above was hiding.

Writing about the 1980s countercultural film scene in *Gegenbilder* (Counter Images, 1996), Gerd Löser points out that these short films became an alternative to the official GDR cinema, and that many Super 8 filmmakers enhanced the films' avant-garde flavour by deliberately embracing the poor quality of the film stock and its technical limitations.[44] In this way, the works frequently drew attention to their non-professional status, whereby life and art abutted, and at the same time recalled the silent film era during the heyday of Modernism. Unlike in mainstream cinema, dialogue was not possible. Consequently, a direct line could be drawn between these Super 8 films and the beginning of the cinema of the avant-garde, with Fluxus, Dada, Surrealism and underground film. In some cases, the features relate to the absurdist adventures of Eugene Ionesco. In Stötzer's films, the female body is shown in new, unexpected ways – unexpected in the GDR, of course, because of her feminist perspective. Furthermore, and drawing on various accounts of dreams from members of the women's groups around Stötzer in Erfurt, the female body is presented in grotesque and absurd ways, as in the groups Galerie im Flur and Frauen für Veränderung. Stötzer's Super 8 movies show women in confined spaces, visualizing their freedom and feelings through costumes and dance, while breaking out of their conventional feminine roles.[45] This act of liberation is not only a political performance but, at the same time, an aesthetic one – one that has also proven to be the engine of the avant-garde movement of Surrealism.

Conclusion

In her 1980s work, Stötzer consistently sought ways to overcome the restrictions of the GDR and its official culture. Mischievously, she teased the fine line between the conventional and the unconventional in the arts, as was expressed in the catalogue *Boheme und Diktatur* as 'sinnstiftendes Alternativkonzept gegen den Normenkanon des Staatssozialismus' (Meaningful Alternative Concept against the Norms of the Canon of State Socialism).[46] Stötzer's marginalizing by the state and male-dominated bohemian scene initiated an unswerving and constant cry for freedom: the impulse to transcend literary and psychological limitations, and explore regions of violence, absurdity, the unexpected and the unusual – all areas of experience inimical to the cultural authorities as well as to the bohemians. This urge for freedom places Stötzer among the heirs of Surrealism.

A prevailing motif in Stötzer's Super 8 movies is the image of the *Mischwesen*, the hybrid. This symbol of the surrealist hero – as with the Centaur in Ernst's paintings, in Breton's poetry and in verses by the GDR poet Mickel – is difficult to pin down. It can only be seen from the apparently mutually exclusive perspectives of reality and dream, the real and the phantasmagorical. It is always in transition, constantly crossing the borders between both states of being. Stötzer's relatively small body of work must be commended for its variety of subversive activities, which succeeded in challenging a status quo that was strongly believed, in both East and West, to be impenetrable and enduring. With others in the 1980s, and braced by her predecessors since the 1950s, she played a distinctive role in the so-called *friedliche Revolution* of 1989. In any kind of political and social context, the questioning and challenging of prevailing societal conventions by visualizing the concealed and by speaking out is an invaluable asset and a gift to humanity.

Many of those active in the various 1980s cultural scenes reanimated or recycled a surrealist heritage, for example by their rejection of chronology and mimesis. Scene and image are more important than story (plot) and action; alienation, paradoxical narration, absurdity and irrationality, and transgression (abrogating laws of time and space) change the way we see the world.[47] These characteristics can be identified not only in Stötzer's work, and in the work of other so-called *halb-inoffizieller* (semi-unofficial)[48] artists and writers; they were also supported by the older generation of writers and by the work of critical academics – all promoters of the avant-garde and Modernism, and in particular of Surrealism. Their aim was to destabilize the pillars of an inflexible Socialist Realist monolith. The academic champions of Surrealism (among whom no women can be identified) will be investigated in the final chapter of this book. By looking, for example, at Erhard

Frommhold and Lothar Lang alongside Hans Mayer and Karlheinz Barck, a counterbalance to the prevailing cultural orthodoxy can be identified.

Notes

1. Kaiser and Petzold, *Boheme und Diktatur in der DDR*, 22.
2. The majority of the countercultural groupings and their outlets were *halb-legal* (semi-legal); they were thus condoned by the state in order to enable the secret police – the Stasi – to infiltrate and try to control them. Also see the final endnote of this chapter.
3. Braun, 'Rimbaud', 978–98; and Biermann, '"Laß, o Welt, o laß mich sein!" Rede zur Verleihung des Eduard-Mörike-Preises', *Die Zeit* 47 (1991) and in: Biermann: *Der Sturz des Dädalus*. Köln: Kiepenheuer & Witsch, 1992, S. 64–72.
4. See Kaiser and Petzold, *Boheme und Diktatur in der DDR*, 297–306; and the brochure *'Eingeschränkte Freiheit'. Der Fall Gabriele Stötzer*, ed. Federal Commissioner for the Records of the State Security Service of the Former GDR. Berlin: BStU, 2014.
5. Timothy Garton Ash, *The File: A Personal History*. London: HarperCollins, 1997, 40.
6. See Alison Lewis, *Die Kunst des Verrats. Der Prenzlauer Berg und die Staatssicherheit*. Würzburg: Königshausen & Neumann, 2003.
7. See BStU, MfS, BdL Nr. 377, 3 and Garton Ash, *The File*, 12.
8. Claus Löser, 'Vorab'. In: Karin Fritzsche and Claus Löser (eds), *Gegenbilder. Filmische Subversionen in der DDR 1979–1989. Texte Bilder Daten*. Berlin: janus press, 1996, 10.
9. BStU, MfS, Eft AOP Nr. 1753/86, 190.
10. Other members included Almuth Falcke, Kerstin Schön, Verena Kyselka, Mechthild Ziegenhagen and Gerlinde Harbig, all from Erfurt.
11. BStU, MfS, HA XX Nr. 6640 vol. 3, 172.
12. Ibid., 182 and 193.
13. See the Introduction of this book; only in November 1988 was the term Socialist Realism denounced at the last Congress of Visual Artists in Berlin. Cf. Thomas, *Kunst in Deutschland seit 1945*; and Ulrike Goeschen, *Vom sozialistischen Realismus zur Kunst im Sozialismus. Die Rezeption der Moderne in Kunst und Kunstwissenschaft der DDR*. Berlin: Duncker & Humblot, 2001.
14. BStU, MfS, BV Hle, Abt. XX ZMA Nr. 6038, 24.
15. BStU, MfS, HA XX Nr. 6640 vol. 3, 215–16.
16. Karlheinz Barck, 'Kontinente der Phantasie'. In: *Surrealismus in Paris 1919–1939. Ein Lesebuch*. Leipzig: Reclam, 1985, 726.
17. Cf. Birgit Dahlke, *Papierboot. Autorinnen aus der DDR - inoffiziell publiziert*. Würzburg: Königshausen & Neumann, 1997; and Antonia Grunenberg, *Aufbruch der inneren Mauer. Politik und Kultur in der DDR 1971–1990*. Bremen: Edition Temmen, 1990. See also Peter Böthig, *Grammatik einer Landschaft. Literatur aus der DDR in den 80er Jahren*. Berlin: Lukas, 1997; and Klaus Michael and Michael Wohlfahrt (eds), *Vogel oder Käfig sein. Kunst und Literatur aus unabhängigen Zeitschriften in der DDR 1979–1989*. Berlin: Galrev, 1999. In the GDR, Klaus Michael was known as the poet Michael Thulin and August Thalheimer.
18. This term was coined by Endler in 'Anläßlich der Anthologie *Sprache & Antwort*. Eine Rundfunksendung (vollständige Fassung)', *ariadnefabrik* 4 (1988): 21; republished as 'Alles ist im untergrund obenauf, einmannfrei … Anläßlich einer Anthologie'. In: *Den Tiger reiten. Aufsätze, Polemiken und Notizen zur Lyrik der DDR*, ed. Manfred Behn. Frankfurt: Luchterhand, 1990, 46.

19. Michael Brake, *Comparative Youth Culture: The Sociology of Youth Cultures and Subcultures in America, Britain, and Canada*. London: Routledge & Kegan Paul, 1985, 163.
20. See, for example, Marlis Gerhardt, *Stimmen und Rhythmen. Weibliche Ästhetik und Avantgarde*. Darmstadt and Neuwied: Luchterhand, 1986, 69.
21. Cf. Justin Doherty, *The Acmeist Movement in Russian Poetry: Culture and the Word*. Oxford: Clarendon Press, 1995.
22. Efim Etkind, 'Die Melpomene des 20. Jahrhunderts'. In: Anna Achmatowa, *Im Spiegelland. Ausgewählte Gedichte*. Munich and Zurich: Piper, 1982, 184; and Fritz Mierau, 'Gedächtnisse'. In: Anna Achmatowa, *Poem ohne Held. Poeme und Gedichte. Russisch und deutsch*. Leipzig: Reclam, 1984, 259–67.
23. Susan Rubin Suleiman, *Subversive Intent: Gender, Politics, and the Avant-Garde*. Cambridge, MA: Harvard University Press, 1990.
24. See ibid., 15–16.
25. Jula Dech, *Hannah Höch. Schnitt mit dem Küchenmesser: Dada durch die letzte Weimarer Bierbauchkulturepoche Deutschlands*. Frankfurt: Fischer, 1989, 5–14 and 59–71.
26. See Ann Charters (ed.), *The Penguin Book of the Beats*. London: Penguin, 1992, 359–69.
27. As discussed in Chapter 3. See also my chapter 'Beat am Prenzlauer Berg. Das Treffen zweier Subkulturen', in *Grenz-Fallstudien*, 41–58.
28. Dahlke, 'Elke Erb', 123–32 (125); see also her interview with Elke Erb, 'Not "Man or Woman", But Rather "What Kind of Power Structure Is This?"', 133–50 (136–37). According to the authorities, this anthology was a compilation of texts by thirty *Pseudoliteraten* (wannabe writers), as is reported in a Stasi file, BStU, MfS, HA XX Nr. 23559, 1.
29. Erb et al., 'Not "Man or Woman", But Rather "What Kind of Power Structure Is This?"', 133–50 (136–37).
30. Erb and Sascha Anderson (eds), *Berührung ist nur eine Randerscheinung. Neue Literatur aus der DDR*. Cologne: Kiepenheuer & Witsch, 1985, 113–18.
31. Gabriele Kachold, *zügel los. prosatexte*, mit 2 Grafiken von Angela Hampel. Berlin and Weimar: Aufbau Verlag, 1989, 22–23.
32. See Beth Linklater, 'Erotic Provocations: Gabriele Stötzer-Kachold's Reclaiming of the Female Body?', *Women in German Yearbook* 13 (1997): 151–70.
33. See Dahlke, 'Zur Männerszene gehört eine Frauenszene. Jüngere Autorinnen in inoffiziell publizierten Zeitschriften der DDR 1979–89'. In: Christine Cosentino and Wolfgang Müller (eds), *'im widerstand/in mißverstand'? Zur Literatur und Kunst des Prenzlauer Berg*. New York: Lang, 1995, 133–50 (150).
34. Stötzer-Kachold, 'das gesetz der szene', *KONTEXT. Beiträge aus Kirche & Gesellschaft* 5 (1989): 13 and 15. Later published in her volume *grenzen los fremd gehen*, mit Zeichnungen der Autorin. Berlin: Janus press, 1992, 133–36. Ellipses added for copyright reasons.
35. Kachold, *zügel los*, 134. Ellipses added for copyright reasons.
36. See Wolf's account of her time under surveillance by the Stasi, in her story *Was bleibt*. Berlin and Weimar: Aufbau Verlag, 1990, 5.
37. 'Der Westen wäre für Gabriele Stötzer … keine wirkliche Alternative gewesen.' ('The west would have been no real alternative … to Gabriele Stötzer'). Quoted in Kaiser and Petzold, 'Tochtersprache im Vaterland. Kunst als 'außerstaatliche Lebensqualität': Die Dichterin und Performerin Gabriele Stötzer als provokante Leitfigur der 80er Jahre in Erfurt'. In: *Boheme und Diktatur in der DDR*, 297–306 (297). This conforms to her statements during the trial after her protest against the 'moralisch verwerflichen Aktion'

(morally reprehensible action), that is, the expatriation of Biermann in November 1976. See 'Eingeschränkte Freiheit'. *Der Fall Gabriele Stötzer*, 27–41.
38. Ulf Christian Hasenfelder, '"Kwehrdeutsch". Die dritte Literatur in der DDR', *neue deutsche literatur* 1 (1991): 82–93.
39. Kachold, *zügel los*, 94.
40. Reinhild Steingröver, *Last Features: East German Cinema's Last Generation*. Rochester: Camden House, 2014, 8.
41. Ibid., 61.
42. Ibid.
43. Christoph Tannert, 'Von Vortönern und Erdferkeln. Die Filme der Bildermacher'. In: Karin Fritzsche and Claus Löser, *Gegenbilder. Filmische Subversion in der DDR 1976–1989. Texte Bilder Daten*. Berlin: Janus Press, 1996, 25–60 (40). See also Claus Löser, *Strategien der Verweigerung. Untersuchungen zum politisch-ästhetischen Gestus unangepasster filmischer Artikulationen in der spätphase der DDR*. Berlin: DEFA-Stiftung, 2011, 295–97.
44. Löser, 'Vorab', 17–22; see also Stötzer, 'Filmen mit Frauen'. In: Karin Fritzsche and Claus Löser (eds), *Gegenbilder. Filmische Subversion in der DDR 1976–1989. Texte Bilder Daten*. Berlin: Janus Press, 1996, 75.
45. Löser, *Strategien der Verweigerung*, 292.
46. Kaiser and Petzold, *Boheme und Diktatur in der DDR*, 303.
47. Michael Lommel et al. (eds), *Surrealismus und Film. Von Fellini bis Lynch*. Bielefeld: transcript, 2008, 11–12.
48. The term 'semi-unofficial', or *halb-inoffiziell*, is often used in research on GDR politics and culture to indicate the oscillation between an official Marxist position and a dissident status. See Stefan Wolle, *Aufbruch nach Utopie. Alltag und Herrschaft in der DDR*. Berlin: Ch. Links, 2011, 270.

Chapter 9

EAST GERMAN ADVOCATES OF SURREALISM

Apart from the persistent Adolf Endler, only a handful of academics actively promoted Surrealism and other avant-garde movements with the aim of challenging the overarching giant, Socialist Realism, which dominated and determined cultural activity in the GDR. Those who questioned the cultural status quo were not naïve, nor did they pretend they could turn back the clock. On the contrary, conscious of the new political constellations in Europe and of the intellectual discussions on postmodernism and the neo-avant-garde in the West, GDR academics were dialectical in their investigations. In the 1980s, most of them followed the West German poet Enzensberger and the Romanist Bürger in arguing that the avant-garde was nothing more than a historical affair, and that a return to its ideals was unthinkable; this was in contrast to Hal Foster's efforts towards its rehabilitation in his 1996 work *The Return of the Real*, as discussed in Chapter 2.

Instead of examining the idea of recycling utopian concepts of historical movements after the Second World War, or repeating Bürger's thesis on the failure of the avant-garde, many academics at higher education institutions and research centres eagerly turned to Gudrun Klatt's book *Vom Umgang mit der Moderne* (On Dealing with Modernity), published in the GDR in 1984. Klatt focuses primarily on cultural concepts of the 1930s and political avant-gardist ideas during that specific period. Consequently, the historical avant-garde is blanked out. This omission motivated Klatt's colleagues to urge her to write a second volume in which the historical avant-garde would be her main focus. A follow-up, however, was never published, in spite of the advice of colleagues such as Dieter Schlenstedt, Werner Mittenzwei and Karlheinz Barck.[1] These academics were committed to challenging the stranglehold of Socialist Realism by promoting Surrealism in the GDR.

This chapter comprises an account of those intellectuals who were at the vanguard of this effort.

Karlheinz Barck (1934–2012)

About ten months before the Wende in Germany, Karlheinz Barck developed his ideas relating to new ways of perceiving reality. With his co-editors Heidi Paris, Peter Gente and Stefan Richter, he contributed to *Aisthesis* (1990), a volume on the aesthetics that had been formulated mainly by the French philosophers Michel Foucault, Jean-François Lyoard and Hélène Cixous. These ideas initiated innovative philosophical and artistic debates in the West in the 1970s and 1980s.[2] *Aisthesis* was part of a major catch-up operation during the times of Mikhail Gorbachev's policy of *glasnost* (openness), which permitted enhanced freedom of speech and of the press in Russia and Eastern Europe. *Glasnost* also allowed a greater public reception of previously undesirable theoretical concepts, which, in spite of the fact that the authorities objected to them, had been noted and considered by intellectuals. The wave of new thought and ideas promoted by Gorbachev brought about innovations far beyond the political sphere. The editors of *Aisthesis* aimed at a new way of seeing. They began, therefore, to question forty-four years of restriction and control, and to underline the most extreme sense of freedom (for many, a lost freedom): 'In jedem Augenblick unseres Lebens sind wir frei, auf *die* Zukunft hin zu handeln, die wir uns wünschen' (In every moment of our lives, we are free to act on *the* future we desire).[3]

As we have seen in this study, working to counter the prevailing orthodoxy had a long history in the GDR. Academics such as Barck championed a more passionate art and avoided adherence to stultifying cultural dogmas. But when it came to promoting a surrealistic way of interpreting the world, these intellectuals meticulously analysed the avant-garde as a historical concept only, and as a result omitted contemporary neo-avant-gardist tendencies. They wanted to avoid being seen as dissidents and consequently as opponents of Marxism. This noble and consistent cause is evident in some of the entries in the handbook *Ästhetische Grundbegriffe* (Basic Concepts in Aesthetics), on which many of Barck's colleagues from the Academy of Science and the Leibniz-Zentrum Allgemeine Sprachwissenschaft Berlin (Leibniz Centre for General Linguistics, Berlin, ZAS), collaborated in the first decade of the twenty-first century. Among the contributors was Dieter Schlenstedt, a prominent member of the Academy. The entry 'Avantgarde', for example, omits any considerations of the discussions in post-war Eastern Europe, for instance during the Formalism Campaigns and the continuation of the avant-garde by other means in the main urban scenes of the

1980s. These movements have been subject to brilliant, penetrating analysis by Kaiser and Petzold.[4]

From 1980 onwards, Barck intensified his work on Surrealism by inviting GDR writers and fellow Romanists to translate French literary and theoretical texts, and by editing the anthology *Surrealismus in Paris 1919–1939*. As managing editor, he presented a range of poetry, prose and manifestos written by French Surrealists such as Breton, Soupault, René Crevel, Ernst, Louis Aragon and Simone Breton-Collinet. Not only did he introduce Surrealism to a wider reading audience in the GDR, he also managed to intensify the already-close relationship between surrealist poetics and poets such as Endler, Hilbig and Hermlin.[5] The publishing house Reclam Verlag, which was one of the most renowned rallying points for fiction in the East German literary world, now officially bolstered Surrealism in the GDR, after it had featured in many semi-illegal *samizdat* publications.[6] In a *Gutachten* (appraisal) for *Surrealismus in Paris*, the Romanist professor at Humboldt University Manfred Naumann recognized the power of surrealist texts but acknowledged at the same time that after 1945, in the new political and cultural frameworks, this power was attenuated: 'Die surrealistischen Texte haben die Explosivkraft, die sie zur Zeit ihres Entstehens gehabt haben mochten, längst verloren' (The surrealist texts have long since lost the explosive power that they had at the time of their formation). Naumann continued by emphasizing that the surrealist energy in the German past and even in the GDR's current affairs was still noticeable. Consequently, and as a true Communist, Naumann warns as follows: 'negieren wir ihn ..., bilden sich geschichtliche Legenden, die der Gegner als Waffe gegen uns nutzt ...' (if we deny it ..., historical legends form, which the opponent will use as a weapon against us ...).[7] Prior to this, Barck, together with Schlenststedt and Wolfgang Thierse, had clearly stressed a critical view on the avant-garde in the 1979 volume *Künstlerische Avantgarde* (Artistic Avant-Garde), by reflecting on and questioning its original utopian impulse under the new political circumstances of the GDR:

> Seit der sechziger Jahre ist – sowohl in sozialistischen wie in kapitalistischen Ländern – eine Diskussion erneut in Gang gekommen, denen Gegenstand und deren Streitfragen schon als geschichtlich erledigt waren: Es geht um die literarische und künstlerische Avantgarde. Allerdings ist die Bestimmung dessen, was hierbei das Problem, selbst bereits strittig; mit Avantgarde werden kontroverse Begriffe ins Spiel gebracht.[8]
>
> Since the sixties – both in socialist and in capitalist countries – a discussion has arisen again, to which the subject and its issues were already settled as historical: It is about the literary and artistic avant-garde. However, the

determination of what the problem is in this regard is itself already contentious; with avant-garde, controversial concepts are brought into play.

The study emphasizes that avant-garde movements were particularly significant during the transformation from Capitalism to Socialism in the 1920s and 1930s, but denies that the utopian impulse is still prevalent in East and West. With this hypothesis, he follows Bürger. Paradoxically, by following Bürger, Barck is in tune with the cultural politics of his country. Yet he also follows the Hungarian Lálzó Illés when it comes to examining the problematic relationship of socialist theory with the avant-garde.[9] It must be noted that he never promoted an adversarial attitude towards socialism, and always supported the avant-gardist resistance against capitalist societies.

This correct but 'well-behaved' stance made Barck one of the most respected among the upper echelons of academics. Inspired by his teacher, Werner Krauss, he promoted modern art and literature in the GDR. He argued *within* the context of official cultural politics and academic discourse. At the same time, however, he operated outside the East German framework and the ideal of real-socialist cultural politics. Consequently, the allusions to an alternative to Socialist Realism, or even to a neo-avant-garde in the GDR and a recurrence of the Surrealist spirit, are blocked.

Diether Schmidt (1930–2012)

According to the Stasi files, in the eyes of the authorities the counterpart of the well-behaved Barck (nicknamed Carlo by friends and colleagues) was the art historian Diether Schmidt. His engagement with the Arbeitskreis Moderne Kunst (Modern Art Working Group) in Dresden, in which he promoted the art of Pablo Picasso and the Dadaists, in addition to the unflattering and somewhat insulting statements he made when comparing the GDR with the Third Reich in relation to modernity, made him an unwanted conspirator, and thus a *Feindobjekt* (enemy): 'Man sollte das Buch von Hannah Höch lesen, dann ist man gegen graue Uniformen und Kollektivgeist in der DDR' (One should read the book by Hannah Höch, then one is against grey uniforms and collective spirit in the GDR).[10] Schmidt saw the art that was tolerated by the state as merely 'abbildende und dienende Kunst' (depicting and servile art).[11] His undiplomatic, unreasonable and sometimes abusive way of portraying the GDR reached its climax in his statements on Picasso:

> Das Werk Picassos war schwer faßbar bei den vorherrschenden Ideotismen in der Kulturpolitik der kommunistischen Parteien und sozialistischen Ländern, die unter dem Deckmäntelchen des sogn. sozialistischen Realismus

meinten den Künstler zwingen zu können, nach dem antiquierten Stil des 19. Jahrhunderts zu malen. ... Picasso war immer gegen jede Form von Staatskunst, deren Zweck nur darin besteht, vorhandene politische Systeme zu verherrlichen und zu beweihräuchern, er war stets ein Feind von solchen üblen Kunsthonig, wie er sich bei uns regelmäßig durch alle Kunstausstellungen ergießt.[12]

The work of Picasso was elusive in the prevailing ideotisms in the cultural policies of the Communist parties and socialist countries, which under the guise of the so-called Socialist Realism meant being able to force the artist to paint after the antiquated style of the nineteenth century. ... Picasso has always opposed any form of statecraft whose sole purpose is to glorify and extol existing political systems; he has always been an enemy of such foul honey as he regularly pours through all art exhibitions.

In 1974, a year after the artist's death, Schmidt wrote a monograph on Picasso which was published by Verlag der Kunst. He categorized the Spanish artist as a Surrealist. Cultural-political gibes like these, and the many political statements which the cultural authorities found completely beyond the pale, resulted in the art historian's arrest in February 1984. After a successful *Ausreiseantrag* (application for an exit visa) and the surrender of his citizenship, Schmidt eventually moved to West Berlin in 1988.

During his years in the GDR, and in addition to his work on Picasso, he wrote and published material on Otto Dix, Oskar Kokoschka, Paul Klee and the Bauhaus. He also wrote about living East German artists, such as Fritz Cremer and Curt Querner. Schmidt was more than just a freelancer; he was also an honorary editor at the Verlag der Kunst in Dresden, and as such, a colleague of the publishing house's chief editor, Erhard Frommhold. Frommhold was another who promoted the avant-garde, and in particular Surrealism, in the visual arts. Both were admirers of Picasso and explored various avenues to import surrealistic art into the cultural landscape of the GDR.

Erhard Frommhold (1928–2007)

Frommhold's biography is far more conventional than that of his colleague in the Dresden Verlag der Kunst. Although it had far-reaching consequences, the publication of his book *Kunst im Widerstand* (Art in Resistance) in 1968 was the only impediment in his career. In a time of extreme global political turmoil, combined with a widening divide between the ideologies of the late 1960s and the Prague Spring on the GDR's doorstep, a new wave of Formalism was to be feared. In this climate, Frommhold invited

contributors from all over the world. In his invitation to Jean-Paul Sartre, he needed to emphasize that the art displayed in the monograph would be anything but merely 'platte politische Illustrationen' (dull political illustrations).[13] The title of the publication that Frommhold started to plan in 1957 reminds us of a 'typical' GDR publication, featuring an art that – according to official discourse – was supposed to oppose international Fascism and support the struggle against oppression and colonialism. However, shortly after publication, between the so-called Kahlschlag Plenum and the sixth Schriftstellerkongreß, the state's perception changed, as we have seen in the preceding chapter:

> Das Buch *Kunst im Widerstand* und große Teile des Verlagsprogramms werden hier von höchster offizieller Stelle als 'Revisionismus' angesehen. Ich habe solche Vorwürfe schon öfter erlebt und konnte mich früher durch Selbstkritik und Reue retten. Aber jetzt scheint es zu einer Explosion zu kommen, aus der ich mich vielleicht nicht retten kann, denn ich kann mich ja nicht von meinem Buch distanzieren. So hat man nun einige Verfahren gegen mich eingeleitet, deren Ausgang abzuwarten und zu fürchten ist. Natürlich sind solche Urteile von Dogmatikern schlimmmster Sorte.[14]

> The book *Art in Resistance* and large parts of the publishing program are considered here by the highest official authority as 'revisionism'. I have experienced such reproaches many times before and could save myself earlier through self-criticism and remorse. But now there seems to be an explosion from which I may not be able to save myself, since I cannot distance myself from my book. So they have now instituted some proceedings against me, whose outcome is to be awaited and feared. Of course, such judgements by dogmatists of are the worst kind.

In the wake of Frommhold's enthusiasm and a new wave of Formalism Campaigns, the German politician Ernst Niekisch wrote in the foreword to *Kunst im Widerstand* that the avant-garde should be defined as a movement to undermine the institutionalized art of the bourgeois world:

> Indem sie [die Kunst] sich gegen überkommene Traditionen und Formen auf dem Gebiet der Kunst erhebt, offenbart sie nur tiefinnere Impulse, die in der Gesellschaft gegen soziale und politische Konventionen und Formen vorhanden sind. Die Kunstrevolutionen sind in der Regel ein Vorzeichen oder eine Begleiterscheinung sozialer und politischer Revolutionen.[15]

> Raising [art] against artistic traditions and forms reveals only deep impulses that exist in society against social and political conventions and forms. Revolutions in the arts are usually forerunners or accompaniments of social and political revolutions.

Indeed, many of the Surrealists, born to wealthy French bourgeois families, wanted to radicalize the world not in the first place with politics, but through art. They were convinced that non-realistic art would bring us to a clearer, sharper perspective on reality and expand the bourgeois parameters. However, Niekisch's ideas can be extended and can also be addressed to the culture politics of the GDR.

The Communist state of mind was not less rigid in its convictions. It produced a highly conventional, predictable and inflexible set of criteria in its concept of Socialist Realism. The East German authorities perceived the avant-garde as a subversive influence which needed, therefore, to be extirpated. In his extended essay on the art presented in his book, Frommhold focuses primarily on Surrealism, and claims that before consideration of Surrealism in terms of art history, one needs to conceive of it as a complete world view and determine its time-critical position. The editor retrieves the avant-garde movement from its historical position and applies it to the contemporary context within which he lives. Viewed in this way, Surrealism becomes a political statement and, at the same time, a comprehensive frame of mind, with the desire to extend into every area of life.

Frommhold's book was received very positively by critics in the West, but it caused a scandal in the GDR. The result was a deluge of the most damning judgements the Communist world had in its artillery: he was called a 'revisionist', a 'nihilist' and an 'anarchist'. The nonconformist publication metamorphosed into a dissident one, and Frommhold was faced with a *Parteiverfahren*, an official Party process. His subjection to the apparatus of the Party resulted in his dismissal as editor-in-chief of the publishing house. He was still permitted to work there, but with severely restricted responsibilities. His dissident status was exacerbated by the publication of Wilhelm Fraenger's massive 1975 monograph on the 'grandfather' of Surrealism, *Hieronymus Bosch*, by Frommhold's publishing house. Further fuel to the fire of his dissidence was provided by his correspondence with his friends. These included the renegade Austrian communist, Ernst Fischer, his wife Louise Eisler-Fischer and the British art critic John Berger, who promoted new ways of perceiving reality.

In the late 1970s and early 1980s, in the wake of the (albeit short-lived) liberalizations after the Eighth Conference of the SED in 1971 – at which Erich Honecker promoted 'Weite und Vielfalt der gestalterischen Möglichkeiten' (breadth and variety of creative possibilities) – non-realistic art was able to develop and grow, and Frommhold was rehabilitated.[16] However, although according to the Stasi he had stepped back onto the Party line, he was never reinstated as editor-in-chief. He was nevertheless awarded the 'Vaterländischer Verdienstorden in Silber' (Silver Patriotic Order of Merit) in October 1989.[17] Until 1991 he was engaged in a personal

campaign to support artists who had found recognition through their abstract work, especially in foreign, non-socialist countries. Among them was the former Dresden painter Ralf Winkler, living in the FRG as 'A.R. Penck'.

Lothar Lang (1928–2013)

Another advocate of Surrealism in the GDR, but one who kept a low profile, was the art historian Lothar Lang. In 1992, after the Wende, Lang published *Surrealismus und Buchkunst* (Surrealism and Book Art). He had already edited similar projects related to other experimental art movements, including Expressionism and Constructivism. He had also promoted the work of generally unsupported artists such as Hermann Glöckner, Gerhard Altenbourg and Carlfriedrich Claus, in parallel with the 'big four' of the Leipzig School, as discussed in Chapter 1. Lang had made his name with his mid-1960s analysis of Bauhaus culture,[18] which had been largely neglected in the GDR.

Lang filled those artistic holes which had been either overlooked or deliberately ignored by the authorities. In common with Diether Schmidt, he joined a team of experts – ranging from artists, philosophers, literary scholars and art historians – who in the early 1990s reviewed the work of the poet, philosopher and visual artist XAGO (alias Rolf X. Schröder). XAGO called himself 'ein europäischer Phantast' (a European dreamer) in the catalogue *Die Grotesken haben Ausgang* (The Grotesques Move Freely, 1993). Lang notes:

> Xagos Bilder offenbaren den Primat der Intellektualität: 'Was ich male, habe ich nie gesehen doch ich habe es erlebt!' Die Malerei ist unterkühlt, surreal. Eine 'Altarmenische Bildhauergasse' erinnert an Dalí. Florales läßt die Bekanntschaft mit Max Ernst vermuten. Groteske Szenerienen verweisen auf zwirnige Strichgebilde bei Paul Klee, verschiedentlich sogar auf die Strichmänner von Georg Grosz. ... In seiner Kunst amalgamieren sich phantastische Traumvorstellungen mit Zeichenhaftem, Irrationalität gebiert Bildlogik. Malerei läßt das möglich sein.[19]

> Xago's paintings reveal the primacy of intellectuality: 'I've never seen what I paint, but I've experienced it!' The paintings are overcooled, surreal. An 'Old Armenian Sculpture Lane' commemorates Dalí. Floras suggest the acquaintance with Max Ernst. Grotesque scenes refer to cross-shaped lines in Paul Klee, and sometimes even to the line men of Georg Grosz. ... In his art, fantastic dream concepts amalgamate with symbolic irrationality giving birth to pictorial logic. Visual art makes that possible.

In *Surrealismus und Buchkunst,* Lang emphasizes the importance of this avant-garde movement, including within the context of GDR literary fiction. Surrealism hints at a 'Verrückung und die vollständige Aushebung logischer Bezugssysteme' (displacement and complete elimination of logical reference systems):

> Die Kombination heterogene Elemente zeigt sich als Kopplung des Zufälligen, als die absurde, konspirativ wirkende Verknüpfung nicht zusammengehöriger Figurationen Das Geheimnisvolle, Wunderbare, Noch-nie-Geschaute ist im Bild sichtbar gemacht. Auf die gnostische Bedeutung solcher Konstellation verweist [auch] Stephan Hermlin.[20]

> The combination of heterogeneous elements manifests itself as a coupling of the contingent, as the absurd, conspiratorial connection of unrelated figurations The mysterious, wonderful, never-seen is made visible in the pictures. To the gnostic meaning of such a constellation Stephan Hermlin refers [as well].

When it came to applying the influence of Surrealism in current cultural affairs, Lang referred to both visual and textual culture. In fiction, too, the projection of non-realistic, often dreamlike landscapes results in something strange and produces innovation. In 1929, Breton wrote that the surreal is the function of our will to alienate the real; these are disturbing words, it seems, for totalitarian states.

Stephan Hermlin (1915–1997) and Hans Mayer (1907–2001)

As previously mentioned in the Introduction and in Chapter 3, the publication *Ansichten über einige Bücher und Schriftsteller* (Views on Some Books and Writers, 1947) by Stephan Hermlin and Hans Mayer laid the ground for those who were eager to characterize the avant-garde in fiction as more than merely a failed historical concept. In the few years prior to the tough Formalism Campaigns, Hermlin and Mayer boldly announced the importance of Surrealism as a Modernist movement, and one which, shortly after the Second World War, needed to be respected and promoted. Each author emphasized the need to embrace international tendencies in fiction and to expand the narrow ideological framework of the German Soviet zone.

Hermlin, in particular, was driven to incorporate modern and avant-garde literature into East German fiction. This fact was also noted by the Stasi, as the authorities were worried about losing such an exemplary comrade. In one of the many files on him, it is negatively stated that 'H.

war schon wegen seiner früheren Gedichte und mit "Zwei Erzählungen", der Novelle "Der Leutnant York von Wartenburg" (über den gefolterten und zum Tode verurteilten Offizier des 20. Juli 1944) und der Erzählung "Reise eines Malers in Paris" in den Ruf eines Surrealisten gekommen' (H. had already attracted attention with his earlier poems and with "Zwei Erzählungen" [Two Tales], the novella "The Lieutenant York von Wartenburg" (about the officer tortured and sentenced to death on July 20, 1944) and the narrative "Reise eines Malers in Paris" [Journey of a Painter in Paris] and gained the reputation of being a Surrealist). These were all publications from 1947.[21]

In the final chapter of *Ansichten*, Hermlin focuses on the French poet Paul Éluard, directly associating him with anti-Fascist resistance, and at the same time aligns him with Surrealism. With this, the Stasi's suspicions about Hermlin were confirmed:

> Wirklich maßgebend für seine [Éluards] ganze spätere Entwicklung wird aber der Moment, da seine 'Gedichte für den Frieden' die Aufmerksamkeit der späteren Gefährten finden, mit denen er zum Teil noch fünfundzwanzig Jahre später in der Widerstandsbewegung verbunden sein wird. ... [Jean] Paulhan brachte ihn mit einer Anzahl junger Dichter zusammen, mit André Breton, Soupault, Aragon und dem Rumänen Tristan Tzara, und diese junge revolutionäre Mannschaft ist es, die die umstrittene und so außerordentlich fruchtbare Bewegung des Surrealismus begründet.[22]

> However, the moment when his [Éluard's] 'Poèmes Pour la Paix' found the attention of his later companions, with whom he would be connected in part some twenty-five years later in the resistance movement, will be decisive for his later development. ... [Jean] Paulhan brought him together with a number of young poets, André Breton, Soupault, Aragon and the Romanian Tristan Tzara, and it is this young revolutionary cohort that establishes the controversial but so extraordinarily prolific movement of Surrealism.

As we saw in Chapter 3, Hermlin's co-author, Hans Mayer, was overlooked by the organizers of the International Kafka Conference in Liblice Castle in 1963, in spite of, or perhaps because of, his international reputation as an expert on Kafka and Modernism. As a professor of German at the University of Leipzig he was a colleague and friend of the philosopher Ernst Bloch. This association had earned him a black mark from the Stasi.[23] Both academics confronted the Communist authorities' clumsy handling of the first uprising against Stalinism in 1956. As a consequence, Mayer moved to the FRG in 1963. Bloch had preceded him in 1961.

Ernst Bloch (1885–1977) and Hanns Eisler (1898–1962)

Writers and academics were restrained when it came to underlining the explosive power of Surrealism, which, according to Lang, was 'disturbing'. In his assessment of the relationship between Modernism and Communism, Ernst Bloch needs to be singled out, as he, together with the composer Hanns Eisler, dared to criticize the powerful dogmas of Georg Lukàcs, which were formulated in his articles in the journal *Das Wort* in the mid-1930s, as we saw in Chapter 1. Bloch and Eisler's preference for the aesthetics of Modernism, and their consequential defence of Expressionism as a more progressive mode of production in the early years of the twentieth century, resulted in a dilemma for them. As Marxists they did not want to betray the efforts of the *Volksfront*, or united front, for the struggle against Fascism. Bloch even defended Stalin's repression and the Moscow Show Trials to his friends Lukàcs and Theodor W. Adorno. This shines a new light on the philosopher, especially with regard to his position later in the GDR.[24] Although Bertolt Brecht never participated at the time in the debate against Lukàcs's nineteenth-century theory of mimesis, his position was represented by Bloch and Eisler.[25] As Bathrick argues, both focused on what Brecht and his artistic friends in the 1920s and 1930s had claimed as *Materialästhetik*, as discussed in Chapter 2.

> Eisler and Bloch articulated an aesthetics of production that drew the links to the evolution of industrial production in the society at large, technological developments within a specific medium, artistic technique, and structural changes occurring in every part of what is culture[26]

This statement during wartime and exile had consequences for the future, in particular during the Formalism debates in the GDR. In the culture of the Cold War, Brecht's epic theatre and Eisler's treatment of the German classic, Goethe (in his new *Faust* opera libretto) were on trial. Negatively evaluated avant-garde movements, such as Constructivism, Dadaism, Surrealism, Expressionism, Bauhaus, and related musicians, architects, visual artists and writers, were considered not only bourgeois and decadent but also proto-Fascist.

Working in the GDR, both Bloch and Eisler experienced, in different ways, authoritarian obstructions to their work. They developed innovative ways to review their previous points of view in a Formalism-driven state. For Bloch it was the principles of utopia, as formulated in his *Geist der Utopie* (*The Spirit of Utopia*, 1918) and his magnum opus *Das Prinzip Hoffnung* (*The Principle of Hope*, 1954–59), with which he countered the hurdles, by revisiting theories in Western and Eastern thought and constructing new

attitudes towards dogmatism. For him, the principle of hope was celebrated as a basic instinct in human existence. Bloch, therefore, speaks of hope as a 'concrete utopia'. It springs from the desires and daydreams of the people, the expression of manifold hopes. Hope is the guiding principle, the individual drive towards, and knowledge of, the potential to lead a fuller, better life, free of humiliation and alienation. To reach this, the human being has to become aware of possibilities which have not yet been exhausted, in order finally to realize them. For Bloch personally, however, this lasted only until 1961. Nevertheless, after his departure from the GDR, and despite his absence, his work had a continuing impact in East German intellectual circles.

Conclusion

Utopian ideas persist very noticeably in any art and literature. In the traces of Surrealism we have followed in the SBZ and GDR, we see that writers explored ways of living which were free from repression and consequently more liberal. Neither in the West nor in the East did the historical avant-garde rise again. But this did not imply, as Bürger claimed, that it had failed. On the contrary, as academics, artists and writers have shown, the utopian flavour remained; even in its different, refurbished variations, Surrealism initiated a utopian *esprit* that would eventually 'rock' the world – and still does.

Notes

1. Gudrun Klatt, *Vom Umgang mit der Moderne. Ästhetische Konzepte der dreissiger Jahre. Lifschitz, Lukács, Lunatscharski, Bloch, Benjamin*. Berlin: Akademie-Verlag, 1984. I would like to thank Klaus Michael for sharing his memories of the days when he was a student of German Literature at the University of Jena, and later an assistant at the Academy of Science in the 1980s.
2. Karlheinz Barck et al. (eds), *Aisthesis. Wahnehmung heute oder Persektiven einer anderen Ästhetik*. Leipzig: Reclam: 1990.
3. Ibid., 464.
4. Barck et al. (eds), *Ästhetische Grundbegriffe. Historisches Wörterbuch in sieben Bänden*. Stuttgart and Weimar: Metzler, 2001–10, Vol. 1, 544–77. Cf. Kaiser and Petzold, *Boheme und Diktatur in der DDR*.
5. Thomas Magnan, 'Die Rezeption des Surrealismus in der DDR. Die Anthologie *Surrealismus in Paris*', *Germanica* 59(2) (2016): 143–48.
6. Cf. Peter Böthig, *Grammatik einer Landschaft. Literatur aus der DDR in den 80er Jahren*. Berlin: Lukas, 1997; and Sonntag, *An den Grenzen des Möglichen*.

7. According to Manfred Naumann in his appraisal on 6 January 1984, which can be found in the Reclam Leipzig-Archiv. In the manuscript of Barck's afterword, later entitled 'Kontinente der Phantasie' (Continents of the Imagination), he spelled the word 'Surrealismus' in the way Walter Benjamin did in his essay 'Der Sürrealismus – Die letzte Momentaufnahme der europäischen Intelligenz' (Surrrealism – The Last Snapshot of European Intelligence) of 1929. In the archive, it is also mentioned that the book was supposed to be entitled 'Paris – Hauptstadt des Surrealismus'.
8. Barck et al., *Künstlerische Avantgarde*, 7. My translation.
9. See Làlzó Illés, 'Sozialistische Literatur und Avantgarde', *Acta Litteraria Academiae Scientiarum Hungaricae* 12(1–2) (1970): 53–64.
10. BStU, MfS B Ddn AU 1005/84, 66. Apart from creating art, the visual artist Hannah Höch also published various texts. See, for example, Hannah Höch, *Werke und Worte*. Berlin: Fröhlich und Kaufmann, 1982.
11. BStU, MfS BV Ddn Abt. XX 186, 20.
12. BStU, MfS BV Ddn AOP 735/84, 130. My translation.
13. Hiltrud Ebert (ed.), *Erhard Frommhold (1928–2007). Lektor und Publizist. 'Meine Biographie sind meine Bücher'*. Berlin: Akademie der Künste, Berlin, 2008, 68.
14. From a letter to the Italian publisher Enzo Nizza of 5 May 1969; see ibid., 69. My translation.
15. Erhard Frommhold (ed.), *Kunst im Widerstand. Malerei, Graphik, Plastik 1922–1945*. Dresden and Frankfurt: VEB Verlag der Kunst and Röderberg-Verlag, 1968, 12. My translation.
16. Karin Thomas, 'Die "andere" deutsche Kunst: Malerei und Grafik in der DDR. Entwicklung und Gegenwart'. In: Paul Gerhard Klussman and Heinrich Mohr (eds), *Literatur und bildende Kunst*. Bonn: Bouvier, 1985, 1–22 (15–16).
17. On 8 May 1988, Frommhold was recommended by the Minister for Culture of the GDR, Hans-Joachim Hoffmann, for his creative work as a communist and publicist. See Erhard-Frommhold-Archiv of the Akademie der Künste, 28 BL, 767.
18. Lothar Lang, *Das Bauhaus 1919–1933. Idee und Wirklichkeit*. Berlin: Zentralinstitut für Gestaltung, 1966.
19. *Die Grotesken haben Ausgang. XAGO, ein europäischer Phantast*. Berlin: edition q, 1993, 109. My translation.
20. Lang, *Surrealismus und Buchkunst*. Leipzig: Edition Leipzig, 1992, 14.
21. BStU, MfS ZAIG, Nr. 24027, T 1 / 2, 4.
22. Hermlin, 'Dichtung und Wahrheit in diesen Jahren'. In: *Ansichten*, 193–98 (194). My translation.
23. See BStU, MfS ZAIG 384, 2.
24. Jack Zipes, 'Ernst Bloch and the Obscenity of Hope. Introduction to a Special Section on Ernst Bloch', *New German Critique* 1 (1988): 3–8.
25. Cf. Ernst Bloch and Hanns Eisler, 'Die Kunst zu erben', *alternative* 12 (1967–68): 216–18.
26. Bathrick, *The Powers of Speech*, 99.

Conclusion

'Max Ernst Was Here!'

Of course, Max Ernst was never there. Nor did Surrealism establish itself as an artistic or literary movement in the GDR. Or did it? No, Max Ernst remained in the USA after 1945, then four years later moved to the south of France and, in 1951, to Paris with his wife, Dorothea Tanning. There he died in 1976. Another Surrealist in exile, Hans/Jean Arp, settled in Switzerland with his wife Sophie Taeuber-Arp. Later, in 1949, he chose the United States as his homeland until his death in 1966. And even before Surrealism's founding father, André Breton, died in 1966, the historical avant-garde movement had lost its initial impetus. In Germany, as we have seen, after the Second World War Enzensberger, later joined by Bürger, declared the avant-garde a merely historical phenomenon that had failed in its purpose to revolutionize arts and politics. It had become, therefore, unrecyclable. For them, a continuation or reinvention – a neo-avant-garde – was an illusion. On completing the nine chapters of this book, however, I can come to no other conclusion than that Surrealism was very much present in the GDR, and that, yes, even Max Ernst 'was here'. During my research in the National Literary Archive in Marbach (DLA), I discovered that two individuals were key to its manifestation. In Marbach I studied the estates of the writer Adolf Endler and the academic Karlheinz ('Carlo') Barck. While their correspondence was not extensive, it was substantial enough to furnish a valuable insight into particular aspects of GDR cultural history. And the only conclusion I could reach is that each facilitated the perpetuation of Surrealism in the GDR. They must thus be seen as titans of Surrealism in the GDR, and be afforded the appropriate respect.

Endler's Phantasmagorical Berlin

Originally from the Ruhr region, Endler settled in the GDR in 1955. As previously described, between 1955 and 1957 he studied in Leipzig, at what would later be called the Johannes R. Becher Institute for Literature. As a convinced Marxist, he assisted in the *Aufbau*, the construction of the new Germany, by helping to drain and to cultivate the meadows of northern Saxony-Anhalt, called 'Wische'. His book *Weg in die Wische* (Way through the Meadow, 1960) documents his activities in a style that very much reflects the precepts of Socialist Realism. Later, he announced his departure from Stalinist dogmas, including the aesthetics of Socialist Realism. A conversation with Eberhard Günther, chief editor of 'his' publisher, the Mitteldeutscher Verlag, is reported in a Stasi file. There, it becomes obvious that the poet categorically rejected the prescribed writing method and began instead to favour an opposing aesthetic model, that of Surrealism.[1] He did not set out to create a movement or to write manifestos, but together with fellow poets, Endler highlighted in his prose and poetry of the 1960s and 1970s ideas of the absurd, the grotesque and of coincidence – profuse examples of which he found in the so-called Real Existing Socialism of the GDR. The series of poems entitled 'Aus den Heften des Irren Fürsten M.' (From the Notebooks of the Lunatic Prince M.), for example, are important cultural-historical documents from the 1970s, in which Breton's surrealist model is reanimated, featuring black humour and the 'montage principle'. Here is an example in the first stanza of the opening ballad of the series:

> Oh der windigen Winterwelt!
> Wie ganz aus Geheimnis gemodelt!
> Wie aus Sternenstaub hergestellt!
> All die Wochen, die man verrodelt!
> Doch plötzlich sind Stimmen, gelln schrill
>
> …
>
> Ich unbemerkt hinter dem Stamm,
> Dem dicken der uralten Eiche,
> Und lauschend… – Als nächster sprach stramm
>
> …
>
> 'Ein Zeitzünder bin ich und quick!
> Hörn Sie, Madam, dieses Ticken!
> Pick, pick, pick, pick, pick, pick, pick, pick!

Bald heißt es, das Köpflien zu zucken!,
Madame, spitz aus Dornen den Dorn...'²

Oh the windy winterworld!
How completely out of mystery!
Made of stardust!
All the weeks you go to waste
But suddenly there are voices, shrill

...

I unnoticed behind the trunk,
The thick of the ancient oak,
And listening... – The next one spoke attentively

...

'I am a time fuse and quick!
Listen, Madame, this ticking!
Pick, pick, pick, pick, pick, pick, pick, pick!
Soon the tiny head will be twitching!,
Madame, spike a thorn out of the thorns...'

This extract is a fairly precise representation of the poet's ability to detect, observe and report on the (for him) typical phantasmagorical jest. One of the most important characteristics of his work, however, is the refusal to distinguish between the real and the unreal, as we have seen in Chapter 5. The boundaries between fact and fiction are deliberately blurred, confusing both the authorities and his readers. In this way, he intended to display his ambivalence towards the system. As a result, Endler was labelled an outlaw and was therefore considered unreliable. He became marginalized and was banned from publication in the state-owned publishing houses. Later, he found alternative outlets in semi-illegal enterprises.³ In his poetry and prose he created a carnivalesque milieu, a shabby underworld in the so-called 'clean' GDR, where his imaginary outsiders, vagabonds, drunks and bootleggers got up to their mischief. One striking example is his provocative treatment of the greatest shrine – and at the same time the most significant taboo – in the GDR: the Berlin Wall. In a little sketch entitled 'Bobbi Bergermann Vormittagsweg' (as quoted in Chapter 5), Endler manages to address the painful margins of Real Existing Socialism, thus rubbing salt into its open wounds. His Berlin is an intermediate world, depicted as the distance between an official upper milieu and his fictitious, shady lower environment – a *horror vacui* of dissonant voices in the capital of

the GDR. Dedicated equally to corresponding voices of the state and the street, Endler – through his motley band of fictional personae – seeks and finds the absurdities in the GDR. He presents himself in different roles and acts under different names, expressed in anagrams, and in this way seeks to illuminate the relationship between the poet, the poet's world and the actual prevailing social conditions. The reader roams through Endler's surreal urban settings and cannot help but smile every time he reads. Or as Wolfgang Hilbig once said in enthusiastic praise of Endler: 'Jedesmal, wenn man etwas von Dir liest, glaubt man, man müsse sich augenblicklich totlachen. Doch dann merkt man plötzlich, daß man schon tot war und daß man sich wieder lebendig belacht hat' (Every time I read something you've written I think I'm going to die of laughter. But then suddenly I realize that I was already dead and have laughed myself back into life).[4] Endler should be included among the most important voices in the landscape of contemporary German-language poetry – or as he puts it himself, as 'eine der verwachsensten Gurken der neuen Poesie' (as one of the most malformed cucumbers on the new poetry scene).[5]

Barck's Quest for Modernism

The other GDR citizen whose estate is deposited in the National Literary Archive and was recently opened is Karlheinz Barck. Barck was associated with the Central Institute for Literary History at the GDR's Academy of Sciences in Berlin. During the so-called Wende, he focused on documenting and analysing modern and postmodern aesthetics. As discussed in Chapter 9, this was more than simply a post-1989/90 catch-up act for GDR scholars, including Barck. The new perspectives made possible after the fall of the Wall and unification gave significant new insights into contemporary European literature, arts and philosophy. Comments mainly on original French texts are translated in the 1990 volume *Aisthesis*, which was followed by the extensive project that resulted in Ästhetische *Grundbegriffe. Historisches Wörterbuch in sieben Bänden* (Aesthetic Basic Concepts: Historical Dictionary in Seven Volumes, 2001–10), edited in cooperation with the highly esteemed scholar of German Studies Dieter Schlenstedt, among others. Before this, however, Barck had rearranged the cultural landscape of the GDR with the publication of his anthology *Surrealismus in Paris 1919–1939* by Reclam Verlag, Leipzig in 1985. With this anthology he formally introduced Surrealism – the polar opposite of Socialist Realism – to a wider audience in the GDR.

Barck's 'shocking' move was the simple fact that he introduced Surrealism to the GDR reader, without much ado, in a book that was published by a state-owned publishing house.[6] Indeed, Barck too was convinced, like

his West German counterparts, that the historical avant-garde had 'failed' and had lost its initial revolutionary aspirations. He refrained, however, from condemning the artistic avant-garde as 'decadent' and 'bourgeois'. The anti-Modernist Georg Lukács had applied these labels, and they were later reproduced by fanatics of Socialist Realism (who must, of course, have been grateful to Enzensberger and Bürger) from the period of the Formalism debate until the late 1980s. Barck avoided applying these derogatory adjectives. His independent scholarly and critical stance is evident in the following quotation from the afterword, 'Kontinente der Phantasie' (Continents of the Imagination), of his anthology. In the Kantian mode, Barck argues:

> Man wird sich … davor hüten müssen, den Surrealismus als eine homogene und auf apodiktische Prinzipien reduzierbare Bewegung aufzufassen. Die Praxis der einzelnen Mitglieder der Gruppe muß sich als ein jeweils authentischer Beitrag zur surrealistischer Bewegung verstanden werden, die ihre geistige Dynamik gerade aus der Unterschiedlichkeit der Aspekte bezieht.[7]

One will have to be wary of conceiving Surrealism as a homogeneous movement reducible to apodictic principles. The practice of the individual members of the group must be understood as a respective, authentic contribution to the surrealist movement, which derives its spiritual dynamics precisely from the diversity of its aspects.

The Endler–Barck Alliance

What do Endler and Barck have in common? While studying the letters and other material in both estates in Marbach, I turned my focus to their treatment of the way in which historical Surrealism was adapted in the GDR. The main trigger for my research interest was the fact that in the second half of the 1980s, their correspondence intensified, although it was of still manageable quantity. As early as 1978, Barck seems to have been inspired by one of Endler's unofficial readings in the homes of colleagues and friends in Prenzlauer Berg. In a letter, the scholar encourages the writer to look closely at the works of Louis Aragon and of the Cuban writer Guillermo Cabrera Infante.[8] Barck argues that their work might encourage, and even advance, Endler's surrealistic project. In the early 1980s, as the editor of the landmark anthology *Surrealismus in Paris*, Barck not only commissioned Endler to translate poems by the Surrealists Breton and Soupault, he also asked him – on a small index card, dated 'Sommer 86' –

to formulate his thoughts on one particular image by Max Ernst, which Endler eventually did in his 2015 autobiography *Nebbich*. There, he quotes from the original note:

> 'PS. Wenn Sie Lust haben, könnten Sie gelegentlich auf 1 Seite (& in welcher Form auch immer) notieren, was Ihnen zu der Zeichnunug von Max Ernst einfällt ... Wir hätten dann ein kleines surrealistisches Cadavre exquis ...'[9]

> 'PS. If you feel like it, you could occasionally jot down one page (in whatever form) what you think of Max Ernst's drawing ... We would then have a little surrealist Exquisite Corpse ...'

With the term 'Exquisite Corpse' Barck refers to a method by which a collection of words or images is collectively assembled. Each collaborator adds to a composition in sequence, either by following a rule or by being allowed to see only the end of what the previous person contributed. This method of collective artwork was common practice with Surrealists – it was used by Max Ernst and André Masson in 1927, for example. The image Barck asked Endler (and apparently others, as the term 'Exquisite Corpse' suggests) to comment on is a reproduction of the 1936 drawing used by Ernst as a template for an engraving he published in 1938, in the fourth

Figure 10.1 Max Ernst, 'Le château étoile' (1936) © bpk; Sprengel Museum Hannover, Germany; Stefan Behrens; © VG Bild-Kunst, Bonn 2021.

edition of the German exile journal *Freie Kunst und Literatur* that appeared in Paris.

Already in 1936, the frottage 'Le château étoile' (after Breton's poem of the same name) had been published in issue 8 of the French Surrealist journal *Minotaure*.[10] Endler gave Breton's poem the title 'Haus aus Funken' (House out of Sparks) when translating or adapting (*nachdichten*) it into German. Endler opens the poem as follows:

Der Falter der Nachdenklichkeit
Nieder setzt er sich auf das rosafarbne Gestirn
Ein Ereignis das ein weiteres Fenster zur Hölle aufmacht[11]

The butterfly of thoughtfulness
He sits down on the pink star
An event that opens another window to Hell

Later, Endler wrote the essay 'Zu einer Grafik von Max Ernst' (On a Graphic by Max Ernst), published in *Nebbich*.[12] He seeks here to 'translate' a visual medium into a textual medium. Pertinent in his transcultural act is his focus on the destructive elements in both Ernst's image and Breton's poem, and the emphasis on the political. For him the two combatting (and interestingly enough, female) bodies in the image are directly linked to the most infamous political figures of the 1930s: Stalin and Hitler. When looking at Ernst's work, Endler noticed, and later wrote, the following:

Eingegattert in einen fünffach gezackten Gußeisen-Stern (auch ein roh zusammengezimmerter Brettersarg in der ungewöhnlichen Gestalt eines Fünfecks könnte es sein, in das man noch lebendigen Leibes eingespannt wird): Vogelköpfiges mit jungem Busen, fast Schlankes, die Arme zu kaum noch freiwilligem Tanz hochgehoben, oder ist auch das Maskerade?, von unten her oder hinterrücks umschlungen von Gallertartigem. ... Eine Kreuzigung im Dreivierteltakt des Staatlichen volksinstrumenten-Orkesters und nach verschollenen Jugendstil-Mustern? Ebenso ließe sich an eine Vergewaltigung, an eine Hochzeitsnacht denken, ruckediguh, ruckediguh? (Ein Ehebett wäre das Fünfeck, der offene Sarg?).[13]

Dropped into a five-pointed jagged cast-iron star (it could also be a roughly cobbled together wooden coffin) in the unusual shape of a pentagram, in which the body is still alive): bird-headed with a young bosom, almost slender, the arms raised to an involuntary dance (or is this a masquerade?), from below or behind embraced in a jelly-like substance. ... A crucifixion in the three quarters-beat of the national instrumental orchestra and in lost Art Nouveau patterns? Likewise, one could think of a rape, of a wedding night, Ruckediguh, Ruckediguh? (A marriage bed would be the pentagon, the open coffin?).

With the description of the violent scene in the five-pointed star – which resembles a modern Laocoön scene – Endler highlights the political agenda of the late 1930s. He quotes from the infamous account of Joseph Stalin to the 1939 Eighteenth Party Congress of the CPSU, in which the Communist dictator described the causal relationship between a series of electoral successes of the Supreme Soviet and the simultaneous liquidation of political opponents. Endler continues by referring to a gruesome synchronization. The essay addresses the Stalin–Hitler or Molotov–Ribbentrop Pact, and its impact on the GDR and its culture, when Endler quotes the infamous ode to Stalin written in 1939 by the Communist poet Johannes R. Becher, who was living in exile in Moscow at the time. For Endler, the horrendous rhyming in that poem is the product of an opportunistic agitprop poet, who not only apparently worships Stalin but also glories in the 'murderous alliance' between both dictators in August 1939. Becher's ode 'An Stalin' (On Stalin) contains these lines:

Du schützt mit deiner
starken Hand
den Garten der Sowjetunion.

...

Nimm diesen Strauß mit Akelei
Als Zeichen für das
Friedensband
das fest sich spannt zur
Reichskanzlei[14]

You protect with your
strong hand
the garden of the Soviet Union.

...

Take this bouquet of Columbine flowers
As a sign of the
peace ribbon
that tightens us with
the Reich's powers

In Endler's view, Breton reveals his anti-Stalinist position in 'Le château étoilé' and Ernst illustrates this in his artwork of 1936. Having been prevented by the Stalinists from addressing the International Congress for the Defence of Culture in Paris in 1935, Breton made a radical turn and

flirted with Stalin's most threatening external enemy instead. As I have described in the Introduction, in 1938 Breton visited Diego Rivera and Frida Kahlo in Mexico City, where Leon Trotsky was living in exile. With Trotsky, he drew up the *Manifesto for Independent Revolutionary Art*, which was concerned with revolutionizing politics through art and not the other way round – a clear contradiction of what Stalin had envisioned with his championing of Socialist Realism.[15] In Endler's text on Ernst's image, voices and events meet on the eve of the Second World War. He connects absurdity, stupidity and terror. The political dimension of Endler's retrospective view in 1986 (the year Barck presented the image to him), and the impact it had on GDR culture, are evident. The two bodies in the picture represent for him, in the first instance, the embracing and later mutually destructive representatives of evil. With their alliance, they opened 'another window to Hell', as the first stanza of Endler's adaptation of Breton's poem intimates.

Endler's comments in his essay also refer to his own individual and personal status and that of the neo-avant-garde in the GDR of the 1980s. Becher – in Endler's eyes, the Bard of Horror – later became the country's first Minister of Culture. He initiated and was strongly associated with the concept of the GDR as a Literaturgesellschaft (literary society), which elevated the country to the status of an educated civilization, based on the heritage of both German classics and Soviet Socialist Realism alike. As we have seen, Endler, who was once drawn to this ideal himself, soon started to find it repugnant and began to write in an altogether challenging, surrealistic mode. Turning away from the official GDR culture meant for Endler a shift towards an alternative, semi-official counterculture, such as the bohemian milieu of the 1980s East Berlin Prenzlauer Berg scene, where, in some quarters, the historical avant-garde was recycled. In this countercultural environment, it was Barck's son, Maximilian Barck, who founded the magazine *Herzattacke*, which recently celebrated its thirtieth anniversary in the art gallery *sans titre* in Potsdam.[16] The aim of this journal was to popularize Surrealism. Endler, whose work had hardly been published by official GDR publishers since the 1970s, saw many of his surrealist texts appear there, both before and after the Wende.

Closing Statements

Regarding the presence of Surrealism in the GDR, the brief Endler–Barck alliance represents a significant component. As this book has shown, the echoes of Surrealism in the fictional literature of the SBZ and the GDR were able to challenge the dogma of Socialist Realism. The latter's aesthetic tyranny, requiring nothing more than the ostentatious celebration of the heroic

efforts of workers and peasants, needed to be crushed because it was far removed from the everyday experience of people living in the East German reality. As discussed frequently in earlier chapters, Endler's surrealistic texts contributed to the weakening of its grip. He was not, of course, alone; many others, such as Erb, Hilbig, Greßmann, Mickel and Stötzer, as well as supportive scholars (as discussed in Chapter 9), were convinced of the value of Surrealism and surrealistic interventions in conventional writing.

Indeed, in this book I have focused only on the literary culture of the GDR. It should be noted that it was fictional literature from the beginning that helped to popularize Surrealism during its early stages, before visual art took over and produced images which have become indelible in our perception. When we now think of Surrealism, we turn immediately to the work of Dalí, Picasso and Ernst. As highlighted in Chapter 6, however, the first Surrealist was a poet: the Uruguay-born Frenchman Lautréamont, who with his *Songs of Maldoror* (1868) broke all the conventions of nineteenth-century literature.

Inherent to Surrealism in the GDR was the principle and adventure of hope; as I have put it, Surrealism was one of the utopian carriers. Each in his own way, Endler and Barck were prominent transnational mediators of Utopia, and of the fictitious alternative social order in the GDR. As this book has revealed, they are but two examples from a pool of various representatives of East German fictional *Nachkriegssurrealismus* (post-war Surrealism).

It may come as a surprise that for many artists and writers, this systematic scrutiny of the GDR authorities did not become a reason to turn against the official parameters. Frank Hörnigk outlines the distinctiveness of the partial independence of cultural activity in the GDR. He argues that since East German art and literature gave expression to the urge for liberation from the official and dominant discourse, or *Herrschaftsdiskurs*, of Communist ideology, it had always maintained its independence.[17] To return to earlier parts of this book, the 'world in-between' described by Homi K. Bhaba in his cultural theory must be seen as a crucial characteristic of GDR culture. It constituted a new artistic attitude in Communist Europe, and can be found in the texts of Volker Braun, Christa Wolf and Heiner Müller, among others. Indeed, GDR cultural politics cannot be defined in antagonistic terms. They are far more subtle, particularly when it comes to determining the relationship between Socialist Realism and the avant-garde. The culture of the 1960s – unlike that of other decades in East Germany – can be characterized by the term *Unschärfe*: diffusion or indistinctness. Different, sometimes opposite, styles and (textual or visual) images overlap and are difficult to identify, and thus do not stand apart. These blurred areas were particularly troublesome for the authorities, since it became hard to identify

where the artist's or writer's loyalties lay. At the same time, the dreaded subversive attitudes became proof of quality. For this reason, Hörnigk's concept of *Unschärfe* is significant for determining art and literature in the GDR. Its culture oscillated between the extremes, creating a unique cultural landscape with intriguing shades of grey.

In the GDR, challenging Socialist Realism did not, as might be expected, lead to straightforward dissidence. Non-realistic poetics initiated a constant dialogue between reality, Marxist ideals and the worlds of the absurd and the grotesque, all of which existed simultaneously. As I have argued elsewhere, in a system built on the twin monoliths of monologue and state directives, dialogue was a revolutionary device. It is in the dialogues between the various poetic texts that the richness of the GDR's cultural politics may be found. The country was represented internationally as a drab, colourless society, offering merely multiple hues of grey – an inaccurate but apparently obstinate impression. I hope to have shown, however, that in the diversity of its cultural life, as in many other social aspects, the GDR offered a far more colourful palette, and was in this respect not so very different from anywhere else.

Notes

1. BStU, MfS, BV Berlin, Abt. XX, Nr. 4539 T. 2/3, 115.
2. Endler, 'Aus den Heften des Irren Fürsten M.' In: *Den Pudding der Apokalypse*, 90–96 (90). Translations all mine, with the help of Paul Clements. Ellipses added for copyright reasons.
3. Berendse, 'Die *Akte Endler*', 474–82.
4. Quoted from Hilbig, 'Der Wille zur Macht ist Feigheit'. In: Berendse, *KRAWARNEWALL*, 24. See also my article 'Laughed Back to Life' in the *Times Literary Supplement*, 31 May 2013, 15.
5. Endler, *Pudding der Apokalypse*, 208.
6. See Magnan, 'Die Rezeption des Surrealismus in der DDR', 143–48.
7. Barck, 'Kontinente der Phantasie', 717–49 (745).
8. DLA, A: Endler, Adolf, 5.02.1978 1 Bl.
9. Endler, 'Zu einer Grafik von Max Ernst'. In: *Nebbich*, 19–21 (21). This was previously published in the journal *ndl* 38(10) (1990): 80–82. See also the original handwritten note from Barck to Endler: DLA, A: Endler, A., Sommer 1986. For this reason, Endler would not have been the only person to be asked to comment on Ernst's image. This also became evident in a conversation I had with Therese Hörnigk in the summer of 2019. She was a former colleague and close friend of Karlheinz Barck and his wife Simone. However, no other comments on Ernst's image are known to me.
10. Werner Spies (ed.), *Max Ernst Œuvre-Katalog*, vol. 1: *Das graphische Werk*. Cologne: DuMont Schauberg, 1975, 22 and 244. The images differ slightly.
11. Endler, 'Haus aus Funken'. In: Barck, *Surrealismus in Paris*, 270–71 (270). This is a German translation of Breton's poem 'Le château étoile', from the volume *Le revolver à cheveux blancs* (1932).

12. Endler, *Nebbich*, 19–21. In Barck's original handwritten note, dated 'Sommer 86' (summer of 1986 – not autumn as Endler wrongly indicates in his text), Max Ernst's image is referred to as a *Zeichnung* (drawing). The 'drawing' Endler received is merely a photocopy of the original screen print on the back of the note, not bigger than an index card. See DLA, A: Endler, A., Sommer 1986.
13. Endler, *Nebbich*, 19–21. The text must have been composed before the Wende, as becomes clear in a letter to Barck of 18 August 1986 in which Endler writes: 'Etwas zu der Max-Ernst-Zeichnung demnächst' (Something on the drawing of Max Ernst follows). See DLA, A: Endler, A., 18.08.1986 1 Bl.
14. Jens-Fietje Dwars, *Abgrund des Widerspruchs. Das Leben des Johannes R. Becher*. Berlin: Aufbau Verlag, 1998, 471. Ellipsis added for copyright reasons.
15. Ernst's image documents this by indicating the crushing of the five-pointed – or Soviet – star and by depicting the violence between the two creatures, signifying the pact and later the hate between the two dictators.
16. The exhibition '30 Jahre Herzattacke' ran from 15 June to 28 July 2019. See https://www.facebook.com/khsanstitre/posts/ausstellung-30-jahre-herzattacke-im-kunsthaus-sans-titre/2536910086340735/ (accessed on 4 October 2019).
17. Frank Hörnigk, 'Die Literatur bleibt zuständig: Ein Versuch über das Verhältnis von Literatur, Utopie und Politik in der DDR', *The Germanic Review* 67(3) (1992): 99–105.

BIBLIOGRAPHY

Primary Literature

Biermann, Wolf, *Alle Lieder*. Cologne: Kiepenheuer & Witsch, 1991.
Borchert, Wolfgang, *Das Gesamtwerk*. Hamburg: Rowohlt, 1980.
Brecht, Bertolt, *Hundert Gedichte 1918–1950*. Berlin: Aufbau Verlag, 1952.
——, *Werke. Berliner und Frankfurter Ausgabe*. Berlin: Aufbau Verlag/Frankfurt: Suhrkamp, 1988–98.
——, *The Collected Poems of Bertolt Brecht*, eds. and trans. Tom Kuhn and David Constantine. New York and London: W.W. Norton, 2019.
Comte de Lautréamont, *The Songs of Maldoror*, trans. R.J. Dent. With illustrations by Salvador Dalí. Washington, DC: Solar Books, 2011.
Czechowski, Heinz, *Die Pole der Erinnerung. Autobiographie*. Düsseldorf: Grupello, 2006.
Eisler, Hanns, *Johann Faustus. Fassung letzter Hand*, ed. Hans Bunge. Berlin: Henschel, 1983.
Endler, Adolf and Karl Mickel (eds), *In diesem besseren Land. Gedichte der Deutschen Demokratischen Republik seit 1945*. Halle: Mitteldeutscher Verlag, 1966.
Endler, Adolf, *Ohne Nennung von Gründen. Vermischtes aus dem poetischen Werk des Bobbi 'Bumke' Bergermann*. Berlin: Rotbuch, 1985.
——, *Schichtenflotz. Papiere aus dem Seesack eines Hundertjährigen*. Berlin: Rotbuch, 1987.
——, *Vorbildlich schleimlösend. Nachrichten aus einer Hauptstadt 1972–2008*. Berlin: Rotbuch, 1990.
——, *Citatteria & Zackendullst. Notizen, Fragmente, Zitate*. Berlin: Ackerstraße, 1990.
——, *Der Pudding der Apokalypse. Gedichte 1963–1998*. Frankfurt: Suhrkamp, 1999.
——, *Uns überholte der Zugvögelflug. Alte und neue Gedichte*. Aschenleben: Verlag UN ART IG, 2004.
——, *Nebbich. Eine deutsche Karriere*. Göttingen: Wallstein, 2005.
——, *Dies Sirren. Gespräche mit Renatus Deckert*. Göttingen: Wallstein, 2010.
——, *Kleiner kaukasischer Divan: Von Georgien erzählen*, ed. Brigitte Schreier-Endler. Göttingen: Wallstein, 2018.
——, *Die Gedichte*, eds. Robert Gillett and Astrid Köhler. Göttingen: Wallstein, 2019.
Erb, Elke and Sascha Anderson (eds), *Berührung ist nur eine Randerscheinung. Neue Literatur aus der DDR*. Cologne: Kiepenheuer & Witsch, 1985.
Erb, Elke, *Der Faden der Geduld*, mit vier Grafiken von Robert Rehfeldt. Mit einem Gespräch zwischen Christa Wolf und Elke Erb. Berlin and Weimar: Aufbau Verlag, 1978.
——, *Winkelzüge oder Nichtvermutete aufschlußreiche Verhältnisse*, mit Grafiken von Angela Hampel. Berlin: Druckhaus Galrev, 1991.
——, *Mountains in Berlin*. Trans. Rosmarie Waldrop. Providence: Burning Deck, 1995.

——, *Sonanz. 5-Minuten-Notaten*. Basel and Weil am Rhein: Urs Engeler Editor, 2007.
——, *Gedichte und Kommentare*, eds. Jayne-Ann Igel et al. Leipzig: poetenladen, 2016.
Fries, Fritz Rudolf, *Der Weg nach Oobliadooh. Roman*. Frankfurt: Suhrkamp, 1966.
Fuchs, Jürgen, *Gedächtnisprotokolle. November '79 bis September '77*. Hamburg: Rowohlt, 1990.
Fühmann, Franz, 'Barlach in Güstrow'. In: *König Ödipus. Gesammelte Erzählungen*. Berlin and Weimar: Aufbau Verlag, 1968.
Fürnberg, Louis, *Lebenslied. Gedichte aus dem Nachlaß*. Berlin: Aufbau Verlag, 1963.
Greßmann, Uwe, *Lebenskünstler. Gedichte*. Leipzig: Reclam, 1982.
——, *Schilda Komplex*, mit Zeichnungen von Christine Schlegel. Ed. Andreas Koziol. Berlin: Edition qwert zui opü, 1998.
Heym, Stefan, *Nachruf*. Frankfurt: S. Fischer, 1990.
Hilbig, Wolfgang, *abwesenheit. gedichte*. Frankfurt: S. Fischer, 1979.
——, *zwischen den paradiesen. Prosa Lyrik*, mit einem Essay von Adolf Endler. Ed. Thorsten Ahrend. Leipzig: Reclam, 1992.
——, *Werke. Erzählungen*, eds. Jörg Bong and Oliver Vogel. Frankfurt: S. Fischer, 2010.
Höch, Hannah, *Werke und Worte*. Berlin: Fröhlich und Kaufmann, 1982.
Kachold, Gabriele, *zügel los. prosatexte*, mit 2 Grafiken von Angela Hampel. Berlin and Weimar: Aufbau Verlag, 1989.
Franz Kafka, *Amerika*, ed. Klaus Hermsdorf. Berlin: Aufbau Verlag, 1967.
——, *Das erzählerische Werk*. Vol. 1 and 2, ed. Klaus Hermsdorf. Berlin: Rüttingen & Löning, 1983.
Kunert, Günter, *Verkündung des Wetters*. Munich and Vienna: Hanser, 1966.
Leising, Richard, *Gebrochen deutsch. Gedichte*. Munich: Langewiesche-Brandt, 1990.
Metken, Günter (ed.), *Als die Surrealisten noch recht hatten. Texte und Dokumente*, 2nd edn. Hofheim: Wolke Verlag, 1982.
Mickel, Karl, *Schriften 1. Gedichte 1957–1974*. Halle: Mitteldeutscher Verlag, 1990.
Morgner, Irmtraud, *Leben und Abenteuer der Trobadora Beatriz nach Zeugnissen ihrer Spielfrau Laura*. Berlin: Aufbau Verlag, 1974.
——, *The Life and Adventures of Trobadora Beatrice as Chronicled by her Minstrel Laura*, trans. Jeanette Clausen. Lincoln and London: University of Nebraska Press, 2000.
Müller, Heiner, *Werke*, ed. Frank Hörnigk. Frankfurt: Suhrkamp, 1998–2011.
Neumann, Gert, *Die Schuld der Worte*. Frankfurt: S. Fischer, 1979/Rostock: Hinstorff, 1989.
Schröder, Rolf X., *Die Grotesken haben Ausgang. XAGO, ein europäischer Phantast*. Berlin: edition q, 1993.
Stötzer-Kachold, Gabriele, *grenzen los fremd gehen*, mit Zeichnungen der Autorin. Berlin: Janus Press, 1992.
Vonnegut, Kurt, *Slaughterhouse-Five or The Children's Crusade: A Duty-Dance with Death*. London: Vintage, 2000.
Wolf, Christa, *Nachdenken über Christa T*. Berlin and Weimar: Aufbau Verlag, 1972.
——, *Was bleibt*. Berlin and Weimar: Aufbau Verlag, 1990.

Secondary Literature – General

Adamowicz, Elza, *Surrealist Collage in Text and Image: Dissecting the Exquisite Corpse*. Cambridge: Cambridge University Press, 2008.
Ades, Dawn et al. (eds), *The Surrealism Reader: An Anthology of Ideas*. Chicago: University of Chicago Press, 2016.

———, (eds), *The International Encyclopedia of Surrealism*, 3 vols. London: Bloomsbury, 2019.
Adorno, Theodor W., *Gesammelte Schriften*, vol. 12, ed. Rolf Tiedemann. Frankfurt: Suhrkamp, 1975.
Aragon, Louis, 'Libertinage, die Ausschweifung'. In: Karlheinz Barck (ed.), *Surrealismus in Paris 1919–1939. Ein Lesebuch*. Leipzig: Reclam, 1985, 398–407.
Assmann, Aleida, *Erinnerungsräume. Formen und Wandlungen des kulturellen Gedächtnisses*. Munich: Beck, 1999.
Bahr, Erhard, 'Kafka und der Prager Frühling'. In: Heinz Politzer (ed.), *Franz Kafka*. Darmstadt: Wissenschaftliche Buchgesellschaft, 1973, 516–38.
Bakhtin, Mikhail M., *Discourse in the Novel, The Dialogic Imagination: Four Essays*, ed. Michael Holquist. Austin: University of Texas Press, 1981.
Barbian, Jan-Pieter, 'Nationalsozialismus und Literaturpolitik'. In: Rolf Grimminger (ed.), *Hanser Sozialgeschichte der deutschen Literatur vom 16. Jahrhundert bis zur Gegenwart*, vol. 9. Munich and Vienna: Hanser, 2009, 53–98.
Bartsch, Karl, 'Surrealism'. In: Jan-Dirk Müller (ed.), *Reallexikon der deutschen Literaturwissenschaft*, vol. 3. Berlin and New York: de Gruyter, 2007, 548–50.
Barron, Stephanie (ed.), *'Degenerate Art': The Fate of the Avant-Garde in Nazi Germany*. Los Angeles: Adams, 1991.
Bauduin, Tessel, *Occultism and Western Esotericism: Work and Movement of André Breton*. Amsterdam: University of Amsterdam Press, 2014.
Benjamin, Walter, 'Der Sürrealismus. Die letzte Momentaufnahme der europäischen Intelligenz'. In: *Gesammelte Werke*, eds. Rolf Tiedemann and Hermann Schweppenhäuser, vol. 2. Frankfurt: Suhrkamp, 1977–99, 295–310.
Berg, Hubert van den and Walter Fähnders (eds), *Metzler Lexikon Avantgarde*. Stuttgart: Metzler, 2009.
Bhabha, Homi K., *The Location of Culture*. London: Routledge, 1994.
———, 'Culture's In-Between'. In: Stuart Hall and Paul du Gay (eds), *Questions of Cultural Identity*. London: Sage, 1996.
Bohrer, Karl Heinz, '1968: Die Phantasie an die Macht? Studentenbewegung – Walter Benjamin – Surrealismus', *Merkur* 12 (1997): 1069–80.
Böhringer, Hannes, 'Avantgarde. Geschichte einer Metapher', *Archiv für Begriffsgeschichte* 22 (1978): 90–114.
Brake, Michael, *Comparative Youth Culture: The Sociology of Youth Cultures and Subcultures in America, Britain, and Canada*. London: Routledge & Kegan Paul, 1985.
Breton, André (ed.), *Anthologie des Schwarzen Humors*. Munich: Rogner & Bernhard, 1979.
———, *Conversations: The Autobiography of Surrealism. 1952. With André Parinaud et al.*, trans. and introduced by Mark Polizzotti. New York: Paragon House, 1993.
Brown, Timothy and Lorena Anton (eds), *Between the Avant-Garde and the Everyday: Subversive Politics in Europe from 1957 to the Present*. New York and Oxford: Berghahn Books, 2011.
Bürger, Peter, *Theorie der Avantgarde*. Frankfurt: Suhrkamp, 1974.
———, *Theory of the Avant-Garde*, introduced by Jochen Schulte-Sasse, trans. Michael Shaw. Minneapolis: University of Minnesota Press, 1984.
Cale, Matthew and Katy Wan (eds), *Magic Realism: Art in Weimar Germany 1919–33*. London: Tate, 2018.
Caws, Mary Ann, *The Poetry of Dada and Surrealism: Aragon, Breton, Tzara, Eluard and Desnos*. Princeton: Princeton University Press, 1970.
Charters, Ann (ed.), *The Penguin Book of the Beats*. London: Penguin, 1992.

Connolly, Thomas C., *Paul Celan's Unfinished Poetics: Reading in the Sous-Oeuvre*. Cambridge: Legenda, 2018,

Cornils, Ingo, *Writing the Revolution: The Construction of '1968' in Germany*. Rochester: Camden House, 2016.

Danchev, Alex (ed.), *100 Artists' Manifestos: From the Futurists to the Stuckists*. London: Penguin, 2011.

Davies, Mererid Puw, *Writing and the West German Protest Movements: The Textual Revolution*. London: imlr books, 2016.

Dech, Jula, *Hannah Höch. Schnitt mit dem Küchenmesser: Dada durch die letzte Weimarer Bierbauchkulturepoche Deutschlands*. Frankfurt: Fischer, 1989.

Doherty, Justin, *The Acmeist Movement in Russian Poetry: Culture and the Word*. Oxford: Clarendon Press, 1995.

Documenta. Kunst des XX. Jahrhunderts. Internationale Ausstellung im Museum Fridericianum in Kassel. Munich: Prestel, 1955.

Dresler, Jaroslav, 'Die Verwirrungen der Zungen. Franz Kafka im Spiegel kommunistischer Kritik', *Osteuropa* 10(7–8) (1960): 473–81.

Durozoi, Gérard, *History of the Surrealist Movement*, trans. Alison Anderson. Chicago and London: University of Chicago Press, 2002.

Eburne, Jonathan P., *Surrealism and the Art of Crime*. Ithaca and London: Cornell University Press, 2008.

Emanuely, Alexander, *Avantgarde I. Von den anarchistischem Anfängen bis Dada oder wider eine begriffliche Beliebigkeit*. Stuttgart: Schmetterling Verlag, 2015.

Enzensberger, Hans Magnus, 'Aporien der Avantgarde'. In: *Einzelheiten II. Poesie und Politik*. Frankfurt: Suhrkamp, 1964, 5–80.

Eörsi, István (ed.), *Georg Lukács: Record of a Life. An Autobiographical Sketch*. London: Verso, 1983.

Ermolaev, Herman, *Soviet Literary Theories 1917–1934: A Genesis of Socialist Realism*. Berkeley and Los Angeles: University of California Press, 1963.

Etkind, Efim, 'Kafka in sowjetischer Sicht'. In: Claude David (ed.), *Franz Kafka. Themen und Probleme*. Göttingen: Vandenhoeck & Ruprecht, 1980, 229–37.

Evans, David and Sylvia Gohl, *Photomontage: A Political Weapon*. London: Gordon Fraser, 1986.

Evans, Richard J., *Hitler's Shadow: West German Historians and the Attempt to Escape the Nazi Past*. London: I.B. Tauris, 1989.

———, *The Third Reich at War 1939–1945*. London: Allen Lane, 2008.

Fähnders, Walter, *Avantgarde und Moderne 1890–1933*. Stuttgart and Weimar: Metzler, 2010.

Foster, Hal, *The Return of the Real: The Avant-Garde at the End of the Century*. Cambridge, MA and London: MIT Press, 1996.

Fowlie, Wallace, *Age of Surrealism*. Bloomington: Indiana University Press, 1960.

Frei, Norbert, *1968. Jugendrevolte und globaler Protest*. Munich: DTV, 2008.

Fuchs, Anne and Mary Cosgrove (eds), *German Life and Letters (Special Issue: Memory Contests: Cultural Memory, Hybridity and Identity in German Discourses since 1990)* 2 (2006).

Garaudy, Roger, 'Kafka, die modern Kunst und wir'. In: Eduard Goldstücker et al. (eds), *Franz Kafka aus Prager Sicht 1963*. Prague: Verlag der tschechoslowakischen Akademie der Wissenschaften, 1965, 199–207.

Garton Ash, Timothy, *The File: A Personal History*. London: HarperCollins, 1997.

———, 'Preface', *Oxford German Studies* 38(3) (2009): 234–35.

Gallée, Caroline, *Georg Lukács. Seine Stellung und Bedeutung im literarischen Leben der SBZ/DDR 1945–1985*. Tübingen: Stauffenburg Verlag, 1996.

Geduldig, Gunter and Marco Sagurna (eds), *too much. Das lange Leben des Rolf Dieter Brinkmann*. Aachen: Alano Verlag, 1994.
Gerhardt, Marlis, *Stimmen und Rhythmen. Weibliche Ästhetik und Avantgarde*. Darmstadt and Neuwied: Luchterhand, 1986.
Goldstücker, Eduard et al. (eds), *Franz Kafka aus Prager Sicht 1963*. Prague: Verlag der tschechoslowakischen Akademie der Wissenschaften, 1965.
Goth, Maja, 'Der Surrealismus und Franz Kafka'. In: Heinz Politzer (ed.), *Franz Kafka*. Darmstadt: Wissenschaftliche Buchgesellschaft, 1973.
Gudmundsdóttir, Gunnthórunn, *Borderlines: Autobiography and Fiction in Postmodern Life Writing*. Amsterdam and Atlanta: Rodopi, 2003.
Guenther, Peter, 'Three Days in Munich, July 1937'. In: Stephanie Barron (ed.), *'Degenerate Art': The Fate of the Avant-Garde in Nazi Germany*. Los Angeles: Adams, 1991, 10–40.
Harbers, Henk (ed.), *Postmoderne Literatur in deutscher Sprache. Eine Ästhetik des Widerstands?* Amsterdam and Atlanta: Rodopi, 2000.
Haslett, Moyra, *Marxist Literary and Cultural Theories*. New York: St. Martin's Press, 2000.
Hindts, Lynn B. and Theodor O. Windt, Jr, *The Cold War as Rhetoric: The Beginnings, 1945–1950*. New York: Praeger Publishers, 1991.
Hopkins, David, *Dada and Surrealism: A Very Short Introduction*. Oxford and New York: Oxford University Press, 2004.
Illés, Làlzó, 'Sozialistische Literatur und Avantgarde', *Acta Litteraria Academiae Scientiarum Hungaricae* 12(1–2) (1970): 53–64.
Kaiser, Paul and Claudia Petzold (eds), *Boheme und Diktatur in der DDR. Gruppen Konflikte Quartiere 1970–1989*. Katalog zur Ausstellung des Deutschen Historischen Museums vom 4. September bis 16. Dezember 1997. Berlin: Fannei & Walz, 1997.
Királyfalvi, Béla, *The Aesthetics of György Lukács*. Princeton and London: Princeton University Press, 1975.
Klemperer, Victor, *LTI. Notizbuch eines Philologen*. Leipzig: Reclam, 1987.
———, *Tagebücher 1945*, ed. Walter Nowojski. Berlin: Aufbau Verlag, 1995.
———, *To the Bitter End: The Diaries of Victor Klemperer 1942–1945*, trans. Martin Chalmers. London: Weidenfeld & Nicolson, 1999.
Kliems, Alfrun, Ute Raßloff and Peter Zajac (eds), *Sozialistischer Realismus. Lyrik des 20. Jahrhunderts in Ost-Mittel-Europa II*. Berlin: Frank & Timme, 2006.
Kraushaar, Wolfgang, *Achtundsechzig. Eine Bilanz*. Berlin: Propyläen, 2008.
Kristeva, Julia, *Powers of Horror: An Essay on Abjection*, trans. L.S. Roudiez. New York: Columbia University Press, 1982.
Kröll, Friedhelm, 'Literatur und Sozialisation'. In: Rolf Grimminger (ed.), *Hanser Sozialgeschichte der deutschen Literatur vom 16. Jahrhundert bis zur Gegenwart*, vol. 10. Munich and Vienna: Hanser, 1986, 164–76.
Kurlansky, Mark, *1968: The Year that Rocked the World*. London: Vintage, 2005.
Löwy, Michael, *Morning Star: Surrealism, Marxism, Anarchism, Situationism, Utopia*. Austin: University of Texas Press, 2009.
Lommel, Michael et al. (eds), *Surrealismus und Film. Von Fellini bis Lynch*. Bielefeld: transcript, 2008.
Lukács, Georg, *Wider den mißverstandenen Realismus*. Hamburg: Claassen, 1958.
———, *The Destruction of Reason*, trans. Peter Palmer. Altantic Highlands: Humanities, 1981.
———, 'The Ideology of Modernism'. In: Arpad Kadarkay (ed.), *The Lukács Reader*. Oxford: Blackwell, 1995, 187–209.
Maeding, Linda, 'Zwischen Traum und Erwachen: Walter Benjamins Surrealismus-Rezeption', *Revista de Filología Alemana* 20 (2012): 11–28.

Mahon, Alyce, *Surrealism and the Politics of Eros, 1938–1968*. London: Thames & Hudson, 2005.
Malanowski, Wolfgang, *1945. Deutschland in der Stunde Null*. Hamburg: Rowohlt, 1985.
Mattenklott, Gert, *Blindgänger. Physiognomische Essais*. Frankfurt: Suhrkamp, 1986.
Matthews, J.H., *Towards the Poetics of Surrealism*. Syracuse: Syracuse University Press, 1976.
Max Ernst, Zeichendieb. Eine Ausstellung der Nationalgalerie, Sammlung Scharf-Gerstenberg, Staatlich Museen zu Berlin. Bonn: VG Bild-Kunst/Berlin: Staatliche Museen zu Berlin, 2019.
Moray, Gerta, 'Miró, Bosch and Phantasy Painting', *The Berlington Magazine* 113(820) (1971): 387–91.
Müller-Mehlis, Reinhard, *Die Kunst im Dritten Reich*. Munich: Heyne, 1976.
Nordau, Max, *Degeneration*, ed. George L. Mosse. Lincoln and London: University of Nebraska Press, 1993.
Olney, James (ed.), *Autobiography: Essays Theoretical and Critical*. Princeton: Princeton University Press, 1980.
Overy, Richard, 'Interwar, War, Postwar: Was there a Zero Hour in 1945?' In: Dan Stone (ed.), *The Oxford Handbook of Postwar European History*. Oxford: Oxford University Press, 2012, 61–78.
Petropoulos, Jonathan, *Artists under Hitler: Collaboration and Survival in Nazi Germany*. New Haven and London: Yale University Press, 2014.
Pike, David, *Lukács and Brecht*. Chapel Hill and London: The University of North Carolina Press, 1985.
Piotrowski, Piotr, *In the Shadow of Yalta: Art and the Avant-Garde in Eastern Europe, 1945–1989*. Chicago: Chicago University Press, 2009.
Polizzotti, Mark, *Revolution of the Mind: The Life of André Breton*. Boston: Black Widow Press, 2008.
Queipo, Isabel Maurer et al. (eds), *Die grausamen Spiele des 'Minotaure'. Intermediale Analysen einer surrealistischen Zeitschrift*. Bielefeld: Transcript, 2005.
Ramirez, Mari Carmen and Héctor Olea, *Inverted Utopias: Avant-Garde Art in Latin America*. New Haven and London: Yale University Press, 2004.
Reents, Friederike (ed.), *Surrealismus in der deutschsprachigen Literatur*. Berlin and New York: de Gruyter, 2009.
Richter, Helmut, *Franz Kafka. Werk und Entwurf*. Berlin: Rütten & Loening, 1962.
Richtig, Ludwig, 'Vom Surrealism und von der Katholischen Moderne zum Sozialistischen Realismus in der slowakischen Lyrik'. In: Alfrun Kliems, Ute Raßloff and Peter Zajac (eds), *Sozialistischer Realismus. Lyrik des 20. Jahrhunderts in Ost-Mittel-Europa II*. Berlin: Frank & Timme, 2006, 129–50.
Rinner, Susanne, *The German Student Movement and the Literary Imagination: Transnational Memories of Protest and Dissent*. New York and Oxford: Berghahn Books, 2013.
Rissler-Pipka, Nanette, 'Picasso und sein Minotaure'. In: Isabel Maurer Queipo et al. (eds), *Die grausamen Spiele des 'Minotaure'. Intermediale Analysen einer surrealistischen Zeitschrift*. Bielefeld: Transcript, 2005, 39–70.
Robinson, Benjamin, *The Skin of the System: On Germany's Socialist Modernity*. Redwood City: Stanford University Press, 2009.
Rühmkorf, Peter, *Wolfgang Borchert mit Selbstzeugnissen und Bilddokumenten*. Reinbek: Rowohlt, 1997.
Sax, Boria, *The Serpent and the Swan: Animal Brides in Literature and Folklore*. Knoxville: University of Tennessee Press, 1998,

Sayer, Derek, *Prague, Capital of the Twentieth Century: A Surrealist History*. Princeton and Oxford: Princeton University Press, 2013.
Schöttker, Detlev, 'Expressionismus, Realismus und Avantgarde – literatur- und medienästhetische Debatten im sowjetischen Exil'. In: Rolf Grimminger (ed.), *Hanser Sozialgeschichte der deutschen Literatur vom 16. Jahrhundert bis zur Gegenwart*, vol. 10. Munich and Vienna: Hanser, 1986, 230–44.
Schmidt, Marianne, *Wolfgang Borchert. Analysen und Aspekte*. Halle/Saale: Mitteldeutscher Verlag, 1974.
Schneede, Uwe M., *Die Kunst des Surrealismus. Malerei, Skulptur, Fotografie, Film*. Munich: Beck, 2006.
Schuller, Karina and Isabel Fischer (eds), *Der Surrealismus in Deutschland (?). Interdisziplinäre Studien*. Münster: Wissenschaftliche Schriften der WUU Münster, 2016.
Seibt, Johanna, 'Process Philosophy'. In: Edward N. Zalta (ed.), *The Stanford Encyclopedia of Philosophy* (Summer 2020 Edition), https://plato.stanford.edu/entries/process-philosophy/ (accessed on 20 October 2020).
Sobotta, Michael, *Berlin in frühen Farbfotografien. 1936 bis 1943*. Erfurt: Sutton Verlag, 2015.
Spies, Werner (ed.), *Max Ernst Œuvre-Katalog*, vol. 1. *Das graphische Werk*. Cologne: DuMont Schauberg, 1975.
———, *Max Ernst Frottages*. London: Thames & Hudson, 1986.
Stahl, Enno, *Anti-Kunst und Abstraktion in der literarischen Moderne. Vom italienischen Futurismus bis zum französischen Surrealismus 1909–1933*. Frankfurt: Lang, 1997.
Sturrock, John, *The Language of Autobiography: Studies in the First Person Singular*. Cambridge: Cambridge University Press, 1993.
Suleiman, Susan Rubin, *Subversive Intent: Gender, Politics, and the Avant-Garde*. Cambridge, MA: Harvard University Press, 1990.
Taberner, Stuart (ed.), *Contemporary German Fiction: Writing in the Berlin Republic*. Cambridge: Cambridge University Press, 2007.
Tall, Emily, 'Who's Afraid of Franz Kafka? Kafka Criticism in the Soviet Union', *Slavic Review* 35(3) (1976): 484–503.
Taylor, Ronald (ed.), *Adorno, Benjamin, Bloch, Brecht, Lukács, Aesthetics and Politics*. London: Verso, 1980.
Thun, Johann, 'Der Kreis um das Jahrbuch *Speichen* als Vermittler des Surrealismus in Deutschland'. In: Karina Schuller and Isabel Fischer (eds), *Der Surrealismus in Deutschland (?). Interdisziplinäre Studien*. Münster: Wissenschaftliche Schriften der WUU Münster, 2016, 219–36.
Tigges, Wim, *An Anatomy of Literary Nonsense*. Amsterdam: Rodopi, 1988.
Tippner, Anja, *Die permanente Avantgarde? Surrealismus in Prag*. Cologne: Böhlau, 2009.
Wasensteiner, Lucy and Martin Faass (eds), *Defending 'Degenerate' Art. London 1938. Mit Kandinsky, Liebermann und Nolde gegen Hitler*. Wädeswil: NIMBUS, 2018.
Wehdeking, Volker (ed.), *Mentalitätsverlust in der deutschen Literatur zur Einheit (1990–2000)*. Berlin: Erich Schmidt, 2000.
Wehle, Winfried, 'Lyrik der Zweiten Moderne. Wandlungen einer dissidenten Sprachbewegung im 20. Jahrhundert'. In: Winfried Wehle (ed.), *Französische Literatur. 20. Jahrhundert: Lyrik*. Tübingen: Stauffenburg, 2010, 9–42.
Zavala, Iris M., 'Bakhtin and Otherness: Social Heterogeneity', *Critical Studies* 2(2) (1990): 77–89.
Zipes, Jack, 'Ernst Bloch and the Obscenity of Hope: Introduction to a Special Section on Ernst Bloch', *New German Critique* 1 (1988): 3–8.

Zuch, Rainer, 'Max Ernst, der *König der Vögel* und die mythischen Tiere des Surrealismus', *Kunsttexte.de* 2 (2014): 1–13.

Secondary Literature – SBZ and GDR

Agde, Günter (ed.), *Kahlschlag. Das 11. Plenum des ZK der SED 1965. Studien und Dokumente.* Berlin: Aufbau Verlag, 1991.
Barck, Karlheinz, Dieter Schlenstedt and Wolfgang Thierse (eds), *Künstlerische Avantgarde. Annäherungen an ein unabgeschlossenes Kapitel.* Berlin: Akademie Verlag, 1979.
Barck, Karlheinz, Heidi Paris, Peter Gente and Stefan Richter (eds), *Aisthesis. Wahnehmung heute oder Persektiven einer anderen Ästhetik.* Leipzig: Reclam: 1990.
Barck, Karlheinz, Martin Fontius, Dieter Schlenstedt, Burkhart Steinwachs and Friedrich Wolfzettel (eds), *Ästhetische Grundbegriffe. Historisches Wörterbuch in sieben Bänden*, Stuttgart and Weimar: Metzler, 2001–10.
Barck, Karlheinz (ed.), *Surrealismus in Paris 1919–1939. Ein Lesebuch.* Leipzig: Reclam, 1985.
———, 'Kontinente der Phantasie', In Barck (ed.), *Surrealismus in Paris 1919–1939. Ein Lesebuch.* Leipzig: Reclam, 1985, 717–49.
Bathrick, David, *The Powers of Speech: The Politics of Culture in the GDR.* Lincoln and London: University of Nebraska Press, 1995.
Bénédicte, Terrisse, 'Du Coup de Grisou à la Apocalypse: Explosion Politique dans "Alte Abdeckerei" (1991) de Wolfgang Hilbig'. In: Georges Felten et al. (eds), *L'explosion en Point de Mire/Die Explosion vor Augen.* Würzburg: Königshausen & Neumann, 2013. 317–34.
Berbig, Roland et al. (eds), *In Sachen Biermann. Protokolle, Berichte und Briefe zu den Folgen einer Ausbürgerung.* Berlin: Ch. Links, 1994.
Berendse, Gerrit-Jan, *Die 'Sächsische Dichterschule'. Lyrik in der DDR der sechziger und siebziger Jahre.* Frankfurt: Lang, 1990.
———, 'Gefundenes Fressen; Karl Mickels Kannibalismus', *Sinn und Form* 6 (1991): 1142–50.
———, 'Zu neuen Ufern: Lyrik der "Sächsischen Dichterschule" im Spiegel der Elbe'. In: Margy Gerber et al. (eds), *Studies in GDR Culture and Society: 10 Selected Papers from the Fifteenth New Hampshire Symposium on the German Democratic Republic.* Lanham: University Press of America, 1991, 197–212.
———, (ed.), *KRAWARNEWALL. Über Adolf Endler.* Leipzig: Reclam, 1997.
———, *Grenz-Fallstudien. Essays zum Topos Prenzlauer Berg in der DDR-Literatur.* Berlin: Erich Schmidt, 1999.
———, 'Das Karnevalprojekt. Chronik eines mißlungenen Lyrik-Experiments 1964–1968', *Wirkendes Wort* 2 (2000): 230–47.
———, 'Karneval in der DDR. Ansätze postmodernen Schreibens 1960–1990'. In: Henk Harbers (ed.), *Postmoderne Literatur in deutscher Sprache. Eine Ästhetik des Widerstands?* Amsterdam and Atlanta: Rodopi, 2000, 233–56.
———, '"Dank Breton". Surrealismus und kulturelles Gedächtnis in Adolf Endlers Lyrik'. In: Karen Leeder (ed.), *Schaltstelle. Neue deutsche Lyrik im Dialog.* Amsterdam: Rodopi, 2007, 73–95.
———, 'Adolf Endler'. In: Ursula Heukenkamp and Peter Geist (eds), *Deutschsprachige Lyriker des 20. Jahrhunderts.* Berlin: Erich Schmidt, 2007, 494–502.
———, 'Fractures Memories: Life Writing in Adolf Endler's Surrealist Anti-Autobiography *Nebbich*', *Seminar* 45(1) (2009): 31–43.

———, 'Laughed Back to Life', *Times Literary Supplement*, 31 May 2013, 15.
———, 'The Politics of Dialogue: Poetry in the GDR'. In: Karin Leeder (ed.), *Rereading East Germany: The Literature and Film of the GDR*. Cambridge: Cambridge University Press, 2015, 143–59.
———, 'Die *Akte Endler*. Eine Gedichtsammlung: Verlegerisches "Gefumel" oder gelungene Zivilisationskritik der späten DDR?' In Ingrid Sonntag (ed.), *An den Grenzen des Möglichen. Reclam Leipzig 1945–1991*. Berlin: Ch. Links, 2016, 474–82.
———, 'Twentieth-Century Poetry'. In: Andrew J. Webber (ed.), *Cambridge Companion to the Literature of Berlin*. Cambridge: Cambridge University Press, 2017, 245–63.
Berendes, Sabine and Paul Clements (eds and trans.), *Brecht, Music and Culture: Hanns Eisler in Conversation with Hans Bunge*. London: Bloomsbury, 2014.
Berger, Manfred (ed.), *Kulturpolitisches Wörterbuch*. Berlin: Dietz, 1970.
Biermann, Wolf, '"Laß, o Welt, o laß mich sein!" Rede zur Verleihung des Eduard-Mörike-Preises', *Die Zeit* 47 (1991) later in *Der Sturz des Dädalus*. Köln: Kiepenheuer & Witsch, 1992, S. 64–72.
Bílik, René, 'Drei Fragen an den Sozialistischen Realismus'. In: Alfrun Kliems et al. (eds), *Sozialistischer Realismus. Lyrik des 20. Jahrhunderts in Ost-Mittel-Europa II*. Berlin: Frank & Timme, 2006, 25–38.
Blake, David (ed.), *Hanns Eisler: A Miscellany*. Luxembourg: Harwood, 1995.
Bleutge, Nico, 'Gedanken wie Reisig zu Füßen. Die Erkenniskraft des Gedichts – vier Umkreisungen zu Elke Erb'. In: Steffen Poppe (ed.), *Elke Erb*. Munich: edition text + kritik, 2017, 28–37.
Bloch, Ernst and Hanns Eisler, 'Die Kunst zu erben', *alternative* 12 (1967–68): 216–18.
Böhme, Thomas, 'Wie was es möglich? Zu Wolfgang Hilbigs Erstveröffentlichung in der DDR'. In: Ingrid Sonntag (ed.), *An den Grenzen des Möglichen. Reclam Leipzig 1945–1991*. Berlin: Ch. Links, 2016, 455–56.
Böhnki, Detlef, *DADA-Rezeption in der DDR-Literatur*. Essen: Verlag Die Blaue Eule, 1989.
Böthig, Peter, *Grammatik einer Landschaft. Literatur aus der DDR in den 80er Jahren*. Berlin: Lukas, 1997
Böttiger, Helmut, 'Monströse Sinnlichkeiten, negative Utopie. Wolfgang Hilbig's DDR-Modern'. In: Heinz Ludwig Arnold (ed.), *Wolfgang Hilbig*. Göttingen: edition text + kritik, 1994, 52–61.
Braun, Volker, 'Rimbaud. Ein Psalm der Aktualität', *Sinn und Form* 5 (1985): 978–98.
Bremer, Kai, 'Erholung durch Störung. Zum Status surrealistischer Malerei und Literatur bei Heiner Müller'. In: Friederike Reents (ed.), *Surrealismus in der deutschsprachigen Literatur*. Berlin and New York: de Gruyter, 2009, 206–10.
Brockmann, Stephen, *The Writers' State: Constructing East German Literature, 1945–1959*. Rochester: Camden House, 2015.
Brohm, Holger, *Die Koordinaten im Kopf. Gutachtenwesen und Literaturkritik in der DDR in den 1960er Jahren. Fallbeispiel Kritik*. Berlin: Lukas Verlag, 2001.
Clark, Mark W., 'Hero or Villain? Bertolt Brecht and the Crisis Surrounding June 1953', *Journal of Contemporary History* 41(3) (2006): 451–75.
Cooke, Paul, *Speaking the Taboo: A Study of the Work of Wolfgang Hilbig*. Amsterdam: Rodopi, 2000.
Dahlke, Birgit, *Papierboot. Autorinnen aus der DDR – inoffiziell publiziert*. Würzburg: Königshausen & Neumann, 1997.
———, 'Zur Männerszene gehört eine Frauenszene. Jüngere Autorinnen in inoffiziell publizierten Zeitschriften der DDR 1979–89'. In: Christine Cosentino and Wolfgang

Müller (eds), *'im widerstand/in mißverstand'? Zur Literatur und Kunst des Prenzlauer Berg.* New York: Lang, 1995,145–67.

———, 'Avant-gardist, Mediator, and ... Mentor? Elke Erb', *Women in German Yearbook* 13 (1997): 123–32.

——— and Elke Erb, 'Not "Man or Woman", But Rather "What Kind of Power Structure Is This?" Elke Erb in Conversation with Birgit Dahlke', *Women in German Yearbook* 13 (1997): 133–50.

Davidson, John and Sabine Hake (eds), *Framing the Fifties: Cinema in a Divided Germany.* Oxford and New York: Berghahn Books, 2007.

Davies, Peter, *Divided Loyalties: East German Writers and the Politics of German Division 1945–1953.* Leeds: Maney, 2000.

Deiritz, Karl, and Hannes Krauss (eds), *Verrat an der Kunst? Rückblicke auf die DDR-Literatur.* Berlin and Weimar: Aufbau Verlag, 1993.

Dresen, Adolf, 'Der Fall Faust. 1968: Der letzte öffentliche Theater-Skandal in der DDR', *Der Freitag*, 19 November 1999.

Dwars, Jens-Fietje, *Abgrund des Widerspruchs. Das Leben des Johannes R. Becher.* Berlin: Aufbau Verlag, 1998.

Decker, Gunnar, *1965. Der kurze Sommer der DDR.* Munich: Hanser, 2015.

Deiritz, Karl and Hannes Krauss (eds), *Verrat an der Kunst? Rückblicke auf die DDR-Literatur.* Berlin and Weimar: Aufbau Verlag, 1993.

Ebert, Hildtrud (ed.), *Erhard Frommhold (1938–2007). Lektor und Publizist. 'Meine Biographie sind meine Bücher'.* Berlin: Archiv der Akademie der Künste, 2008.

Eidecker, Martina Elisabeth, *Sinnsuche und Trauerarbeit. Funktionen von Schreiben in Irmtraud Morgners Werk.* Hildesheim: Olms, 1998.

Eigler, Friederike, 'At the Margins of East Berlin's "Counter Culture": Elke Erb's *Winkelzüge* and Gabriele Kachold's *zügel los*', *Women in German Yearbook* 9 (1993): 145–61.

Emde, Silke von der, *Entering History: Feminist Dialogues in Irmtraud Morgner's Prose.* Oxford: Lang, 2004.

Emmerich, Wolfgang, *Kleine Literaturgeschichte der DDR. Erweiterte Neuausgabe.* Leipzig: Gustav Kiepenheuer, 1996.

———, 'Deutsche Intellektuelle: was nun? Zum Funktionswandel der (ostdeutschen) literarischen Intelligenz zwischen 1945 und 1998'. In: Laurence McFalls and Lothar Probst (eds), *After the GDR: New Perspectives on the Old GDR and the Young Länder.* Amsterdam: Rodopi, 2001, 3–27.

———, 'Schicksale der Moderne in der DDR'. In: Sabina Becker and Helmuth Kiesel (eds), *Literarische Moderne. Begriff und Phänomen.* Berlin: de Gruyter, 2007. 417–34.

———, 'The GDR and Its Literature: An Overview'. In: Karen Leeder (ed.), *Rereading East Germany: The Literature and Film of the GDR.* Cambridge: Cambridge University Press, 2015, 8–34.

Endler, Adolf, 'Im Zeichen der Inkonsequenz. Über Hans Richters Aufsatzsammlung "Verse, Dichter, Wirklichkeiten"', *Sinn und Form* 6 (1971): 1358–66.

———, 'DDR-Lyrik Mitte der Siebziger. Fragment einer Rezension', *Amsterdamer Beiträge zur neueren Germanistik* 7 (1978): 67–95.

———, 'Alles ist im untergrund obenauf, einmannfrei ... Anläßlich einer Anthologie'. In: *Den Tiger reiten. Aufsätze, Polemiken und Notizen zur Lyrik der DDR.* Frankfurt: Luchterhand, 1990, 40–65.

———, 'Hölle/Maelstrom/Abwesenheit. Fragmente über Wolfgang Hilbig'. In: Wolfgang Hilbig, *zwischen den paradiesen. Prosa Lyrik*, mit einem Essay von Adolf Endler, ed. Thorsten Ahrend. Leipzig: Reclam, 1992, 313–44.

Erbe, Günter, *Die verfemte Moderne. Die Auseinandersetzung mit dem 'Modernismus' in Kulturpolitik, Literaturwissenschaft und Literatur der DDR*. Opladen: Westdeutscher Verlag, 1993.
Erpenbeck, Fritz, 'Formalismus und Dekadenz. Einige Gedanken aus Anlaß einer mißglückten Diskussion', *Theater der Zeit* 4(4) (1949): 1–8.
Farrelly, Daniel J., *Goethe in East Germany, 1949–1989: Towards a History of Goethe Reception in the GDR*. Columbia: Camden House, 1998.
Fehervary, Helen, *Anna Seghers: The Mythic Dimension*. Ann Arbor: University of Michigan Press, 2001.
Finger, Evelyn, 'Das Museum bin ich: Ein Gespräch mit Adolf Endler', *Die Zeit*, 29 June 2006. See also http://zeus.zeit.de/2006/27/endler-interview (accessed on 26 September 2006).
Franzlik, Margret, *Erinnerung an Wolfgang Hilbig*. Berlin: Transit Verlag, 2014.
Fried, Erich, 'In diesem besseren Land. Buchbesprechung'. In: Michael Lewin (ed.), *Gedanken in und an Deutschland. Essays und Reden*. Vienna: Europa Verlag, 1988, 28.
Fritzsche, Karin and Claus Löser (eds), *Gegenbilder. Filmische Subversion in der DDR 1976–1989. Texte Bilder Daten*. Berlin: Janus Press, 1996.
Frommhold, Erhard (ed.), *Kunst im Widerstand. Malerei, Graphik, Plastik 1922–1945*. Dresden and Frankfurt: VEB Verlag der Kunst and Röderberg-Verlag, 1968.
Fulbrook. Mary, *Power and Society in the GDR, 1961–1979: The 'Normalisation of the Rule'?* Oxford and New York: Berghahn Books, 2013.
Gabelmann, Thilo, *Thälmann ist niemals gefallen? Eine Legende stirbt*. Berlin: Das Neue Berlin, 1996.
Geißler, Cornelia, '"ich möchte schon, dass man lacht." Ein Gespräch mit dem Dichter Adolf Endler über Poesie und Literaturbetrieb', *Berliner Zeitung*, 26 January 2000.
Geist, Peter, 'Nachwort'. In: Adolf Endler, *Die Gedichte*, eds. Robert Gillett and Astrid Köhler. Göttingen: Wallstein, 2019, 851–65.
Gerhard, Ute (ed.), *Schreibarbeiten an den Rändern der Literatur. Die Dortmunder Gruppe 61*. Essen: Klartext, 2012.
Goeschen, Ulrike, *Vom sozialistischen Realismus zur Kunst im Sozialismus. Die Rezeption der Moderne in Kunst und Kunstwissenschaft der DDR*. Berlin: Duncker & Humblot, 2001.
Gröschner, Annett, 'Zumutung. Meine frühen Erb-Lektüren'. In: Steffen Poppe (ed.), *Elke Erb*. Munich: edition text + kritik, 2017, 77–81.
Grunenberg, Antonia, *Aufbruch der inneren Mauer. Politik und Kultur in der DDR 1971–1990*. Bremen: Edition Temmen, 1990.
Hamburger, Michael, 'In the Corvine Mode', *Times Literary Supplement*, 21 May 1976: 622.
Hartmann, Anneli, *Lyrik-Anthologien als Indikator des literarischen und gesellschaftlichen Prozesses in der DDR (1949–1971)*. Frankfurt: Lang, 1983.
Hasenfelder, Ulf Christian, '"Kwehrdeutsch". Die dritte Literatur in der DDR', *neue deutsche literatur* 1 (1991): 82–93.
Hecht, Werner, *Die Mühen der Ebenen. Brecht und die DDR*. Berlin: Aufbau Verlag, 2013.
Heisig, Bärbel, *'Briefe voller Zitate aus dem Vergessen'. Intertexualität im Werk Wolfgang Hilbigs*. Frankfurt: Peter Lang, 1996.
Hell, Julia, 'Wendebilder. Neo Rauch and Wolfgang Hilbig', *The Germanic Review* 77 (2002): 279–303.
Hempel, Leon, *Stillstand und Bewegung. Hoher Stil in der Lyrik Ost- und Westdeutschlands*. Berlin: GegenSatz Verlag, 2011.
Hermlin, Stephan and Hans Mayer, *Ansichten über einige Bücher und Schriftsteller*. Berlin: Volk und Welt, 1947.

Hermsdorf, Klaus, *Kafka in der DDR. Erinnerung eines Beteiligten*. Berlin: Theater der Zeit, 2006.

Herzfelde, Wieland, 'George Grosz, John Heartfield, Erwin Piscator, Dada und die Folgen oder die Macht der Freundschaft', *Sinn und Form* 23(6) (1971): 1224–51.

Hörnigk, Frank, 'Die Literatur bleibt zuständig. Ein Versuch über das Verhältnis von Literatur, Utopie und Politik in der DDR', *The Germanic Review* 67(3) (1992): 99–105.

Hörnigk, Therese, *Christa Wolf*. Göttingen: Steidl, 1989.

Esther Hool, *Den Klang übersetzen. Elke Erb als Dichterin und Marina Zwetajewas Nachdichterin*, Ph.D. thesis. Utrecht: University of Utrecht, 2019.

Huyssen, Andreas, 'The Search for Tradition: Avant-Garde and Postmodernism in the 1970s', *New German Critique* 22 (1981): 23–40.

Jäger, Manfred, *Kultur und Politik in der DDR 1945–1990*. Cologne: Edition Deutschland Archiv, 1995.

Kaiser, Paul and Claudia Petzold, *Boheme und Diktatur in der DDR. Gruppen, Konflikte, Quartiere 1970–1989*. Berlin: Fannei & Walz, 1997.

Klatt, Gudrun, 'Schwierigkeiten mit der Avantgarde. Beobachtungen zum Umgang mit dem Erbe der sozialistischen Avantgarde während der Übergangsperiode in der DDR'. In: Karlheinz Barck, Dieter Schlenstedt and Wolfgang Thierse (eds), *Künstlerische Avantgarde. Annäherungen an ein unabgeschlossenes Kapitel*. Berlin: Akademie Verlag, 1979, 257–71.

———, *Vom Umgang mit der Moderne. Ästhetische Konzepte der dreissiger Jahre. Lifschitz, Lukács, Lunatscharski, Bloch, Benjamin*. Berlin: Akademie-Verlag, 1984.

Kolbe, Uwe, *Brecht*. Frankfurt: S. Fischer, 2016.

Krabiel, Klaus-Dieter, *Brechts Lehrstücke. Entstehung und Entwicklung eines Spieltyps*. Stuttgart and Weimar: Metzler, 1993.

Kuhn, Tom et al. (eds), *Brecht on Performance: Messingkauf and Modelbooks*. London: Bloomsbury, 2014.

Kurella, Alfred, *Kritik in der Zeit. Literaturkritik der DDR 1945–1975*. vol. 1. Halle and Leipzig: Mitteldeutscher Verlag, 1978.

———, *Das Eigene und das Fremde. Beiträge zum sozialistischen Humanismus*, ed. Hans Koch. Berlin: Dietz Verlag, 1981.

Lang, Lothar, *Das Bauhaus 1919–1933. Idee und Wirklichkeit*. Berlin: Zentralinstitut für Gestaltung, 1966.

———, *Malerei und Graphik in der DDR*. Leipzig: Reclam, 1983.

———, *Surrealismus und Buchkunst*. Leipzig: Edition Leipzig, 1993.

Laschen, Gregor, *Lyrik aus der DDR. Anmerkungen zur Sprachverfassung des modernen Gedichts*. Frankfurt: Athenäum-Verlag, 1971.

——— and Ton Naaijkens, 'Gespräch mit Adolf Endler', *Deutsche Bücher* 1 (1981): 1–18.

Lauter, Hans, *Der Kampf gegen den Formalismus in Kunst und Literatur, F*ür eine fortschrittliche deutsche Kultur. Berlin: Dietz, 1951.

Laux, Carmen and Patricia F. Zeckert (eds), *Flachware. Fußnoten der Leipziger Buchwissenschaft*. Leipzig and London: Plöttner, 2012.

Leeder, Karen, *Breaking Boundaries: A New Generation of Poets in the GDR*. Oxford and New York: Oxford University Press, 1996.

———, (ed.), *Schaltstelle. Neue deutsche Lyrik im Dialog*. Amsterdam and New York: Rodopi, 2007.

———, (ed.), *Rereading East Germany: The Literature and Film of the GDR*. Cambridge: Cambridge University Press, 2015.

Lehmann, Jürgen, *Russische Literatur in Deutschland. Ihre Rezeption durch deutschsprachige Schriftsteller und Kritiker vom 18. Jahrhundert bis zur Gegenwart*. Stuttgart: Metzler, 2015.

Leske, Birgid, and Marion Reinisch, 'Exil in Großbritannien'. In: Ludwig Hoffmann et al. (eds), *Exil in der Tschechoslowakei, in Großbritannien, Skandinavien und in Palästina*. Leipzig: Reclam, 1980, 147–305.

Lewis, Alison, *Die Kunst des Verrats. Der Prenzlauer Berg und die Staatssicherheit*. Würzburg: Königshausen & Neumann, 2003.

Link, Jürgen, 'Klassik als List, oder über die Schwierigkeiten des späten Brecht beim Schreiben der Wahrheit'. In: Jan Knopf (ed.), *Interpretationen. Gedichte von Bertolt Brecht*. Stuttgart: Reclam, 1995, 162–63.

Linklater, Beth, 'Erotic Provocations: Gabriele Stötzer-Kachold's Reclaiming of the Female Body?', *Women in German Yearbook* 13 (1997): 151–70.

Löser, Claus, *Strategien der Verweigerung. Untersuchungen zum politisch-ästhetischen Gestus unangepasster filmischer Artikulationen in der Spätphase der DDR*. Berlin: DEFA-Stiftung, 2011.

Lohse, Karen, *Wolfgang Hilbig. Eine motivische Biographie*. Leipzig: Plöttner, 2008.

Lucchesi, Joachim (ed.), *Das Verhör in der Oper. Die Debatte um die Aufführung Das Verhör des Lukullus von Bertolt Brecht und Paul Dessau*. Berlin: BasisDruck, 1993.

Lüdke, Martin, 'Bohemien im Arbeiter- und Bauernstaat: Kaum mehr nachvollziehbare Bewusstseinslage', *Frankfurter Rundschau*, 1 June 2005, http://www.fr-Online/in_und_ausland/kultur_und_medien/ literatur/?cm_cnt=68355 (accessed on 26 September 2006).

Magnan, Thomas, 'Die Rezeption des Surrealismus in der DDR. Die Anthologie *Surrealismus in Paris*', *Germanica* 59(2) (2016): 143–48.

Mayer, Hans, *Zur deutschen Literatur der Zeit*. Reinbek: Rowohlt, 1956.

———, *Außenseiter*. Frankfurt: Suhrkamp, 1975.

———, *Deutsche Literatur 1945–1984*. Berlin: Siedler, 1988.

Mazenauer, Beat, 'Höhere Sirenen befahlen', *Freitag*, 18 March 2005, http://www.freitag.de/2005/11/05112102.php (accessed on 26 September 2006).

Michael, Klaus and Michael Wohlfahrt (eds), *Vogel oder Käfig sein. Kunst und Literatur aus unabhängigen Zeitschriften in der DDR 1979–1989*. Berlin: Galrev, 1999.

Mierau, Fritz and Sieglinde Mierau (eds), 'Lob der Torheit', *Herzattacke. Literatur- und Kunstzeitschrift* 31(1) (2019): 190–220.

Mierau, Fritz (ed.), *Mitternachtstrolleybus. Neue Sowjetische Lyrik*. Berlin: Verlag Neues Leben, 1965.

———, 'Gedächtnisse'. In: Anna Achmatowa, *Poem ohne Held. Poeme und Gedichte. Russisch und deutsch*. Leipzig: Reclam, 1984, 259–67.

———, 'Russen in der UB Leipzig. Karlheinz Barck zum Gedächtnis'. In: Ingrid Sonntag (ed.), *An den Grenzen des Möglichen. Reclam Leipzig 1945–1911*. Berlin: Ch. Links, 2016, 285–89.

Mittenzwei, Werner (ed.), *Dialog and Kontroverse mit Georg Lukács*. Leipzig: Reclam, 1975.

———, 'Brecht und der Freundeskreis der Materialästhetik. Kunstentwürfe zu Beginn der dreißiger Jahre und ihre Schicksale'. In: Klaus Siebenhaar and Hermann Haarmann (eds), *Preis der Vernunft. Literatur und Kunst zwischen Aufklärung, Widerstand und Anpassung. Festschrift für Walter Huder*. Berlin and Vienna: Medusa, 1982, 67–83.

———, *Die Intellektuellen. Literatur und Politik in Ostdeutschland 1945–2000*. Berlin: Aufbau Verlag, 2003.

Ng, Alan G., *GDR Poetry's 'Geburtsstunde' as Historical Artifact*, Ph.D. thesis. Madison, WI: University of Wisconsin-Madison, 2002, www.alan-ng.net/lyrikabend/dissertation/e-book.pdf (accessed on 19 February 2018).

Opitz, Michael and Michael Hofmann (eds), *Metzler Lexikon DDR-Literatur. Autoren – Institutionen – Debatten*. Stuttgart and Weimar: Metzler, 2009.

Opitz, Michael, *Wolfgang Hilbig. Eine Biographie*. Frankfurt: S. Fischer, 2017.
Pabst, Stephan, *Post-Ost-Moderne. Poetik nach der DDR*. Göttingen: Wallstein, 2016.
Pachnicke, Peter and Klaus Honnef (eds), *John Heartfield*. New York: Abrams, 1992.
Pamperrien, Sabine, *Versuch am untauglichen Objekt. Der Schriftstellerverband der DDR im Dienst der sozialistischen Ideologie*. Frankfurt: Lang, 2004.
Papenfuß, Bert and Ronald Lippok (eds), *Psychonautikon Prenzlauer Berg*. Fürth: starfruit publications, 2015.
Parker, Stephen. 'Brecht and *Sinn und Form*: The Creation of Cold War Legends', *German Life and Letters* 60(4) (2007): 518–33.
———, *Bertolt Brecht: A Literary Life*. London: Bloomsbury, 2014.
Paul, Georgina, '*Unschuld, du Licht deiner Augen*: Elke Erb in the Company of Friederike Mayröcker in the Aftermath of German Unification'. In: Karen Leeder (ed.), *Schaltstelle: Neue deutsche Lyrik im Dialog*. Amsterdam and New York, Rodopi, 2007, 139–62.
Peitsch, Helmut, 'Leseland'. In: Michael Opitz and Michael Hofmann (eds), *Metzler Lexikon. DDR-Literatur. Autoren – Institutionen – Debatten*. Stuttgart and Weimar: Metzler, 2009, 189–91.
Pfeiffer, Ingrid et al., *A.R. Penck. Werke 1961–2001*. Düsseldorf: Richter, 2007.
Pfeil, Ulrich, *Die 'anderen' deutsch-französischen Beziehungen. Die DDR und Frankreich 1949–1990*. Cologne: Böhlau, 2004.
Poppe, Steffen (ed.), *Elke Erb*. Munich: edition text + kritik, 2017.
Raddatz, Fritz J., 'Zur Entwicklung der Literatur in der DDR'. In: Manfred Durzak (ed.), *Die deutsche Literatur der Gegenwart. Aspekte und Tendenzen*. Stuttgart: Reclam, 1971, 337–65.
Rasch, William, 'Theories of the Partisan. *Die Maßnahme* and the Politics of Revolution', *Brecht Yearbook* 24 (1999): 331–43.
Redeker, Horst, *Abbildung und Aktion. Versuch über die Dialektik des Realismus*. Halle: Mitteldeutscher Verlag, 1966.
Richtig, Ludwig, 'Vom Surrealism und von der Katholischen Moderne zum Sozialistischen Realismus in der slowakischen Lyrik'. In: Alfrun Kliems et al. (eds), *Sozialistischer Realismus*. Berlin: Frank & Timme, 2006, 129–50.
Rosellini, Jay, *Wolf Biermann*. Munich: Beck, 1992.
Rühmkorf, Peter, *Wolfgang Borchert mit Selbstzeugnissen und Bilddokumenten*. Reinbek: Rowohlt, 1997.
Schebera, Jürgen, *Hanns Eisler. Eine Biografie*. Berlin: Henschel, 1981.
Scherstjanoi, Elke (ed.), *Zwei Staaten, zwei Literaturen? Das internationale Kolloquium des Schriftstellerverbands in der DDR, Dezember 1964. Eine Dokumentation*. Munich: Oldenbourg Verlag, 2008.
Schmidt, Marianne, *Wolfgang Borchert. Analysen und Aspekte*. Halle/Saale: Mitteldeutscher Verlag, 1974.
Schubbe, Elimar (ed.), *Dokumente zur Kunst-, Literatur- und Kulturpolitik der SED*. Stuttgart: Seewald, 1972.
Sonntag, Ingrid, 'Wurde Hilbigs Stimme Stimme auf der Leipziger Buchmesse ausgestellt?' In: Carmen Laux and Patricia F. Zeckert (eds), *Flachware. Fußnoten der Leipziger Buchwissenschaft*. Leipzig and London: Plöttner, 2012, 39–50.
——— (ed.), *An den Grenzen des Möglichen. Reclam Leipzig 1945–1991*. Berlin: Ch. Links, 2016.
Steingröver, Reinhild, *Last Features: East German Cinema's Last Generation*. Rochester: Camden House, 2014.
Steinkamp, Maike, *Das unerwünschte Erbe. Die Rezeption 'entarteter' Kunst in Kunstkritik, Ausstellungen und Museen der SED und früheren DDR*. Berlin: Akademie Verlag, 2008.

Straube, Robert, *Veränderte Landschaften. Landschaftsbilder in Lyrik aus der DDR.* Bielefeld: transcript Verlag, 2016.
Tannert, Christoph, 'Von Vortönern und Erdferkeln. Die Filme der Bildermacher'. In: Karin Fritzsche and Claus Löser, *Gegenbilder. Filmische Subversion in der DDR 1976–1989. Texte Bilder Daten.* Berlin: Janus Press, 1996, 25–60.
Thomas, Karin, 'Die "andere" deutsche Kunst. Malerei und Grafik in der DDR. Entwicklung und Gegenwart'. In: Paul Gerhard Klussman and Heinrich Mohr (eds), *Literatur und bildende Kunst.* Bonn: Bouvier, 1985, 1–22.
———, *Kunst in Deutschland seit 1945.* Cologne: DuMont, 2002.
Verdofsky, Jürgen, 'Endlich Endler', *Frankfurter Rundschau,* 15 November 2019.
Visser, Anthonya, *'Blumen ins Eis'. Lyrische und literaturkritische Innovationen in der DDR. Zum kommunikativen Spannungsfeld ab Mitte der 60er Jahre.* Amsterdam: Rodopi, 1994.
Völker, Klaus, '"Und kein Führer führt aus dem Salat". Brecht, der antistalinistische "Stalinist"'. In: Therese Hörnigk and Alexander Stephan (eds), *Rot gleich Braun. Nationalsozialismus und Stalinismus bei Brecht und Zeitgenossen.* Berlin: Theater der Zeit, 2000, 127–52.
Westheider, Ortrud and Michael Philipp (eds), *Hinter der Maske. Künstler in der DDR.* Munich: Prestel Verlag, 2017.
White, John J., *Bertolt Brecht's Dramatic Theory.* Rochester: Camden House, 2004.
Winkler, Norbert and Wolfgang Kraus (eds), *Franz Kafka in der kommunistischen Welt. Kafka-Symposium 1991 – Klosterneuburg.* Cologne: Böhlau, 1993.
Winnen, Angelika, *Kafka-Rezeption in der Literatur in der DDR. Produktive Lektüren von Anna Seghers, Klaus Schlesinger, Gert Neumann und Wolfgang Hilbig.* Würzburg: Königshausen & Neumann, 2006.
Wolff-Poweska, Anna, 'The German Democratic Republic's Attitude Towards the Nazi-Past', *Pzeglad Zachodni* 1 (2011): 73–102.
Wolle, Stefan, *Der Traum von der Revolte. Die DDR 1968.* Berlin: Ch. Links, 2008.
———, *Aufbruch nach Utopie. Alltag und Herrschaft in der DDR.* Berlin: Ch. Links, 2011.
Wix, Gabriele, 'Elke Erb: Leben im Kommentar'. In: Steffen Poppe (ed.), *Elke Erb.* München: edition text + kritik, 2017, 3–11.
Zima, Peter V., 'Der Mythos der Monosemie. Parteilichkeit und künstlerischer Standpunkt'. In: Hans-Jürgen Schmitt (ed.), *Einführung in Theorie und Funktion der DDR-Literatur.* Stuttgart: Metzler, 1975, 77–107.

Index

11. Plenum des ZK der SED, 33–34, 70, 79–81, 119, 173. *See also* Kahlschlag Plenum

A
absurd, 5, 13, 45, 69, 81, 99, 132–33, 140, 163, 182, 191
absurdism, 102
absurdity, 10, 72, 81, 99, 101, 160, 164, 184, 189
Abusch, Alexander, 33. *See also* Minister of Culture
Adenauer, Konrad, 18, 98, 103
Adorno, Theodor W., 30, 178
agitprop, 99, 188
Akademie der Künste der DDR, 26, 45, 153
Akhmatova, Anna, 73, 136, 155
alienation, 7, 164, 179
 Bertolt Brecht, 27, 40
 Franz Kafka, 161–62
Allende, Salvador, 98
Altenberg, Peter, 102
Altenbourg, Gerhard, 175
Anders, Richard, 4
Anderson, Sascha, 97, 148, 157
Anthology of Black Humour, 63, 100, 109, 117. *See also* Breton, André
anti-fascist, 21, 22–24, 82, 177
Aragon, Louis, 2, 170, 185
Arendt, Erich, 4, 107, 133
Arp, Hans/Jean, 1, 16–18, 21, 181
Assmann, Aleida, 112
avant-garde, 1, 6, 19–25, 28, 33–34, 39–42, 45–50, 154, 170
 historical avant-garde, 1–2, 6, 8, 12–15, 20–21, 39, 60, 64, 73, 76, 81–83, 90, 132, 135, 143, 154, 168, 181, 185, 189
 neo-avant-garde, 34, 48, 83–84, 97, 133, 136, 157, 168, 171, 181, 189

B
Bachmann, Ingeborg, 135, 159–60
Bakhtin, Mikhail Michajlovic, 107–9
Balzac, Honoré de, 27
Barck, Karlheinz, 5, 8, 13, 40, 100, 121, 154, 165, 168–74, 181, 185–89
Barck, Maximilian, 189
Barlach, Ernst, 19, 26
Barron, Stephanie, 19
Bathrick, David, 23–24, 46, 134, 178
Bartsch, Kurt, 71, 96
beat generation, 24, 102, 155–57
beat poet, 55, 99, 135
Becher, Johannes R., 22, 26, 28, 32–33, 81, 188–89. *See also* Minister of Culture
Becker, Jurek, 123
Benjamin, Walter, 29, 42, 99
Benn, Gottfried, 28, 118. *See also* Expressionism/Realism debate, Alfred Kurella, Georg Lukács and Klaus Mann
Berkeley, 54
Berlin, 8, 22, 28, 42, 44, 80, 83, 92, 94, 97–99, 103, 107, 120. 131, 145, 182–83
 East Berlin, 4, 31, 42, 47, 54, 84, 100, 111, 118, 122, 125, 133, 148, 157–61, 189

West Berlin, 4, 7, 18, 53–54, 84–86, 118–19, 149, 172
Berlin Wall, 5, 25, 53, 71, 100, 183
Bhabha, Homi K., 57, 77, 83
Bieler, Manfred, 4
Biermann, Wolf, 13, 21, 69–72, 81, 84–86, 93, 96
Biermann-Ausbürgerung (expatriation), 70, 93, 119, 149, 161
Bitterfeld, 73
Bitterfelder Weg, 73–74
Bleutge, Nico, 131, 133
Bloch, Ernst, 13, 54, 177–79
Blok, Alexander, 73
Bobrowski, Johannes, 4, 82
Bock, Ulrich, 53
Bode, Arnold, 21
Böthig, Peter, 154
Böttiger, Helmut, 122, 127
bohemian, 4, 7, 122, 134, 148–49, 156–57, 164, 189
Bohrer, Karl Heinz, 55
Borchert, Wolfgang, 10–11
Bosch, Hieronymus, 81
Brake, Michael, 154–55
Brando, Marlon, 156
Brasch, Thomas, 50, 53
Braun, Volker, 50, 71, 134, 190
Brecht, Bertolt, 4, 12, 19, 24–32, 39–50, 56, 91, 178. *See also* alienation
Bredel, Willi, 22, 27–28
Brentano, Bernard von, 42
Breton, André, 2–3, 12, 21, 24, 59, 63, 72, 86, 91, 99–100, 108, 117, 143, 164, 170, 176, 181, 185–87, 188–89
Brinkmann, Rolf Dieter, 135
British Broadcasting Cooperation (BBC), 93
Brohm, Holger, 75
Bruyn, Günter de, 27
Budapest, 33, 151
Bürger, Peter, 1, 8, 20, 48, 83–84, 134, 168, 171, 179, 181, 185
Bukharin, Nikola, 30, 56

C
Cabrera Infante, Guillermo, 185
Cambridge, 17
Celan, Paul, 4, 41

Chagall, Marc, 21
Char, René, 27
Chemnitz, 8
Chirico, Giorgio de, 21
Cixous, Hélène, 169
Claus, Carlfriedrich, 108, 133, 175
Cold War, 7, 9, 11, 14, 20, 22, 25, 34, 42–43, 46, 57–58, 63, 65, 69, 71, 74, 103, 150, 178
Cologne, 8
Communism, 3, 13, 33, 61, 74, 178
concrete poetry, 124, 144
Connolly, Thomas C., 41
Constructivism, 21, 175, 178
counterculture, 6, 134, 149, 153, 157, 189
Crevel, René, 170
cosmopolitics, 25, 27, 70
cultural memory, 112
Czechowski, Heinz, 9, 103

D
Dada, 5, 21, 135, 156, 164
Dadaism, 7, 117, 149, 155, 178
Dahlke, Birgit, 131, 136, 138, 142, 154, 157–58
Dalí, Salvador, 8, 116, 190
Davies, Mererid, 5
Dean, James, 156
Debord, Guy, 5
decadence, 22, 25, 33, 49, 63–64
degenerate art, 1, 19, 23, 26, 45, 64, 117, 151
Dessau, Paul, 27, 39, 42, 46–47, 49–50
Deutsche Film-Aktiengesellschaft (DEFA), 22, 162
Deutsches Literaturarchiv (DLA), 181
Di Prima, Diane, 155–56
Dickinson, Emily, 136
Dix, Otto, 19, 42, 172
documenta, 21–22, 46
Döblin, Alfred, 19, 29
Draesner, Ulrike, 143
Dresden, 8–9, 171–72
Dresen, Adolf, 53
Dubček, Alexander, 58, 85
Duras, Marguerite, 156
Dutschke, Rudi, 84
Dymschitz, Alexander, 25–26

E

écriture automatique, 116, 134, 143
Ehrenburg, Ilja, 32
Eidecker, Marina Elisabeth, 120
Eisler, Hanns, 27, 32, 39, 41–49
Eisler, Hilde, 32
Eisler-Fischer, Louse, 174
Éluard, Paul, 2, 58, 82, 121, 177
Emde, Silke von der, 119
Emmerich, Wolfgang, 54, 119
Endler, Adolf, 13, 24, 57, 69–76, 83, 86, 101–3, 117–27, 133, 140, 143, 148, 168, 170, 181–90
 Nebbich, 91–112, 186–87
entartete Kunst, 1, 11, 18–19, 23
Enzensberger, Hans Magnus, 1, 5, 8, 20, 134, 168, 181, 185
Eörsi, István, 30
Erb, Elke, 13, 57, 70, 104, 107, 118, 148–51, 157, 190
 Winkelzüge oder Nicht vermutete, aufschlussreiche Verhältnisse, 131–45
Erbe, Günter, 23
Erfurt, 148, 151, 158, 161–63
Ernst, Max, 1, 8, 21, 76, 116, 164, 170, 181, 186–90
Erasmus of Rotterdam, 81
Erpenbeck, Fritz, 25–28, 33
Evans, Richard J., 17
Ewers, Hans Heinz, 105
Expressionism/Realism debate, 20, 23–35, 39, 48, 65, 82, 178. *See also* Gottfried Benn, Alfred Kurella, Georg Lukács and Klaus Mann

F

Feuchtwanger, Lion, 28, 42
Federal Republic of Germany (FRG), 7, 21, 34, 46, 53–54, 73, 84, 112
Field, Noel, 43
Fischer, Ernst, 62–63, 174
Formalism Campaigns, 5, 7, 12, 20, 22–49, 56, 72–73, 91, 151, 169, 173, 176
Forum debates, 75, 96, 134
Foster, Hal, 48–49, 83, 168
foundation myth, 18, 22, 54
Foucault, Michael, 169
Fraenger, Wilhelm, 5, 174

France, 2, 21, 59, 61, 181
Frankfurt am Main, 34, 106
Freud, Sigmund, 2, 132
Fried, Erich, 93, 131
Fries, Fritz Rudolf, 13, 57, 73, 117–20, 133
Frommhold, Erhard, 5, 13, 165, 172–74
Fuchs, Günter Bruno, 4
Fühmann, Franz, 26, 74, 122
Fürnberg, Louis, 63
Fulbrook, Mary, 53

G

Gallée, Caroline, 32
Garaudy, Roger, 62–63
Garton Ash, Timothy, 13, 149–50
Gaulthier, Xavière, 156
GDR Writers' Union, 96
Gente, Peter, 169
Gerhardt, Marlis, 155
German Classicism, 31, 64
German Democratic Republic (GDR), 42, 53, 64
Gillespie, Dizzy, 118–19
Ginsburg, Allen, 55
Girnus, Wilhelm, 26
Glöckner, Hermann, 133, 175
Greßmann, Uwe, 13, 69, 76, 79–81, 108, 190
godfather, 32, 109, 116–17
Goebbels, Joseph, 105
Goethe, Johann Wolfgang, 31–34, 47, 49, 65, 178
Gogh, Vincent van, 110
Goldstücker, Eduard, 61
Goll, Yvan (Iwan Lassang), 1
Gorbachev, Mikhail, 169
Gorki, Maxim, 30, 56
Goth, Maja, 63
Gröschner, Annett, 136–37
Grosz, George, 21, 42, 156
grotesque, 5, 7, 10, 13, 45, 76, 71, 85, 92, 94–97, 111, 117–18, 120, 132, 140, 163, 182, 191
Grunenberg, Antonia, 154
Grün, Max von der, 73
Gudmundsdóttir, Gunthórunn, 111
Günther, Eberhard, 91, 182
Guenter, Peter, 19

Gumilev, Nikolay, 155
Gusdorf, Georges, 104

H
Hamburger, Michael, 4, 93
Hampel, Angela, 133
Harich, Wolfgang, 33
Havemann, Robert, 84
Hauptmann, Elizabeth, 42
Heartfield, John, 21, 25, 39, 42–50, 56, 91, 156
Hecht, Werner, 24, 27, 45, 50
Heisig, Bernhard, 21
Heldt, Werner, 8
Hermlin, Stephan, 5, 13, 57–58, 71–72, 75, 170, 176–77
Hermsdorf, Klaus, 61, 63, 65
Herzfelde, Gertrud, 44
Herzfelde, Wieland, 41, 45
Hensel, Kerstin, 133, 136
Hilbig, Wolfgang, 13, 57, 59, 101, 133, 170, 184, 190
 Alte Abdeckerei, 117–27
Historikerstreit, 23
Hitler, Adolf, 1, 8, 11, 17, 23, 26, 29, 91, 103, 187–88
Höch, Hannah, 155–56, 171
Höpcke, Klaus, 152
Hörnigk, Frank, 83, 190–91
Hofer, Karl, 8
Hoffmann, E.T.A., 135, 159
Holocaust, 117, 122–25
Honecker, Erich, 34, 86, 93, 96, 119, 150, 174
Hornig, Günther, 133
Howarth, William, 110
Huchel, Peter, 32, 62, 70–75, 107
Hübner, Johannes, 4
humanism (*Humanismus*), 31, 64–65
Hussel, Horst, 133

I
Illés, Làlzó, 171
Institute of Literature in Leipzig, 24, 33, 90. See also Johannes. R. Becher Institut für Literatur
Ionesco, Eugene, 163
Iron Curtain, 25, 60

J
Jahnn, Hans Henny, 4
Jandl, Ernst, 143
Janet, Pierre, 143
Janka, Walter, 33
Jäger, Manfred, 12, 25, 45
Johannes. R. Becher Institut für Literatur, 26, 33, 182. See also Institute of Literature in Leipzig
Johnson, Uwe, 118
Joyce, James, 29

K
Kahlau, Heinz, 72
Kahlschlag Plenum, 34, 148, 170. See also 11. Plenum des ZK der SED
Kaiser, Paul, 34, 148, 170
Kafka, Franz, 12, 29, 33, 57–65, 70, 84, 117, 177. See also alienation
Kahlo, Frida, 3, 189
Kant, Immanuel, 65, 185
Kassel, 21
Khaldei, Yevgeny, 8
Khlebnikov, Velimir, 73, 76
Khrushchev, Nikita S., 31, 56, 59
Királyfalvi, Béla, 30
Kirsch, Rainer, 71, 82
Kirsch, Sarah, 70–71, 76, 82, 103, 107, 123, 136, 140
Klatt, Gudrun, 168
Klee, Paul, 108, 172
Kleist, Heinrich von, 135
Klemperer, Victor, 9, 22
Klünner, Lothar, 4
Koch, Hans, 33, 76, 78
Köhler, Barbara, 136
Kolbe, Uwe, 50, 93
Kraus, Karl, 31
Kraushaar, Wolfgang, 55
Krauss, Werner, 171
Kristeva, Julia, 85
Kröll, Friedhelm, 18
Kulturpolitik, 31, 56
Kunert, Günter, 59, 62, 90
Kunze, Reiner, 59

Kurella, Alfred, 24, 27–28, 62. *See also* Expressionism/Realism debate, Gottfried Benn, Georg Lukács and Klaus Mann

L
Lachnit, Wilhelm, 8
Lang, Lothar, 3, 8–9, 13, 165, 175–77
Lange-Müller, Katja, 148, 157
Laschen, Gregor, 100, 139, 145
Laughton, Charles, 44
Lauter, Hans, 27
Lautréamont (Isidore Lucien Ducasse), 2, 116–17, 125, 190
Leipzig, 11, 24, 26, 57, 90, 96, 104, 119, 125, 175, 177, 182
Leiris, Michel, 121
Leising, Richard, 13, 69, 72, 76, 79
Leitdiskurs, 5
Lenin (Vladimir Ilyich Ulyanov), 12, 31, 45, 123
Leseland / Literaturgesellschaft, 72, 79, 92, 139, 189
Lessing, Gotthold Ephraim, 65
Lewis, Alison, 150
Life Writing, 110–12
Löser, Gerd, 163
London, 43–44
Lorenc, Kito, 140
Ludwig, Paula, 19
Lüdke, Martin, 104, 108
Lukács, Georg, 12, 20, 25, 27–34, 55–57, 65, 117, 185. *See also* Expressionism/Realism debate, Gottfried Benn, Alfred Kurella and Klaus Mann
Lunacharsy, Anatoly, 29
Luxemburg, Rosa, 39
Lyotard, Jean-François, 169

M
Maetzig, Kurt, 22
magical realism, 117, 119
Magritte, René, 116
Mallarmé, Stéphane, 127, 144
Mandelstam, Osip, 155
Mann, Klaus, 28. *See also* Gottfried Benn, Expressionism/Realism debate, Alfred Kurella and Georg Lukács

Mann, Thomas, 19, 24, 29, 31, 44
Marx, Karl, 7, 48, 100
Marxism, 12, 28, 90, 169
Masson, André, 116, 186
Materialästhetik, 40–42, 178
Mattheuer, Wolfgang, 21
Matthies, Frank-Wolf, 108
Maurer, Georg, 33
Mayakovsky, Vladimir, 24, 90
Mayer, Hans, 5, 13, 55, 57–58, 63, 75, 78, 161, 165, 176–77
Mayer-Foreyt, Hans, 21
Mayröcker, Frederike, 131, 135–36, 143
Mazenauer, Beat, 103
Mehring, Franz, 31
memoir, 1, 107
Mexico, 2–3, 189
Michael, Klaus, 154
Mickel, Karl, 13, 69–78, 83, 92, 103, 108, 118, 164, 190
Minister of Culture, 33
Mierau, Fritz, 72–73, 81–82
Mierau, Sieglinde, 72, 81–82
Minotaure, 63, 124, 187
Miró, Joan, 8, 116
Mitteldeutscher Verlag, 73, 91, 134, 182
Mittenzwei, Werner, 34, 40–41, 61, 168
modern, 19, 26–27, 57, 62, 78, 102, 110, 154, 171, 176, 184, 188
Modernism, 4–5, 8, 11–13, 19, 21–22, 30–32, 39, 54, 57–59, 61–62, 64–65, 70, 117–18, 127, 133, 139, 149–50, 163–64, 147–48, 184
Moog, Christa, 157
monosemia, 5, 7, 63
montage, 24–27, 39, 50, 99, 111, 120, 156, 163, 182
Morgner, Irmtraud, 13, 73, 90, 117–20
Moscow, 28–31, 178, 188
Motte-Fouqué, Friedrich de la, 135, 159
Müller, Heiner, 13, 50, 57, 90, 117, 161, 190
Müller, Inge, 107
Munich, 18–19

N
Naaijkens, Ton, 100
Nachdichtung, 72–73, 121

Nachkriegssurrealismus, 4, 14, 143, 190
Nadrealism, 2, 21, 59
Nagy, Imre, 33
National Socialism, 3, 8, 73
Naumann, Manfred, 170
Neher, Casper, 42
Neruda, Pablo, 94
Neue Leipziger Schule, 21
Neues Deutschland, 25
Neumann, Gert, 59, 121, 125
New York, 1, 44
Newman, Cecil, F.S., 8
Niekisch, Ernst, 173
Nineteen-Sixty-Eighters, 18, 54
Nordau, Max, 19
North America, 84, 99, 102
Novalis, 125
Nationalist Socialist Labour Party (NSDAP), 18

O
Opitz, Michael, 121, 125
Ottwalt, Ernst, 42
Ovid (Publius Ovidius Naso), 124

P
Pacific Palsade, 44
Papenfuß, Bert, 108, 137, 143, 148, 162
Paris, 1, 3, 28, 53–54, 63, 108, 120, 181, 187–88
Paris, Heidi, 169
Parker, Stephen, 44
Pastior, Oskar, 143
pan-German, 10–11
Penck, A.R. (Ralf Winkler), 9, 162, 175
Petöfi Club, 33, 55
Petöfi, Sándor, 55
Petzold, Claudia, 34, 148, 170
Phantasmagoria, 91–92, 164, 182–83
picaresque, 101, 118–20
Picasso, Pablo, 21, 32, 124, 171–72, 190
Pike, David, 27
Piscator, Erwin, 41
Poche, Klaus, 96
Polizzotti, Mark, 109
postmodernism, 83–84, 168
Prague, 33, 53, 59, 61, 63, 85

Prague Spring, 53–54, 58, 60, 63, 85, 151, 173
Prenzlauer Berg Connection, 93, 97, 100, 126, 154, 161

R
Rabelais, François, 81
Raddatz, Fritz J., 4, 104, 108
Rauch, Neo, 133
Ray, Man, 116, 163
Real Existing Socialism, 182–83
rebellion, 5, 65, 76, 154–55
Reclam Verlag, 121, 170
Rembrandt van Rijn, 110
Rimbaud, Arthur, 127
Richter, Helmut, 61
Richter, Stefan, 169
Rinne, Susanne, 53
Rivera, Diego, 3, 189
Rossellini, Roberto, 8
Rudolph, Wilhelm, 8–9
Rülicke, Käthe, 49

S
Sächsische Dichterschule, 33, 50–51, 72, 78, 92–93, 103–4, 136
samizdat, 82, 97, 121, 170
Sandberg, Herbert, 32
Santa Monica, 44
Sartre, Jean-Paul, 173
Scarry, Elaine, 136
science, 94, 97
science fiction, 10
Schlenstedt, Dieter, 8, 75, 168, 170
Schiller, Dieter, 75
Schiller, Friedrich, 32, 65
Schleime, Cornelia, 136, 148, 157, 162
Schlesinger, Klaus, 59, 96
Schmidt, Arno, 143
Schmidt, Diether, 13, 45, 171–72, 175
Schmidt, Heinz H., 32
Schreier-Endler, Brigitte, 103
Schröder, Rolf X. (XAGO), 133, 175
Schubert, Dieter, 96
Schultze-Naumburg, Paul, 19
Schumacher, Ernst, 61
Schwitters, Kurt, 19, 118
Seghers, Anna, 59

Sinn und Form, 32, 62, 70, 93
Schütz, Klaus, 85
Schwitters, Kurt, 19, 118
Snyder, Gary, 156
Socialist Unity Party (SED), 3, 7, 11, 14, 18, 21, 23–26, 33, 42–43, 46–47, 54, 59, 70, 75–76, 90, 99, 119, 134, 153, 162, 174
Sonntag, Ingrid, 121
Soupault, Philippe, 11, 116, 143, 170, 185
Soviet Military Administration in Germany (SMAD), 25
Soviet Occupied Zone (SBZ), 1, 3–4, 6, 11–12, 18, 22, 25, 31, 39, 44–45, 48, 55–57, 116, 134–35, 179, 189
Spain, 2, 28
Speichen
 literary archive, 3
 poetry yearbook, 4
Spoerl, Heinrich, 105
Stalin, Joseph (Joseb Besarionis dze Jughashvili), 22, 30–31, 33, 41, 55–56, 59, 72, 75, 178, 187–89
Stalinism, 3, 73, 83, 177
Stasi, 13, 45, 91, 97. 107, 139, 149–62, 171, 176–77, 182
Steingröver, Reinhild, 162
Stephan, Inge, 155
Sternheim, Carl, 103
Stötzer, Gabriele, 13, 133, 136, 148–64, 190
 Stasi files, 153, 164
 Super 8-videos, 156, 160–64
'Storm and Stress' years, 12, 25–26, 45
Sturrock, John, 106
Suleiman, Susan, 155–56

T
Taeuber-Arp, Sophie, 181
Tanning, Dorothea, 181
Tanguy, Yves, 116
Third Reich, 11, 13, 17–19, 23, 27, 112, 117, 171
Thomas, Karin, 152
Ticha, Hans, 133

Tippner, Anja, 83
Tokyo, 54
Tragelehn, B.K., 71
Trojan Horse, 24, 61
Trotsky, Leon, 3, 189
Trotskyism, 3
Tschesno-Hell, Michael, 22
Tsvetaeva, Marina, 136
Tübke, Werner, 21

U
Uhlmann, Joachim, 4
Uhse, Bodo, 62
Ulbricht, Walter, 18, 43, 93, 103, 117, 150
underground, 13, 77, 95, 99, 122, 126–27, 134, 148, 151–63
Unschärfe, 83, 190–91

V
Völker, Klaus, 4, 29
Vonnegut, Kurt, 10

W
Waldrop, Rosmarie, 131, 136
Wegner, Bettina, 53
Wehrmacht, 10, 122
Weigel, Sigrid, 155
Wende, 92, 123, 134, 142, 169, 175, 184, 189
Wendisch, Trak, 69
White, John J., 41
Wolf, Christa, 13, 90, 135, 139, 160–61, 190
Wolf, Gerhard, 75, 162
Wolle, Stefan, 53, 56
Wort, 24, 28–29, 178
Wühr, Paul, 143

Z
Zavala, Iris M., 74, 99
Zero Hour, 17–18
Zhdanov, Andrei, 30, 56
Žižek, Slavoj, 48–49
Zweig, Arnold, 82

www.ingramcontent.com/pod-product-compliance
Lightning Source LLC
Chambersburg PA
CBHW071341080526
44587CB00017B/2915